Twentieth Century
United States Photographers

TWENTIETH CENTURY
UNITED STATES PHOTOGRAPHERS

A Student's Guide

Kristin G. Congdon and Kara Kelley Hallmark

GREENWOOD PRESS
Westport, Connecticut • London

Library of Congress Cataloging-in-Publication Data

Congdon, Kristin G.
 Twentieth century United States photographers : a student's guide /
Kristin G. Congdon and Kara Kelley Hallmark.
 p. cm.
 Includes bibliographical references and index.
 ISBN-13: 978–0–313–33561–7 (alk. paper)
 ISBN-10: 0–313–33561–3 (alk. paper)
 1. Photographers—United States—Biography—20th century. I.
Hallmark, Kara Kelley. II. Title.
 TR139.C65 2008
 770.92'273—dc22 2007015228

British Library Cataloguing in Publication Data is available.

Library of Congress Catalog Card Number: 2007015228
ISBN-13: 978–0–313–33561–7
ISBN-10: 0–313–33561–3

First published in 2008

Greenwood Press, 88 Post Road West, Westport, CT 06881
An imprint of Greenwood Publishing Group, Inc.
www.greenwood.com

Printed in the United States of America

The paper used in this book complies with the
Permanent Paper Standard issued by the National
Information Standards Organization (Z39.48–1984).

10 9 8 7 6 5 4 3 2 1

We dedicate this book to the photographers
in it who have inspired us to see in new ways.

CONTENTS

ALPHABETICAL LIST OF ARTISTS

Abbott, Berenice

Adams, Ansel

Arbus, Diane

Avedon, Richard

Boody, Meghan

Bourke-White, Margaret

Brigman, Anne

Bubley, Esther

Butcher, Clyde

Callahan, Harry

Casebere, James

Charlesworth, Sarah

Christenberry, William

Coleman, Bill

Cox, Renee

Crewdson, Gregory

Cunningham, Imogen

Curtis, Edward S.

Dater, Judy

DeCarava, Roy

Dunning, Jeanne

Edgerton, Harold E.

Evans, Walker

Friedlander, Lee

Gaskell, Anna

Goldin, Nan

Groover, Jan

Hine, Lewis

Lange, Dorothea

Leibovitz, Annie

Levine, Sherrie

Levinthal, David

Levitt, Helen

Little Turtle, Carm

Man Ray

Mann, Sally

Mapplethorpe, Robert

Mark, Mary Ellen

Meatyard, Ralph Eugene

Metzker, Ray K.

Meyerowitz, Joel

Misrach, Richard

Modica, Andrea

Morgan, Barbara

Newman, Arnold

Owens, Bill

Parks, Gordon

Porter, Eliot

Post Wolcott, Marion

Rosler, Martha

ACKNOWLEDGMENTS

FIRST AND FOREMOST, WE WOULD LIKE TO THANK GREENWOOD PRESS'S Acquisition Editor, Debby Adams, for giving us another opportunity to work with Greenwood and for being a constant source of encouragement and positive support. We would also like to thank all of the other editors at Greenwood who contributed to this final product, including Kaitlin Ciarmiello, Leanne Small, and Erin Ryan. Also, we would like to thank the editorial team and production staff at Apex Publishing.

A very special thank you to all of the artists who gave us biographical information, provided images for the text, and shared their stories with us: Meghan Boody, Clyde Butcher, James Casebere, Sarah Charlesworth, Bill Coleman, Renée Cox, Gregory Crewdson, Judy Dater, Jeanne Dunning, Nan Goldin, Lee Friedlander, David Levinthal, Carm Little Turtle, Mary Ellen Mark, Joel Meyerowitz, Richard Misrach, Andrea Modica, Bill Owens, Martha Rosler, Andres Serrano, Lorna Simpson, the Starn Twins, Jerry Velsmann, William Wegman, Deborah Willis, and Joel-Peter Witkin.

For a few of the deceased artists, we were fortunate to be in contact with their family members, estate representatives, and foundation staff who provided images and assisted with biographical fact checking. Thank you to Michelle Franco at the Richard Avedon Foundation; Jean Bubley, niece of artist Esther Bubley; Anne Coleman Torrey at the Aaron Siskind Foundation in New York City; Pamela Vanderzwan at the James Casebere Studio; Mia Nrell at the Lorna Simpson Studio in New York City; and Gaudéricq Robiliard at the Starn Studio in New York City. Our book is better because of your assistance.

There were many museums and galleries around the world that assisted us by providing exhibit brochures with images of artwork from which to choose and acted as liaisons to the artists to ensure accuracy of information. We would like to extend thanks to: Karen Mansfield at the Worcester Art Museum in Worcester, Massachusetts; Ann B. Gonzalez at the San Francisco Museum of Modern Art in California; Jacklyn Burns at the J. Paul Getty

Museum in Los Angeles, California; Denise M. Panarello with the Big Cypress Gallery in Ochopee, Florida; Lauren Panzo and Kay Broker at the Pace/MacGill Gallery in New York City; Elizabeth White with the Sarah Charlesworth Studio; Carl Ingleby and Teri Schau with the Bill Coleman Studio; Amy Young and Shelley Walker at the Robert Miller Gallery in New York City; Caroline Burghardt at Luhring Augustine Gallery in New York City; Julie Quon with Kinz Tillov and the Feigen Contemporary Gallery in New York City; Daniel Cheek at Fraenkel Gallery in San Francisco, California; Janet Borden at Janet Borden, Inc. in New York City; Jeffrey Smith at Contact Press Images in New York City; Jody Berman at Laurence Miller Gallery in New York City; Jessica Marx at Art and Commerce in New York City; Meredith Lue with the Mary Ellen Mark Studio; Jon Smith with the Joel Meyerowitz Studio; Libby McCoy with the Bill Owens Studio; Callie Morfeld Vincent with the Amon Carter Museum in Fort Worth, Texas; Rachel Lieber at Mitchell-Innes & Nash in New York City; Kara Schneiderman at the Lowe Museum of Art, University of Miami in Coral Gables, Florida; Peter Schuette at Metro Pictures Gallery in New York City; Sara Hindmarch at the High Museum of Art in Atlanta, Georgia; Barbara Puorro Galasso at the George Eastman House of Photography in Rochester, New York; Ariel Dill with the William Wegman Studio; Wendy Griffiths at the Modern Art Museum in Fort Worth, Texas; Katrina del Mar at the Nan Goldin Studio; Barbara A. Gilbert with the Joel-Peter Witkin Studio; Catherine Edelman at the Catherine Edelman Studio in Chicago; Melanie Walker, daughter of Todd Walker; Amanda Parmer and Sarah Baron at the Paula Cooper Gallery in New York City; Eliana Glicklich at the Artist's Rights Society in New York City; Janet Morgan, granddaughter of Barbara Morgan; Peter brunnell with the Minor White Archive at Princeton Univeristy; Katie Pratt with the Imogen Cunningham Trust; Mary Steele with Palm Press, Inc., and the Harold Edgerton Estate; Cheryl Poling with the Center for Creative Photography, Phoenix; Laura Platt Winfrey with Carousel Research, Inc., in New York City; Kimberly Tishler at the Visual Arts and Galleries Association in New York City; and Sarah H. Paulson at the Ronald Feldman Gallery in New York City.

A special thanks to English teacher and Editor-at-large Lea Kelley Lowrance for editorial assistance throughout the project. Many thanks as well to Stephen Goranson from Duke University's library, who checked and re-checked pieces of information and references. Without the two of you, we could not have tended to details nearly as well as we have.

We send our gratitude to Danny Coeyman, the Assistant for the Cultural Heritage Alliance at the University of Central Florida (UCF), who performed several months of good work as a research assistant. Tess Bonaci, also from UCF, did library work. We thank several photographer friends who made suggestions of artists to include in the book: Julie Kahn, Rebecca Sittler, and Laine Wyatt. We learned from all of you.

Lastly, we thank our respective partners in life, David Congdon and John Hallmark, for your never-ending cheerleading and continuous support.

INTRODUCTION

PHOTOGRAPHY'S CHANGING LANDSCAPE

Like other art forms, photography in the United States changed dramatically in the twentieth century, but the growth in its popularity has been far more noticeable. Major art museums are developing vast and extensive collections of photography. When the Metropolitan Museum of Art in New York acquired hundreds of photographs from the Gilman Paper Company's Collection in 2005, they increased their status as one of the world's pre-eminent institutions for photography, making headline news in the art world. It was estimated that the value of this collection on the open market would exceed $100 million. In 2006, the J. Paul Getty Museum quadrupled its gallery space for photographs to display the 31,000 works it has acquired in the last two decades in an effort to have contemporary relevance. Many Chelsea galleries are dedicated to photography, and audiences for photography exhibitions are substantial. More than one hundred venues for viewing photography exhibitions exist in New York alone. The demand for seeing photography is so high in the twenty-first century that the George Eastman House in Rochester and the International Center of Photography are partnering to produce an online collection of key works. This will be "one of the largest freely accessible databases of masterwork photography anywhere on the Web, a venture that will...provide an immense resource for photography aficionados, both scholars and amateurs" (Kennedy B1).

The value of photographs sold at auction each year has doubled since 2001. In 1999 Man Ray's *Glass Tears* (1930–1933) sold for $1.3 million. While few photographs get near this staggering price, in 2004 Diane Arbus print of *Identical Twins, Roselle, New Jersey* (1967) sold at Sotheby's for $478,400, and Robert Mapplethorpe's photograph titled *Calla Lily* (1986) sold for $242,700. According to *New York Times* writer, Philip Gefter, it is not unusual for a well-known photographer's work to sell for six-figure prices.

The number of photography books, like this one, has also steadily increased, because pictures tell stories, and stories are always popular. Gefter wonders if people are reading less and looking at pictures more for storytelling activity. Some artists feel that it is much better to have your art in a book than on a gallery wall because a book is like a traveling show; thus, more people will see it. In a sense, we could say that editors and authors of photography books have become museum curators. Because so many photographs are digitized today, having them printed on paper has become more valued. And because we live in a digitized world, production costs for publishing photography books have been lowered (Woodward 106). Actor Ben Stiller, who collects photographs, says "I prefer buying a vintage print if I can, but that's not the main point. The great thing about photography is that you can cut a picture from the pages of a magazine and enjoy it as much as a vintage print" (Finkel 39). Indeed, many people believe that remarkable photographs can be found—and enjoyed—everywhere.

So what makes photography so compelling? Photographs document moments in time; they present and interpret emotions, tell stories, and act as catalysts to telling new ones. Twentieth-century photojournalists have helped to promote environmentalism, change legislation, and encourage patriotism, and they have been responsible for the formation of new and creative ideas. Photographs can inspire awe and can take us to places where we have never been. They can help us explore issues of race, class, gender, sexuality, disease, and disability. Photographs can be used as propaganda and as catalysts for action.

The power of photographs can come from many places. One powerful way in which a photograph speaks is based on the approach that the artist takes in framing the work.

FRAMING THE PHOTOGRAPH

The manner in which the photographer leads us into new ways of seeing by framing images from unusual perspectives often marks a change in the photographic process and our understanding of the world. For instance, Neal Rantoul, head of the photography program at Northeastern University, uses a square-format camera, as do many other contemporary artists like Sally Mann. According to Jeffrey Hoone, square photographs "give us more information on the top and bottom of the frame, hide things that are on either side, and distort perspective in a way that is uniquely photographic" (Hoone B15). Photographs also can be printed in large scale, dramatically changing the way we experience them. We see more detail, and we can become enveloped in their space.

Photographs are being placed in various new contexts. Based on how and where we see them, photographs can function in new ways, changing our experience in relationship to them. For instance, Rochester, New York can be rather bleak during the winter months, where snowfall can top nine feet. To brighten the season during January 2006, large-scale photographs of Santa Monica Bay sunrises were displayed outside the George Eastman

House. These photographs, which were taken by Robert Weingarten, brought the exquisite color of southern California to the gray scenery of upstate New York. Thus, sun-starved New Yorkers had an opportunity to become refreshed with color and "sunshine."

Photographs no longer have to be technically perfect, aesthetically beautiful, or well composed to be valued. If they have historical significance, they can be compelling. For instance, the well-known photograph of the Chinese student who had a climactic showdown with several tanks in Beijing's Tiananmen Square in 1989 continues to influence China's government. Chinese students, many of whom died, were protesting their government's corruption, joblessness, and the lack of free speech. The power of this image continues to inspire courage. American Jeff Widener, an Associate Press photographer, got a concussion from the commotion in the square while capturing the photograph. He used borrowed film, which he gave to another U.S. citizen to sneak out of the country.

If images tell a good story or make us think about something in a new way, they can easily be embraced. For example, in 2005, when an exhibition of photographs on immigrants was shown at Ellis Island, many were surprised that the people in the pictures were not the stereotypical poverty stricken huddled masses. Instead, reported one visitor, "I immediately got stunned by the dignity, the pride, [and] the self-confidence" of the people coming into the United States (Shattuck A15).

The way in which we view photographs is also changing. Because so many images are now digitized and posted on the Internet, they are often framed by the computer screen and viewed in the context of the cyberspace experience.

EXPANDING THE SUBJECT MATTER

Due in part to the expansion and proliferation of communication and visual images in our everyday world, we see death, terror, pornography, and other (perhaps) objectionable pictures on a regular basis. There are more of them, they are less hidden, and more frequently analyzed and critiqued. We know that powerful photographs can be taken of terrible events like the bombing of New York's World Trade Towers on September 11, 2001. We were horrified as a nation to see snapshots taken by soldiers of tortured Iraqi prisoners in the jail at Abu Ghraib in 2004. When these images were displayed as art at the International Center of Photography in New York City, new questions were raised about appropriate content for photographs and who could be considered a successful photographer. However, some people, recognizing the power of these images, believed that the role and place of the photograph in our culture had dramatically changed because of these terrifying images. We can also think about the recent exhibitions of photographs of African Americans being lynched or dramatic and horrifying images from the holocaust of European Jews and others during World War II. These images are all powerful, and they move us in ways that sadden us greatly.

Luc Sante's book titled *Evidence* (1992), which looks at street violence in New York City from 1840 to 1919, includes photos of corpses from the municipal archives. Sante writes that when he first saw the pictures, they would not leave him alone. Thomas Boyle, who wrote a review of the book for *The New York Times*, warned squeamish readers to stay away since the book includes gore and various stages of decomposition. In spite of the offensive nature of the images, Boyle claims that the book—and photographs—transcends that which disturbs because the details "evoke the real past underlying the official one" (Boyle 31). The same can be said of many early documentary photographers' work presented in this volume. We understand a period of time far better than we might have because of the images they have captured. What is different in the case of Sante's images, however, is that the photographers who took these pictures were police, not professional image-makers.

DEFINING THE PHOTOGRAPHER AND CRITIQUING THE PHOTOGRAPHIC PROCESS

In keeping with the idea that intriguing photographs can be taken by everyday people, in 2005 the Metropolitan Museum of Art curated a major exhibition on photographs of ghostly apparitions taken mostly by nonprofessionals. Titled *The Perfect Medium: Photography and the Occult*, it surveyed the myriad ways in which photography has been used to prove the existence of supernatural beings. From the 1870s through the 1930s, many people believed that cameras could capture that which might be invisible to the human eye. When these apparitions were made visible by the camera, the images were used as proof that spirits had been seen and that they existed. Although most of the images have been explained as fraud, there are a few photographs that have never been adequately explained (Kennedy AR18). But even as fraud, the pictures are compelling.

While photography has always provided us with new ways of seeing, questions continue to be raised about boundaries between photographers and their subjects. When Walker Evans secretly snapped pictures of New York's subway riders from 1938 to 1941, he referred to himself as a "spy" and a "voyeur" (Boxer AR32). In the wake of the September 11, 2001 bombings, New York City government officials considered banning photography in the subways for security reasons, making the act of taking pictures even more suspect (Boxer AR32).

Cameras increasingly are being placed in the hands of people who were, just a short time ago, seen as only subjects. In central Florida, when the muck farms were being closed in the late 1990s due to the pollution of Lake Apopka, local folklorists and historians wanted to document the history of the farmworkers. Since it was difficult for photographers to gain access to the farms, educators set up classes to teach young farmworkers to do the documentary work. Images from these classes formed the highly acclaimed exhibition *The Last Harvest*, which traveled around the state for many years. Around the world, people are now

documenting their own lives. In 1992, in Chiapas, Mexico, residents were given cameras, film, and basic instructions on how to use the equipment. This continuing project, called the Chiapas Photography Project, has worked with more than 250 Maya photographers from various ethnicities, and they have published seven books. The founder of the project, Carlota Durate, claims that the photographers currently have "a sense of having a legitimate place in the world" (Kino AR40).

As interest in folk art has increased, vintage photographs have captured the attention of art enthusiasts. Everyday remembrances have become even more important than they were in the past. Photographs can be found in memory vessels along with such other objects as seashells, beads, buttons, and nuts. They are reproduced on cloth and made into photo-quilts or personalized tee shirts. Photographs become parts of pins, necklaces, bracelets, and rings.

Even photo postcards are becoming objects of interest. Both amateur and professional photographers have produced thousands of images, with the strongest popular interest now focusing on the years between 1907 and 1930. Collector and artist Harvey Tulcensky claims that "the discrete charm of real photo postcards for me...derives from inspired, idio-syncratic visions, methods, and purposes rather than from professional values" (Alden 74). Furthermore, at a time when computerization makes images more homogeneous, photo postcards offer viewers and collectors something more personal and idiosyncratic.

The digitization of images has created a proliferation of images in cyberspace for poten-tial viewing by Web surfers. Many other examples could be cited that demonstrate the in-creased democratization of the photographic process. While everyday people in the United States have been taking photographs for decades, what is striking in the twenty-first century is that many of their photographs are being valued in new and different ways.

EXPLORING TECHNOLOGY

New technology is revolutionizing the way we see photographs and the manner in which they are produced. We are never sure anymore if a photograph has been changed or ma-nipulated. We aren't always sure if a stage has been set solely for the purposes of the pho-tograph. We aren't always clear on what the photographer's role is in making an image. Did the artist actually snap the shot or is constructing and setting the stage more important to ownership of the work? What happens when a photographer works with a team, as is the case of Gregory Crewdson and Annie Liebovitz? Should others also be credited somehow?

Although photographers have cropped and retouched photographs throughout the twentieth century, the ways in which photographs can be manipulated have increased, and it is no longer always important to hide the manipulation. Photographs often incorporate other artistic media. Havana artist Carlos Garaicoa takes pictures of decaying buildings and then draws imaginary additions onto the photographs.

But it is computers and still-video cameras that have made such a marked difference in the way photographers work today. Film and chemical processing can be done away with completely. From a digital image, an artist can easily change the size and color of a photograph or edit it in any number of other ways. Photographs can easily be montaged and collaged with the aid of a computer. In the 1980s the ways in which computers were being used to "play" with photographic images was already staggering. Nancy Burton, a New York conceptual artist, constructed composite faces on the computer using facial features from many different individuals. Bone structures, chins, and other parts of the face could be called up from her "library" of body parts. Los Angeles artist Joni Carter used an electronic stylus and freeze-framed sports images to make "paintings." Former *Life* magazine photographer Howard Sochurek translated "forms of energy used by modern medical machinery to examine the body, such as sound, gamma rays and X rays, into familiar visual forms more accessible to the layman: color prints" (Gomez 151). So striking were the results of Sochurek's work that critics regarded his so-called medical images as works of art.

While technology has been changing photography for decades, Richard Woodward recently reported that the "year 2005 may be remembered as a watershed in the history of photography, a crucial date when one generation of artists lifted off into the blue sky while another was brought down to earth, left once again to ponder its slave-master relationship to technology" (Woodward 105). One reason for making his claim was due to Kodak's announcement that its manufacturing of black-and-white printing papers was coming to an end after 117 years. Other producers of black-and-white paper were already out of business. For photographers who prefer to work in darkrooms and on paper working in monochrome, the floor has collapsed beneath them. In reaction to the drastically changing landscape of photography today, Susan Bright believes that there will soon be a revival of black-and-white photography and modernist aesthetics, after a decade of large-scaled color images.

Because many photographers now print their digital images on a printer, many wonder if film will soon be the next item to vanish from the photographer's tools. Soon Nikon will cease making most of its film cameras. As technology changes, photography changes with it. And with the excitement of new innovations, comes nostalgia for what we have lost. The speed and convenience of digital photography has also given us clarity and reproducibility, but we have lost the varied surfaces and textures of the older, slower processes. Consequently, as Lyle Rexer points out, many photographers are working to revive nineteenth-century processes.

FRAMING THIS BOOK

Reflecting on the idea that interesting photographs can represent various perspectives, this book includes artists who deal with deep philosophical issues and artists who

document lives lived in poverty for the purpose of creating social change, as well as artists who take pictures of famous people, made for the general public for the purpose of helping define what it means to be a star. Some artists take us on journeys into the sublime with pictures of spectacular landscapes, while others document the destruction of our earth to make it visible and to inspire action.

In keeping with the idea that compelling photographs can come from all kinds of people and contexts, this book includes photographers who are valued as "the best" from the art world perspective, as well as artists who are readily recognized by everyday people in mainstream society. We have included artists from all time frames throughout the twentieth century and have made an effort to inform the reader about what inspired and motivated each person. These 76 photographers have come from all walks of life. Some have been famous in their lifetimes; others are more studied since their deaths. A few of the photographers in this book are young and not so well known in the art world.

The photographs in this volume demand that viewers approach them in varying ways. Some will be immediately understood and enjoyed, while others will need second and third looks, research, and perhaps philosophical thinking.

The essays on each artist are intended to provide the reader with introductory material. A glossary at the end of the book can be used to help the novice with words that are not readily understood. Italicized words in the text are found in the glossary. We hope that these varied photographers will entice the reader to learn more and delve more deeply into the issues that have been presented, both in the visual images, and in the text. Mostly, we hope that the readers will enjoy learning about these photographers in some small or grand way. Their ideas and images have taken us on a marvelous journey, one that is best shared with others.

Bibliography

Alden, Todd. "Passing Thoughts on Passing Things: Real Photo Postcards." *Folk Art* 30, no. 4 (Winter 2005/2006): 72–77.

Boxer, Sarah. "Tunnel Visions." *New York Times*, October 17, 2004: AR32.

Boyle, Thomas. "Murder Most Photogenic." Review of *Evidence* by Luc Sante. *New York Times Book Review*, January 10, 1993: 31.

Calvo, Dana. "Profiles in Courage." *Smithsonian* 34, no. 10 (2004): 17–18.

Cheroux, Clement, Pierre Apraxine, Andrea Fischer, Denis Canguihem, and Sophie Schmit. *The Perfect Medium: Photography and the Occult*. New Haven, CT: Yale University Press, 2005.

Congdon, Kristin G. *Community Art in Action*. Worcester, MA: Davis, 2004.

Finkel, Jori. "Arttalk: Ben Stiller Calls the Shots." *Artnews* 104, no. 7 (2005): 39.

Friedman, Devin. Foreword by General Wesley Clark. *A Soldier's Portfolio: This Is Our War*. New York: Artisan, 2006.

Gefter, Philip. "For Photography, Extreme Home Makeover." *New York Times*, October 15, 2006: AR29.

———. "Defining the Moment, for the Moment, Anyway." *New York Times*, October 16, 2005: AR33.

———. "A Thousand Words? How About $450,000?" *New York Times*, March 13, 2005: AR32.

Gefter, Philip. "Photography Reveals Itself between Covers." *New York Times*, January 16, 2005: AR29.

Gomez, Edward M. "Phototechnology: The Future Is Now." *Artnews* 88, no. 4 (1989): 151.

Hoone, Jeffrey. "Outside the Frame." Photographs by Neal Rantoul. *Chronicle of Higher Education*, February 9, 2007: B15.

Kennedy, Randy. "California Dreaming on Such a Winter's Day." *New York Times*, January 12, 2006: B1 & B7.

———. "The Ghost in the Darkroom." *New York Times*, September 4, 2005: AR1 & AR18.

———. "Amassing a Treasury of Photography." *New York Times*, July 20, 2005: B1 & B7.

———. "Met Museum Acquires Gilman Trove of Photos." *New York Times*, March 17, 2005: B1.

Kino, Carol. "Self-Portraits by Invisible People." *New York Times*, October 23, 2005: AR40.

Rexer, Lyle. *Photography's Antiquarian Avant-Garde: The New Wave in Old Processes.* New York: Harry N. Abrams, 2002.

Sante, Luc. *Evidence.* New York: Farrar, Straus & Giroux, 1992.

Shattuck, Kathryn. "When Old and New World Met in a Camera Flash." *New York Times*, August 6, 2005: A15 & A21.

Woodward, Richard B. "Altered States." *Artnews* 105, no. 3 (2006): 104–109.

BERENICE ABBOTT

1898–1991

BERENICE ABBOTT IS BEST KNOWN FOR BLACK-AND-WHITE PHOTOGRAPHIC documentation of New York City through the greatest architectural transition that the city has ever undergone. Born in Springfield, Ohio, in 1898, Abbott grew up with her single mother. Separated from her father and five other siblings, she experienced feelings of loneliness. Abbott attended Lincoln High School in Cleveland, and upon graduation, she boldly had her long hair cut into a chin length bob (which was quite shocking at the time) in preparation for college and a new life. She enrolled at The Ohio State University, where she soon became friends with *avant-garde* artists and writers. Abbott mentioned some years later that she felt this new short haircut gave her an air of big city sophistication that attracted these new friends.

Before completing the bachelor's degree program, Abbott and her friends decided to move to New York City in 1918 to pursue educational opportunities in the artistic epicenter. She settled in the bohemian art community of Greenwich Village, where she rented a large house with visual and literary artists, including writer, Djuna Barnes; philosopher, Kenneth Burke; and literary critic, Malcolm Cowley. Soon Abbott was intermingling with the most controversial artists and thinkers in New York. Hippolyte Havel, a well-known Czech anarchist and writer, took the young Abbott under his wing, and she became known as his unofficial adopted daughter.

When Abbott first arrived in New York City, she planned to study journalism. However, she was uninspired by her coursework and promptly withdrew. Instead she began to study sculpture and began meeting local artists such as **Man Ray** and Sadakichi Hartmann. Around 1920, many New York artists, including Man Ray, began to leave for Paris; she followed suit and departed for Europe in 1921. She studied sculpture in Paris and in Berlin for about two years before she was approached by Man Ray about a job. He hired Abbott as a darkroom assistant precisely for her inexperience in photography and her ability to closely

follow his instructions. While working for Man Ray in his portrait studio in Montparnasse, Abbott was introduced to the medium that would take her artistic career in a new direction. She was drawn to photography and quickly began to learn basic techniques. In lieu of a pay raise, Man Ray allowed Abbott to use his studio when she first started to experiment.

In 1925, Man Ray introduced Abbott to the French photographer, Eugène Atget. She instantly became enthralled with the straightforward quality of his work for which Atget was well known. Abbott was fortunate to spend time with the artist and photograph him just before his death. Although Atget had a successful career as a documentary photographer, Abbott felt that his work did not receive the artistic accolades that it deserved. After his death, Abbott took on the responsibility of increasing exposure to Atget's work, primarily in the United States. More specifically and profoundly, she changed the status of his work from pure documentation to art. She worked for the next 40 years to promote his work, through exhibition organization, collection, and management of a large portion of his oeuvre, editing collections of his work for publication, and writing numerous essays. She is given credit for single handedly elevating Atget from a French documentary photographer to an international artist.

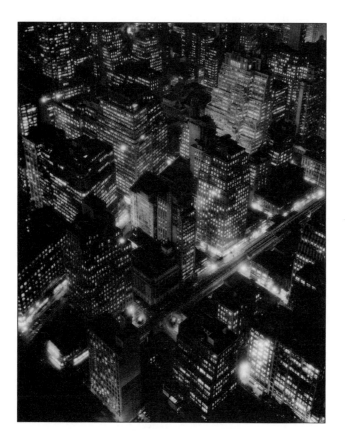

Berenice Abbott. *New York at Night* (1932). Gelatin silver print, 13¹⁵⁄₁₆ × 11 inches (35.4 × 27.9 cm). Eliza S. Paine Fund in memory of William R. and Frances T. C. Paine. Courtesy of Worcester Art Museum, Worcester, Massachusetts.

Inspired by Atget's straightforward approach to the medium, Abbott adopted this method and photographed in what is referred to as *straight photography*, attempting to depict the image as realistically as possible. This was in direct contradiction to the work of the most popular photographers of the day, including **Alfred Steiglitz,** who promoted imaginative manipulation of the photographic image. Abbott photographed people in her artistic and literary communities, such as Jean Cocteau and James Joyce. She also captured the images of people she was not acquainted with, such as everyday people walking through the city. Abbott's natural inclination toward photography and her dedication to **Man Ray** and the study of photographic techniques and art was beginning to be recognized by the art community. By 1926, she had her first Paris solo exhibition, which was hosted by the gallery Au Sacre du Printemps. After running her own studio for a short time, she went to Berlin to study photography and then back to Paris, where she opened yet another studio.

After eight years in Paris she decided to return to New York City in 1929 for a visit. Overwhelmed by the changes in architecture and the newly erected urban skyline, she was motivated to stay and seize the opportunity to photograph the city, of which she commented:

> I am an American, who, after eight years' residence in Europe, came back to view America with new eyes. I have just realized America—its extraordinary potentialities, its size, its youth, its unlimited material for the photographic art, its state of flux particularly as applying to the city of New York. (Yochelson 13)

She became consumed with photographing New York City and literally shot thousands of negatives over several years. Through the early years of this project, Abbott was able to secure some funding, but the money was inconsistent, and she was forced to seek other work. She accepted a position as the first photography instructor at the New School for Social Research in New York City in 1933. Although she was terrified of teaching at first, the classroom proved to be a comfortable environment for Abbott, and she remained on the faculty there until 1958.

Despite financial obstacles and the responsibility of other jobs, Abbott continued with the massive undertaking of photographing all of New York City. Her efforts were recognized by a young curator, Grace Mayer at the Museum of the City of New York. Mayer organized Abbott's first one-person exhibition in New York City on October 8, 1934, entitled *New York Photographs by Berenice Abbott.*

After years of fundraising she received sponsorship from the Museum of the City of New York and was eventually awarded the large funding she needed from the Federal Art Project (FAP) in 1935. The FAP was initiated in 1935 under the government agency of the *Works Progress Administration* (WPA) and assisted artists in work that was recognized as a benefit to all citizens. Clearly, Abbott's project fit the bill, and in addition to being an impressive artistic undertaking, this work became important historical documentation of the city's changing landscape in the early and mid-twentieth centuries. In the photograph *Cliff and Ferry Street* (Nov. 29, 1945), she captured the transition that the city was undergoing by showing

a clear view down the street with cars next to horse and buggy, small business retail store signs hanging along the street with an ominous and very modern sky scraper in the shadows of a heavy fog as the backdrop. In another work, *New York at Night* (1932), Abbott photographed the illuminated city skyline. This body of work resulted in the E.P. Dutton & Co. publication *Changing New York* (1939), which showcased 97 photographs accompanied by text written by Abbott's life partner and art critic, Elizabeth McCausland. Many years later 305 photographs from this period were compiled in another publication, *Berenice Abbott Changing New York: The Complete WPA Project* (1997) by New Press.

Abbott's contributions to the art world are significant and varied. Her work as a straight photographer led to technical projects, and in 1958, she was commissioned to shoot the images for a high school science textbook. Although widely known for her documentary style work, Abbott also experimented with processes that altered the image. She created what she called a *distortion easel*, which caused various effects on the image while in the dark room and a telescopic lighting pole more commonly known today as an *autopole* used for attaching lights. Abbott founded The House of Photography in 1947 to sell her inventions; however, the business did not stay open for long due to lack of marketing and the premature deaths of two designers.

As a young woman Abbott was more open about being a lesbian than in the later years of her life. In the early 1920s she had a relationship with artist Thelma Ellen Wood. In 1935, she moved into a Greenwich Village loft apartment with art critic, Elizabeth McCausland, and the two lived together until McCausland's death in 1965. Although private about her sexual orientation, Abbott photographed members of the bisexual, lesbian, and gay communities of Paris in the 1920s and in New York from the 1930s to 1965.

In the mid-1950s Abbott and McCausland took a road trip up U.S. Highway 1 from Florida to Maine, while Abbott photographed the architecture of small towns along the way. Upon their return to New York City, Abbott was diagnosed with lung damage from exposure to air pollution. After a lung operation she moved away from the city to the country in Monson, Maine, where she remained until her death at age 93 in 1991.

Abbott literally fell into photography, which led to a prolific career, evidenced by the inclusion of her photographs in numerous high profile collections and the retrospective exhibitions of her work, along with several published monographs. Berenice Abbott contributed to the world of art and photography for more than 60 years, leaving behind an important historical oeuvre of twentieth-century U.S. architecture, the art of Eugène Atget, and the legacy of an early twentieth-century woman, who worked and lived as a successful artist despite emotional, economic, and societal obstacles.

Bibliography

Abbott, Berenice. *Berenice Abbott, Eugene Atget.* Santa Fe, NM: Arena Editions, 2002.
———. *Berenice Abbott: Documentary Photographs of the 1930s.* Cleveland, OH: The Gallery, 1980.

Abbott, Berenice. *Berenice Abbott Photographs.* Washington, DC: Smithsonian Institute Press, 1990.

———. *Changing New York.* New York: Dutton, 1939.

———. *Greenwich Village: Yesterday and Today.* New York: Harper, 1949.

———. *New York in the Thirties, as Photographed by Berenice Abbott.* New York: Dover, 1973.

———. *A Portrait of Maine.* New York: Macmillan, 1968.

Levere, Douglas. *New York Changing: Revisiting Berenice Abbott's New York.* New York: Princeton Architectural Press, 2005.

National Museum for Women in the Arts. *Berenice Abbott Biography.* Retrieved October 26, 2006, from http://www.nmwa.org/collection/profile.asp?LinkID=175.

Stanton, Melissa. "New York, New York." *Life* 21, no. 6 (May 1998): 96–98.

Yochelson, Bonnie. *Berenice Abbott: The Museum of the City of New York: Changing New York, The Complete WPA Project.* New York: Museum of the City of New York and New Press, 1997.

Places to See Abbott's Work

Art Institute of Chicago, Chicago, Illinois
Bibliothèque Nationale, Paris, France
Birmingham Museum of Art, Birmingham, Alabama
Cincinnati Art Museum, Cincinnati, Ohio
David Winton Bell Gallery at Brown University, Providence, Rhode Island
Fred Jones Jr. Museum of Art at the University of Oklahoma, Norman, Oklahoma
Gibbes Museum of Art, Charleston, South Carolina
Grande Rapids Museum of Art, Grand Rapids, Michigan
Harvard University Art Museums Database, Cambridge, Massachusetts
Hofstra Museum, Hofstra University, Hempstead, New York
International Museum of Photography, George Eastman House, Rochester, New York
J. Paul Getty Museum, Los Angeles, California
Juniata College Museum of Art, Huntington, Pennsylvania
Los Angeles County Museum of Art Database, Los Angeles, California
Metropolitan Museum of Art, New York, New York:
Minneapolis Institute of the Arts, Minneapolis, Minnesota
Montana Museum of Art and Culture, Missoula, Montana
Museum of Fine Arts, Boston, Massachusetts
Museum of Fine Arts, Houston, Texas
Museum of Fine Arts, Santa Fe, New Mexico
Museum of Modern Art, New York, New York
National Gallery of Art, Washington, DC
National Museum of Women in the Arts, Washington, DC
New York Public Library Digital Gallery, New York, New York: http://digitalgallery.nypl.org
Pomona College Museum of Art, Pomona, California
San Francisco Museum of Art, San Francisco, California
Smithsonian American Art Museum, Washington, DC
Springfield Museum of Art, Springfield, Ohio
The Phillips Collection, Washington, DC
University of South Florida Contemporary Art Museum, Tampa, Florida
Virtual Museum of Canada: at http://www.virtualmuseum.ca/English/index_flash.html
Walker Art Center, Minneapolis, Minnesota

ANSEL ADAMS

1902–1984

NOT ONLY IS ANSEL ADAMS KNOWN AS ONE OF THE MOST REVERED photographers of the twentieth century, he is also celebrated for his life as a conservationist, writer, musician, and teacher. So adamant was he about the power of photography as art, that he worked with Beaumont Newhall, the prominent photographic historian, to establish photography departments at the Museum of Modern Art, the first department of its kind, at the San Francisco Museum of Modern Art, and at the California School of Fine Arts. As a consultant for Polaroid, he wrote more than three thousand technical notes to help other photographers. As a passionate mountaineer and nature photographer, he is often referred to as the official photographer for the Sierra Club. Of all his many accomplishments, he is perhaps best known for his photographs of the National Parks.

Born in San Francisco in 1902 to loving and supportive parents, he was their only child. Due to his grandfather's wealth, his early years were spent comfortably. When the 1906 earthquake hit San Francisco, his life, like those around him, changed dramatically. The family business collapsed and his father, Charles, had to take work as an accountant, a job he found to be repetitive and mundane. He desperately wanted more for his son, which led him to support Ansel's creative leanings.

Ansel was a restless, erratic student who got expelled from school many times. After a final expulsion at the age of 12, Charles decided to have him schooled at home. Music became important to Ansel, and a strict piano teacher was hired who demanded perfection. She refused to allow him to learn anything new until the assigned piece was performed precisely. In 1915, his father bought him a season's pass to the Panama-Pacific Exposition, which stimulated his interest in all kinds of subjects including art. In 1916, when he was home sick with a cold, his aunt gave him a copy of James M. Hutchings's 1886 book, *In the Heart of the Sierras*. So enticing were Hutchings's tales of adventure that he insisted that his family go to Yosemite for their summer vacation. On this first trip Adams took pictures

with a new Kodak No. 1 Box Brownie camera. This was the beginning of Adams's love affair with the Sierra Nevada Mountains with its canyons that reach seven thousand feet in depth and an eastern section that rises over ten thousand feet above the Owens Valley.

When he was 17 (the same year he joined the Sierra Club), Adams met Virginia Best in Yosemite. Years later, in 1928, he married her, and together they had two children. Virginia was his lifelong companion, who shared his love of the wilderness and helped entertain numerous friends and visitors that surrounded him on a daily basis. During the early years of their marriage, he supported his family by doing commercial photography that ranged from taking pictures of corpses in Los Angeles to open-pit mines in Utah.

Although his work eventually extended to places all around the United States (with many photographs of the Southwest), he will always be intricately connected to the Sierra Mountains, and Yosemite in particular. So connected to the mountains was Adams that it was sometimes said that he grew to look like one. Like so many others who lived in the West

Ansel Adams. *Winter—Yosemite Valley, California* (ca. 1951). Gelatin silver print, 7⁷/₁₆ × 9⁹/₁₆ inches (18.89 × 24.29 cm). San Francisco Museum of Modern Art. Gift of Mrs. Walter A. Haas. © The Ansel Adams Publishing Rights Trust.

during his time, he wore boots and a Stetson, and he grew a beard, which gave him freedom from shaving.

Adams was well aware of the ideas embedded in the modern art movements of his time. He adhered to many of them, but he also incorporated older traditions that related the landscape to spirituality. He encouraged experiencing the wilderness, both intellectually and emotionally. It was at Half Dome in Yosemite where he found that he could make poetry out of nature. His photographs are about communicating emotion that comes from Adams' keen ability to capture light, contrast, repetition, and movement. He presents us with breathtaking images of fresh snow, reflections in clear waters, majestic clouds, cascading waterfalls, textured bark, delicate leaves on aspen tress, prickly cacti, rippled sand, and his beloved mountains. *Oak Tree, Sunset City, Sierra Foothills, California, 1948* shows us thousands of bare branches that frame the setting sun. In *Mount Williamson, Sierra Nevada, from Manzanar, California, 1945*, the viewer is positioned on the ground with massive and repetitive rocks that lead out to the mountains, covered with clouds. *Dawn, Mount Whitney, California, 1932* presents us with an expansive sky above a cliff. Clouds rest below, as the eye is lead to a sliver of a moon reaching way above the rocks. A close-up of the base of leather-like tree bark contrasts rough texture with wispy, growing grass in *Burned Stump and New Grass, Sierra Nevada, California, c. 1935*.

Not only was Adams visually astute, he also had an excellent command of the written language, and his words often sound like poetry. He sent many letters in his lifetime, traveling with a typewriter so that he could pound out a correspondence whenever he had time.

While he worked hard on everything he did, he had little interest in recording dates, preferring to live in the moment and seizing the day by waking early. Energy defined him. Once, when on a trip, he found that he had left a lens behind. He trekked 12 miles back to get it, and when he returned to camp at dawn, he continued another 12 miles before resting. Adams loved being in the mountains, but sometimes the territory he traversed was difficult. Reflecting on the extreme temperatures he often had to endure, he once said, "I expect to retire to a fine-grained photographic heaven where the temperatures are always consistent" (Nancy Newhall 144).

Adams believed in sharing his knowledge. In 1932, after returning from a mountain trip and capturing some successful images, he founded Group f/64 with six other photographers, including **Edward Weston**, Willard Van Dyke, and **Imogene Cunningham**. The name referred to one of the smaller lens stops that focused on depth and clarity. Its purpose was to garner excitement in photography and encourage new talent. They were interested in what they called "straight" or "pure" photography, and they aimed to raise photography to the stature of art. They recognized that there was an artistic aspect to creating sharp focuses, a pleasing contract of lights and darks, and good composition that could make for strong artistic statements.

In 1938, Adams published a glorious limited-edition book, *Sierra Nevada: The John Muir Trail*. The Interior Secretary, Harold Ickes, gave a copy to President Franklin D. Roosevelt.

This publication was a catalyst for the establishment of Kings Canyon as a national park, one of the Sierra Club's most successful early campaigns. From 1944 to 1958, Adams received three Guggenheim grants to photograph the national parks.

Adams loved the dawn because it has a penetrating light that causes the world to look as if it is coming alive. He was so sensitive to light that if a light meter didn't tell him the information he thought it should, he determined that it needed adjusting—and he was most often right.

As a photographer who increasingly worked with confidence, he had no indecision about lens, filers, or positioning of the camera. Once he knew his craft, he believed the photograph was either there or it wasn't. Stooping under the focusing cloth to view through Adams's camera, Beaumont Newhall once claimed that he could see through Adams's camera better than he could see through his own eyes.

Adams's passion was to express huge themes. He was concerned that our open landscape was increasingly being populated and overrun with cement, homes, and tourists. His desire

Ansel Adams. *Clouds, from Tunnel Overlook, Yosemite National Park, California* (ca. 1934). Gelatin silver print, 7 × 9¼ inches (17.78 × 23.5 cm). San Francisco Museum of Modern Art. Gift of Mrs. Walter A. Haas. © The Ansel Adams Publishing Rights Trust.

was to promote an ideal America that had its roots in a sacred earth and could lift one's spirit in the grandest way. He once wrote:

> The artist has an inescapable obligation…both the natural and human world are imperiled.… This peril lies in overpopulation, pollution, depletion of resources, and the destruction of natural and cultural beauty. The power of art to counteract this destruction, not merely to veil it, is—I am sure—tremendous. I believe photography has both a challenge and an obligation: to help us see more clearly and more deeply, and to reveal to others the grandeurs and potential of the one and only world which we inhabit. (Turnage 13)

While Adams often wrote his own text, he also collaborated with others, pairing their text with his photographs. One of his many collaborators was Nancy Newhall, who was Beaumont Newhall's wife. They believed that text carefully matched with a photograph could produce a larger emotional response than either the text or the photograph alone. In 1952, Adams became one of the founders of the magazine *Aperture*. Numerous books and publications have been written by and about Adams.

Adams died of heart failure complicated by cancer. Many writers claim that Ansel Adams contributed more than anyone else to the idea that photography should become an acceptable fine art medium, a belief that is little debated today. Even more important to many was his role as one of the leading environmentalists of the twentieth century. He left us with more than 40 thousand photographs, 50 thousand letters and notes on a myriad of subjects, his multivolume photography manuals that set the standard, and a legacy of environmental work.

Bibliography

Alinder, Mary Street. *Ansel Adams: A Biography*. New York: Henry Holt, 1996.

Alinder, Mary Street, and Andrea Gray Stillman, eds. Foreword by Wallace Stegner. *Ansel Adams: Letters and Images 1916–1984*. Boston: Little, Brown, 1988.

Brooks, Paul. "Introduction." In *Ansel Adams: Yosemite and the Range of Light*. Boston: Little, Brown, 1979, 7–28.

Newhall, Beaumont. "Foreword." In Nancy Newall, *Ansel Adams: The Eloquent Light: His Photographs and the Classic Biography*. New York: Aperture, 1980, 7.

Newhall, Nancy. *Ansel Adams: The Eloquent Light: His Photographs and the Classic Biography*. New York: Aperture, 1980.

Spaulding, Jonathan. *Ansel Adams and the America Landscape: A Biography*. Berkeley: University of California Press, 1995.

Stillman, Andrea G., ed. *Ansel Adams: The American Wilderness*. Boston: Little, Brown, 1990.

Turnage, William A. "Introduction." In *Ansel Adams: The American Wilderness*, ed. Andrea G. Stillman. Boston: Little, Brown, 1990, 5–15.

Places to See Adams's Work

California Museum of Photography, University of California, Riverside, California
Center for Creative Photography, University of Arizona, Tuscon, Arizona
Cleveland Museum of Art, Cleveland, Ohio
Fine Arts Museums of San Francisco, San Francisco, California
Fred Jones, Jr. Museum of Art, University of Oklahoma, Norman, Oklahoma
Harvard University Art Museums, Cambridge, Massachusetts
Los Angeles County Museum of Art, Los Angeles, California
Mint Museum of Art, Charlotte, North Carolina
MIT List Visual Arts Center, Boston, Massachusetts
Museum of Fine Arts, Houston, Texas
Museum of Fine Arts, Santa Fe, New Mexico
Museum of Modern Art, New York, New York
San Francisco Museum of Modern Art, San Francisco, California
Smithsonian American Art Museum, Washington, DC
Spencer Museum of Art at the University of Kansas, Lawrence, Kansas

DIANE ARBUS

1923–1971

DIANE ARBUS TAUGHT US THAT ALL FAMILIES ARE SOMEWHAT CREEPY, AND those who first appear creepy are somewhat normal. She had an uncanny ability to approach people on the street, ask if she could photograph them, and then expose their secret lives. Although she was lambasted during her lifetime for being exploitative and morbid, many critics regard her as one of the twentieth century's most important photographers.

Born to a wealthy family, her father, David Nemerov, ran Russek's department store on Fifth Avenue in New York, which sold fur and clothing. Arbus's family wealth embarrassed her as she found it staged and showy. The second of three children, her name was pronounced "Dee-Ann" as her mother named her for a character in a favorite play. The family was full of talent. Howard, her older brother and a Pulitzer prize-winning poet, was named U.S. poet laureate in 1988. Her younger sister, Renée Sparkia, became a sculptor and designer. When her father retired, he successfully took up painting. Arbus attended the Ethical Culture Fieldston School, a school mostly populated from wealthy, liberal Jewish families. Her talent for art was recognized early in her life.

She met and fell in love with Allan Arbus when she was 14 and he was 19. His father was the nephew of one of her father's business partners. Allan gave Arbus her first camera shortly after they were married in 1941. She was 18. As both members of the couple enjoyed photography, they turned their apartment bathroom into a darkroom. The family gave them jobs taking fashion shots for advertisements for Russek's. During World War II, Allan became a military photographer. When the war was over, they worked for top women's magazines and advertising agencies as commercial photographers. Most often Arbus would stage the scene, and Allan would take the shot. By 1954, they had had two daughters, Doon and Amy. As lucrative as the work was, they both found their jobs in the high-end industries unsatisfying. Arbus wanted to be an artist, and Allan wanted to act.

Diane Arbus. *Identical twins, Roselle, N.J.,* from the portfolio Diane Arbus: A box of ten… (1967). Gelatin silver print, 14⅞ × 15 inches (37.78 × 38.1 cm). San Francisco Museum of Modern Art. Gift of Margery Mann. © Estate of Diane Arbus.

The marriage became stressful as they both increasingly disliked their work, and Arbus began experiencing bouts of depression similar to the episodes her mother had had before her. In 1956, while Allan continued to shoot fashion images, he also started taking acting classes. Arbus began doing her own work following in the footsteps of other artists who were interested in street photography. By 1959, the marriage dissolved, and Arbus moved into a Greenwich Village carriage house with her two daughters. In the fall of the same year, she was fortunate to get work with *Esquire* magazine to do a photo essay on New York City's eccentrics. These images were purposely blurred similar to the work of other street photographers like Robert Frank.

Arbus studied with Lisette Model, and in 1962, she changed cameras so that her images could be sharper, and detail could be exposed and explored. Her images also became square. While she didn't earn a lot of money, she did gain recognition. In 1967, the Museum of Modern Art in New York mounted an exhibition called *New Documents*, which introduced her photographs and marked a dramatic change in traditional documentary photography. Popular with both magazine editors and museum curators, she was invited to represent the United States in the 1972 *Venice Biennale*. This was an especially noteworthy honor since no other American photographer had ever been invited. In spite of all the attention and acclaim, her depression, along with illness from hepatitis, continued to plague her. On July 26,

1971, she took an overdose of barbiturates, slit her wrists, and lay in the bathtub to die. She was found two days later.

Her first retrospective was held at the Museum of Modern Art in New York in 1972, shortly after her death. Heavily attended, it created a great deal of debate. Some found the images repulsive and disturbing, while others reacted to their beauty. Some writers found the people in her pictures to be pathetic and pitiful and claimed that the images evoked no feelings of compassion. Other critics were intrigued with her ability to portray her subjects stripped bare to the bone.

Part of Arbus's strength was her ability to show us what binds families or groups of people who have connections to each other that function in family-like ways. In 2003, Mount Holyoke College Art Museum, in collaboration with the Spencer Museum of Art of the University of Kansas, curated a show called *Family Albums*. Shortly after, the San Francisco Museum of Modern Art displayed a more comprehensive exhibition, the first since 1972. The exhibition and the accompanying catalog and book are based on a book project that Arbus wanted to publish years before she died. She believed that all her photographs could be seen as a family album—or what she called "a Noah's ark" of humanity (Woodward AR33). These two exhibitions were important because until this time her work had been locked up in estate battles since her death. As new material was introduced to the public, with the support and participation of her oldest daughter Doon, a new awareness and interest in her work was created. As exhibitions traveled, others were curated, and her work became more widely visible, debates about the meaning of her photographs increased. These recent shows were important not only because new photographs were shown, but also because her books, letters, and cameras were also available for study. These items, seen together, communicate a kind of power and intelligence that defines Arbus's character.

Many writers believe that Arbus has often been misunderstood as a predator who exploited her subjects by portraying their weaknesses and flaws. She was interested in awkwardness, but she approaches this characteristic with sympathy. And it was not her main theme. Instead, she loved individualism and the strength it took to embrace it. She recognized that acceptance of difference in our society is difficult, and she is now more likely to be viewed as an empathetic photographer. She understood that difference often entailed feelings of isolation. Her photographic approach says a lot about the way she felt about herself, but it would be wrong to trivialize the meaning of her work by simply saying that she identified with her subjects' pain, aloneness, or alienation. She may have sought out pain, as Sontag suggests, to lessen hers, rather than to understand her own pain better. She never solved the problem of her own identity, lack of belonging, and awkwardness, but by asking general questions about how individuals negotiate their place in the world, she charted a new course for the photographic medium.

Arbus had some common strategies on how to photograph her subjects. One was to use the intimate private space of the bedroom. Feminist writer Germaine Greer described

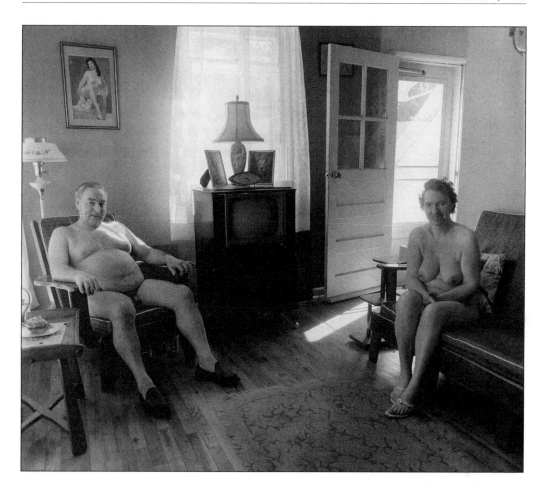

Diane Arbus. *Retired Man and His Wife at Home in a Nudist Camp One Morning, N.J.* (1963). Gelatin silver print, 19⅞ × 16 inches (50.48 × 40.64 cm). San Francisco Museum of Modern Art. Gift of Margery Mann. © Estate of Diane Arbus.

a photographic session with Arbus that took place in the Chelsea Hotel in New York. She remembers the frail photographer uncomfortably straddling her on a bed as she clicked away at the camera, looking for signs of suffering. Greer claims that had Arbus been a man, she would have kicked him off her.

Arbus understood that the camera has the power to entice people to reveal various aspects of their character. She claimed that they like the attention a photographer gives. Taking photographic portraits of individuals who were out of the social mainstream of her upbringing gave her psychological release. She explained that it is "impossible to get out of your skin into somebody else's." But by engaging in her subject's lives she was able to reveal that "someone else's tragedy is not the same as your own…" (Johnson 206). She clearly adored her subjects. She was especially drawn to people who were born with disabilities.

Because their trauma didn't descend on them sometime during their lives, but always existed, she claimed that they had "already passed their test in life" (Johnson 206). She referred to these people as aristocrats.

Her best-known images have become icons: *Child with a toy hand grenade in Central Park, N.Y.C.* (1962), *Retired man and his wife at home in a nudist camp one morning, N.J.* (1963), *A young man in curlers at home on West 20th Street, N.Y.C.* (1966), *Identical twins, Roselle, N.J.* (1967), and *A Jewish giant with his parents in the Bronx, NY* (1970). Arbus once said she wanted to capture "the space between who someone is and who they think they are" (Decarlo 69). She is remembered as an artist who raised questions about the role of the photographers to their subjects and to their audience.

In her well-regarded book *On Photography*, Sontag reflected on Arbus' suicide and the photographs she left behind: "The fact of her suicide seems to guarantee that her work is sincere, not voyeuristic, that it is compassionate, not cold" (Sontag 37). We know that Arbus got excited about celebrities, circuses, carnivals and magic, odd and eccentric people, and people living on the margins of society. She photographed with passion and urgency and was not intimidated by the danger of a dank or seedy situation. Her photographs are direct, frontal, and naked. Looking at her work, one is reminded of the turbulent 1960s and how intense art and the desire for experience often were at that time. Diane Arbus, who repeatedly placed herself in risky situations to capture the shot she wanted, has had an enormous influence on contemporary photography.

Bibliography

Arbus, Diane. *Diane Arbus.* New York: Aperture, 1972.

Bosworth, Patricia. *Diane Arbus: A Biography.* New York: Alfred A. Knopf, 1984.

Decarlo, Tessa. "A Fresh Look at Diane Arbus." *Smithsonian* 35, no. 2 (2004): 68–76.

Johnson, Brooks. *Photography Speaks: 150 Photographers on Their Art.* New York: Aperture, 2004.

Lee, Anthony W., and John Pultz. *Diane Arbus: Family Albums.* New Haven, CT: Yale University Press, in association with the Mount Holyoke College Museum of Art and the Spencer Museum of Art, University of Kansas, 2003.

Lubow, Arthur. "Arbus Reconsidered." *New York Times Magazine*, September 14, 2003: 28–33, 72, 114.

Rubinfien, Leo. "Where Diane Arbus Went." *Art in America* 9 (2005): 65–76.

Sontag, Susan. *On Photography.* New York: Picador, Farrar, Straus, and Giroux, 1973/1977.

Woodward, Richard B. "Diane Arbus's Family Values." *New York Times*, October 5, 2003: AR33.

———. "Shooting from the Hip." *Artnews* 102, no. 9 (2003): 106–109.

Places to See Arbus's Work

Birmingham Museum of Art, Birmingham, Alabama
Center for Creative Photography, University of Arizona, Tucson
Cleveland Museum of Art, Cleveland, Ohio
Harvard University Art Museums, Cambridge, Massachusetts

Los Angeles County Art Museum, Los Angeles, California
Metropolitan Museum of Art, New York, New York
Milwaukee Art Museum, Milwaukee, Wisconsin
Mount Holyoke College Art Museum, South Hadley, Massachusetts
Museum of Contemporary Art, Grand Avenue, Los Angeles, California
New Orleans Museum of Art, New Orelans, Louisiana
Spencer Museum of Art, University of Kansas, Lawrence, Kansas
Williams College Museum of Art, Williamstown, Massachusetts

RICHARD AVEDON

1923–2004

WORLD-RENOWNED PHOTOGRAPHER RICHARD AVEDON CROSSED ARTIS-
tic boundaries between the worlds of fashion, fine art, and documentary. He was born to
Russian Jewish immigrant parents in 1923 in New York City, where he attended De Witt
Clinton High School. While in high school, he was the co-editor with James Baldwin of the
literary magazine, *The Magpie*. He collected autographs from actors, singers, and perform-
ers as a way into the world of accomplishment and celebrity. Avedon's mother supported his
interest in the theater and the arts. With an early interest in photography, his sister Louise
became his first model. She was a shy and quiet girl with a beautiful face that captivated
Avedon and the rest of his family. His father owned a woman's dress shop, which he lost
at the onset of the 1930s Depression.

During World War II, he worked as a photographer in the U.S. Merchant Marines tak-
ing I.D. photographs. After the war ended Avedon studied with the famed art director of
Harper's Bazaar, Alexey Brodovitch, who taught at The Design Laboratory at the New
School for Social Research in New York City. After just one year Avedon was given the job
of staff photographer at *Harper's Bazaar* and sent on assignment to photograph fashion in
Paris. He left the magazine when he accepted a staff photographer position with *Vogue*
in 1966 and worked there until 1990. In 1985, he began working for the French publication
Egoïste.

Avedon was widely known for pioneering modern fashion photography. He added drama
to fashion by staging scenes; the models were actors in his play. He brought attention to the
models' wardrobes by portraying the clothes in motion. For instance, he often instructed the
models to move, to run across the stage, or to stand in front of a fan giving the clothing life.
He captured the movement by anticipating just the right moment to take the photograph.
Avedon was very much in control of the image and the leader in the dance between the
photographer and the subject.

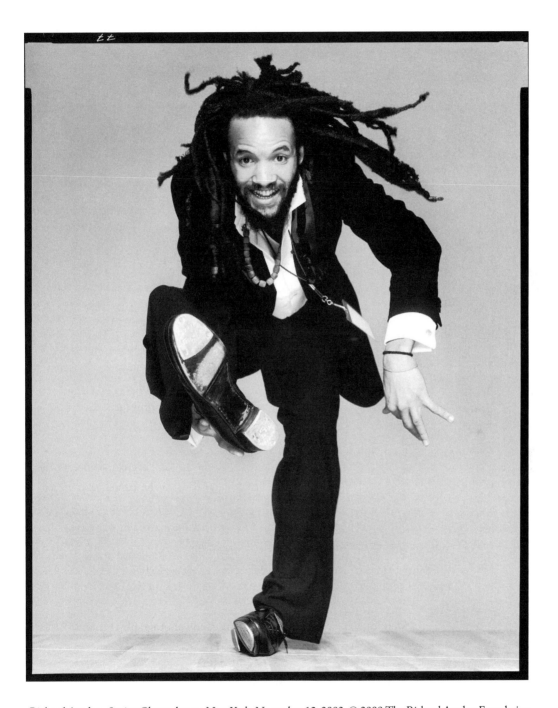

Richard Avedon. *Savion Glover*, dancer, New York, November 12, 2003. © 2008 The Richard Avedon Foundation.

His portrait work was groundbreaking in making iconic images of artists, writers, dancers, presidents, and politicians. By photographing the celebrated, Avedon became a celebrity himself. At an early point in his career, his life was loosely portrayed in the 1957 movie *Funny Face*, as a fashion photographer named Dick Avery.

Avedon was interested in more than fashion and celebrity. He chronicled the main events in the second half of the twentieth century. In the 1960s, he photographed events surrounding the Civil Rights Movement in the South. In 1970, he went to Vietnam to photograph the war and the Mission Council. He was at the Brandenburg Gate on New Year's Eve 1989, just after the fall of the Berlin Wall, encapsulating the exuberant emotion on the faces of the celebratory crowds who were reunited with family and friends after many years.

After a trip to the Southwest, Avedon was commissioned by the Amon Carter museum to do the series *In the American West*. He spent six summers from 1979 to 1984 taking photographs. He wanted to photograph blue-collar workers, people with whom he had no familiarity. He photographed everyday people in truck stops, stockyards, and town streets. For this project he used his signature white background to photograph the portraits. These photographs represented a sharp departure from previous works and were quite controversial.

Perhaps some of his most controversial work is that of his father. When his father was diagnosed with terminal cancer, Avedon photographed him in different stages of illness. Avedon photographed through his fear of losing the father that he never felt emotionally close to. He was criticized for revealing the private side of illness and the process and anguish of death; however, some critics felt that these photographs were tender, compassionate, and steeped in the reality of death that we must all face.

In 1992, he was hired as the first staff photographer at *The New Yorker*, which is where he made many memorable portraits. Some of his most famous portraits are those taken against a stark white background without props or special lighting. Avedon worked with his subjects to evoke a raw visceral expression of emotion. Admittedly, he often talked about certain topics or gave them direction to elicit certain feelings. For instance, in the photograph of the dancer, *Savion Glover* (2004), Avedon photographed him in mid-air, hair flying, arms and legs in motion, looking directly at Avedon with a joyful expression. The fleeting magic of Glover's movement is frozen in time.

He was philosophical about photography and often commented on the subject:

> The moment an emotion or fact is transformed into a photograph, it is no longer a fact but an opinion. There is no such thing as inaccuracy in a photograph. All photographs are accurate. None of them is the truth. (Bailey 1)

He maintained this philosophy throughout his career.

Avedon published his work in more than a dozen monographs between 1959 and 2005. His work was exhibited internationally in galleries and museums such as the Museum of Modern Art in New York City, the Marlborough Gallery in New York City, Seibu Museum in Tokyo, the Metropolitan Museum in New York City, Dallas Museum of Art in Dallas, Texas, the High Museum in Atlanta, Georgia, the Whitney Museum of American Art in New York City, Carnegie Museum of Art in Pittsburgh, Pennsylvania, and the National Portrait Gallery in London, among many others. His success as an internationally renowned photographer is also evidenced by the number of awards and honors that he received during his lifetime, including the 1941 Poet Laureate of New York High Schools, endorsement by the Royal Photographic Society, and the Americans for the Arts, National Arts Award Lifetime Achievement Award.

He died from a brain hemorrhage on October 1, 2004, while on assignment for *The New Yorker* in San Antonio, Texas. In 2005, The Richard Avedon Foundation was established. The Foundation is dedicated to historical preservation of his huge body of work and upholding his rich legacy. Considered to be one of the most influential and prominent artists of the twentieth century, Richard Avedon is among the preeminent portrait and fashion photographers of the twentieth century.

Bibliography

Avedon, Richard. *An Autobiography: Photographs by Richard Avedon*. New York: Random House, 1993.

————. *Woman in the Mirror*, essay by Anne Hollander. New York: Harry N. Abrams, 2005.

"Avedon." *Modern Painters* (December 2004/January 2005): 88–93.

Bailey, David. "Richard Avedon." *Creative Review* 24, no. 11 (2004).

Capote, Truman. *Observations: Photographs by Richard Avedon*. New York: Simon and Schuster, 1959.

Krauss, Nicole. "Nothing Rhymes with White." *Modern Painters* 15, no. 4 (2002): 40–43.

Kuspit, Donald. "Avedon versus Winogrand." *Art New England* 24, no. 2 (February/March 2003): 12–13, 74–75.

Whitney, Helen. *Richard Avedon: Darkness and Light*. American Masters Production, DVD 87 minutes. New York: Wellspring Media, 2002.

Woodward, Richard B. "Defining the Big Shot." *Artnews* 103, no. 11 (2004): 58.

Places to See Avedon's Work

Amon Carter Museum, Fort Worth, Texas
Andreas Reinhardt Collection, Winterthur, Switzerland
Art Institute of Chicago, Chicago, Illinois
Center for Creative Photography, University of Arizona, Tucson, Arizona
Fotomuseum Winterthur, Switzerland
High Museum of Art, Atlanta, Georgia
International Museum of Photography, George Eastman House, Rochester, New York
Kunstmuseum Basel, Switzerland

Los Angeles County Museum of Art, Los Angeles, California
Metropolitan Museum of Art, New York, New York
Minneapolis Institute of the Arts, Minneapolis, Minnesota
Musée de L'Elysée, Lausaunne, Switzerland
Museum of Modern Art, New York, New York
National Portrait Gallery, London, England
National Portrait Gallery, Washington, DC
Richard Avedon Web site: www.richardavedon.com
San Francisco Museum of Modern Art, San Francisco, California
Smithsonian Institution, National Museum of American History, Washington, DC
Vancouver Art Gallery, Vancouver, Canada
Victoria and Albert Museum, London, England

MEGHAN BOODY

b. 1964

MEGHAN BOODY CREATES DIGITALLY MANIPULATED PHOTOGRAPHS OF GIRLS and young women in terrifying settings. Placing layered symbolic meaning in her work, her images provoke narratives that are nonlinear and psychologically rich, which allows for multiple interpretive possibilities.

Born in New York City as Margaret Liscomb Boody, Meghan's father worked at Columbia University. When he retired, he was the associate director of executive programs at the Graduate School of Business. Her mother worked for the Educational Records Bureau where she was a tester. Her great-grandfather was the Mayor of Brooklyn from 1892 to 1894. As an only child with two working parents, she was often left alone to create a world of her own. She made houses and sets for her toy animals and dolls, and she spent her time playing with her dog and many pet mice. She remembers, "I imagined myself having [a] City Mouse/Country Mouse existence" (Boody, personal communication, January 22, 2007). In the summers and on weekends, her family went to Long Island were she "felt liberated and less alone, roaming the fields barefoot and shirtless, making forts with the neighborhood kids" (Boody, personal communication, January 22, 2007).

Boody went to school at Georgetown University where she was a French major. She also enjoyed taking courses in philosophy and psychology and had a special interest in the well-known French authors Gustave Flaubert and André Gide. Her junior year was spent in Paris, where she studied under the famous philosophers Jacques Derrida and Jean François Lyotard. Under Lyotard's tutelage she intensively studied Edmund Burke's writings on the sublime and the beautiful. When she graduated from Georgetown in 1986, she moved to Paris to live and to write fiction. When her writing didn't give her the results she had wanted, she took a class in photography at the Parisian branch of Parsons, only because she couldn't get into other courses that she wanted more. To her surprise she immediately felt comfortable with the medium, acknowledging that writing was hard for her and taking

photographs was easy. Returning to New York, she began working with German photographer Hans Namuth who documented the New York School of artists. Boody claims, "His extremely strict work ethic and flawless eye spurred me on, and he quickly had me printing his exhibition and book prints. By going on shoots with him and organizing his archives, I gained an education in art history, something I very much needed" (Boody, personal communication, January 22, 2007). It was Namuth who taught her how to work though the artistic process. He also taught her that the print should "sing." She remembers, "His feisty refusals to compromise his vision and his unswerving pursuit of print excellence had a big effect on me" (Boody, personal communication, January 22, 2007).

In 1995, Boody married James C. Ayer Jr., a portfolio manager and a graduate of Yale and Oxford universities. Although the marriage did not last, together they have a son whom Boody sees as one of her current influences. Since her son's birth, Boody recognizes that her work "is a little lighter and more reality based" (Boody, personal communication, January 22, 2007).

Boody's photographs include cyborgs that are often naked or only partially clothed. The young women or girl models, who sometimes wear period clothing, are photographed in her studio. She then places their images into settings that can come from scenes taken from magazines and other various sources. The landscapes are most often cold and foreboding, although some of her photographs can seem enchanting.

In her solo show at New York's Sandra Gering Gallery in 1997, Boody's photographs were accompanied by music. The songs related to the titles of the work, such as "Polly Wolly Doodle" or "Just a Spoonful of Sugar." While these tunes may at first seem lighthearted, coupled with the artists' sinister scenes, they take on a different, unsettling tone. Art critic Stephanie Cash describes two of the images: "In *I Love Little Pussy*, a young girl in a party dress sits beside a giant woolly mammoth with a prosthetic trunk. While the interaction between these two characters is minimal and unclear, *Sweet Thumbelina Don't be Glum* is more explicit; a walrus with a maggot-like tail advances onto a prone girl on an ice floe who is wired as if undergoing physiological tests in a ghoulish experiment" (Cash 122).

Although Boody sometimes provides narrative for her works, having this added information is not necessary for enjoying the images. However, for some viewers, the narrative can give insight into the artist's mind. Boody's statement for *NY Doll (Tales of an Ice Queen)* sets the stage for her cyborg: "In the opulent slivers of cracked ice lay the Goddess, blue lipped and anemic, waiting to enfold her pursuer in her frigid embrace. She didn't mean any harm. She had only followed the rules." We know she is a cyborg when we read: "Fear firmers and force feeding are fine for awhile, she liked to say. But in the end, selves must be dismantled quickly and painlessly." There are also references to fairy tales that turn to nightmares: "'I'll never grow up' was her mantra as the pack ice reached its shiny tentacles inside her. Snow white, sewn tight, please grant the wish I wish tonight" ("WOMENTEK—Meghan Boody").

Boody's images place females in impossible situations. Once they gain hope to move past or through a difficult space or trauma, they find themselves once again facing another

Meghan Boody. *Foundling Home* (2006). Fuji-flex print, 50 × 70 inches. Courtesy of Sandra Gering Gallery, New York.

anxiety-producing environment. Boody claims that she presents "a balancing act that hovers between being lost and being found." Relying on the ubiquitous fairy tale where female characters wait to be rescued, Boody creates discomfort. She explains that her subjects are most often adolescents who continuously have to make choices. As they actively engage with their worlds, they build character. She is "the woman-child caught in a labyrinth of choice, a nether world of past and future, pushing forward towards an altered state" (Boody, "Statement").

In her 2000 exhibition at Sandra Gering Gallery, titled *Psyche and Smut*, Boody created two compelling characters. Psyche is a little girl from the Upper East Side of New York. She falls through the space inhabited by bourgeois society, and reminiscent of Alice who fell through the rabbit hole, she finds herself in a place surrounded by elves and frogs. Here she meets *Smut*, her alter ego. They try to find harmony with each other as they go on a journey though the subconscious. There are several incidents where Psyche tries things out for the first time, like smoking or dressing like a princess. There are 13 digital photomontages in this series. Small images of the story's characters are placed at the bottom of each large image.

Many contemporary photographers play with the idea of the photograph as document or an authentic representation of something. Photographers like **Cindy Sherman, Laurie**

Simmons, and **Gregory Crewdson** have challenged this idea by staging their photographic scenes. Like these artists Boody constructs a different kind of truth by exploring ideas or stories about how we construct our worlds. By looking at the interior of our lives (our subconscious) instead of focusing on the exterior, physical world, a different kind of inquiry takes place. Based on the similarities of Boody's approach with other photographers who explore these kinds of ideas, her work was exhibited in the 2003 Orlando Museum of Art show called *Constructed Realities* that was based on a 1989 exhibition by the same name.

While Boody has been influenced and inspired by many photographers, writers, and philosophers, she adds to her list the early allegorical work of Henry Peach Robinson, a photographer who used several negatives to make one image, and Oscar Rejlander, a pioneering Victorian photographer who also experimented with the medium by combining prints. About their work she says, "Meaningful messages seem to seep through their theatrical, highly posed, yet sometimes offhand narratives" (Boody, "Statement").

Boody's images include dark hiding places (both physical and psychological), surreal toxic atmospheres, and settings that evoke medieval tales. Her recent work continues to place female subjects in desperate situations. *Fire* (from the *Lighthouse Project*) (2006), a huge 50″ × 72″ color print, is an image of a barefoot young woman who walks away from a burning mansion. She seems dazed and unsure of where she is going.

The detail in Meghan Boody's work helps hold the viewer's interest as the fairytale unfolds. There is so much information in each series that they can be approached in myriad ways by various different people.

Bibliography

Boody, Meghan. "Statement." New York: Looking Glass Labs, 2006.

Cash, Stephanie. "Meghan Boody at Sandra Gering." *Art in America* 85, no. 4 (1997): 122.

Giovannotti, Micaela. "Meghan Boody: Sandra Gering Gallery, New York." Review. Translation by Rosalind Furness. Retrieved November 22, 2002, from http://www.temeceleste.com/eng/archartreviews.asp?ID=132.

Köhler, Michael. With texts by Zdenek Feliz, Michael Köhler, and Andreas Vowinckel. *Constructed Realities: The Art of Staged Photography.* Zurich, Switzerland: Edition Stemmle, 1989/1995.

Korotkin, Joyce. "Meghan Boody: Sandra Gering Gallery." *The New York Art World.* October 2000. Retrieved January 21, 2007, from www.TheNewYorkArtWorld.com.

"Weddings: Meghan Boody, James C. Ayer Jr." *New York Times*, December 10, 1995: 64.

"WOMENTEK-Meghan Boody." Retrieved November 22, 2002, from http://www.asci.org/WOMENTEK/mb.html.

Places to See Boody's Work

Fondazione Teseco, Pisa, Italy

Progressive Corporation. Mayfield Village, Ohio

Whitney Museum of Art, New York, New York

MARGARET BOURKE-WHITE

1904–1971

MARGARET BOURKE-WHITE'S SUCCESS AS A PHOTOGRAPHER IS OFTEN associated with her ability to have been in the right place at the right time, but it was her keen eye, fearlessness of spirit, and strong desire to capture the truth that made her a photographer's photographer. She was a pioneer of the photographic essay and a woman who was not afraid to face danger to get the right shot. She stood on top of skyscrapers in strong winds to photograph Manhattan, was in a troopship that was torpedoed off the coast of Africa, and flew a combat mission in World War II. It has been said that she took more press photographs than any other photographer in history.

She was born in New York City to a father who was an accomplished engineer-designer that worked in the printing industry and enjoyed photography as a hobby and a mother who later in life worked in the field of publications for the blind. Raised in New Jersey, she was taught not to give up easily. She left home for college in 1921 beginning summer classes at Rutgers and Columbia University, where she took a course at the Clarence H. White School of Photography. Later she attended the University of Michigan, Purdue, and Western Reserve, finally graduating from Cornell in 1927. While at Michigan, she worked on the yearbook and met and married Everett Chapman, a graduate student in engineering. The marriage quickly failed.

Her early photographs were marked by new ideas expressed in modern art. She found beauty in the machine, and she concentrated on capturing its essential nature and simplicity. Focusing on dramatic contrasts of light and dark, she often made the camera's placement ambiguous by hovering above or below the imaged space. She took industrial scenes of a Cleveland steel company that captured the attention of Henry Luce, who offered her a job at his new magazine, *Fortune*.

In the 1930s, *Fortune* sent Bourke-White to Germany to study industrial subjects like the North German Lloyd shipping docks and the I. G. Farben nitrogen plants. Noting

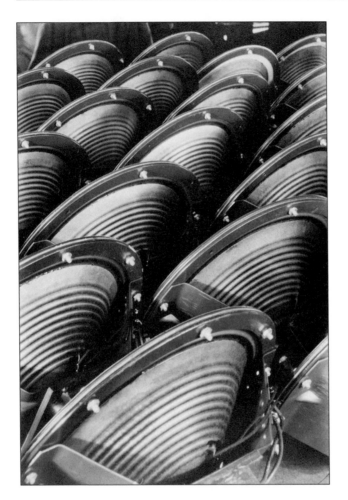

Margaret Bourke-White. *Untitled (RCA Speakers)* (ca. 1935). Gelatin silver print, 13⅞ × 10¹⁵⁄₁₆ inches (35.24 × 27.78 cm). San Francisco Museum of Modern Art. Gift of Sondra May Steinman.

Germany's rearmament in 1933, she wrote a chilling article on what she saw. She also focused her energies on the Soviet Union during this time. Her first of several trips to Russia occurred in 1930. Forty of her eight hundred photographs from her first excursion, which covered five thousand miles, appeared in her first book, *Eyes on Russia*, published in 1931. One of her most memorable images from this series depicts two men on an outside stairway of a worker's club. The young man goes up the stairs as the older man descends. After her second trip to Russia, she wrote six well-illustrated articles for the *New York Times* about everyday life and work. In 1934, she reported on the Dust Bowl disaster for *Fortune*, and in 1935, she did some of her best journalistic writing for *The Nation* as she described the devastated farmlands she saw when flying over the Texas Panhandle all the way to the Dakotas. Although she had previously been publishing social documentary articles with Paul Taylor early in the 1930s, *The Nation* article had wide visibility that spurred on a major effort to photograph what was happening in farm life across the United States. In the early 1930s,

she also created photomurals for the RCA Building at Rockefeller Center in New York and the Ford and the Aluminum Company of America buildings at the Century of Progress International Exposition in Chicago.

In 1935, Bourke-White met writer Erskine Caldwell, and in June of 1936, they traveled together through eight Southern states documenting the plight of sharecroppers and tenant farmers during the Depression, which resulted in the publication of their 1937 book, *You Have Seen Their Faces*. Caldwell taught Bourke-White a new way of working with subjects as he presented himself in a patient and slow manner, which allowed farm workers to reveal themselves. In her 1963 autobiography, *Portrait of Myself*, Bourke-White reflected on her travels with Caldwell and his way of working:

> Erskine would be hanging over the back fence, and the farmer would be leaning on his rake, the two engaged in what I suppose could be called a conversation—that is, either Erskine or the farmer made one remark every fifteen minutes. Despite the frugal use of words, the process seemed productive of understanding on both sides. (Johnson 166)

This way of working gained the confidence of farmers, reassuring them that Caldwell and Bourke-White were not there to ridicule them. A second collaborative book was published in 1941, titled *Say, Is This the U.S.A.?*, which is on the industrialization of the country. Bourke-White married Caldwell in 1939; it was a marriage that lasted only until 1942.

This driven photographer gained more notoriety when she began photographing for *Life*, the wildly successful pictorial magazine. As a member of the original staff, her first assignment was to photograph the newly built Fort Peck Dam in Montana, a *Works Progress Administration* (WPA) project that she had first photographed in 1933. The first issue was published on November 19, 1936, and Bourke-White's photograph appeared on the cover. Her photo essay, which was the lead story, focused on the workers who build the dam and the townspeople who supported it.

This willful image-maker became *Life's* most important photographer. She was sent all over the world taking photographs in South Africa, Slovakia, Hungary, and Pakistan. She documented the first German air raids on Moscow in 1941. Soon after this she became an accredited war correspondence for *Life*. The first official female photographer of the U.S. Army Air Corps, she was the first woman to fly from North Africa on bombing missions; and in 1945, she witnessed the devastation and liberation of a concentration camp in Buchenwald, Germany. Reflecting on such horrifying images, Bourke-White acknowledged that she sometimes had to cease fully seeing: "Sometimes I have to work with a veil over my mind. When I photographed the murder camps the veil was so tightly drawn that I hardly knew what I had taken until I saw the prints of my own photographs" (Mydans 26). Her World War II assignments took her to Great Britain, North Africa, Italy, and Germany. The images she created had clarity, good composition, and keen attentiveness to human

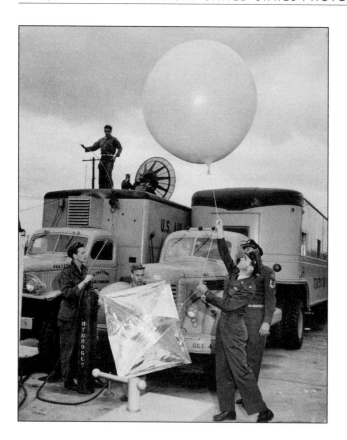

Margaret Bourke-White. *Strategic Air Command, Carswell Air Force Base, Texas (soldiers with balloon)* (1951). Gelatin silver print, 13¼ × 10¾ inches (33.66 × 27.31 cm). San Francisco Museum of Modern Art. Gift of Michal Venera.

emotion and activity. After the war, in 1946, she published the book *Dear Fatherland, Rest Quietly* on the fall of Hitler's Germany. Her steely determination to get the photograph she wanted sometimes put her in danger's way. Recognizing her strong will to get an image she said, "Sometimes I could murder someone who gets in my way when I am taking a picture. I become irrational. There is only one moment when a picture is there, and an instant later it is gone—gone forever. My memory is full of those pictures that were lost" (Sandler 151). Bourke-White would contribute to *Life* for approximately 30 years and didn't officially resign until 1969.

One of her most recognized images is of Mahatma Gandhi, who she photographed just hours before he was assassinated. Her work in India from 1946 to 1948 was published in her 1949 book *Halfway to Freedom*. From 1949 to 1950, she photographed South Africa, where she did notable stories about the lives of gold miners in their dangerous and brutal environments.

Perhaps a small part of Bourke-White's success was due to her striking appearance. She was tall and handsome with clear blue eyes. She colored her hair when it was unusual for women to do so and wore pants to the office before it was mainstream. In 1957, Bourke-White stopped photographing, and in 1959, she was diagnosed with Parkinson's disease.

She fought the disease with the same strength that she tackled most every challenge. She kept mobile, dancing as much as she could. After she fell and cracked three ribs, Parkinson's took over. Her mind remained clear to the end. Bourke-White was strong willed, courageous, talented, and discerning. She was driven by the desire to capture an image that revealed something new. In her autobiography she wrote:

> I know of nothing to equal the happy expectancy of finding something new, something unguessed in advance, something only you would find, because as well as being a photographer, you were a certain kind of human being, and you would react to something all others might walk by....Of course, I am at the very core a photographer. It is my trade—and my deep joy. (Johnson 166)

Bibliography

Brown, Theodore, M. "Introduction: A Legend That Was Largely True." *The Photographs of Margaret Bourke-White*, ed. Sean Callahan. New York: New York Graphic Society, 1972, 4–23.

———. *Margaret Bourke-White: Photojournalist.* Ithaca, NY: Andrew Dickson White Museum of Art, Cornell University, 1972.

Goldberg, Vicki. *Margaret Bourke-White.* New York: Harper and Row, 1986.

Johnson, Brooks, ed. *Photography Speaks: 150 Photographers on Their Art.* New York: Aperture.

Mydans, Carl. "Foreword: A Tireless Perfectionist." In *The Photographs of Margaret Bourke-White*, ed. Sean Callahan. New York: New York Graphic Society, 1972, 24–27.

Rosenblum, Naomi. *A History of Women Photographers: Updated and Expanded.* New York: Abbeville, 2000.

Sandler, Martin W. *Against the Odds: Women Pioneers in the First Hundred Years of Photography.* New York: Rizzoli International Publications, 2002.

Places to See Bourke-White's Work

Brooklyn Museum of Art, New York, New York
Cleveland Museum of Art, Cleveland, Ohio
George Arents Research Library, Syracuse University, Syracuse, New York
George Eastman House, Rochester, New York
Library of Congress, Washington, DC
Museum of Modern Art, New York, New York
St. Louis Museum of Art, St. Louis, Missouri

ANNE BRIGMAN

1869–1950

ANNE BRIGMAN IS CONSIDERED TO BE ONE OF THE FOREMOST PICTORIALIST photographers and one of the most controversial woman artists in the early twentieth century. She was born to English parents in Honolulu, Hawaii in 1869. Her early experience living in the lush environment of Hawaii would later influence her artwork. At the age of 16, she moved to the Bay Area of California with her parents, who worked as Protestant missionaries. There is little known about her childhood in Hawaii or her teen years living in California. In 1894, when she was in her mid-twenties, she met and married Martin Brigman, a sea captain.

What sparked Brigman's interest in art is a mystery. However, it is widely documented that she was initially trained as a painter and that her interest turned to photography around 1900. Her transition to photography was an evolution rather than a complete shift, as she incorporated many painting techniques into her photography. This process reflected the *avant-garde* photography style of the day, pictorialism. Pictorialist photographers manipulated their images to have an expressive aesthetic, resembling that of a painting. She marked directly on the negatives and prints with pencils, charcoal, and etching tools. Brigman is also known to use multiple exposures to create a layering and dreamlike effect. Indeed, she was known to use favorite landscape elements repeatedly in final prints. Brigman developed a distinctive style of photography, and soon she was invited to participate in a local group show. In 1902, she exhibited her art work in the second annual exhibition hosted by the California Camera Club at the San Francisco Salon.

An early work, *Heart of the Storm* (1902), is a romantic scene of soft and sensuous lines and dark shadows. It is arguably one of her most recognizable and widely reproduced prints. This out-of-focus black-and-white image is representative of her photographs of nude figures in nature. In *Heart of the Storm*, the male and female figures meld together and with the tree that envelopes them; they have become one with nature in a romanticized and eroticized way.

Anne Brigman. *The Heart of the Storm* (1902). Courtesy of The J. Paul Getty Museum, Gift of the Michael and Jane Wilson Collection.

Her favorite subject matter was the nude female in nature, a very controversial subject for a female photographer. For a woman to have a professional career at all was exceptional; for Brigman to show a nude woman out of doors heightened the controversy. She became one of the first artists, male or female, to photograph nude women in natural surroundings.

Primarily living on the West Coast, most of Brigman's work was done in the Sierra Nevada Mountains of Northern California. In 1926, Brigman wrote about a summer photographic expedition in the Sacramento Valley of California. She mentioned the delicate nature of her work:

> To get those shadows, a time exposure was necessary and when I put on the K.1 ray filter I had to make exposures of such duration, that the memory of it still scares me. I simply held my breath and counted all the counts I dared. I have basic knowledge, but then my paraphernalia was so limited that I had to launch out into another dimension—a kind of swan dive—and I hit right! (Brigman, 1926, par. 17)

She hiked in search of just the right backdrop in which to shoot her work. At first frustrated with the unbearable summer heat and lack of interesting scenery, she was delighted at the onset of a storm, "I knew no one, and, as I said a while back, cared nothing. Then came

the storm weather and with it, the joy of working—light on a dark mountain lake, glories of sunrise, cloud masses, and strange trees" (Brigman, 1926, par. 23).

She was happy to find several trees and settings for her photographs, "Rare, rare in their minds as well as in their slim, fine bodies, have given me of their simple beauty and freedom, that I might weave them into the sagas of these wind swept trees on high peaks" (Brigman, 1926). Brigman used models that were young, thin and athletic; she positioned their bodies to follow the lines of the trees and rocks to create a unity of nature and humanity. Decades after these photographs were taken, scholars have made feminist connections to the liberation of women and Brigman's portrayal of women as free to be one with nature, away from domesticity.

Already a successful photographer and revered as one of the leaders in the field, **Alfred Stieglitz** recognized Brigman's work as important toward the *Photo-Secession Movement* agenda of broadening the definition of photography to include it as an expressive art form. He invited Brigman to join the photo secession movement in 1903, and in 1906, she was invited to become a Fellow of the group. Brigman became one of the most prominent members of the Photo-Secession Movement and the only artist from the West Coast and perhaps more notably, the only woman to be honored as a Fellow.

In 1910, she left her husband and went to New York City to spend eight months with Stieglitz and other Photo-Secession artists associated with his gallery, 291. Stieglitz was impressed and began to promote her work, and he frequently published her photographs in the renowned periodical *Camera Work*. This was a turning point in Brigman's career. She became widely acclaimed and influenced the work of many fledgling photographers, including **Edward Weston** and **Imogen Cunningham**. In 1914, Brigman expressed her feelings of gratitude for gallery 291 in an article. Although she does not mention Stieglitz by name, Brigman is grateful to the man who funded the gallery space for a three-year lease and who gave her a chance because her work was "rotten—but worth while" (Brigman, 1914: 19).

In 1929, she moved to Long Beach, California, to care for her ill mother. This change in address also marked a change in her style from pictorialist to *straight* photography, a realistic documentary approach to the medium. Brigman started shooting the beach scenery and industry of Los Angeles County. This work was largely unknown until exhibited at the Oakland Museum of California in a retrospective, *A Poetic Vision: The Photographs of Anne Brigman* in 1997.

Brigman was also a critic and poet. She published her writing in periodicals such as *Camera Craft, Design for Arts in Education,* and *Camera Works.* Just before her death, she published *Songs of a Pagan* (1949), which featured 22 of her poems and photographs. Until her death Brigman exhibited her work regularly in venues throughout the United States.

She died in Eagle Rock, California, just outside of Los Angeles in 1950. Her name is also documented as Annie W. Brigman, Ann Wardrope Nott, Ann Wardrope Brigman, Anne Nott, Anne W. Brigman, and Annie Brigman. Poet and artist, she was a remarkable female

Anne Brigman. *Threnody* (1911).
Platinum print, 9⅜ × 6¹/₁₆ inches
(23.81 × 15.4 cm). San Francisco
Museum of Modern Art, Gift of
Robert Durden.

artist pushing the boundaries of what was acceptable for women and for artists. Anne Brigman was one of the most important contributors to the Photo-Secessionist Movement and pictorialist photography.

Bibliography

Anne W. Brigman Biography. J. Paul Getty Museum. Retrieved December 27, 2006, from http://www.getty.edu/art/gettyguide/artMakerDetails?maker=1760&page=1.

Brigman, Annie. "What 291 Means to Me." *Camera Works* 47 (July 1914): 17–19.

———. "The Glory of the Open." *Camera Craft* 33, no. 4 (April 1926). Retrieved December 27, 2006, from http://www.communityzoe.com/articles/brigman.html.

———. *Songs of a Pagan*. Caldwell, ID: Caxton Printers, 1949.

Ehrens, Susan. *A Poetic Vision: The Photographs of Anne Brigman*. Santa Barbara, CA: Santa Barbara Museum of Art, 1995.

Heyman, Therese Thau. *Anne Brigman: Pictorial Photographer, Pagan Member of the Photo Secession.* Oakland, CA: Oakland Museum, 1974.

Lahs-Gonzales, Olivia, Lucy Lippard, and Martha A. Sandweiss. *Defining Eye: Women Photographers of the 20th Century.* St. Louis, MO: St. Louis Art Museum, 1997.

Weisman, Celia Y. "A Poetic Vision: The Photographs of Anne Brigman by Anne Brigman; Susan Ehrens." *Woman's Art Journal* 19, no. 1 (Spring–Summer 1998): 62.

Places to See Brigman's Work

George Eastman House, Rochester, New York

J. Paul Getty Museum, Los Angeles, California

Joseph Bellows Gallery, La Jolla, California

Metropolitan Museum of Art, New York City, New York

Oakland Museum, Oakland, California

Smithsonian American Art Museum, Washington, DC

ESTHER BUBLEY

1921–1998

BEST KNOWN FOR HER CANDID IMAGES OF EVERYDAY PEOPLE, ESTHER Bubley gave us a view of the United States from the World War II years through the postwar era. She also took pictures all over the world, publishing in many top magazines of her day, like *Life* and the *Ladies' Home Journal*. Her work captured isolated human moments that defined life in the public sphere, enticing viewers to construct a story. She had a gift for creating strong compositions, and because she was exceptionally skilled at putting people at ease, she was able to capture intimate portrayals of her subjects.

The fourth of five children, Bubley was born in 1921 in Phillips, Wisconsin, to parents who were both Jewish immigrants. Her father, an automobile supply store manager, was from Russia, and her mother was from Lithuania. The family moved to New York in 1923 but returned to Superior, Wisconsin, in 1930 or 1931. Esther was a precocious child who skipped two grades. In high school she became aware of the *Farm Security Administration* (FSA) photographs. These images, coupled with pictures in *Life* magazine, inspired her interest in documentary photography. For two years she attended Superior State Teachers College (now the University of Wisconsin at Superior) intending to become a teacher. When she discovered that teaching was not her calling, she dropped out of school for a year to work at Mando Photo Services in Duluth, Minnesota. She then studied photography at the Minneapolis School of Art (now the Minneapolis College of Art and Design).

In 1941, Bubley moved to Washington, DC, to look for work but was unsuccessful. She then relocated to New York, but jobs were hard to obtain because no one wanted to hire a female photographer. She eventually found an unsatisfying temporary job with *Vogue Magazine*. In 1942, she began work microfilming rare books in the National Archives in Washington, DC. This led to her big break, working in the darkroom at the Office of War Information (OWI), which was headed by Roy Stryker. During this time she also worked

on her own to develop her skills as a photographer. **Gordon Parks** and other OWI photographers encouraged her to build her portfolio.

Bubley's big opportunity came in 1943 when Stryker gave her a six-week OWI assignment to travel across the country on buses, which had become an important mode of transportation due to the war rationings on gas and tires. While her task was to bring back images of a transportation system that functioned efficiently for both soldiers and civilians, her images did not always capture a spirit of togetherness and resilience. Instead, they portrayed crowded waiting areas, tired and anxious passengers, racial segregation, disturbing views of poverty, and open, often empty, roadways. Not all the portraits were comfortably reassuring. There was more isolation than harmoniousness in this series of work. Although her bus pictures were taken 12 years before Rosa Parks refused to sit at the back of the bus where African Americans had designated seats, Bubley was keenly aware of the negative

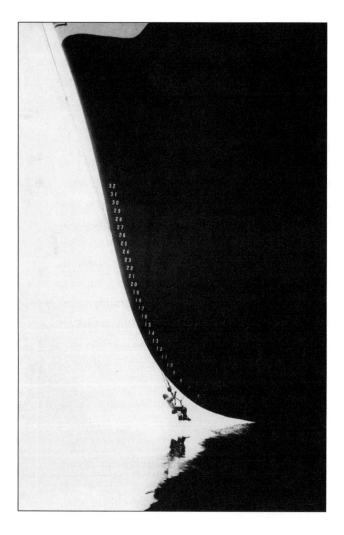

Esther Bubley. *Ship's Painter, Aruba, Pepsi-Cola International* (1957). Courtesy of Jean Bubley. © Esther Bubley Estate.

effects of segregation. Perhaps because her photographs didn't communicate the kind of uplifting story many wanted to hear and see, or perhaps because Bubley was not as experienced as other photographers competing for space at the time, her images weren't readily celebrated and published. However, some of her bus images were published in *U.S. Camera* and *Minicam*.

During World War II, Roy Stryker was hired to direct a project for Standard Oil Company (New Jersey) to help repair their damaged reputation due to a partnership they had with a German petrochemical company. He again hired Bubley to travel and photograph. This time she was sent to various oil towns in Texas. One of her first stops was Tomball, a boomtown near Houston. Here, in a period of six weeks, she astutely recorded the town's activities in six hundred photographs. She shot images of women visiting at a café, men playing dominos, residents singing in churches, and families selling berries on the roadsides. Unlike some of her photographs from the bus series, these images more often depict people who are joyfully engaged in life. Some of these pictures were published in *Coronet* magazine. Her visits to other places, including Andrews County and Utopia, were equally as impressive. Stryker was so pleased with these images that he assigned her to travel on buses throughout New York, Pennsylvania, and Ohio. From this trip she produced photographs that in 1948 won a First Award from the University of Missouri and the *Encyclopedia Britannica*.

Photographing the South during World War II, Bubley's images documented both consistency and change in the landscape. While Jim Crow signs remained fixed in the landscape, a changing South was represented by soldiers getting ready to report to duty or to go home on leave and women working in office spaces.

Bubley also photographed well-known people like Charlie Parker and Albert Einstein, even though she is better known for her images of everyday people engaged in everyday activities. Residents in boarding houses, teenagers dancing at a birthday party, women with mental illness, hospital operating scenes, and a children's chorus leave the viewer with questions about the complexity of individual lives. Bubley often shot her subjects close-up, capturing feelings of agitation and aloneness.

In her 30s, Bubley began to travel the world as a freelancer, often working for Standard Oil and Publishing's magazine, *The Lamp*. Comfortable in myriad settings, she published stories on African Americans for the picture magazine *Our World*. In 1946, she took photographs of Howard University's School of Medicine, Chicago's meat-packaging industry, and everyday life in New Orleans. In 1948, she became a regular contributor to *The Ladies' Home Journal* series on "How America Lives," which documented families all over the country from varying income levels. Bubley was able to take her time in creating each of these stories. Her relationship with this magazine, which lasted from 1946 to 1953, was especially successful, and it was an honor to be selected to participate. In 1949, she worked with *Ladies' Home Journal* to document a four-part series on mental illness, focusing

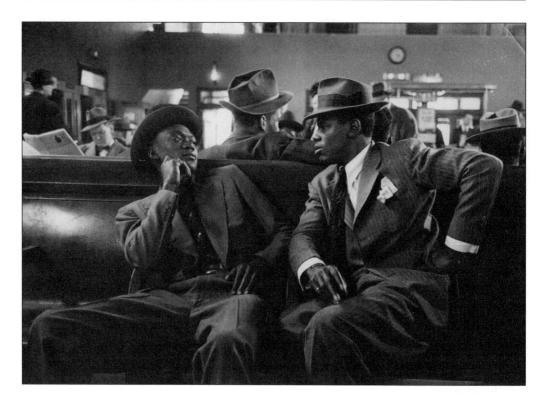

Esther Bubley. *Two Men in the Bus Station* (1947). Courtesy of Standard Oil (New Jersey) Collection. Photographic Archives, Ekstrom Library, University of Louisville. Courtesy of Jean Bubley.

on two oppressive and prison-like hospitals, Pennsylvania State Hospital in Philadelphia and Greystone Park Psychiatric Hospital, close to Trenton, New Jersey. Bubley also photographed a newer facility near Anoka, Minnesota. She later remarked that this was the most interesting assignment that she had ever experienced.

A few years after this, she photographed life-and-death activities in the Pittsburgh Children's Hospital. In 1952, 13 prints from this experience were featured in the exhibition *Diogenes with a Camera*, curated by **Edward Steichen,** at the Museum of Modern Art. Her 1954 UNICEF photograph of Moroccan women won first prize in *Photography* magazine's competition. She was the first woman to win this distinguished award. In 1955, Steichen included her work in his exhibition *The Family of Man*. Over the years Bubley would publish her photographs in numerous other magazines, including *Life, Minicam, Our World, Woman's Day, McCalls, Good Housekeeping, Saturday Evening Post, The New York Times Magazine* and *Time*. She was also instrumental in the development of what was then called "documentary advertising," a process that used real people in ads.

Esther Bubley was a private, reserved, and unassuming woman. These characteristics placed her subjects at ease and allowed her to capture intimate portraits. However, these

characteristics also prevented her from being a good publicist for her own work, in contrast to more flamboyant colleagues like **Margaret Bourke-White.** She didn't readily share ideas about her work, nor did she keep a diary. She was an animal lover and an avid gardener. She married once in 1948 to Ed Locke, who was an assistant to Stryker, but they separated after 18 months, and the marriage was annulled after three years. From 1944 until she died, Bubley made her home in New York City, cutting back on her travels when she was in her mid-forties. In her later years she wanted to create a photo essay on New York's homeless population, but this project did not come to fruition. In the early 1970s she published two children's books, *How Puppies Grow* and *How Kittens Grow,* and later a book on plants called *A Mysterious Presence.* In 1981, Esther Bubley's *World of Children in Photographs* was published, and in 1995, *Charlie Parker* was published in France (and in French). Esther Bubley died from cancer in 1998.

Underrated as an artist during the last part of the twentieth century, in recent years her work has received greater recognition. In 2004, the Library of Congress developed a Web site on Bubley, and major exhibitions are increasingly being done on her work. Recently critics have said that her work defies easy interpretation, a response that perhaps resonates more today than it did half a century ago when a clear concise message was sometimes more valued.

Esther Bubley is also notable for the way in which she demonstrated courage and independence as a woman during a time when it was unusual for women to travel alone, especially overseas. While she was keenly aware of the difficulties she faced as a female photographer, she was able to successfully work for prestigious clients and top magazines in a highly competitive male-dominated field.

Bibliography

Brannan, Beverly W. "Private Eye." *Smithsonian* 34, no. 12 (March 2004): 21–22.

Bubley, Jean. Unpublished biographical information on Esther Bubley. Personal correspondence, September 5, 2006.

Dieckmann, Katherine. "A Nation of Zombies." *Art in America* 11 (November 1989): 55–61.

Kidd, Stuart. *Farm Security Administration Photography, the Rural South, and the Dynamics of Image-Making, 1935–1943.* Studies in American History, Volume 52. Lewiston, NY: Edwin Mellen Press, 2004.

Plattner, Steven W. *Roy Stryker: U.S.A., 1943–1950.* Foreword by Cornell Capa. Austin: University of Texas Press, 1983.

Yochelson Bonnie. With Tracy A. Schmid. *Esther Bubley: On Assignment.* New York: Aperture, 2005.

Places to See Bubley's Work

Akron Art Museum, Akron, Ohio
Amon Carter Museum of American Art, Fort Worth, Texas

George Eastman House, Rochester, New York
Library of Congress, Washington, DC
National Portrait Gallery, Smithsonian Institution, Washington, DC
New York Public Library, New York, New York
Pittsburgh Photographic Library, Carnegie Library of Pittsburg, Pennsylvania
University of Louisville, Special Collections and Archives, Ekstrom Library, Louisville, Kentucky

CLYDE BUTCHER

b. 1942

KNOWN FOR HIS LARGE-SCALE LANDSCAPES, CLYDE BUTCHER HAS MADE a name for himself photographing the corridors of Florida's uninhabited spaces. One of the most striking things about Butcher's enormous photographs is that they are black and white. The vibrant and fluid color schemes of Florida's landscapes are usually the focal point in portraits of the state's vast wildlife and expansive coasts. Instead, his images are void of color, redirecting the focus to the intricacies illuminated by the shades of light and dark; the details in the tree roots, the reflections in the swamps, the ripples in the surf, and the curvature of drift wood.

Butcher did not start out as a photographer. He studied architecture as an undergraduate student at California Polytechnic Institute in San Luis Obispo. However, he was not a natural illustrator and struggled with traditional architecture design assignments. Instead of drawing his designs, he constructed small wooden mock ups of his buildings and then took photographs with adjusted lighting to make them appear natural. The department faculty took note of Butcher's exceptional skills in photography. When the department made space for a dark room, Butcher was named supervisor. In addition to his dark room duties, he read voraciously about the mechanics of photography, teaching other students as he learned.

After college he moved into a small house on a hill near La Honda, California, with his wife Niki. The couple often had friends and family living with them to help pay the rent. He was a struggling artist making architectural models that were high-cost projects exceeding any reasonable profitability. Niki worked a variety of jobs but was unable to earn a high pay without a college degree. It was not long before Butcher was forced to reexamine his art and consider a more profitable approach to working creatively and independently. Photography was a skill that Butcher had already developed and would be his natural choice of medium.

Clyde Butcher. *Cayo Costa Island #1* (Florida Series) (1988). Courtesy of the artist and Big Cypress Gallery, Ochopee, Florida.

A nature lover, Butcher often took photographs outdoors and indeed has become well known for his wide sweeping landscapes. He wrote about the special relationship that he has with the wilderness. After the sudden death of his son, Butcher fled to the great outdoors to be alone, where he found healing and the will to carry on. He said:

> Wilderness to me is a spiritual necessity. When my son was killed by a drunk driver it was to the wilderness that I fled in hopes of regaining my serenity and equilibrium. The mysterious spiritual experience of being close to nature helped restore my soul. It was during that time I discovered the intimate beauty of the environment. My experience reinforced my sense of dedication to use my art form of photography as an inspiration for others to work together to save nature's places of spiritual sanctuary for future generations. (Butcher, *Clyde Butcher Web site*)

Although Butcher has photographed nature all over the world, he is perhaps best known for his Floridian landscapes. He has been photographing Florida since he and Niki moved there more than 25 years ago. In *Cayo Costa Island #1* (1988), the water's reflection leads to the pristine sand, the row of tall palm trees and onward to a cloud filled

sky—quintessentially Florida. Butcher has a personal relationship with nature that he expresses in his photography and that he wants others to experience as well. He said about his work:

> I think my work creates feelings. In a lot of my photos, in the center, there is nothing there. The center of interest is a void, so you can get into the photograph. It doesn't keep you out....I make my photos so they don't look good small. They're meant to be large to be experienced. The eye has to scan the photo so the brain can piece it together. This creates experiences rather than compositions. (Butcher, *Clyde Butcher Newsletter,* 2)

Indeed his prints are so large at 5 × 8 feet that many patrons have inquired about the logistics of processing. Butcher specially designed the dark room in his Venice Studio and Gallery that is frequently open to the public for touring.

Butcher is devoted to preserving the many natural wonders of Florida. In addition to his participation in fighting to save Florida's wildlife and natural preserves, Butcher's art functions as a vehicle toward social consciousness in its own way. Alone the photographs are breathtaking works of art that if nothing else show us the magnificence that nature has to offer; with Butcher's voice of social consciousness and education, they become representative of a land that is quickly changing and in danger of losing its natural resources. In his book *Living Waters: Aquatic Preserves of Florida* (2004), he introduces the body of work with information about Florida's landscape and the state of crisis that it is in due to the population explosion and the development that comes with expansion.

He has traveled the world in search of subject matter and inspiration. On a recent trip to Cuba, Butcher made a series of photographs of the landscape and on occasion the local architecture. A departure from Butcher's typical work, *Cuba—Banao OE* (2003) is a picture of a simple cemetery. The graves are built just above ground due to the high sea level; the crowded plots create a sea of concrete. Yet, the hilly horizon and the puff of clouds above the graves command notice and redirect our attention back to nature.

In another series he took close-up shots of orchids with altered lighting, which morphed the blossoms into bright white abstract designs against a solid black background. In *Ghost Orchid #1 OE* (1999), the sharp outline of the delicate flower contrasts with the soft ethereal light that surrounds the blossom, making it eerily like a ghost of itself.

Clyde Butcher is an artist hard at work. In September 2007, his prints were exhibited at the Muscarelle Museum of Art at the William and Mary College in Williamsburg, Virginia. This exhibition will feature his work of the American landscape from all over the country and will occur simultaneously with the *America 400* Celebration in Jamestown. His work has been exhibited all over Florida and throughout the United States in venues such as the Walton Arts Center in Fayetteville, Arkansas; the Museum at Texas Tech University in Lubbock, Texas; Indian Hills Community College in Ottumwa, Iowa;

Clyde Butcher. *Cuban Banao OE* (out of USA series) (2002). Courtesy of the artist and Big Cypress Gallery, Ochopee, Florida.

Bergstrom-Mahler Museum in Neenah, Wisconsin; and the Chicago Public Library in Chicago, Illinois.

Butcher has received numerous awards for his work including the Artist Hall of Fame Award by the State of Florida, the Lifetime Achievement Award from the North American Nature Photography Association, the Humanitarian of the Year for 2005 from Florida International University, and the **Ansel Adams** Conservation Award by the Sierra Club for excellence in photography and work toward public awareness of the environment. Public Broadcasting System (PBS) has completed two videos about Butcher and his work, *Visions of Florida* and *Big Cypress Preserve: Jewel of the Everglades*. He has also participated in PBS documentaries about Florida's natural environment, *Living Waters: Aquatic Preserves of Florida* and *Apalachicola River: An American Treasure*. Butcher has produced several monographs of his work and limited edition artist books. He routinely gives lectures on his work at the Venice Chamber of Commerce.

An environmentalist as well as an artist, Clyde Butcher has two galleries, the Big Cypress Gallery and the Venice Studio. His daughter, Jackie, and his wife, Niki, are both involved

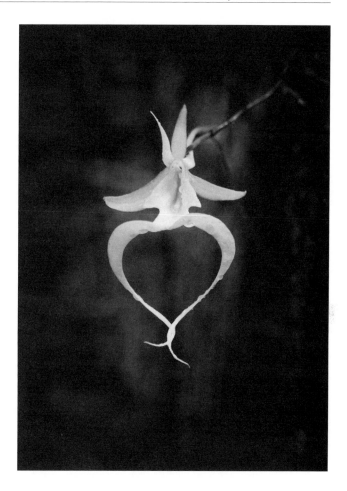

Clyde Butcher. *Ghost Orchid #1* (1999). Courtesy of the artist and Big Cypress Gallery, Ochopee, Florida.

in what has become something of a family business. The work of Clyde Butcher transcends mere picture making; the gigantic photo murals create a visceral and lasting experience.

Bibliography

Butcher, Clyde. *Clyde Butcher: Florida Landscapes*, 2nd ed. Foreword by Glen A. Long and "Beyond the Frame" by Christine Ellinghausen. Fort Meyers, FL: Shade Tree Press, 1994.
———. *Living Waters: Aquatic Preserves of Florida*. Ochopee, FL: Big Cypress Gallery, 2004.
———. *Clyde Butcher Newsletter* 25 (2007).
———. *Clyde Butcher Website*. Retrieved February 6, 2007, from www.clydebutcher.com.
Shroder, Tom, and John Barry. *Seeing the Light: Wilderness and Salvation: A Photographer's Tale*. New York: Random House, 1995.

Places to See Butcher's Work

Big Cypress Gallery, Ochopee, Florida
Clyde Butcher Web site: www.clydebutcher.com
Venice Gallery and Studio, Venice, Florida

HARRY CALLAHAN

1912–1999

REVERED AS ONE OF THE MOST SIGNIFICANT CONTRIBUTORS TO MODERN photography, Harry Callahan was a self-taught photographer. Harry Morey Callahan was born in Detroit, Michigan on October 22, 1912. In 1934, he enrolled at Michigan State College in Lansing as a chemical engineering major, and one year later he changed his major to business. Callahan had first been hired as a shipping clerk in the parts division of Chrysler Motors in 1933; after he dropped out of school in 1936, he went back to work at Chrysler. Later that same year he married Eleanor Knapp, who was to become his most famous model. It is unknown exactly what motivated Callahan to pursue photography; perhaps his life with Eleanor prompted him to purchase his first camera in 1938. He systematically began to teach himself the technical elements of photography. An avid walker, he would go out every morning shooting images wherever he went. Callahan joined the Camera Club that same year, in 1938. He decided to join the photography guild at work in 1940.

In 1941, he had the opportunity to take a photography class taught by a professional photographer. Callahan was greatly influenced by the lecture and workshop given by renowned photographer, **Ansel Adams.** He often credited this experience as the pivotal point when he decided to seriously pursue photography as an art. Shortly after his class with Adams, Callahan quit the photography guild and purchased an 8" × 10" view camera and started making contact prints. Like Adams, Callahan photographed the natural landscape. In his black-and-white photograph *Detroit* (1941), Callahan framed a delicate composition of light and dark, line and shape, accentuated by the water's reflection. The cross outline of the electrical poles lined up along the road evoke a rhythmic and almost spiritual quality to the work.

Although Callahan is widely known for photographing his personal life, he also experimented with abstract photography. In 1943, he began working on a series of snow and water landscapes that were highly abstracted by manipulating the exposure time. These

black-and-white works are delicate and at first glance resemble ink drawings. As in *Weeds in Snow, Detroit* (1943), the weeds have become black scribbles, and the snow has become a blank white sheet of paper. The title is our only clue about the subject matter.

Callahan met and befriended many of the preeminent photographic artists in the United States. While on a trip to New York City in 1942, he met photographer **Alfred Stieglitz** at his gallery, An American Place. By 1945, Callahan moved his family to New York, where he met many successful photographers including: **Berenice Abbott, Helen Levitt, Paul Strand,** Lisette Model, and **Minor White.** He applied for a fellowship at the Museum of Modern Art in New York City but was rejected, which prompted his return to Detroit in 1946. Although he no longer lived in the epicenter of the art world, Callahan continued to socialize with the leading photographers of the day, including **Edward Steichen** and **Aaron Siskind,** who were to become his lifelong friends and colleagues.

He photographed the streets, people, and most commonly, his wife, Eleanor, and daughter, Barbara, after her birth in 1950. In particular Eleanor was a central figure in his work from 1947 to 1960, just as she was to his life. He photographed her everywhere and in different poses, close-up and at a distance, using double and even triple exposures. In 1958, he was honored with the Graham Foundation Award for Fine Arts. With the $10,000 award Callahan took his wife and daughter to France. While there, he photographed both Eleanor and Barbara in the French countryside. In one photograph, *Eleanor, Aix-en-Provence, France* (1958), he used double exposure to show the nude shadow of her back laying on top of a scenic landscape in Aix-en-Provence.

Callahan did not separate work from family life; everything about his life informed the other parts equally. He documented the world directly around him. Although he photographed those closest to him, he had a straightforward approach to the subject and focused on line, shape, light, and shadows rather than a romantic or sentimental portrayal. Callahan had a different sense about the nature of what a photograph means. He remarked on art criticism concerning photography, "I don't see how anybody can criticize pictures—I really don't. If an art critic is a good writer, then a review is worth reading, but I don't think it has much to do with the pictures" (Callahan 8).

Not long after his return to Detroit in 1946, he was hired by artist László Moholy-Nagy to teach photography at the Institute of Design in Chicago. Just three years later he was appointed the head of the photography department in 1949. In 1951, he taught a summer course at the Black Mountain College in North Carolina along with artists Robert Motherwell, Ben Shahn, Arthur Siegel, and Jonathan Williams. In 1961, after a successful 15 years, he left the Institute of Design to develop the photography department at the heralded Rhode Island School of Design. He taught there until 1977 when he retired from teaching. Callahan encouraged his students to photograph what mattered to them, to care about their subjects. Callahan encouraged students to love the process and respect their role in it. He was a highly revered and beloved educator.

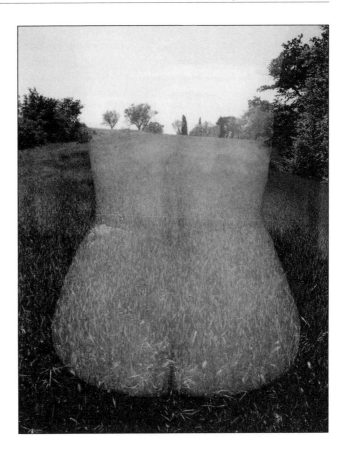

Harry Callahan. *Eleanor, Aix-en-Provence, France* (1958). © The Estate of Harry M. Callahan. Courtesy Pace/MacGill Gallery, New York.

Although he was denied the fellowship at the Museum of Modern Art in New York in 1946, he had the opportunity to exhibit his work there on several occasions, including a major retrospective in 1976: *Harry Callahan: Studies of Nature.* Callahan exhibited his photographs in dozens of venues, such as 750 Studio Gallery and The Art Institute of Chicago in Chicago, Illinois; The George Eastman House in Rochester, New York; The University of Warsaw in Poland; MIT Creative Photography Gallery in Boston, Massachusetts; Witkin Gallery and PaceMacGill Gallery in New York, New York; the National Gallery of Art in Washington, DC; and the Barbican Art Gallery in London, England.

In 1983, he moved to Atlanta, Georgia. On March 15, 1999, Harry Callahan died. Although he left behind an enormous amount of work, including more than 100,000 negatives and 10,000 proof prints, he claimed to make less than ten complete works each year. Endeared educator and dedicated artist, Harry Callahan was a significant contributor to the development of academic photography in the twentieth century.

Bibliography

Callahan, Harry. *Harry Callahan* [with an essay by Jonathan Williams]. New York: Aperture Foundation, 1999.

Callahan, Harry. *Eleanor.* New York: Callaway Editions, 1984.

Dow, Jim. "Harry Callahan, 1912–1999: A Remembrance." *Afterimage* 26, no. 6 (May/June 1999): 3.

Pittari, Michael. "Atlanta." *Art Papers* 24, no. 1 (January/February 2000): 39–40.

Sheets, Hilarie M. "Harry Callahan: Pace/MacGill." *Artnews* 102, no. 10 (2003): 155–156.

Susser, Deborah Sussman. "Harry Callahan: Center for Creative Photography." *Artnews* 105, no. 7 (2005): 188.

Weinstein, Michael. "Harry Callahan." *New Art Examiner* 25 (1997): 43–44.

Williams, Jonathan. "Remembering Harry Callahan." *Aperture* 156 (Summer 1999): 95.

Places to See Callahan's Work

Center for Creative Photography, University of Arizona, Tucson, Arizona

Corcoran Gallery of Art, Washington, DC: *Barbara in Florence, Italy* (no date)

David Winton Bell Gallery, Brown University, Providence, Rhode Island

DePaul University Museum, Chicago, Illinois: *Untitled* (no date)

Det Nationale Fotomuseum, Copenhagen: *Providence, Rhode Island* (1971)

Eastman House Museum of Photography and Film, Rochester, New York

Fred Jones Jr. Museum of Art, University of Oklahoma, Norman, Oklahoma: *Eleanor, Chicago* (1949)

Harvard University Art Museums, Cambridge, Massachusetts

Kemper Museum of Contemporary Art, Kansas City, Missouri: *Bob Fine* (1952); *Eleanor, Indiana* (1948)

Los Angeles County Museum of Art, Los Angeles, California

Massachusetts Institute of Technology List Visual Arts Center, Cambridge, Massachusetts

Metropolitan Museum of Art, New York, New York: *Untitled (triptych),* (1946)

Museum of Contemporary Art, Los Angeles, California

Museum of Fine Art, Santa Fe, New Mexico

Museum of Modern Art, New York, New York

Museum of the Rhode Island School of Design, Providence, Rhode Island

PaceMacGill Gallery, New York, New York

Philadelphia Museum of Art, Philadelphia, Pennsylvania

Smithsonian American Art Museum, Washington, DC

JAMES CASEBERE

b. 1953

BEST KNOWN FOR TAKING PHOTOGRAPHS OF CONSTRUCTED STAGE SETS that are somewhat surreal, James Casebere focuses on historical subjects, most often taken from the history of the United States. His emphasis is on creating emotional spaces rather than on actual physical places.

Casebere was born in Lansing, Michigan. His upbringing was middle-class and suburban. He studied at Michigan State University and received his BFA from the Minneapolis College of Art and Design in 1976. He was awarded an MFA from California Institute of Arts in Valencia in 1979. His most striking student experience was working with the famous sculptor Claes Oldenburg, who showed him how everyday objects could generate ideas about universal themes. This idea continues to guide much of his artwork. Casebere has had residencies at several schools including Cooper Union, Harvard, and Yale.

Two approaches are taken to creating his stage sets. One is to produce room-size installations with over-sized objects placed in them. These are seen as artworks in themselves and are displayed in museum and gallery settings. The photographs that are taken of these arrangements are viewed as documentary images instead of artworks, since the room sculptures are intended to be experienced rather than photographed as art. His more common approach, which he began in the mid-1970s, is to form table-size miniature still lifes. These constructions are created just for photographic purposes and are never placed on display. In this case the photograph is the artwork. Focusing on the built environment, his early subjects range from his 1970s domestic interiors to his 1980s public places.

Casebere's interest in social commentary is evident. Occasionally, he reflects on visual art experiences. He explains: "Some of the best 'Cowboy' movies were made during the McCarthy era—either as cleverly veiled social criticism, which had to be concealed back then, or as a glorification of the conservative values." Recognizing this paradox, he continues, "In taking up

popular motifs from the American West, I wish to examine the way and the extent to which cultural myths penetrate our public and private lives" ("Biographies of the Artists" 144).

Casebere's miniature sets are made from plaster, styrofoam, paper, and cardboard. The emotional impact comes largely from his lighting. The constructed stage sets are made with a minimalist approach that eliminates detail. This sparseness causes viewers to fill in the blanks with their own experiences and memories. Photographically, the images are flattened and eerie in appearance. The light most often evokes a sense that it is nighttime. Because his camera frames his models within their created space, the size of the construction is not revealed in the photograph, creating pictorial illusion. Viewers aren't sure if the buildings are life size.

His early images were inspired by thoughts about different parts of the home and what the objects in them symbolized. While his first photographs do not have the technical sophistication and skill of his later work, they do effectively address social structures in metaphorical terms. They communicate, for instance, individual limitations and the power of

James Casebere. *Asylum* (1994). Dye destruction print, 24 × 30 inches and 48 × 60 inches, edition of 5. Courtesy of the Artist and Sean Kelly Gallery, New York.

social pressure to conform. From an interest in domestic spaces, Casebere expanded his subject area to include an exploration of how large institutions affect our everyday lives.

In the 1990s, Casebere began to make models of actual prisons such as Sing Sing in Ossining, New York, or the Prison at Cherry Hill in Philadelphia as a critique of imprisonment. His models are based on images and texts and not the actual subject. The result is a visual composite that is an interpretation of his findings. The spaces seem vast, empty, unsettling, and isolating, feelings that come largely from his keen skill at producing light and shadow. As his work is an imitation, based on copies of that which is real, he raises questions about the nature of photography as imitation, as he more generally poses ideas about reality and truthfulness. In *Sing Sing #2* (1992), for instance, the artist has created an image of the prison that is not architecturally truthful, but in his refinements, what Casebere has created is an image of a building that is massive and claustrophobic. In this way he has communicated a truthfulness of sensibility.

His image titled *Panopticon Prison #2* (1992) is based on the nineteenth century's idea of what the ideal prison should be like. With this design a guard should be able to observe all the prisoners at one time. Here he lights up only one of the 19 small windows in what appears to be an ominous curved building. Viewers are drawn to this one lone window-space, as their imaginations can't help but wonder what is going on inside, while asking whether the rest of the rooms or cells have been abandoned. While the photographs of *Panopticon Prison* are based more on an ideal prison, *Sing Sing* (1992) and *Prison at Cherry Hill* (1993) are actual prisons. Both are lit with a kind of light that seems surreal. They are silent images with long histories of incarceration that speak loud, uncomfortable truths.

Besides homes and prisons, Casebere has analyzed libraries, factories, churches, and asylums as institutional spaces that have helped form Western culture. These are institutions that can be symbolized by their public space. Many of them are in crisis or decline, or they occupy an increasingly questionable or changing place in American culture. For example, *Industry* (1990) is a photograph of a table-top construction of an eighteenth-century factory building. In this image he explores the ways that architecture encourages, perhaps even demands, efficiency and focus, possibly to the detriment of the human spirit.

As one of his most impressive photographs, *Apse* (1996) is a large-scale monochromatic print of the interior of a church. Introducing subtle coloring to the vast and open barrel vaulted room adds to the cool, aging, and empty feeling of the space. From its round window with what appears to be gridded ironwork, but is actually a reproduced sewer duct grill, white light flows into the room. In this space Casebere has created a place of quiet and isolation. This is a space that could be meditative like a monastery, but it has a kind of loneliness to it as well. This image, like all his work, has multiple, often conflicting meanings. It takes time and effort to work through his work. Viewers must read it slowly and carefully to fully engage in Casebere's conversation.

Casebere's images create a dialogue about photography's relationship to sculpture and set design. Knowing that he creates the sculptural forms he photographs, viewers can think about the work as sculpture, photography, and performance. Viewers must get into the mind of the performer to enjoy the theatrical pleasures that are presented in the images. Critic James Crump points out that Casebere works with approaches that other photographers like **Cindy Sherman** and **Laurie Simmons** have taken as they all construct stage sets. Crump writes that Casebere "began by seeking to confront the way that film, television and the advertising media have furnished what he calls our unconscious 'visual library'" (57).

More recently, Casebere has created work based on Philips Academy in Andover, Massachusetts. In these carefully composed, obsessively designed and lighted works, the artist includes subtle color. His works have also progressively gotten larger and more impressive. Casebere's images are compelling because of their luscious contrasts in light and dark, which are seductively beautiful and elegant. But his work is also disturbing and challenging because of the kinds of questions he raises about America's social structures.

In 2002 and 2003, Casebere continued exploring ideas surrounding colonial American and neoclassical spaces. Thomas Jefferson's Monticello was of particular interest to the artist. As in his earlier work, Casebere continues to position us in a space between our lived reality and our unconscious.

His latest work involves images from the geographical area of the Levant in the Middle East. Located at the eastern end of the Mediterranean Sea, it includes Lebanon, Syria, Greece, Turkey, and Egypt. Once again he explores complex histories and present understandings that can be communicated though his constructed spaces. These architectural spaces, like all his spaces, speak of both the specific and the archetypal. They raise important philosophical questions about work, religion, economics, and the law.

James Casebere lives and works in Brooklyn with his wife, photographer, **Lorna Simpson.** In his new studio designed by London-based architect David Adjaye, Casebere has space to create both large and small-scale models. As a fitting space for this photographer to work, it is a classical, open space that emphasizes symmetry and light.

Bibliography

"Biographies of the Artists." *Constructed Realities: The Art of Staged Photography*, ed. Michael Köhler with texts by Zdenek Flelix, Michael Köhler, and Andreas Vowinckel. Zurich: Edition Stemmle: 1989/1995, 143–158.

Browne, Alix. Photographs by Nikolas Koenig. "Double Vision." *New York Times Magazine*, September 3, 2006: 44–47.

Crump, James. "Solitary Spaces." *Art in America* 10 (1997): 56–57, 59.

Hirsch, Robert. *Exploring Color Photography: From the Darkroom to the Digital Studio*, 4th ed. New York: McGraw-Hill, 2005.

"James Casebere: Mutable." Press release for 2003 exhibition at Sean Kelly Gallery.

"James Casebere: The Levant." Press release for 2007 exhibition at Sean Kelly Gallery.

Vidler, Anthony. "Staging Lived Space: James Casebere's Photographic Unconscious." *James Casebere: The Spatial Uncanny*. New York: Sean Kelly Gallery and Edizioni Charta, Milano, 2001.

Zellen, Jody. "James Casebere." Retrieved on January 10, 2007, from http://artscenecal.com/Articles File/Archive/Articles200/Articles0600/JCasebereA.html.

Places to See Casebere's Work

Addison Gallery of American Art, Phillips Academy, Andover, Massachusetts
Albright-Knox Museum, Buffalo, New York
Allen Memorial Art Museum, Oberlin, Ohio
Baltimore Museum of Art, Baltimore, Maryland
Birmingham Museum of Art, Birmingham, Alabama
Brooklyn Museum of Art, Brooklyn, New York
Carnegie Museum of Art, Pittsburg, Pennsylvania
Contemporary Art Museum, University of South Florida, Tampa, Florida
Dallas Museum of Art, Dallas, Texas
Davis Museum and Cultural Cener, Wellesley, Massachusetts
Fogg Museum, Harvard University, Cambridge, Massachusetts
Guggenheim Museum, New York, New York
High Museum of Art, Atlanta, Georgia
Jewish Museum, New York, New York
Los Angeles County Museum of Art, Los Angeles, California
Metropolitan Museum of Art, New York, New York
Museum of Fine Arts, Boston, Massachusetts
Museum of Fine Arts, Houston, Texas
Museum of Modern Art, New York, New York
Neuberger Museum, State University of New York at Purchase, Purchase, New York
New Orleans Museum of Art, New Orleans, Louisiana
New School of Social Research, New York, New York
Orlando Museum of Art, Orlando, Florida
Rose Art Museum, Waltham, Massachusetts
San Diego Museum of Contemporary Art, San Diego, California
San Francisco Museum of Modern Art, San Francisco, California
St. Louis Art Museum, St. Louis, Missouri
Tampa Museum of Art, Tampa, Florida
University Art Museum, University of New Mexico, Albuquerque, New Mexico
University of Iowa Museum of Art, Iowa City, Iowa
Walker Art Center, Minneapolis, Minnesota
Whitney Museum of Art, New York, New York
Williams College Museum of Art, Williamstown, Massachusetts

SARAH CHARLESWORTH

b. 1947

AS A *CONCEPTUAL* ARTIST, SARAH CHARLESWORTH USES PHOTOGRAPHY TO create a pathway leading toward an idea. Working from a feminist perspective, she sees art as a way to communicate ideas about the conditions of society and to provoke dialogue and action toward change.

She was born in East Orange, New Jersey, on March 29, 1947. Charlesworth enrolled at Barnard College in New York City just after high school. At Barnard, she majored in art history and took several studio classes, including painting. She was a student of Douglas Huebler, who was well known for his work in the *minimalist* tradition and who had begun to experiment with conceptual art and dematerialization. Dematerialization is the notion that the idea is the art alone, void of any art object or physical product. In 1968, she attended one of the first exhibitions of conceptual art featuring the work of four artists, including Joseph Kosuth. The exhibition was curated by Seth Siegelaub and was held in a leased space on 52nd Street. This was the first time that she experienced art that considered the idea to be more important than the object. This was a turning point in the way she thought about art. As a senior, she presented a conceptual artwork that was represented as 50 photographic images without text for her graduating thesis. During these early years living in New York City and attending a liberal college, Charlesworth was exposed to 1960s politics during the height of the Civil Rights Movement and the early days of the feminist movement, which greatly impacted her perspective and art work. Although photography was not her primary medium, Charlesworth was skilled and able to support herself financially as a freelance photographer for about seven years after graduating from Barnard in 1969.

In the early 1970s, Charlesworth became romantically involved with the artist, Joseph Kosuth, which led to artistic and intellectual collaborations between the two. During these years she spent much of her time writing art analysis for a variety of publications and working with the *Fox*, a short-lived *avant-garde* publication that she co-founded with Kosuth.

She also co-founded the artist's group, Artists Movement for Cultural Change, which fostered dialogue regarding the search for meaning in art. Charlesworth did not make art objects during these years; rather, her art analysis that manifested in discussion, writings, and organizational work was her art. At this time she took classes in photography, economics, linguistics, anthropology, and semiotics at the New School for Social Research in New York City.

After spending several years focused on the intellectual debate of conceptual art and working with photographer Lisette Model at the New School, Charlesworth began to reconsider the role of the art object. Conceptual artists were in direct opposition to producing another commodity for the art world that was disconnected from society, which led to dematerialization or complete absence of any object. However, without the object, Charlesworth began to think that conceptual art could not function wholly within the art system. She said, "Art as an idea was once a good idea, but art as idea as product, alas, moves in the world of commodity products" (Linker 75).

By the late 1970s she started working on her first series of objects, *Modern History* (1977–1979). She cut and saved newspaper clippings from around the world announcing specific events, such as the kidnapping of Italian Prime Minister Aldo Moro by the Red Brigade, the Pope's visit to Auschwitz, and photographs of a solar eclipse. Then, much like that of **Sherrie Levine,** who photographed the work of other photographers and called it her own, Charlesworth photographed the headlines and displayed them on the wall as art. With this work, she is commenting on the role that photography has played in the construction of historical record. Aligning with contemporary thought of the 1970s and 1980s, Charlesworth worked from the perspective that history is largely fiction as its meaning is dependent on individual interpretations and diverse viewpoints of events, which becomes falsely documented as one historical truth.

In 1983, she began by depict objects that are regularly portrayed as fetishes in mass media in *Objects of Desire*. Exploring the meaning of the codes that we use to signify sexuality and beauty, including gender identification and role models, was similar to that of artists such as **Laurie Simmons, Cindy Sherman,** and **Barbara Kruger.** Charlesworth wrote about the loaded implications that come with fashion:

> Codes of dress and body language carry with them complex and all too often oppressive standards or expectations of desirability or sexuality…a slinky evening gown, a leather jacket, a tentative bridal gown, and so on, all embody assumptions and values whose import extends beyond the language of dress to the underlying human attitudes and relations they bespeak. (Charlesworth 1995: 78)

In *Figures* (1983–1984), a large Cibrachrome print laminated with lacquer, Charlesworth presents a *diptych* of two photographs. The left side shows an elegant evening gown of silver satin formed to the shape of a woman's body against a black back drop, recalling

the glamorous shape of Marlene Dietrich in the Hollywood movie *Desire*. However, in Charlesworth's rendition her head and arms are removed, and she has been reduced to a sex object. The other side shows the female form lying on the ground and fully wrapped from head to foot in the same silver fabric. The figure lies against a red background, wrapped tightly, the shiny satin silhouettes her curvy shape, ending abruptly with feet and hands hog tied, a symbol of sadomasochism and sexual control. Both images represent a woman's sexuality and the objectification of women in mass media; Charlesworth explained that "the postures are the exterior trappings of identity" (Linker 78).

In *Text* (1992–1993) Charlesworth explored the relationship between seeing and looking. This black-and-white gelatin silver print portrays the soft outline of a book that is completely covered with thick white satin. The open book is hidden by the swath of fabric, but on closer inspection the words on the pages begin to reveal themselves. The process of looking shifts from an aesthetic experience to reading the words from a book. In this work

Sarah Charlesworth. *Text* (1991–1993). Gelatin silver print in lacquered wood frame, 31 × 21 inches. Courtesy of the artist.

it is evident that Charlesworth is still interested in the role of the conceptual art object and its power to convey meaning. She challenges the viewer to engage in a process of intellectual analysis to reach the very best that her work has to offer.

Charlesworth began teaching in 1985 when she was offered a position at New York University. For two years she was an instructor in advanced photography. In 1992, she went to work at the School of Visual Arts in New York City, where today she is a graduate faculty member in the masters program in photography and related media. She holds dual posts at the School of Visual Arts and at the Rhode Island School of Design, where she works with the graduate tutorial masters in photography program. In addition to her varied teaching appointments, Charlesworth has been invited to speak at academic and art institutions all over the country, including Bard College in New York, Princeton University in New Jersey, Columbia University in New York, Whitney Museum of American Art in New York City, and Light Work Gallery in Syracuse, New York.

The first major retrospective of her work opened in 1997 at SITE Santa Fe in New Mexico. Charlesworth has enjoyed the success of exhibition. Her work has been shown in galleries and museums all over the world, such as Margo Leavin Gallery in Los Angeles; Baldwin Gallery in Aspen, Colorado; Rena Branston Gallery in San Francisco; Tyler Gallery of Art at Temple University in Philadelphia; Zona in Florence, Italy; MTL Gallery in Brussels, Belgium; and the Metropolitan Museum of Art in New York City. As an art critic and historian, Charlesworth has published several articles in academic and art journals including *A.R.T. Press, October, Artforum, Art in America,* and *Bomb Magazine.* In 1995, she co-curated, along with artists Laurie Simmons and Cindy Sherman, the exhibition *Somatogenies* at the Artists Space in New York City. She has received several grants for her work including three from the National Endowment for the Arts in 1976, 1980, and in 1983.

Although regarded as one of the leading photographers in contemporary art, she explained her perspective on how she uses photography in her work:

> I don't think of myself as a photographer. I've engaged questions regarding photography's role in culture…but it is an engagement with a problem rather than a medium. The creative part of the work is just as much like painting or design as it is like photography. I'm not using a camera and it's not based on recording a given world but on creating or structuring a given world. (Charlesworth 1997: 43)

Today, she lives and works in New York City. Artist Sarah Charlesworth uses the camera as her primary tool to communicate socially conscious and feminist ideas about gender, mass media, history, society, and life.

Bibliography

Charlesworth, Sarah. *Sarah Charlesworth: A Retrospective,* ed. Janine Sieja Hagerman. Santa Fe, NM: Site Santa Fe, 1997.
———. "Objects of Desire." *Art Journal* 54 (Spring 1995): 78.

————. *Sarah Charlesworth: In Photography*. Buffalo, NY: CEPA Gallery, 1982.

————. *Sarah Charlesworth: 14 Days*. Brussels, Belgium: MTL Galerie, 1977.

Hoy, Anne. *Fabrications, Staged, Altered and Appropriated Photographs*. New York: Abbeville Press, 1989.

Linker, Kate. "Artifacts of Artifice." *Art in America* 86, no. 7 (1998): 74–79, 106.

Morgan, Anne. "Peering through History: An Interview with Sarah Charlesworth." *Art Papers* 22, no. 3 (May/June 1998): 18–21.

Unger, Miles. "Rose Art Museum/Waltham: Sarah Charlesworth: A Retrospective." *Art New England* 20, no. 6 (October/November 1999): 41.

Places to See Charlesworth's Work

Addison Galley of American Art, Phillips Academy, Andover, Massachusetts

Allen Memorial Art Museum, Oberlin College, Oberlin, Ohio

Art Gallery of Toronto, Toronto, Canada

Baldwin Gallery, Aspen, Colorado

Baruch College, New York, New York

Berkeley Museum of Art, University of California, Berkeley, California

Birmingham Museum of Art, Birmingham, Alabama

Cleveland Museum of Art, Cleveland, Ohio

High Museum of Art, Atlanta, Georgia

International Center of Photography, New York, New York

Israel Museum, Jerusalem, Israel

Los Angeles County Museum of Art, Los Angeles, California

Margo Leavin Gallery, Los Angeles, California

Montclair Museum, Montclair, New Jersey

Museum of Contemporary Art, Los Angeles, California

Museum of Contemporary Art, San Diego, California

Museum of Fine Arts, Boston, Massachusetts

Museum of Fine Arts, Santa Fe, New Mexico

Museum of Modern Art, New York, New York

National Museum for Women in the Arts, Washington, DC

New Britain Museum of American Art, New Britain, Connecticut

New York Public Library, New York, New York

Orlando Museum of Art, Orlando, Florida

Princeton University Museum, Princeton, New Jersey

Rose Art Museum, Brandeis University, Waltham, Massachusetts

Sarah Charlesworth Studio Web site: www.sarahcharlesworth.net

Sheldon Memorial Art Gallery, University if Nebraska, Lincoln, Nebraska

Smith College Art Museum, Northampton, Massachusetts

Smithsonian Institute, National Museum of American Art, Washington, DC

Stedelijk Van Abbemuseum, Eindhoven, Holland

Tang Museum, Saratoga Springs, New York

Vancouver Art Gallery, Vancouver, British Columbia, Canada

Victoria and Albert Museum, London, England

Walker Art Center, Minneapolis, Minnesota

Whitney Museum of American Art, New York, New York

Yale University Art Gallery, New Haven, Connecticut

WILLIAM CHRISTENBERRY

b. 1936

ALTHOUGH WILLIAM CHRISTENBERRY IS A PHOTOGRAPHER WHO IS CLOSELY associated with the South, and Alabama in particular, he prefers to be more broadly thought of as an artist, since he also paints and sculpts. He now lives in Washington, DC, and each year, along with his wife and children, he returns to the same sites in Alabama to photograph. His images reflect his love for the landscape and vernacular architecture of rural Alabama, as well as the terror and racism that is also a part of his white southern heritage.

Christenberry was born in Tuscaloosa, in a hospital close by the University of Alabama campus. Because his parents were young, poor, and starting a family during the Depression, they had to borrow money to pay the hospital bills. His father's parents lived on a farm in Steward, and his mother's family had a farm in Akron, not far away. Raised in Tuscaloosa, William spent summers in rural Hale County with his grandparents. He lived in his grandmother's during his senior year in high school, through his years in college, after his parents moved to Mobile. Working his way though college, he earned both his undergraduate and graduate degrees in art in 1958 and 1959 from the University of Alabama, where his focus was on painting. Like many painters studying art at the time, he approached the canvas with an eye toward abstract expressionism. He was the first member of his family to finish college, and at the age of 24, he was hired as an instructor to teach drawing at his alma mater. He began teaching at Memphis State University in 1962, where he met his wife, Sandra, who was from Michigan. In 1968, he moved to Washington, DC, to teach at the Corcoran School of Art. His paintings of the rural vernacular architecture of his beloved home state soon expanded into sculpture made from old pieces of wood, tin, and signs. Reflecting on the vast changes taking place as people moved from family farms to urban living, and race relations moved from segregation to integration, his work increasingly became as much about deep-seated historical issues as it was about formally composed works of art.

Hale County has many striking antebellum buildings and significant historical sites that have intrigued Christenberry over the span of his life. Although wealthy families live in this area, it has a history of being one of the poorest counties in the state. Because there were so many poor tenant farmers in Hale County, the area was full of inexpensive vernacular housing. Many of the families surrounding his family's farm had been included in the famous 1936 book *Let Us Now Praise Famous Men*, by James Agee with photographs by **Walker Evans.** Christenberry discovered the book when a second edition was published in 1960. While he began taking photographs of the Alabama landscape using a Brownie camera at age nine, and later took images for inspirational use for his landscape paintings, it was Evans that caused him to think about photography in a more serious way. He started shooting images of the same places that Evans had taken years before him and was motivated to take other photographs of Hale County and neighboring Perry County. In 1994, Christenberry remarked, "I guess somebody would say that I am literally obsessed with the landscape where I am from. I don't really object to that. It is so ingrained in me. It is who I am. The place makes you who you are, creates who you are" (Gruber, preface). His Alabama roots give him inspiration, and his 800-mile annual drive with his wife and children, to his ancestral family, inspires the art he makes in his Washington studio. He believes that by

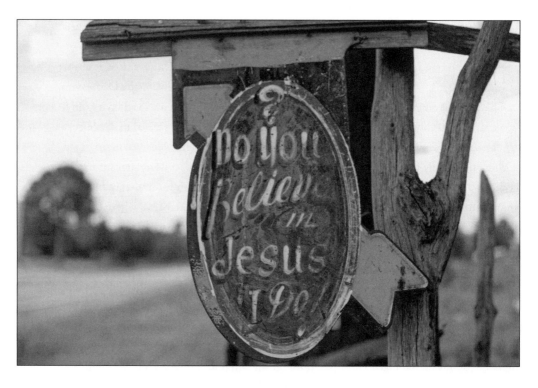

William Christenberry. *"Do You Believe in Jesus, I Do," Stephen Syke's Place, near Aberdeen, Mississippi* (1966). © William Christenberry. Courtesy Pace/MacGill Gallery, New York.

living in Washington, he has the necessary distance he needs to be able to see and reflect on Alabama's history and culture.

After teaching for a short time at the University of Alabama, Christenberry went to New York to find a job. He tried several things: working in a gallery, cleaning a church, and being a guard at the Museum of Modern Art, all uninspiring positions. Then he heard that Walker Evans was working at Time-Life and *Fortune* magazine, and he knew he had to meet him. Evans was immediately drawn to the young artist who had come from a place he had photographed so many years before. Walker Evans had come to Hale County to photograph the year Christenberry was born. With so much in common, in the two men became friends. In fact, it was Evans who encouraged Christenberry to return to the South to photograph.

Christenberry began making color photographs in 1960 using a simple Brownie camera. He claims that the small photographs he took as references for his paintings of the Alabama landscape "are probably among the most natural things I've done, for I did not think of them as art" (Johnson 274). In 1977, he started using an 8" × 10" camera to capture more detail.

The places where people are buried, especially his relatives, are places to which he is drawn. Each year he visits the Havana Methodist Church and the adjacent cemetery where his grandparents are buried. His grandfather, Daniel Keener (D.K.), was clearly the head of the family, and he was both respected and feared. Memories of his grandfather, along with other family memories, are repeated and passed down to his children. As is true in most families, there are both pleasant and difficult times that make up his family history. For Christenberry the hard times include the suicide of his Uncle Robert and the tragic death of his sister Danyle.

In 1990, the Amon Carter Museum, in partnership with the Friends of Photography, curated an exhibition titled *Of Time & Place: Walker Evans and William Christenberry*. The work of both artists was shown together, raising questions about how a place changes and stays the same. The similarities and differences in the two photographers' perspectives on the area, one coming from the outside, the other as a cultural insider, are also examined in this show. Both photographers focused on universal ideas that can be explored by focusing on narrowly defined places.

Sometimes Christenberry makes sculpture that is inspired by a photograph. Many of his buildings are constructed using cardboard and wood and placed on red Alabama dirt. His pleasing images of abandoned sheds, for example, can turn into sculptural pieces that communicate something violent and terrifying, as they suggest places where angry brutal acts could take place. Seen together, his work questions any nostalgic message that might be communicated about the South. William Christenberry's photographs not only document the South, and in particular his Alabama homeland, they communicate memories and raise issues about heritage and identity. His images also reflect on the changing Alabama landscape, the displacement of a rural way of life, and the violence and love in lives lived in a place that resonates to all who know it.

Bibliography

Broun, Elizabeth. "Foreword." *William Christenberry*. Foreword by Elizabeth Broun, essays by Walter Hopps, Andy Grundberg, and Howard N. Fox. New York: Aperture and Smithsonian American Art Museum, 2006, 14–17.

Enjeart, James. With Greg Glazner, Literary Editor; Arthur Ollman, Co-Curator; Lynda Rodolitz, Production Director. *Photographers, Writers, and the American Scene: Visions of Passage*. Santa Fe, NM: Arena Editions, 2002.

Gruber, J. Richard. *William Christenberry: The Early Years*. Tuscaloosa, AL: University of Alabama Press, 1996.

Grundberg, Andy. "Orders of Memory: Photography in the Art of William Christenberry." *William Christenberry*. Foreword by Elizabeth Broun, essays by Walter Hopps, Andy Grundberg, and Howard N. Fox. New York: Aperture and Smithsonian American Art Museum, 2006, 178–187.

Johnson, Brooks. *Photography Speaks: 150 Photographers on Their Art*. New York: Aperture, 2004.

Seidel, Miriam. "William Christenberry at the Pennsylvania Academy and the Fabric Workshop." *Art in America* 12 (December 1997): 100–101.

Southwell, Thomas W. *Of Time & Place: Walker Evans and William Christenberry*. San Francisco: The Friends of Photography and the Amon Carter Museum, Fort Worth, in Association with the University of New Mexico Press, Albuquerque, 1990.

Stack, Trudy Wilner. Essays by Allen Tullos and Trudy Wilner Stack. *Christenberry Reconstruction: The Art of William Christenberry*. Jackson: University Press of Mississippi and the Center for Creative Photography, The University of Arizona, 1996.

Weil, Rex. "William Christenberry." *Artnews* 94, no. 4 (1995): 151.

Places to See Christenberry's Work

Columbus Museum, Columbus, Georgia
Corcoran Gallery of Art, Washington, DC
High Museum, Atlanta, Georgia
Kemper Museum of Contemporary Art, Kansas City, Missouri
Library of Congress, Washington, DC
Mobile Museum of Art, Mobile, Alabama
Montgomery Museum of Fine Arts, Montgomery, Alabama
Museum of Contemporary Photography, Columbia College, Chicago, Illinois
Museum of Modern Art, New York, New York
Phillips Collection, Washington, DC
Smithsonian American Art Museum, Washington, DC

BILL COLEMAN

b. 1925

WHEN BILL COLEMAN CALLED TO TALK TO ME ABOUT HIS LIFE AND WORK, he proclaimed, "My life is simple and can be summed up in one sentence" (interview with artist). This may be wishful thinking on his part, as Coleman has lived a full life, traveling the world, working as a freelance photographer for the better half of a century, and heralded for photographing the elusive Amish people. Perhaps his desire for simplicity is what drew him to the Amish in the first place.

Born in Hartford, Connecticut, in 1925, he attended Pennsylvania State College and then studied photography at the Rochester Institute of Technology. Coleman says that he really did not learn much about photography in the classroom. Rather, it was during a trip to Italy where he spent hours perusing the art museums that he first became inspired to create. He explained that this feeling got into his subconscious, and it is this same inspiration that continues to motivate him. However, he does not regard himself as an artist. Although he works to make artful images, he says that photography is reflective of what is already out there. To him real art—the kind found in the best art museums—is painting and sculpture, not photography.

In the early days of his career, Coleman set up a commercial photography studio. For years he photographed the sorority girls at Pennsylvania State among other freelance contracts. Coleman enjoyed a moderate success in the commercial industry until the age of 50. Coleman could not have guessed the turn of events one afternoon while driving through the country-side of Pennsylvania. He found himself behind a slow buggy with a broken wheel, and he stopped and offered assistance. He met the buggy driver, an Old Order Amish man, who invited Coleman to his village. Coleman accepted this rare invitation and went to the village on several occasions to see the man and his family, always bringing with him a tub of ice cream.

After earning the trust of this family and eventually the entire village, Coleman began to photograph this tiny community of people who have built their lives around rejecting such

technology. After becoming aware of the sensitivity they felt toward the camera and being photographed, Coleman restricted his work to photographing the scenery, barns, homes, animals, and with permission, the children. An average photo shoot turned into an obsession, lasting more than 30 years. Indeed a worthy historical document has been created. To this day he maintains the secrecy of the village.

Coleman said that when he goes into the Amish village, he tries to take with him as little as possible from our plastic world into their pristine and innocent life. He is enraptured with the way that they live and the grand rewards that they experience in their simple acts of living. They are completely self-sufficient without need or want of a world driven by technology. He explained, "By presenting the lives of the Amish in my photography, I am trying to bring back with me a part of their honest and refreshing approach to living" (interview with artist).

His oeuvre of Amish images is expansive and organized by series such as animals, barn raising, children, buggies, cemetery, quilts, and the natural landscape. In *Ladies in Waiting* from the series of *Laundry Lines*, four dresses are neatly hung to dry in the sunshine. The simple dresses are dyed brilliant blue, green, purple, and red; the colors are illuminated

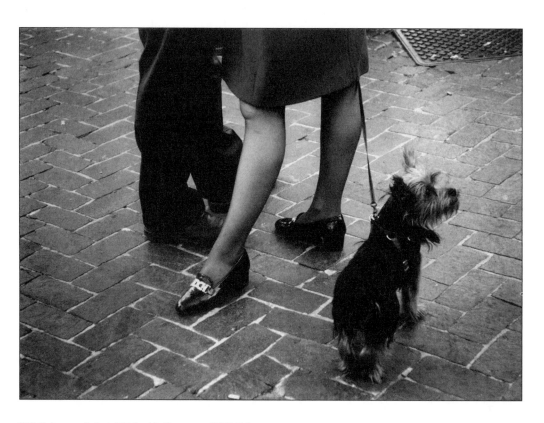

Bill Coleman. *Italy # 329* (n.d.). Courtesy of Bill Coleman.

by the sun filtering through the fabric. The vibrant colors show that they wear more than the standard black-and-white garments that they are generally depicted wearing in movies and mass media. In *Henry with Friends* from the series of *Children with Pets*, a young boy brushes his pony while his dog and small cat look on; this barefooted boy could be any farm kid hanging out with his pets.

His work has been recognized for its beauty and for capturing the secret lives of a pre-industrial culture living among us. Indeed he has produced the largest body of work documenting the Amish culture in the United States ever, and as such, it is a noteworthy record. Editorials have been written about Coleman in *Reader's Digest* and *Country Living*. The Hasbro Toy Company purchased the rights to his Amish imagery for puzzles that were a financial success.

Coleman was not initially aware of the widespread attention that his work was receiving. When I asked Coleman about awards and honors that he may have received, he said, "I don't go for that stuff, I just do my work" (interview with artist). He told me a story about his artwork being stolen from a bathroom wall in a restaurant in New York. The restaurant bought another copy, and now it is bolted to the wall. He told me this story with a chuckle and that this was a moment he felt the increased popularity in his work. However much he may shy away from the spotlight, his work has been noticed.

One day he received a phone call from a man who identified himself as Robert Redford. Coleman assumed that he was one of his friends playing a joke, and he hung up the phone without intention of returning the call. A few days later Redford called back and to Coleman's astonishment was interested in hiring him for a photo shoot. Redford was working on the film *A River Runs Through It* (1992), and he wanted Coleman to take the publicity shots. Coleman was hesitant since he was not accustomed to working in the Hollywood film industry. Redford told him to fly out and shoot the set just as he did with the Amish. Coleman agreed and was flown out with his assistants to Sundance, where he spent several days taking pictures on location for the movie's publicity campaign. He said that this was a great experience, commenting that Redford was a genuine and friendly person who showed generosity of spirit and who grossly overpaid him.

Forever impressed with his first visit to Italy, Coleman returned to photograph the landscape of the architecture, culture, and people. Although he primarily shoots in color and only occasionally in black and white, he did choose black and white to portray a vibrantly colorful country and culture. In his vivid compositions of the country, the vibrant qualities of the culture still shine through. In *Como-Street Scene* people gather round to watch a street artist; pedestrians, young and old, some casual and visiting with friends while others walk on by. In another image from the series, a man floats down the canal on his gondola, surrounded by the tall ancient architecture—a classic Italian scene.

Today, Bill Coleman continues to photograph the Amish, where he spends the majority of his time; otherwise, he is in the studio dark room. He can also be found at art shows such

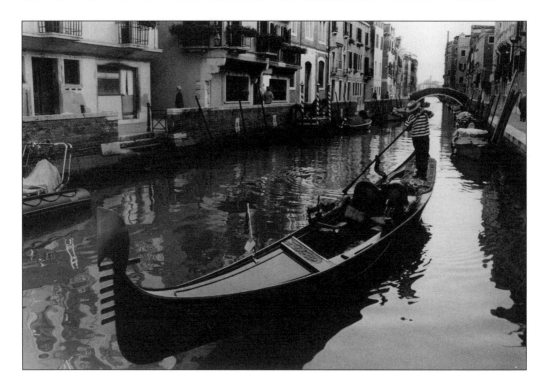

Bill Coleman. *Italy #364* (n.d.). Courtesy of Bill Coleman.

as the prestigious Coconut Grove Annual Arts Festival in South Florida, the Paradise City Arts Festival in Marlborough, Massachusetts and in Philadelphia, Pennsylvania; and the Ann Arbor Summer Art Fair in Ann Arbor, Michigan. He has had two marriages and one child from each marriage. Now he says that he is married to his work; he lives and breathes photography. Bill Coleman's relationship with his work and with the Amish has resulted in an impressive document that is both artistically stunning and historically significant.

Bibliography

Coleman, Bill. *The Gift of Friendship*. Portland, Maine: Ronnie Sellers Productions, 2005.
———. *The Gift to be Simple: Life in Amish Country*. San Francisco: Chronicle Books, 2001.
Hallmark, Kara. Interview with the artist.

Places to See Coleman's Work

Bill Coleman's Web site about his work with the Amish: www.amishphoto.com
Bill Coleman's Web site about his work in Italy: www.billcolemanphoto.com

RENEE COX

b. 1960

ONE OF THE MOST CONTROVERSIAL PHOTOGRAPHERS WORKING TODAY,
Renee Cox photographs her own body as a celebration of being black and female. Bold
in the way she poses herself, her work has been highly debated ever since she exhibited
her 1993 photograph *Mother and Child*. Cox's large-scale color images confront, question,
and reinvent the roles society has given to black women.

Born an only child to an upper middle-class family in Colgate, Jamaica, the family moved
to Scarsdale, New York, when she was a child, Her mother was a social worker, and her
father was an insurance executive. She went to a private Roman Catholic school in Queens
and attended high school in Scarsdale. She studied at Syracuse University and then had a
career in commercial photography. In 1992, Cox graduated from the School of Visual Arts
in New York with an MFA.

In 1994, Marcia Tucker at the New Museum of Contemporary Art in New York City or-
ganized an exhibition that both delighted and jarred the art world. *Bad Girls* displayed the
work of artists who were dealing with feminist issues in "new and refreshing ways" (Tucker 4).
The term, which was appropriated from black English, was meant to mean "good." The work
in this exhibition was aimed at challenging the status quo in outrageous ways. In Cox's
Mother and Child (1993), she presents her strong nude body while holding her toddler son.
Wearing dreadlocks and high heels, her look is defiant. Her well-lighted son is held in a hor-
izontal position like a battle shield, contracting both Cox's stance and the black background
of the picture. In this image Cox has found agency in herself and her own experience. Oth-
ers do not define her. Like many black feminist women, Cox uses her power to reinvent
what it means to be a black woman while she challenges cultural stereotypes. This work was
widely circulated in art and non-art magazines. It became a 1990s icon of a strong woman,
and it helped redefine motherhood. Painter Chuck Close was so taken with the image that
he made a photo portrait from it.

Renee Cox. *Mother and Child*
(1993). Gelatin silver print.
© Renee Cox. Courtesy Robert
Miller Gallery, New York.

In *Chillin with Liberty* (1998), a 60" × 48" ektachrome print, Cox, dressed as a superwoman action figure, places herself on top of the Statue of Liberty. Slick shiny black boots with spiked heels define her shapely legs as she is framed by a purple night sky. Dressed in a body-hugging leotard in red, green, black, and yellow, this Cox superhero is named Rajé, who comes with a matching doll. She is sexy and strong. Rajé's quest is to fight for all people who are oppressed by dismantling the patriarchal world order. In explanation she writes, "My work addresses issues of race and gender, and particularly of power and sublimination. Calling attention to the constraints of classification imposed by Western patriarchal constructs, my images demand enlightenment though an equitable realignment of our race and gender politics" ("The Photographers" 85). In another photograph Rajé is shown liberating Aunt Jemima and Uncle Tom, who are imprisoned as mascots on boxes of pancake mix and brown rice.

Cox also addresses what she calls "the bisexual duality of the human psyche" ("The Photographers" 85). She deals with this issue head on in perhaps her most controversial and

ambitious work, *Yo Mama's Last Supper* (1996), modeled after Leonardo da Vinci's famous painting of the Last Supper. Five panels long, this work became the subject of a hot debate when it was exhibited at the Brooklyn Museum of Art. Cox was once again center stage in the public's eye. In her bold and brazen style, a nude Cox took the place of Jesus Christ. All the disciples surrounding her were black with the exception of Judas, who is white. Many people were shocked and outraged, especially Roman Catholics. Mayor Rudolph Giuliani called this work obscene and asked for a commission to be set up to establish "decency standards" that would keep such a work from being shown in any New York museum that received public funding. Cox responded claiming to have a right to interpret the Last Supper, just as da Vinci had done before her. With this photograph she positioned herself in a debate that has roots in seminaries around the world. She asks what place women (and in her case black women and men) have in religion and how the story (this particular story as well as the story of the history of black men and women) might be told differently, in a more inclusive manner. By taking on the role of Jesus, she has positioned herself as divine and powerful, a role not often represented by a female of any color. This was not the first time she changed the image of Jesus. In 1994, at the Whitney Museum's exhibition titled *Black Male*, in her work *It Shall be Named*, she presented a multi-panel photograph of Jesus as a black man.

Her more recent work from the turn of the century strikes more directly at the origins of racial and sexual stereotypes. Viewers are once again confronted with her nude, muscular body in her series titled *American Family*. Some images in this series juxtapose photographs from Cox's family albums with sexually charged pictures of the artist. For example, one pair of images places Cox in skimpy tight clothes that readily expose her body next to a 1960s photograph of a woman in a modest bathing suit. Part of this series includes work that recreates the art cannon's masterworks. They include Manet's *Olympia* and *Dejeuner sur l'Herbe*, and Ingres's *La Grand Odalisque*. In these large images, along with friends and family members, she confronts viewers in ways that disrupt the original works. For example, in Cox's response to Manet's *Dejeuner sur l'Herbe*, she replaces Manet's fully dressed white men with meagerly dressed black men.

Renee Cox uses humor, pop culture, and a burlesque approach to critically challenge and change representations of race and gender. In doing so she has been both scorned and praised. She insists that her work is aimed at communicating the need for black women to be resilient, to preserve, and to sustain power to change the future.

Cox has been awarded fellowships by the New York Foundation for the Arts and the Mc-Dowell Colony. She has had exhibitions in various prestigious places including the Whitney Museum of Art in New York and the *Venice Biennale*.

Bibliography

Bryant, Linda Goode. "'All That She Wants': Transgressions, Appropriations, and Art." *Bad Girls*. New York: New Museum of Contemporary Art and Cambridge, MA: MIT Press, 1994, 96–108.

Cembalest, Robin. "Thank You, Mr. Mayor." *Artnews* 100, no. 4 (2001): 59.

"Renee Cox." Retrieved on January 7, 2007, from http://www.reneecox.net/bio.html.

"Renee Cox—Artist, Art." Retrieved on October 26, 2006, from AskART: The American Artists Bluebook at http://www.askart.com/AskART/artists/search/Search_Grid.aspx?searchtype= PERIODICAL&artists=115482.

"The Photographers: Renee Cox." In *Committed to the Image: Contemporary Black Photographers*, ed. Barbara Head Millstein, with essays by Clyde Taylor and Deba P. Patnaik. New York: Brooklyn Museum of Art, 84–85.

Schambelan, Elizabeth. "Renee Cox at Robert Miller." *Art in America* 6 (2002): 128.

Tucker, Marcia. "Introduction and Acknowledgments." *Bad Girls*. New York: New Museum of Contemporary Art and Cambridge, MA: MIT Press, 1994, 4–9.

Places to See Cox's Work

Arizona State University Art Museum, Tempe, Arizona

Hood Museum of Art, Dartmouth College, Hanover, New Hampshire

GREGORY CREWDSON

b. 1962

GREGORY CREWDSON WORKS WITH LARGE FILM CREWS TO PRODUCE A single photograph. Known for his ability to evoke narrative from an image and his talent for impeccable lighting, he has created a new way of making photos that are grand in both scale and production process. Creating discomfort and mischief in his scenes, he quickly and effectively triggers viewers' imaginations. The sets are so complex and well thought out that messages that form the story can come from many aspects of the photograph. In a way what Crewdson does is compress an entire film or soap opera into a single image. A man with tremendous energy, he is also a teacher and an exhibition curator.

The oldest of three children, Crewdson was born and raised in Brooklyn, New York, to a family who regularly participated in cultural activities. His mother was a dancer, and his father was a psychoanalyst who sparked his interest in the workings of the mind. As a young boy, Crewdson tried to listen to the conversations his father was having with patients, often catching bits and pieces of the communication. The mystery and storytelling involved in his father's work, which often focused on Freudian analysis, piqued his curiosity. He remembers with clarity the day his father took him to see an exhibition by **Diane Arbus** at the Museum of Modern Art. At the age of 12, these psychologically complex images made a strong impression. Still, he didn't start to explore photography until he was in college at the State University of New York at Purchase, where he studied with **Jan Groover** and **Laurie Simmons.** After finishing his BA in 1985, he went to Yale graduate School of Art, where he recognized that "everything changed in contemporary art with **Cindy Sherman**" (Kazanjian 273). Crewdson's work elaborates on Sherman's 1970s series of staged images that referenced film stills, while casting herself in the role of the star.

Crewdson graduated from Yale in 1988 and began teaching there in 1994. He met and married a fellow art student when he was in college, but the marriage only lasted six years. In his role as a Yale professor, he has helped inspire a new generation of artist-photographers.

He is now in his second marriage to gallery director Ivy Shapiro, who is also the daughter of well-known sculptor Joel Shapiro.

Inspired by film, museum dioramas, and short stories (especially those written by John Cheever), Crewdson believes that photography can establish an entire world. He likes the idea that popular films have the power to speak to anyone, which is a goal Crewdson has for his photographs. Since he grew up in New York City, the suburbs also inspire him, partly because they seem so foreign and alien.

After college he began spending time in Lee, Massachusetts, where his parents have property. Obsessed by the film *Close Encounters of the Third Kind*, he began building dirt mounds, first outside, then inside, and photographing them. He started adding things like birds' eggs, grass, trees, and eventually casts of his own body parts that were invaded by vines. The result was his series titled *Natural Wonder*.

Crewdson's role in making these time-consuming photographs is not necessarily as the person behind the camera shooting the picture. Instead, he may stand by while his "cinematographer," Rick Sands or Dan Karp snaps the shot. But it is Crewdson who works for weeks to design and direct the creation of each image. In his untitled photograph that mimics *Ophelia* by the nineteenth century British painter Sir John Everett Millais, where a

Gregory Crewdson. *Untitled (Trouble with Harry's)* (Summer 2004). Digital C-print, 64¼ × 94¼ inches (163.2 × 239.4 cm). Courtesy of the artist and the Luhring Augustine Gallery, New York.

woman is floating in a flooded living room, he plans and helps construct the scene, selects the model, and works with a lighting designer. This photograph is part of the *Twilight* series that plays with ideas about suburbia. In these photographs Crewdson examines the paradoxical beauty and sadness of everyday life. The places where his stage sets are constructed vary. The flooded living room was constructed at Mass MoCa museum in North Adams, Massachusetts. Given the elaborateness of the scenes, what Crewdson does as a photographer is more like what Steven Spielberg does as a filmmaker than, for instance, what **Ansel Adams** did in his role as a photographer.

Most of the pictures in the *Twilight* series from the late 1990s were taken outdoors in western Massachusetts, just between dusk and dark. In these images suburbia has gone mad. Dazed residents become obsessed with dirt and what might be underneath it, or they are searching for something in the sky. No one seems happy. In taking these photographs the timing is important. Crewdson explains, "Twilight is this magic hour between day and night, when ambient and artificial light come together. It's a time of transcendence when extraordinary things happen" (Hirsch 199). As with all his photographs, the narrative is ambiguous and open to varying interpretations.

In 2005, Crewdson exhibited 20 untitled large-scale digital C-prints under the title *Beneath the Roses*. The first image depicts a panoramic view of a deserted street in a small town. A car is positioned at an intersection with the driver's door left open. A blonde-haired woman sits in the passenger seat with a dazed look on her face. The streetlights, shop windows, and car headlights help create a mood that effectively communicates that something horrible has happened in a town that should be safe and predictable. Other images echo this idea. A woman sits at the edge of her bed that is littered with an uprooted rose bush that apparently was dragged into her house and slapped onto the pillows. An older man, bent with age and dressed in a raincoat, looks into a liquor store window that has closed on a rainy night. These works come across as more pessimistic and less playful than his earlier works.

Most of Crewdson's ideas come from some kind of need to play with a visual idea that keeps appearing in his mind. Certain themes or motifs continuously appear in his work, like the school bus, a pregnant woman, butterflies, and flowers. In all his pictures Crewdson aims to create a psychological encounter in what otherwise would appear to be an everyday scene. Something is always disturbingly out of place.

While Crewdson is famous for being a photographer, he also has a musical background. In 1979, together with Eric Hoffer, his best friend from high school, he formed Speedie, a five-piece band. It was Crewdson who conjured up the song "Let Me Take Your Foto" more than 25 years ago. In 2005, this same song was revived and used as an advertising theme for Hewlett-Packard's PhotoSmart 475 GoGo Photo Printer. His influence crosses other boundaries. For example, he took the photographs for the ads that promoted the HBO hit series "Six Feet Under."

Gregory Crewdson takes an ordinary situation and projects his own anxiety or desire onto the scene. Each photograph contains psychological tension, an aspect of voyeurism, and sensual color and light. Evoking dreamlike characteristics, his mysterious images include floating women, flowerbeds growing inside homes, holes in hardwood floors that beam out light like flashlights, a pile of flowers stacked high on a suburban street, and a flowered stalk seen outside a window that compels a man in his underwear to begin the climb. Crewdson's photographs are puzzles that invite storytelling. In this way viewers work with the artist to finish a narrative that Crewdson began.

Bibliography

Frankel, David. "Gregory Crewdson." *Artforum* 38, no. 10 (2002): 182.

Hirsch, Robert. *Exploring Color Photography: From the Darkroom to the Digital Studio*, 4th ed. New York: McGraw-Hill, 2005.

Kazanjian, Dodie. "Twilight Zone." *Vogue* (May 2002): 268–273, 299–300.

Moody, Rick. "On Gregory Crewdson." In *Twilight: Photographs by Gregory Crewdson.* New York: Harry N. Abrams, 2002, 6–12.

Smith, Roberta. "Gregory Crewdson: 'Beneath the Roses.'" *New York Times*, June 3, 2005: E36.

Wilton, Kristine. "Gregory Crewdson." *Artnews* 104, no. 8 (2005): 129.

Yablonsky, Linda. "A Photographer's Pop Star Moment." *New York Times*, September 11, 2005: AR8.

Zalewski, Daniel. "The Ultimate Film Still." *New York Times Magazine*, March 25, 2001: 51–53.

Places to See Crewdson's Work

Brooklyn Museum of Art, Brooklyn, New York
Contemporary Museum, Honolulu, Hawaii
Detroit Institute of Art, Detroit, Michicgan
Guggenheim Museum, New York, New York
International Center for Photography, New York, New York
Los Angeles County Museum of Art, Los Angeles, California
Metropolitan Museum of Art, New York, New York
Museum of Fine Arts, Boston, Massachusetts
Museum of Modern Art, New York, New York
Orlando Museum of Art, Orlando, Florida
Princeton University Art Museum, Princeton, New Jersey
St. Louis Art Museum, St. Louis, Missouri
San Francisco Museum of Modern Art, San Francisco, California
Whitney Museum of Art, New York, New York

IMOGEN CUNNINGHAM

1883–1976

DIVERSE IN TECHNIQUE AND MULTI-FACETED IN SUBJECT MATTER, IMOGEN Cunningham is considered to be one of the most prominent photographers of the twentieth century. She was born in Portland, Oregon, on April 12, 1883. Her father, Isaac Burns Cunningham, named her after one of Shakespeare's heroines. Isaac, who was a freethinker, avid reader, spiritualist, and a vegetarian, was very influential in Cunningham's life as an artist. He encouraged his young daughter to learn to read before she became school age. Despite economic hardship that came along with a family of 10, Isaac enrolled her in art classes every summer and on weekends during the school year. Due to lapses in her father's employment, the family did not have a permanent residence in the early years, which left gaps in her formal education. Eventually, the family settled near Seattle, and she could attend school regularly. After she graduated from Broadway High School in Seattle, Cunningham wanted to continue her education. Since there was no financial support for higher education, and she was unwilling to accept the traditional homemaker and wife position that her mother had chosen, she set about making plans to finance her own education.

Cunningham was 20 years old when she enrolled at the University of Washington in Seattle in 1903. Already enchanted with photography and the work of artists Gertrude Käsebier and **Alfred Stieglitz,** she sought academic advice when art and photography classes did not exist at the university. She was instructed to register as a science major if she wanted to be a photographer, as this was considered more of a technical profession than one of the arts. Cunningham studied chemistry and worked in the department as a secretary making slides for botany lectures, foreshadowing her later work photographing plant life. In 1905, she purchased a mail order camera and began taking self-portraits. Always a staunch supporter of Cunningham's artistic pursuits, her father built a makeshift darkroom in a woodshed by sealing the cracks with paper and putting a candle inside a red box for the light source.

Along with her chemistry assignments, Cunningham studied photography diligently and chose for her graduating thesis topic "Modern Processes of Photography."

In 1907, Cunningham graduated from the University of Washington. Directly after graduation she took a job working for the **Edward S. Curtis** studio. While working at the Curtis studio with photographer A. F. Muhr, she learned platinum printing techniques, which became a point of departure for her next project. In 1909, she traveled to Germany on a grant from her college sorority, Pi Beta Phi. There she studied chemistry in Dresden and completed a paper on the economic benefits of printing on hand-coated paper for platinum prints rather than commercial papers.

She left Europe in 1910. En route back to Seattle, she stopped in New York City for several days. There she visited Alfred Stieglitz's 291 Gallery, at the time considered to be the most prominent source for avant-garde art. Cunningham was well acquainted with the gallery and its publication, *Camera Work*, which would later publish her photographs. She had the occasion to meet Stieglitz for which she remarked, "Of course I was greatly impressed and rather afraid of him. I felt Stieglitz was sharp but not chummy" (Lorenz, 1993: 15). She was impressed and influenced by photographs taken by many of the Gallery 291 artists,

Imogen Cunningham. *Alfred Stieglitz, Photographer* (1934). Silver gelatin print, 9½ × 7⁹/₁₆ inches (24.1 × 19.2 cm). Purchased with funds provided by the National Endowment for the Arts. Courtesy of Worcester Art Museum, Worcester, Massachusetts. Photograph by Imogen Cunningham © The Imogen Cunningham Trust.

including **Edward Steichen** and **Anne Brigman.** Although the leading edge photography scene was indeed in New York City, she did not consider living there primarily for financial reasons and made her way home to the West Coast.

Once back in Seattle she opened a successful *pictorialist* portrait studio, which she operated for seven years. These pictorialist portraits were slightly out of focus and often staged to evoke romanticism. She transformed a small cottage where patrons came to sit for their portrait and may have the occasion to share a cup of tea with Cunningham in a space that resembled a comfy living room. However, she also took many portraits in situ and traveled to patron's homes with her straw basket full of equipment in tow. During these years in Seattle, she became known as the only photographer in town who created pictorialist portraits. In addition to commissioned portrait jobs, Cunningham experimented after hours by dressing her friends in costumes and posing them in melodramatic scenes.

Cunningham grew up with a keen sense about traditional women's roles and questioned why women were not equal partners in society. She was a strong voice for women's equality during the *first wave feminist movement*, which predated women's right to vote. In 1913, she wrote an article entitled "Photography as a Profession for Women." In this essay she urged women to consider the craft and to seek careers for themselves. She wrote, "Why women for so many years should have been supposed to be fitted only to the arts and industries of the home is hard to understand" (Lorenz, 1993: 16). Yet she does submit to this traditional life for a little while.

Cunningham was introduced to etcher Roi Partridge through friends John Butler and Clare Shepard. After several months of intimate correspondence and swapping etchings and photographs, Partridge fell madly in love with Cunningham and insisted that she come to Europe to marry him. She married Partridge in 1915, and the couple moved to Seattle where he set up an etching room adjacent to her photography studio. After the birth of their first son that same year, Cunningham primarily stayed home but continued to photograph in every spare moment. They had twin boys two years later, which further committed her to being home with the children for several years. In 1917, Partridge accepted a teaching job at Mills College, and they moved to San Francisco.

For several years she did not have a darkroom and had to send her film out for developing. Despite the limitations that she faced without a studio and the time required for her domestic obligations, she continued to work voraciously. She shifted her focus to what was immediately around her, photographing her young sons and Partridge. She took an interest in the plants and flowers from her garden, which inspired her first sharp focused images, a significant departure from her previous dreamlike soft images. Her interest in photographing flora and foliage from the garden increased. From 1923 to 1925 she photographed the *Magnolia Flower Series*, which became some of her most popular work. Some of these images are spontaneous moments in nature, and others are deliberately manipulated to create a composition of exact shape, line, and form.

Cunningham explored the boundaries within photography throughout her career. She is well known for her experimentation with double exposure. One of her first works with double exposure was taken of her mother in 1923. This photograph shows her mother tending to domestic duties, while the second image of a crown of spoons rests on top of her head. Cunningham was direct about her disdain for the household work required of women and often wondered why her mother submitted to this role so willingly. Cunningham shows her mother crowned as if royalty; she is queen of the home as the spoons symbolize domestic life.

She often portrayed people in the act of their daily lives or professions. By the late 1920s she was commissioned to photograph visiting artists, musicians, and performers at Mills College where Partridge was still teaching. She wanted to show the artist's craft in the portrait; for instance, in *Hand of Gerald Warburg* (1929), the frame is a close-up of his hand playing the cello. In *Three Harps* (1935) she used double exposure to create three images of the same harp one overlapping the next, evoking a sense of rhythm.

In 1932, Cunningham co-founded the California art movement known as f64, which supported straight photography and the pursuit of capturing images in their purest form with technical proficiency. **Ansel Adams** and **Edward Weston** were also involved in the formation of the group. Cunningham's involvement with the group did not distract her from

Imogen Cunningham. *Man Ray, Photographer, Paris* (1960). Silver gelatin print, 7⅞ × 7 inches (20 × 17.8 cm). Purchased with funds provided by the National Endowment for the Arts. Courtesy of Worcester Art Museum, Worcester, Massachusetts. Photograph by Imogen Cunningham © The Imogen Cunningham Trust.

other projects or photographic methods. In 1934, Cunningham was invited by *Vanity Fair* magazine to come to New York City on assignment. During her stay she visited Alfred Stieglitz at his new gallery, An American Place. This time he was well aware of her work and reputation and agreed to let her photograph him. She was in New York City for one month during which time she photographed the city streets and neighborhoods. She then traveled to Washington, DC, where she visited several museums and was particularly affected by an Asian art exhibition at the Freer Art Gallery. Upon her return to Oakland, she and Partridge divorced. Although they were no longer able to be married, they remained friends, and Cunningham became married to her work for the rest of her life.

During World War II photographic supplies were limited and patrons scarce. Cunningham photographed service men and rented out her house to make ends meet. Just after the war she sold her house and moved to San Francisco. She was asked to teach at the newly formed photography department at the California School of Fine Arts. From 1947 to 1950, under the Chair Ansel Adams, Cunningham was an instructor along with Edward Weston, **Minor White,** and **Dorothea Lange.** Although she was not entirely comfortable with teaching as a profession, students often came to her home for further instruction and advice. She continued to work throughout her life, challenging herself with new techniques and seeking fresh subject matter from street performers and passersby to friends and colleagues. She photographed children playing on the street and political material, such as politicians and protests during the Civil Rights Movement. Continually evolving as an artist, Cunningham also worked with color photography and even spent time using a Polaroid camera.

During the 1950s she received renewed recognition from the New York City art world when her friend photographer Lisette Model helped get her an exhibition at The Museum of Modern Art. Her work has been exhibited in venues around the world, including the Film and Foto Exhibition in Stuttgart, Germany; Berkeley Art Museum; M. H. De Young Memorial Museum in San Francisco; the Los Angeles County Museum; and the Dallas Museum of Art, among many others. She had a vast and prolific career marked by an expansive oeuvre, publications, exhibitions, and several honors and awards including Artist of the Year 1973 by the San Francisco Art Commission.

In 1975, Cunningham established The Imogen Cunningham Trust to maintain, exhibit, and promote her work after her death. She died in San Francisco on June 23, 1976. Cunningham was a scholar of photography, as well as an artist, in perpetual search of challenging the medium. With a career that spanned more than 70 years, Imogen Cunningham was one of the most important photographers of the twentieth century.

Bibliography

Cullum, Jerry. "Branching out." *Artnews* 99, no. 11 (2000): 106–110.

Cunningham, Imogen. *Imogen Cunningham: Photographs* [Introduction by Margery Mann]. Seattle and London: University of Washington Press, 1970.

Dater, Judy. *Imogen Cunningham: A Portrait.* New York: New York Graphic Society, 1979.

Imogen Cunningham Trust. *Chronology.* Retrieved December 19, 2006, from http://www.imogen cunningham.com/CHRONOLOGY/content_chronology.html.

Lahs-Gonzales, Olivia, Lucy Lippard, and Martha A. Sandweiss. *Defining Eye: Women Photographers of the 20th Century.* St. Louis, MO: St. Louis Art Museum, 1997.

Ledes, Allison Eckardt. "Capturing Light: Masterpieces of California Photography, 1850–2000 at the Oakland Museum." *The Magazine Antiques (1971)* 159, no. 3 (2001): 384–386.

Lorenz, Richard. *Imogen Cunningham: Ideas without End, A Life in Photographs.* San Francisco: Chronicle Books, 1993.

————. *Imogen Cunningham: Flora.* Boston: Little Brown, 1996.

————. *Imogen Cunninhgam: Portraiture.* Boston: Little Brown, 1997.

————. *Imogen Cunningham: On the Body.* Boston: Little Brown, 1998.

Muchnic, Suzanne. "Galka Scheyer and the Avant-Garde: Norton Simon Museum." *Artnews* 102, no. 9 (2003): 133.

"Masters of Light: Landesgewerbe Amt, Stuttgart." *Artnews* 90, no. 4 (1991): 125–129.

Rule, Amy, Ed. *Imogen Cunningham: Selected Texts and Bibliography.* Boston: G.K. Hall, 1993.

"Shear Energy: Imogen Cunningham has Fun with Her Photographer." *Artnews* 101, no. 7 (2002): 200.

Simpson, Pamela H. "Imogen Cunningham." *Woman's Art Journal* 18, no. 1 (1997): 66–67.

Places to See Cunningham's Work

Amon Carter Museum, Fort Worth, Texas

Ansel Adams Gallery, Yosemite Park and Monterrey, California

Art Institute of Chicago, Chicago, Illinois

Center for Creative Photography, University of Arizona, Tucson, Arizona

Cincinnati Art Museum, Cincinnati, Ohio

Dallas Museum of Art, Dallas, Texas

Detroit Institute of Arts, Detroit, Michigan

Fine Arts Museums of San Francisco, California: *Magnolia Blossom* (ca. 1925)

Fred Jones Jr. Museum of Art at the University of Oklahoma, Norman, Oklahoma: *Laura Anderson* (no date); *Morris Graves, Painter* (1950)

Gunwald Center for the Graphic Arts, University of California, Los Angeles, California

Hallmark Cards, Kansas City, Missouri

Harvard University Art Museums, Cambridge, Massachusetts

Henry Art Gallery, University of Washington, Seattle, Washington

High Museum of Art, Atlanta, Georgia

Hofstra Museum at Hofstra University, Hempstead, New York

Imogen Cunningham Web site: www.imogencunningham.com

International Museum of Photography at the George Eastman House, Rochester, New York

J. Paul Getty Museum, Santa Monica, California

Kalamazoo Institute of Arts, Kalamazoo, Missouri

Los Angeles County Museum of Art, Los Angeles, California

Mills College Art Gallery, Oakland, California

Minneapolis Institute of Arts, Minneapolis, Minnesota

Museum of Contemporary Art, Chicago, Illinois

Museum of Fine Arts, Boston, Massachusetts

Museum of Fine Arts, Houston, Texas

Museum of Fine Arts, St. Petersburg, Florida
Museum of Modern Art, New York, New York
National Museum of American History, Division of Photographic History, Smithsonian Institution,
 Washington, DC
National Museum of Women in the Arts, Washington, DC
New Orleans Museum of Art, New Orleans, Louisiana
Norton Simon Museum, Pasadena, California
Oakland Museum of California, Oakland, California
Oklahoma City Art Museum, Oklahoma City, Oklahoma
Philadelphia Museum of Art, Philadelphia, Pennsylvania
Pomona College Museum of Art, Pomona, California
San Francisco Museum of Modern Art, San Francisco, California
Seattle Art Museum, Seattle, Washington
Stanford University Museum of Art, Stanford, California
The Phillips Collection, Washington, DC
University Art Museum, Berkeley, California
Weston Gallery, Carmel, California

EDWARD S. CURTIS

1868–1952

IN THE EARLY PART OF THE TWENTIETH CENTURY, EDWARD CURTIS PRODUCED a huge body of work on Native Americans from North America. His work has been both highly praised and condemned based on the way in which his subjects were portrayed. His twenty-volume collection of books titled *The North American Indian*, focusing on what he referred to as the "vanishing Indian," is one of the most ambitious book projects ever undertaken. While Curtis is best known for his photographs, scholars equally value his prolific text.

Curtis began documenting Indians in 1896, estimating that it would take him about 10 years to complete his project. By 1905, he was in dire need of financial resources and far from reaching his goal. In 1906, with the help of Theodore Roosevelt, he was able to attract monetary support from J. Pierpont Morgan, and in spite of continual challenges, his efforts took on a new energy. For years Curtis and his associates documented tribes in the Southwest, the Great Plains, and the Pacific Northwest, and numerous exhibitions were shown in places such as Washington, DC, Boston, New York, and Pittsburg. His work continued with steely determination. His 20 books were published from 1907 to 1930. Each volume is full of information about a tribe's culture, folklore and history, kinship and organizational structures, expressive arts, and religion. Every book includes 75 exquisitely reproduced *photogravures*, which are engravings commercially made from photographs. While secondary information was cited in these books, most of the information came from Curtis's fieldwork.

Born in Whitewater, Wisconsin, to a working class family, Curtis left school after receiving an elementary education in Cordova, Minnesota. He was probably introduced to photography in St. Paul or Minneapolis. In 1887, he migrated to Washington State with his father; the rest of the family later joined them, settling on a farm across the Puget Sound from Seattle. His father died soon after the move, leaving young Curtis to support his

Edward Curtis. *Girl and Jar—San Ildefonso*, from the portfolio *The North American Indian* (1905). Library of Congress, Prints and Photographs Division, Edward S. Curtis Collection. Reproduction number: LC–USZ62–117709.

mother and siblings. He tried several kinds of jobs and was soon able to buy into a photography and engraving studio in Seattle. His son, Harold, reports that Curtis was so good with his hands that he built his first camera using instructions from an article in the *Seattle Post-Intelligencer*. Exhibiting his tremendous energy and drive, he quickly owned his own studio and became the most successful society photographer in Seattle. People enjoyed his presence and were charmed by his personality. He was equally comfortable spending time in the Roosevelt home at Oyster Bay as he was on an Indian reservation.

Curtis's early work focused on landscapes and portraiture, all captured from a romantic perspective. In 1896, he won an award from the Photographer's Association of America establishing him as an important photographer. His quick rise in society corresponded with his marriage to Clara Phillips, with whom he had four children. He joined a mountaineering club to experience the landscape and began exploring the work of major art photographers to learn more about his medium. Around the turn of the century, Curtis turned his attention to Native Americans. He became devoted to the work that would consume him when

he took a trip with George Bird Grinnell, editor of the magazine *Forest and Stream*, to visit the Blackfeet and watch them perform the sun dance.

So devoted to his work was Curtis that it cost him his marriage, time with his children, his financial stability, and his health. He divorced in 1919, giving Clara the photography studio to manage. He then moved to Los Angeles to build his own studio, which was managed by his daughter Beth Curtis Magnuson, who was basically left alone to manage the business. So exhausted was Curtis that he had a breakdown after the last volume of his books was completed. Aimed at wealthy individuals and major libraries, less than 300 of the complete sets were sold.

Curtis also worked with film. In 1914, he produced what is often referred to as the first feature-length narrative documentary film, *In the Land of the Head Hunters*, based on the culture of the Kwakiutl Indians of the Canadian northwest coast. In this film, as in his photographs, Curtis asked Native Americans to change from their blue jeans and cotton shirts into traditional regalia worn by their ancestors. They were instructed to put on masks,

Edward Curtis. *The Eagle Medicine Man—Apsaroke* (c. 1908). Library of Congress, Prints and Photographs Division, Edward S. Curtis Collection. Reproduction number: LC–USZ62–117711.

nose-rings, and clothing made from cedar-bark. He built a stage set for the film, portraying it as an authentic village, and staged a whale hunt with a dead whale.

Sometimes Curtis's way of staging his subjects was extreme, as he occasionally dressed different tribes in the same clothing, and he was known to crop out Indians wearing store-bought clothing from his pictures. In some cases they were asked to re-enact traditional ceremonies that were outlawed by the Bureau of Indian Affairs in 1900. These laws had been made to eradicate traditional culture, and children were being taken from their homes to become schooled in the ways of white North Americans. Due to Curtis's direction, many of the scenes in his photographs are not authentic. Anne Makepeace, who interviewed several people who had been photographed by Curtis, points out that often they were documented doing daily activities like grinding corn in dress that was saved for special occasions. In spite of how these actions are seen by us today, they were fairly common practice at the time, and most critics acknowledge this work as important documentation even with the manipulative staging.

No one else has photographed Native Americans with Curtis's intensity. Traveling in Indian territory was not always easy. Harold Curtis reports that once when camping in the Navajo territory of Canyon de Chelly with his father, thieves took all the horses, leaving the entire Curtis entourage stranded. After several days an Indian wandered into the camp and offered to get back the horses for a price. Curtis gave him a sack of money—dollars that he usually gave his subjects for posing—and in a very short time, the horses were returned. Rugged landscape, wildlife, thick flies, and sickness also presented challenges, and traveling with precious camera equipment and fragile glass plates was not easy. Sleeping was also difficult, and it is said that Curtis slept only a few hours each night. His stamina was legendary.

Curtis created more than forty thousand negatives, nearly all on glass plates. He believed that he was photographing a race of people who would soon cease to exist, at least as he saw them. His bust-length portraits were carefully taken with a soft-focus lens, in a manner that sharply captured the face but left the edges of the photograph in a fading blur. By using this approach, he was able to focus the viewer's attention on facial features, making his subjects look proud and dignified, surrounded by a space filled with drama. Curtis sometimes touched up his portraits, giving them highlights in places that would produce the look he wanted. The difficult part, according to Curtis's family folklore, was to get his subject to look at the camera.

Curtis had a good command of composition. He liked clear-cut silhouettes and strong outlines. In one 1906 photo of Hopi women, titled *Watching the Dancers*, the subjects are seen from their backsides, white blankets pulled around them, on top of an adobe building, creating a bold repetitive pattern across the backdrop of the sky.

In 1970, 40 years after the publication of the last volume of *The North American Indian*, the Pierpont Morgan Library in New York gave Curtis's work a major exhibition, and in 1972, the Philadelphia Museum of Art followed suit with another exhibition. Anthropologist Joseph Epes Brown, in his introductory essay to the publication that accompanied the

Philadelphia exhibition, pointed out that although it was common in Curtis's time to see Native Americans as a vanishing group of people, we recognize that they have not disappeared. Brown enticed viewers to re-interpret Curtis's work by thinking about a different kind of loss that had been affecting all of humankind: this was the loss of the sacred.

Although he was not well known at the time of his death, his work has become increasingly studied, published, and displayed. Curtis's ambitious body of work is now published in one rather large (though not complete) paperback volume. A documentary film about him by Anne Makepeace, completed in 2000, is now widely screened, and many of Curtis's images are available in digital form on the Web. Increasingly, his photographs and verbal text are being made available to the general public. One such effort is the 1995 publication *Prayer to the Great Mystery: The Uncollected Writings and Photography of Edward S. Curtis*, edited by Gerald Hausman and Bob Kaoun. Another is *Edward S. Curtis and the North American Indian Project in the Field*, edited by Mick Gidley.

Curtis's work remains controversial and much debated. Most everyone agrees that his version of North America's Native Americans is romanticized. No one questions the command he had over his medium, and so important is his work to us today (we have nothing else like it) that even Native Americans study his images to learn about the history he portrayed.

Bibliography

Brown, Joseph Epes. "Introduction: Mirrors for Identity in the Photographs of Edward S. Curtis." In *The North American Indians*. New York: Aperture, 1972. (n.p.)

Bush, Alfred L., and Lee Clark Mitchell. *The Photograph and the American Indian*. Princeton, NJ: Princeton University Press, 1994.

Cardozo, Christoper. Foreword by Louise Erdrich. Introduction by Anne Makepeace. *Edward S. Curtis: The Women*. New York: Bulfinch Press, 2005.

Gidley, Mick, ed. *Edward S. Curtis and the North American Indian Project in the Field*. Lincoln: University of Nebraska Press, 2003.

Gidley, Mick. "Introduction." *Edward S. Curtis and the North American Indian Project in the Field*, ed. Mick Gidley. Lincoln: University of Nebraska Press, 2003, 1–29.

Goldberg, Vicki. "Fiddling with History in a Cause That Seemed Just." *New York Times*, November 17, 1991: H35, H42.

Graybill, Florence Curtis, and Victor Boesen. Introduction by Harold Curtis. Photographs prepared by Jean-Anthony du Lac. *Edward Sheriff Curtis: Visions of a Vanishing Race*. Boston: Houghton Mifflin, 1976.

Makepeace, Anne. "Edward Curtis: Dialogue: Dressing Up, Whose Idea Was It Anyway?" Retrieved August 21, 2006, from http://www.thirteen.org/americanmasters/curtis/dress_about.html.

Places to See Curtis's Work

Center for Creative Photography, University of Arizona, Tuscon, Arizona
J. Paul Getty Museum, Los Angeles, California
Library of Congress, Washington, DC
San Francisco Museum of Modern Art, San Francisco, California

JUDY DATER

b. 1941

JUDY DATER HAS BEEN PHOTOGRAPHING FACES FOR MORE THAN 40 YEARS, including her own. Dater's work emerged during the height of the feminist movement when many female artists were using their own bodies to explore politically inspired issues, such as sexual stereotypes, women's roles in the home and in the workplace, and reproductive rights.

Dater grew up in a conservative middle-class family in Los Angeles, California, in the 1940s and 1950s. At the age of 15, she was the youngest student in an all-adult painting seminar that she took at the Art Center School in Los Angeles. She started her college studies at the University of California in Los Angeles (UCLA), where she experimented with nude self-portraits as an undergraduate student. After a while she started to photograph girlfriends who were willing to pose for her in the nude. For Dater it was a natural extension of life drawing. At UCLA she took a photography class with Jack Welpott, who later became her second husband. After this class she decided to transfer to San Francisco State her senior year. Throughout the 1970s she worked with Welpott on portraits of women and produced several collaborative works including *Women and Other Visions* (1975).

In 1964, she went to a conference in Big Sur, California, where she met several prominent photographers, including **Ansel Adams, Imogen Cunningham,** Michael Murphy, and Brett Weston, the son of **Edward Weston.** Meeting these artists was a turning point for Dater, of which she said, "They made me feel I could do what I wanted to do" (Kyne 18). In particular Dater was greatly impressed with Cunningham. The two became friends, and Cunningham remarked that she wanted to photograph the much younger and beautiful Dater. Instead Dater photographed Cunningham, in one of her most recognized and famous images. The portrait of Cunningham with Twinka Thiebaud, taken in the early 1970s, shows the fully clothed Cunningham gazing at the nude Twinka who looks directly back at her. Dater is

commenting on the traditional positioning of the dressed male artist looking at the nude female, while she is oblivious to his gaze. Here Dater positions a woman as the gazer and the model in a position of awareness.

Dater's portraits from this time period are reminiscent of Cunningham's *pictorial* photography, with altered lighting and exposure to create an effect more like a painting than that of photography. In her black-and-white portrait *Twinka Thiebaud* (1970), Dater dramatically poses the young model like a Hollywood movie still or publicity shot for a film.

After the death of Imogen Cunningham in 1976, Dater published a book dedicated to her mentor and friend in 1979.

Dater's work has been criticized for the raw style in many of her nude portraits of women. In *Maggie* (1970) the sitter is shown nude from the waist up. Maggie's direct gaze and slouched posture oppose prevailing ideals about female beauty and sexuality. In *Self Portrait with Mist* (1980), the black-and-white portrait shows Dater's nude body in complete shadow against a white mist. Although we cannot see her nudity, it is apparent that she is outside and confident standing tall with her hands on hips looking head on into the misty evening.

Judy Dater. *Self Portrait with Mist* (1980). Courtesy of the artist.

In other works Dater sets the stage, costume, and characters. Like that of Dater's contemporary **Cindy Sherman,** she put herself in the portrait, not as herself, but a character to express a feminist message. In *Ms. Cling Free* (1982), Dater dresses up in a hot pink sexy maid uniform wearing thick make-up. Her arms are overflowing with cleaning supplies and equipment as she stands in high heels on a stage with a satin curtain back drop; she can be a sex object, and she can keep the house clean to boot. In another image from the series, *Death by Ironing* (1982), she stands in the same maid's uniform and same expressionless face. Except this time the cord of the iron is wrapped around her neck, although she seems not to notice. She is numb from the repetitive nature of her domestic chores that have become the source of her demise.

Other notable self-portraits are those that she took when recovering from a divorce from Jack Welpott in the early 1980s. The end of their marriage was tumultuous and caused Dater much angst. She reveals her most vulnerable sides, showing us a bored and overweight housewife.

In the 1990s her approach shifted from an in-your-face feminism to looking outside of herself at the locations where she traveled in Spain, France, and California. Experimenting with enlarging prints to wall-size posters, she commented, "Really shows the patterns of photography" (Hayde, 1996, par. 6).

Dater started teaching as an instructor at the University of California Extension in San Francisco in 1966. She taught there for eight years before resigning to take a job teaching at the San Francisco Art Institute in 1974. She worked there until 1978. Other teaching positions included posts at the Kansas City Art Institute in Lawrence, the International Center of Photography in New York City, and at San Jose City College in California. In 2007, she continues to give the occasional guest lecture.

She has received many awards, such as the National Endowment for the Arts on two occasions, the Marin Arts Council Individual Artist Grant, a Guggenheim Fellowship, and the **Dorothea Lange** Award from the Oakland Museum in California. Her work has been exhibited in countless galleries and museums around the world. Notably Dater is regarded for her technical proficiency in a wide range of processes and equipment. With more than 40 years of photography on her resume, Dater continues to be fascinated with faces, which she says come out like self-portraits since she can never remove herself from the work as the portrait inevitably reflects the sitter's response to Dater. These later portraits are void of props and setting, with close-up shots that focus solely on the woman's facial expression and raw emotion.

Dater lives and works in Berkeley, California. She married again in early 2007. Judy Dater has contributed a notable body of work to the development of what is known as feminist art through portraits of women staged in costume and straightforward just as they are, challenging stereotypes and broadening the definition of "woman."

Bibliography

Dater, Judy. *Cycles*. Essays by Clarissa Pinkola Estes, PhD, and Michiko Kasahara. Pasadena, CA: Curatorial Assistance, 1994.

———. *Imogen Cunningham: A Portrait*. Boston: Little, Brown, 1979.

Hayde, Monica. "Getting under the Surface." *Palo Alto Weekly Online*. Retrieved April 12, 1996, from http://www.paloaltoonline.com/weekly/morgue/cover/1996_Apr_12.2NDART12.html.

Karlstrom, Paul. "Interview with Judy Dater on June 2, 2000." Smithsonian Archives of American Art. Retrieved February 15, 2006, from http://www.aaa.si.edu/collections/oralhistories/transcripts/dater00.htm.

Kyne, Barbara. "Veterans of Bay Area Art." *Artweek* 30, no. 12 (December 1999): 17–18.

Welles, Elenore. "Judy Dater: November 19, 2004 at Michael Dawson Gallery, Hollywood." Retrieved February 15, 2006, from http://artscenecal.com/ArticlesFile/Archive/Articles2004/Articles1204/JDaterA.html.

Places to See Dater's Work

Bibliotheque Nationale, Paris, France
Center for Creative Photography, University of Arizona, Tucson, Arizona
Indiana University, Kinsey Institute for Sex Research, Bloomington, Indiana
International Center for Photography, New York, New York
International Museum for Photography, Rochester, New York
Metropolitan Museum of Art, New York, New York
Michael Dawson Gallery, Los Angeles, California
Minneapolis Institute of Art, Minnesota
Museum of Modern Art, New York, New York
National Gallery of Canada, Ottawa, Canada
Stanford University, Stanford, California
Toppan Collection, Tokyo Metropolitan Museum of Photography, Tokyo, Japan
University of California, Los Angeles, California
Visual Studies Workshop, Rochester, New York
Yale University Art Gallery, New Haven, Connecticut

ROY DECARAVA

b. 1919

EXCEPT FOR A SMALL FRACTION OF HIS WORK, ROY DECARAVA'S PHOTO-graphic subject has always been New York City. For more than 50 years, he has created images that reflect the everyday life of New Yorkers, with an emphasis on African Americans. His photographs range from great jazz singers and musicians to the loving and intimate pictures of the private lives of families living in Harlem. More recently he has increasingly focused on abstractly exploring light and shadow. In all his photographs he demonstrates a technical skill that any photographer would envy. He has worked as a photojournalist for many magazines including *Life*, *Look*, *Time*, and *Sports Illustrated*.

DeCarava was born in Harlem in 1919. His mother was an immigrant from Jamaica. His father was absent from his life after his parents separated after a very short marriage. He was supported by his extended family and encouraged to explore art and music. An only child, he found life on the streets exciting. Children played games like marbles, stickball, tops, and "skelly," a game that uses checkers positioned on a manhole cover. In the spring neighborhood youth flew kites with razor blades on the tail, hoping to cut a competitor's kite string. He and his childhood playmates also made rings from peach pits, chalk drawings on the street, and scooters from old roller skates. Like many children his age, he went to the movies, which gave him lessons in the visual aesthetic of black and white. Although he had wanted to be an artist from the time he was a young boy, at Textile High School his horizons about the possibilities of art really expanded. There he discovered the work of Vincent Van Gogh, Michelangelo, and Leonardo daVinci. In 1938, he attended the Cooper Union School of Art, where he stayed for only two years due to consistent and repeated experiences of racism. Continuing his art education at the Harlem Community Art Center, and later the George Washington Carver Art School, he met and learned from extraordinary artists like Paul Robeson, Langston Hughs, Romare Bearden, Jacob Lawrence, and Charles White. Beginning his art exploration as a painter, he switched to a focus

on printmaking. In 1947, he had his first one-person exhibition at New York's Serigraph Galleries.

Working at odd jobs from an early age throughout his school years, he increasingly became aware of racism and racial segregation. But his educational experiences with racism turned out to be mild in comparison to what he experienced when joining the army in 1942. DeCarava was married at the time and expecting a child. Stationed first in Virginia and then in Louisiana, where segregation was extreme, he questioned fighting for a country overseas that was so prejudicial at home. So difficult was this experience that he was hospitalized in a psychiatric ward for a month and subsequently was discharged from the military.

DeCarava first started working with a camera in the 1940s when he needed photographs for his printmaking activities. It wasn't long before he realized that photography was the best tool for what he wanted to express. Early on he exhibited a keen sense of composition and an uncanny way of capturing intimate moments.

The streets in which DeCarava grew up were becoming ghettos during the Depression years. However, the talented mix of African Americans who had come to Harlem during the Great Migration had fueled the 1920s Harlem Renaissance, and artists continued to thrive, some funded though the Federal Art Project of the *Works Progress Administration* (WPA), a program that employed DeCarava's mother as a clerical worker. DeCarava, like many of his contemporaries, wanted to show racial pride in his work. He worked with a 35mm camera, the new camera of choice for young ambitious photographers, as it enabled him to visually explore the environment with relative ease.

DeCarava worked as a social worker during the day, and when he left work at 5:00 P.M., he took to the streets with his camera. The subway was an early subject since it was part of his daily routine. These images depict the rhythm of the work world's dayshift. He would soon move into photojournalism, working for major magazines. These experiences helped him develop his photographic skills, although he remained grounded in an independent and artistic way of composing his images. Like so many others from his photographic generation, DeCarava was influenced by Henri Cartier-Bresson, the French photographer who believed that the man in the street could represent the human values of a culture. The immediacy of experience and capturing the precise right moment became important.

Shortly after **Edward Steichen** took over the Department of Photography at the Museum of Modern Art (MoMA), DeCarava introduced his photographs to him. Steichen liked DeCarava's work, and in 1950, he purchased three images for $50 a piece. Equally as helpful, Steichen began to include his work in group exhibitions. His influence helped DeCarava win an important fellowship from the John Simon Guggenheim Memorial Foundation, the first African American to be awarded this honor. At 32 years of age, he was able to spend a year photographing Harlem. His goal was "to show the strength, the wisdom, the dignity of the Negro people. Not the famous and the well known, but the unknown

Roy DeCarava. *Man Coming Up
Subway Stairs* (1952). San Francisco
Museum of Modern Art.
The Helen Crocker Russell
and William H. and Ethel W.
Crocker Family Funds Purchase
© Roy DeCarava.

and the unnamed, thus revealing the roots from which spring the greatness of all human beings…" (Galassi 19).

While DeCarava's early photos were straightforward in their simplicity, his later images were more technically driven as he found ways to use a full range of contrast, from extreme whites to dense, thick blacks. Although he focused on specific projects, like Harlem life or jazz portraits, he feels that his work should be seen as a whole. It is his unique sensibility that provides the connection. It is lyrical and grounded in metaphors. Each image, though specific, can be universalized, as they are not bound to specificity. As curator Peter Galassi points out, "The part stands for the whole: the bars for the prison, the street for the city, the couple for love" (Galassi 29).

In 1955, DeCarava partnered with Langston Hughes in *The Sweet Flypaper of Life*, placing 140 of his images with text by Hughes. Intimate family pictures are well matched with

Hughes's narrative about a grandmother who ignores St. Peter's command to come home to heaven. The book was both a critical and commercial success. Also in 1955, DeCarava and his wife opened A Photographer's Gallery in Manhattan, a significant and rare space for photography exhibitions at the time.

In 1969, DeCarava had an exhibition at The Studio Museum in Harlem, displaying two decades of his work. Other exhibitions have followed in various places including Texas, California, and Sweden. Although he had many rewarding experiences doing freelance jobs, overall DeCarava found working as a contract photographer was time consuming and took away from the energy he wanted for his personal photography. In 1975, he joined the faculty at Hunter College and taught there for almost two decades.

In 1996, the Museum of Modern Art in New York curated a traveling retrospective of his work. Around 200 images were displayed. According to the curator, Peter Galassi, the story of photography "cannot be told adequately without a full account of the work of Roy DeCarava, one of its distinctive protagonists" (Galassi 9).

DeCarava is married to Sherry Turner DeCarava, an art historian who knows her husband's work well. In 2006, he won the prestigious National Medal of Art. As De-Carava ages, he continues to take photographs, but he doesn't travel far. He takes more

Roy DeCarava. *Lingerie, New York* (1950). San Francisco Museum of Modern Art. Purchased through a gift of Theodore and Phyllis Swindells. © Roy DeCarava.

self-portraits, images of pets, and interiors of the home. Occasionally, he will photograph old friends.

It is DeCarava's expert use of light and darkness, exhibiting a vast array of grays that makes his work so compelling. But his subject matter is equally as dazzling. It is not just subjects of men, women, and children in his neighborhood; rather, the subject is also what is in his soul. He once said, "What you're really doing is, you're really going inside yourself and describing yourself and what you believe in. Every picture that you take is another word in your bibliography of experiences" (Sloan 4). Seen from this perspective his work, like the artist, is contemplative and graceful. DeCarava cares about the well being of people, and this desire is made visible though his photographs.

Bibliography

DeCarava, Roy, and Langston Hughes. *The Sweet Flypaper of Life*. New York: Hill and Wang, 1955.

DeCarava, Sherry Turner. "Pages from a Notebook." In *Roy DeCarava: A Retrospective*. Peter Galassi with an Essay by Sherry Turner DeCarava. New York: Museum of Modern Art, 1996, 41–60. (Distributed by Harry N. Abrams, New York.)

Galassi, Peter. "Preface and Acknowledgments." In *Roy DeCarava: A Retrospective*. Peter Galassi with an Essay by Sherry Turner DeCarava. New York: Museum of Modern Art, 8–9.

———. "Introduction." In *Roy DeCarava: A Retrospective*. Peter Galassi with an Essay by Sherry Turner DeCarava. New York: Museum of Modern Art, 11–39.

Robertson, Rebecca. "Roy DeCarava." *Artnews* 105, no. 2 (2006): 129.

Sloan, Lester. "Roy DeCarava Retrospective." Neiman Reports: The Neiman Foundation for Journalism at Harvard University, 52, no. 2 (1998). Retrieved January 1, 2007, from http://www.nieman.harvard.edu/reports/982NRsum98/Sloan_DeCarava.html.

Woodward, Richard B. "Roy DeCarava." *Artnews* 103, no. 1 (2004): 140.

Places to See DeCarva's Work

Corcoran Gallery of Art, Washington, DC
Harvard University Art Museums, New Haven, Connecticut
Museum of Fine Arts, Houston, Texas
Museum of Fine Arts, Santa Fe, New Mexico
Museum of Modern Art, New York, New York
Smithsonian American Art Museum, Washington, DC

JEANNE DUNNING

b. 1960

JEANNE DUNNING IS A PHOTOGRAPHER WHO IS BEST KNOWN FOR HER humorous yet uncomfortable and anxious explorations about body image. In her work skin becomes a metaphor for that which is on the border between interior and exterior realities. Inspired by art and film, her photographs and videotapes are outrageous and provoking. They view the body as both alien and sensuous. In lush colors her images also confront representational perspectives on still life, landscape, portraiture, and the nude figure. Often associated with feminist commentary, her photographs are marvelously composed, expertly focused, and clearly lit. Dunning is also a sculptor and a video artist.

Born in Connecticut, she is a Chicago-based artist. She earned her BA from Oberlin College in 1982 and her MFA from the School of the Art Institute of Chicago in 1985. She has been influenced by many photographers, including **Man Ray, Edward Weston, Sherry Levine, Carolee Schneemann, Cindy Sherman,** and **Hannah Wilke.** Weston inspired her with his photographs of the curvaceous female body that he visually related to a landscape. His picture of a halved artichoke gave her ideas about food and its visual relationship to body parts. She was drawn to Man Ray's close-ups of one body part that metaphorically resembled another. Like Man Ray and other surrealists, Dunning takes fragmented parts of the body out of their holistic context. In this way objects can take on another life, communicating a fresh idea. For example, when she skinned plums and pulled the stems from them, the hole that was left carried a number of different interpretations. Wilke's late photographs, where she exposed her cancerous body to the camera, were especially compelling to Dunning. She admired Wilke for her willingness and strength to expose her bald, ill, and bloated body.

Dunning's photographic explorations began in 1987 when she created a series of pictures on camouflaged insects in their natural environments. Taken as close-ups they cannot be seen as documentary images, thereby questioning scientific inquiry and objective truth. In the same year she began the series *Untitled Landscapes*. At first viewing these images appear

to be landscapes with a strange kind of unidentifiable terrain, but when more carefully ana-
lyzed, they can be seen for the different parts of the body that they are. Close-ups of various
kinds of body hair, for example, look like fields of grass or sand dunes sparsely covered with
sea grass. She explains how the first piece she ever made about the body, *Untitled Landscape I*
(1987), came about: "When I took this picture of the hairs on my (unshaved) leg, I was just
fooling around, trying to use up a roll of film, but when the slides came back from the photo
lab I saw that the leg had become a landscape.... The *Untitled Landscapes* developed out of
a play between what I thought I was taking a picture of and how I saw the picture after the
fact" (Dunning 75).

Her next series, *Untitled Holes*, which she began in 1992, continues this exploration, but
focuses on orifices and the idea of holes, representing what is concealed and what is revealed.
Close-ups of beautiful and sensuous fruit look like orifices, or possibly wounds. In *Hand
Hole* (1994) she focuses on interlacing fingers. As with many of her other photographs, she
has created a mysterious space by bringing the camera in close and manipulating the scale.
Because what we first see is not what the image actually is; viewers allow themselves to take
time in exploring the picture.

In the 1990s, using food in conjunction with the nude female body, Dunning created vi-
sions of women as dessert, dripping with whipped cream, butterscotch pudding, icing, and
other delectable sweets. Naked women were dressed up like ice-cream sundaes and photo-
graphed. Like her other work these large color prints are sometimes ambiguous since they
don't readily communicate what is being depicted. Close-up images of skin covered with
food are once again photographed as landscape. In one of her videos in this series, a woman
studies layers of whipped cream on her lap while another blends into a bed full of pudding.
Viewers can think about this work either as a commentary on male sexual fantasies or on
our addiction to sugar.

Bringing together close-ups of food and facial portraits in matching oval frames, *Leak-
ing 2* (1994) pairs a peeled tomato with a woman eating the ripe fleshy object as it oozes
and drips from her mouth. There is a kind of playfulness in this work that smacks of free-
dom. While the woman, who stares directly at the viewer, is crassly breaking cultural rules,
she is also releasing her inhibitions. The texture of the tomato is associated with the texture
of the woman's skin. As viewers, we are both repulsed and elated by this work. Our emo-
tions focus on ideas of self-control and freedom of letting go.

In *Blob 2* (1999) Dunning responds to the 1958 film *The Blob* where a red gelatin-like
mass from outer space descends on a quiet community, devouring its victims while growing
large within them. Dunning's blob has no specific structure. It defines and redefines itself
like a beanbag. In this photograph a woman, lying on a tile kitchen floor, tries to push away
this flabby blob that has attached itself to her body. In another image in the same blob
series, the unwanted attachment hangs out from under a woman's shirt and falls onto a
plate positioned before her. The connection she makes between food, body fat, and obesity

Jeanne Dunning. *The Blob 4* (1999). Ilfochrome photograph mounted to plexiglass and frame, 37 × 48¾ inches. Courtesy of the artist & Kinz, Tillou + Feigen, New York.

is immediately recognized. In *Bathtub 2* a woman takes a bath with the blob. As a way of countering the nightmarish images, she also created photographs of women who embrace and relax with the blob. A video in the same series depict a woman painfully trying to dress in a way that conceals the unwanted "flesh," making viewers uncomfortably aware of attempts to hide various aspects of our physique under clothing. These performances make it clear how difficult it can be to feel comfortable in our own bodies.

It is easy to wonder how Dunning's work would be received if it were created by a man. Meanings might be differently construed. However her work is viewed, it clearly raises provocative questions about gender and sexuality by looking at the relationship of a woman's self to her body and her body to the rest of the world.

Bibliography

Clifford, Katie. "Jeanne Dunning." *Artnews* 99, no. 5 (2000): 228–229.
Coleman, A.D. "Jeanine Dunning." *Artnews* 96, no. 11 (1997): 165.

Cruz, Amanda. "Directions: Jeanne Dunning." Brochure for the exhibition at the Hirshhorn Museum and Sculpture Garden, Smithsonian Institution, July 12–November 2, 1994.

Dunning, Jeanne. "Thoughts for *Study After Untitled.*" In Heidi Zukerman Jacobson. With essays by Jeanne Dunning and Russell Ferguson. *Jeanne Dunning: Study After Untitled.* Berkeley: University of California, Berkeley Art Museum and Pacific Film Archive, 2006, 75–79.

Jacobson, Heidi Zukerman. With essays by Jeanne Dunning and Russell Ferguson. *Jeanne Dunning: Study After Untitled.* Berkeley: University of California, Berkeley Art Museum and Pacific Film Archive, 2006.

Lahs-Gonzales, Olivia. "Defining Eye/Defining I: Women Photographers of the 20th Century." *Women Photographers of the 20th Century: Selections from the Helen Kornblum Collection.* Olivian Lahs-Gonzales and Lucy Lippard with an Introduction by Martha A. Sandweiss. St. Louis, MO: St. Louis Art Museum, 15–129.

Reilly, Maura. "Jeanne Dunning at Feigen Contemporary." *Art in America* 7 (2000): 103.

Places to See Dunning's Work

Allen Memorial Art Museum, Oberlin, Ohio
Art Institute of Chicago, Chicago, Illinois
Harold Washington Library, Chicago, Illinois
Illinois State University Galleries, Normal, Illinois
Milwaukee Art Museum, Milwaukee, Wisconsin
Museum of Contemporary Art, Chicago, Illinois
Museum of Contemporary Art, Grand Avenue, Los Angeles, California
Museum of Contemporary Photography, Columbia College, Chicago, Illinois
Museum of Modern Art, New York, New York
The Speed Museum, Louisville, Kentucky
State of Illinois Museum, Springfield, Illinois

HAROLD E. EDGERTON

1903–1990

KNOWN TO MANY AS "DOC," HAROLD EDGERTON WAS AN INVENTOR, AN educator, an engineer, a physicist, and a photographer whose works have become well recognized by the general public. He skillfully captured an image of a drop of milk splashing on a plate, an apple and an electric light bulb pierced by a bullet, the atomic bomb exploding, and a booted foot at the moment it hits a football. He portrayed multiple flash pictures of tennis players, fencers, and golfers in action sequences. Some of his photos are as memorable as **Dorothea Lange's** migrant mother or Picasso's *Guernica*. His photographs help us to see the unseen.

Born in 1903 in Fremont, Nebraska, Harold was the first of three children. His father, Frank, was a high school principal and a football coach. In Harold's early years the family moved to Washington, DC, where Frank worked for a short time as a reporter for the *Washington Times* and attended law school. The family, missing their beloved state of Nebraska, soon returned home where Frank practiced law.

In 1909, Harold and his father watched the Wright brothers on one of their early flights at Fort Meyer, Virginia. This experience made a huge impression on the young boy. Harold first learned photography from a favorite uncle who lived in Iowa. Exploring the developing process, he used his family's kitchen as a darkroom. Harold began inventing things as a young child. He remembers constructing a searchlight for the porch roof of his Nebraska home. Finding that a narrow light beam was difficult to form, this experiment became his first lesson in optics. As a high school student, during the summers, he worked for the Nebraska Power and Light Company in Aurora, Nebraska, where the huge generators captured his interest. This work experience was what inspired him to become an electrical engineer, a field that was then in its early stages of development.

In 1925, Edgerton graduated with a BS in electrical engineering from the University of Nebraska in Lincoln. After graduating he worked for General Electric for a year, analyzing the success of large rotating electrical motors. In 1926, he entered the Massachusetts

Institute of Technology (MIT) and received his MS in 1927 and his doctorate in 1931. MIT immediately hired him, and he was able to work his way up to full professor by 1948. Although he was a world traveler, his MIT laboratory remained his home base.

Married to Esther May Garrett in 1928, together they had three children. The couple entertained students each year at an annual party in their home. A flashing strobe light was placed on their front door, a meal was prepared and served, and Edgerton would lead the group in songs he played on his guitar.

Edgerton's teaching style was hands-on. He believed that if students could see how something worked, they would understand it better, and the experience might lead them to some other question or idea. He taught that perfection could not be obtained. No matter how hard he tried to capture a symmetrical splash from drops of milk on a plate, the result was always irregular.

The invention that Edgerton is best known for was created in 1932, at the height of the Depression. His stroboscopic light would revolutionize photography. It was an extremely powerful piece of equipment that allowed the photographer to capture a sequence of precise images of a person or an object as they moved quickly through space. Working as an engineering instructor at MIT at the time, he earned very little money and lacked the funds to apply for a patent. He approached patent attorney David Rines hoping that he would help him with the necessary paperwork without pay. Rines agreed, never knowing that the challenge before him would take so many years that the inventor would never earn a dime from the invention. But Edgerton's subsequent inventions were financially successful. Among them were sonar and deep-water probes that would be used by underwater divers like Jacque-Yves Cousteau and the team of explorers who discovered the Titanic. With Cousteau he searched for ancient vessels and other artifacts in the Mediterranean, the Atlantic, the Aegean Sea, and in Lake Titicaca in Bolivia. Edgerton also invented and directed the use of equipment that was used during World War II for nighttime aerial reconnaissance photography. This equipment provided the military with crucial intelligence information about the location of enemy troops. In 1946, he received the Medal of Freedom from the War Department for the important role he played in winning the war.

The new strobe light (often called "speedlight") was not placed on display until 1937 or 1938 (the exact date is unclear). In 1939, along with James R. Killian, Jr., who later became MIT's president, Edgerton published the photographic results of his strobe light in *Flash! Seeing the Unseen by Ultra High-Speed Photography*. The response was overwhelmingly enthusiastic, and a new kind of journalism was born.

Analyzing movement, such as bullets in flight, fascinated Edgerton. Bullets move over 15,000 miles per hour, and Edgerton's strobe exposures are so precise they could capture a bullet's position in a millionth of a second. Being able to examine a moving object in space in this manner presented scholars with new understanding. For example, Edgerton's photographs demonstrated that when a bullet encounters a hard object, the bullet becomes

Harold Edgerton. *Untitled (Shutter Sequence)* (ca. 1935). © Harold & Esther Edgerton Foundation, 2007 courtesy of Palm Press, Inc.

liquid for an instant. When this happens, it loses its shape, then solidifies again as it shatters into pieces.

Working with two former students, Kenneth Germeshausen and Herbert E. Grier, Edgerton formed a company called EG&G. In 1940, the company was invited to the MGM studios in Hollywood where they worked on a number of films. *Quicker than a Wink* won an Oscar. Due to the skill and inventiveness of EG&G's members, the film was able to demonstrate how a rattlesnake strikes, what happens to smashed teacups, and how a cat lands on its feet.

Edgerton's accomplishments are so many that it is difficult to list them all. He took the first studio flash picture in color in 1937, a football-kick photograph. He published an article in *National Geographic* that showed us the flight patterns and wing movements of hummingbirds, and along with Germeshausen and Grier, he designed a still camera shutter that decreased the exposure time from four to ten-millionths of a second. A version of the strobe he invented is now a common devise in everyday cameras.

In 1990, Harold Edgerton died from a heart attack. His work continues to fascinate museum visitors, school children, scientists, and everyday people. In spite of his widespread success as a photographer, Edgerton thought of himself first and foremost as an engineer. Although many writers have drawn correlations between Edgerton's photographs and the work of the Futurists, a 1912 school of painters and sculptors, primarily from Italy, the engineer's thoughts remained focused on science and not art. Nonetheless, it is interesting to note that the Futurists' doctrine maintained that speed could destroy form, an idea that Edgerton found intriguing.

His awards and recognitions are many. They include the Progress Award from the Society of Motion Picture and Television Engineers (1959), the New England Aquarium Citation for accomplishments in oceanography (1964), the Morris E. Leeds Award from the Institute of Electrical and Electronics Engineers (1965), the Technical Achievement Award from the American Society of Magazine Photographers (1965), the John Oliver LaGorce Gold Medal from the National Geographic Society (1968), the U.S. National Medal of Science awarded by President Richard M. Nixon (1973), and the Eastman Kodak Gold Medal from the Society of Motion Picture and Television Engineers (1983). His laboratory

notebooks now reside in MIT's Edgerton Center, where they continue to be studied by scholars and students from all over the world.

Bibliography

Barrett, Terry. *Criticizing Photographs: An Introduction to Understanding Images.* Mountain View: Mayfield Publishing, 1990.

Edgerton, Harold E. "Foreword." In *Stopping Time: The Photographs of Harold Edgerton.* Ed. Gus Kayafas. Text by Estelle Jussim. New York: Harry N. Abrams, 1987, 7–8.

Edgerton, Harold E., and James R. Killian Jr. *Flash! Seeing the Unseen by Ultra High-Speed Photography.* 2nd rev. ed. Boston, MA: Charles T. Branford, 1954.

———. *Moments of Vision: The Stroboscopic Revolution in Photography.* Cambridge, MA: Massachusetts Institute of Technology, 1979.

Jussim, Estelle. *Stopping Time: The Photographs of Harold Edgerton.* Ed. Gus Kayafas. Text by Estelle Jussim. New York: Harry N. Abrams, 1987.

Places to See Edgerton's Work

George Eastman House, Rochester, New York
Massachusetts Institute of Technology's Edgerton Center, Cambridge, Massachusetts
Massachusetts Institute of Technology Museum, Cambridge, Massachusetts
Museum of Modern Art, New York, New Yokr
San Francisco Museum of Modern Art, San Francisco, California
Schenectady Museum, Schenectady, New York
Smithsonian Institution, Washington, DC
Victoria and Albert Museum, London, England

WALKER EVANS

1903–1975

ALTHOUGH HE REJECTED THE LABEL OF *ARTIST,* WALKER EVANS IS CONSIDERED to be one of the most significant photographic artists of the twentieth century, particularly for his work with the *Farm Security Administration* (FSA) during the Great Depression. He was born on November 3, 1903, in St. Louis, Missouri, to a family of wealth. He grew up in various preparatory schools in Toledo, Ohio, Chicago, Illinois, and New York City, New York. In 1922, he graduated from the boarding high school, Phillips Academy in Andover, Massachusetts. Afterward, he attended Williams College in Williamstown, Massachusetts for one year. In 1923, he moved to New York City with aspirations of becoming a writer and worked a variety of odd jobs for a few years.

In 1926, his parents gave him the financial support to go to Europe, where he attended the Sorbonne University in Paris. His academic studies were centered on literature, and he often referred to himself as a "man of literature" throughout his life. However, he was unsure about his capabilities as a writer and turned to photography as a creative alternative while in Europe. Evans photographed the streets, buildings, and people with a *roll film camera*. While there, he was influenced by the work of French photographer, Eugène Atget, who was well known for his extensive work as a documentary photographer. It is unclear why Evans did not stay in Paris longer than one year. In 1927, he returned to the United States. Evans felt that his experience in Europe gave him a new perspective with which to view American culture.

Upon his return to New York City, Charles Lindbergh had just returned from his solo nonstop flight across the Atlantic Ocean. Several millions of people turned out for the celebration to welcome Lindbergh home to New York City, and Evans had the good fortune to photograph the spectacular event. In *Lindbergh Day Parade* (1927), he captured the uniformed band members complete with hats from behind as they stood crowded together waiting to perform. The ground is covered in littered confetti, alluding to the escalating

excitement and energy of the crowds just as the event was starting. The image is spontaneous, yet the composition is balanced and striking.

He was critical of American commercialism, as was his circle of artists, writers, and intellectuals; yet, ironically, he understood that he must participate in the art world to survive as a photographer. He met philanthropist and editor of the magazine *Hound & Horn*, Lincoln Kirstein, in 1929. Kirstein became a mentor to Evans, easing the way for him into the world of publishing and exhibition. Kirstein even influenced Evans's style by introducing him to the work of photographer **Lewis Hine.** Evans was impressed by his academic approach and the candid realism portrayed in Hine's photographs. This style was in opposition to the leading contemporary *Photo-Secession Movement* of the day, most notably **Alfred Stieglitz, Edward Steichen,** and **Anne Brigman** whose work aimed at expression rather than realism. Evans was aware of Stieglitz's work and that of his colleagues, yet he disagreed with their philosophy and maintained that photography should reflect reality, and indeed photography was not a fine art medium, such as painting or sculpture.

By 1930, Evans was photographing full time while continuing to write on the side. In 1931, Kirstein prompted Evans to work with architect, John Brooks Wheelwright, on a book of nineteenth-century New England architecture. This project marks an important point in the evolution of Evans's style. He needed a camera with a larger format than he was accustomed to using. Photographer Ralph Steiner brought the appropriate equipment for Evans to use and was astonished to learn that Evans needed technical lessons as well. Evans was a quick study and proceeded to create a strong body of work, resulting in 30 photographs that were exhibited at the Museum of Modern Art in 1933 and off and on at several art museums until 1940.

In June of 1935, he was hired by the U.S. *Farm Security Administration* (FSA) for a test assignment in West Virginia and Pennsylvania to photograph the coal mines and industrial towns. His work passed the test, and that September, he accepted a full-time position with the FSA as part of the first group of photographers, which included **Arthur Rothstein,** Carl Mydans, **Dorothea Lange,** and Ben Shahn. It was then that he met the FSA photographer recruiter Roy Stryker. Evans was upfront about his antiestablishment views and that he would work for the FSA without subscribing to any certain ideology. This independent attitude was troublesome for Stryker, yet Evans's work was strong and kept him employed there until 1937. Although Evans's career spanned more than 40 years, he is known primarily for the work he did while working for the FSA during that two-year stint. His projects included traveling through the Southeast, resulting in a body of work that represents some of the earliest photographic documentation of the Deep South.

Evans distanced himself from his subjects, often to such a degree that they were unaware of the photograph being taken. He became famous for capturing a spontaneous moment with a clinical lens that kept his subjects at a literal and emotional distance. This quality

Walker Evans. *Tenant Farmer's Wife, Alabama* (1936, printed 1971). Gelatin silver print, 9⅜ × 7⅛ inches (23.81 × 18.1 cm). San Francisco Museum of Modern Art. SFMMA, Sale of Paintings Fund Purchase. © Estate of Walker Evans.

is present in his work, *Tenant Farmer's Wife, Alabama* (1936). The effects of the economic depression clearly seen on her face, Evans was reporting on the state of the American public and the downfall of the U.S. government, which ironically hired him to do so. He also photographed architecture, streets, and public interiors as in *Barber Shop New Orleans* (1935). The empty space that is typically full of razors buzzing and the social talk between the barbers and clients is quiet. The details of the swivel chairs, towels, scissors, combs, and mirrors on the wall become the central elements in this somber image. He used a Leica camera for this work, which was shared with Ben Shahn. For this reason, his last assignment with the FSA has been questioned as being Shahn's work.

Although he was critical of American journalism and insecure as a writer, Evans accepted a position as an associate editor for *Fortune Magazine* in 1945. He worked there for the next 20 years. In 1965, he left the magazine when he accepted a position at Yale University as a professor of graphic design. During his years at Yale, he continued to create and exhibit his own work. In 1968, he was awarded an honorary degree from Williams College and became a Fellow of the American Academy of Arts and Letters. In 1972, he was the artist-in-residence

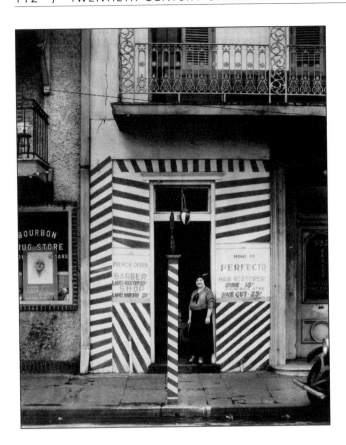

Walker Evans. *Barber Shop, New Orleans* (1935, printed 1971). Gelatin silver print, 9½ × 7⁹/₁₆ inches (24.13 × 19.21 cm). San Francisco Museum of Modern Art. SFMMA, Sale of Paintings Fund Purchase. © Estate of Walker Evans.

at Dartmouth College in Hanover, New Hampshire. In 1974, Evans retired and was made a professor emeritus at Yale.

Evans published numerous articles in periodicals such as *Fortune Magazine, Architectural Record, Hound & Horn, Creative Art, Harper's Bazaar,* and *Mademoiselle.* Additionally, there are dozens of monographs covering his work. Evans's photographs were exhibited in a handful of galleries in New York City and museums such as the Museum of Modern Art, along with the Art Institute at Chicago and the National Gallery of Art at the Smithsonian Institute in Washington, DC. Although his work was included in many group shows and in solo exhibitions, Evans felt that it was more appropriate for photographs to be printed in books than hanging on the walls of galleries.

Much of his personal life remains private. Evans married Jane Smith Ninas in 1941. He died on April 10, 1975, in New Haven, Connecticut. His work was a model for many great photographers to follow including **Helen Levitt, Lee Friedlander,** and **Diane Arbus.** Artist, writer, and educator, Walker Evans documented American life from the 1930s through the early 1970s with technical proficiency and an unsentimental lens, yet with striking poignancy and aesthetic quality.

Bibliography

Ayers, Robert. "Walker Evans: Carbon and Silver." *Artnews* 105, no. 10 (2006): 171.

Evans, Walker. *American Photographs.* Essay by Lincoln Kirstein. New York: Museum of Modern Art, 1938. Reprinted in 1962 and 1989 by MOMA and in 1975 by East River Press.

———. *Wheaton College Photographs.* Foreword by J. Edgar Park. Norton, MA: Wheaton College, 1941.

"The Evans File." *Art Journal* 63, no. 3 (2004): 102–106.

Mora, Gilles, and John T. Hill. *Walker Evans: The Hungry Eye.* New York: Harry N. Abrams, 1993.

Pollack, Barbara. "Walker Evans: Metropolitan Museum of Art." *Artnews* 99, no. 4 (2000): 162.

Rubinfien, Leo. "The Poetry of Seeing." *Art in America* 88, no. 12 (2000): 74–85, 132–135.

"Walker Evans' 'Counter-Aesthetic.'" *Afterimage* 31, no. 1 (2003): 10–12.

Places to See Evans's Work

Allen Art Museum at Oberlin College, Oberlin, Ohio

Birmingham Museum of Art, Birmingham, Alabama

Carnegie Museum of Art, Pittsburgh, Pennsylvania

Center for Creative Photography, University of Arizona, Tucson, Arizona

Cincinnati Art Museum, Cincinnati, Ohio

Corcoran Gallery of Art, Washington, DC

David Winton Bell Gallery at Brown University, Providence, Rhode Island

Detroit Institute of Arts, Detroit, Michigan

Fred Jones Jr. Museum of Art at the University of Oklahoma, Norman, Oklahoma

Harvard Art Museums, Cambridge, Massachusetts

High Museum of Art, Atlanta, Georgia

Hofstra Museum at Hofstra University, Hempstead, New York

Hood Museum of Art, Hanover, New Hampshire

J. Paul Getty Museum, Los Angeles, California

Los Angeles County Museum of Art, Los Angeles, California

Metropolitan Museum of Art, New York, New York

Milwaukee Art Museum, Milwaukee, Wisconsin

Museum of Fine Arts, Houston, Texas

Museum of Modern Art, New York, New York

New York Public Library Digital Gallery, New York, New York: http://digitalgallery.nypl.org

Peabody Essex Museum, Salem, Massachusetts

Pomona College Museum of Art, Pomona, California

Rockford Art Museum, Rockford, Illinois

San Francisco Museum of Modern Art, San Francisco, California

Smart Museum of Art at the University of Chicago, Chicago, Illinois

Smith College Museum of Art, Northampton, Massachusetts

Snite Museum of Art at the University of Notre Dame, Indiana

St. Louis Art Museum, St. Louis, Missouri

Victoria and Albert Museum, London, England

Williams College Museum of Art, Williamstown, Massachusetts

Yale University Art Gallery, New Haven, Connecticut

LEE FRIEDLANDER

b. 1934

CONSIDERED ONE OF THE MOST IMPORTANT PHOTOGRAPHERS OF THE twentieth century, Lee Friedlander is a MacArthur Award winner. With an eye toward the vernacular, he has photographed numerous subjects including cityscapes, industrial sites, patriotic monuments, landscapes, musicians, nudes, and self-portraits. In spite of his varied subjects, his photographs are easily recognizable. He is mischievous and rigorous and is an expert at finding the art in the everyday. His best works demand and deserve a second and third look; otherwise, pieces of the puzzle go amiss.

Friedlander was born in Aberdeen, Washington. After graduating from high school in 1953, he moved to Los Angeles where he studied at the Art Center of Los Angeles. He moved to New York City in 1955, and in 1958, he married Maria DePaoli. Together with his wife and children, he traveled through Europe for a year in 1964. He has taught at the University of California, Los Angeles, the University of Minnesota and Rice University. He took his first trip to Japan in 1977 when he began taking pictures of the landscape. In the last few years, he hasn't strayed far from home since arthritis hampers his movement.

He began his career by following in the streetwise realism of **Walker Evans** and **Robert Frank.** In 1956, he began photographing jazz musicians and blues singers for Atlantic Records album covers.

His recent works are busy, compact, and dizzying. Critic Malcolm Jones claims that, "There is an increasing artlessness to the compositions, a lack of contrivance. Instead, what you get is the pure joy of looking at the world—and looking hard" (59). In all his photographs there is a strong desire to document the world. Friedlander claims that it is self-interest that motivates him, because photographing is a way to understand one's self. In 1970, he wrote, "This search is personally born and is indeed my reason and motive for making pictures" (Johnson 232).

Friedlander's big entrance into the art world came when he was in the Museum of Modern Art's 1967 exhibition, *New Documents*, with **Diane Arbus** and Garry Winogrand.

The purpose of this exhibition was to show new developments in the photographic medium. Friedlander's contribution was his layered street images. From that time on he has been seen as a star photographer in the museum world.

His series of monuments from the 1970s came at a low point for traditional kinds of patriotism, as the Vietnam War was ending, and the Watergate scandal had been exposed. With a sense of humor, he took his shots. Art critic Michael Kimmelman writes, "He photographs a statue of Andrew Jackson on horseback so as to make the former president look as if he's shooing away pigeons, a statue of a doughboy as if he's talking to women on a sidewalk in Stamford, Conn. He photographs the Gateway Arch in St. Louis so that it resembles a stream of urine coming from the flagpole on the state capitol building, a picture more fetching and funnier than it sounds" (B33).

Friedlander's photographs of nudes, from the early 1990s, rejected idealized ideas about women's bodies. Instead, in a voyeuristic manner, they focus on dirty feet, bruises, and sagging flesh in intense detail. Displayed at New York's Museum of Modern Art, these images gave us another way of seeing the human form.

Somehow, Friedlander makes many of his photographs look like large snapshots. In a 1999 New York gallery exhibition of images, which he took while traveling across North America, his small town pictures reveal a sameness in the small towns that made titles of the specific places necessary. Although he fills his images with numerous objects and interactions, he has a highly developed sense of composition. He often frames his scenes by having the viewer look though windows, doors, or fencing. Breaking the rules of composition, he frequently cuts the image in two by placing a vertical line like a telephone pole or a stop sign in the middle of the photograph. Sometimes he hides the subject from view with over-grown trees, thereby making other, more interesting subjects difficult to look at.

In his photograph titled *Las Vegas, Nevada* (2002), instead of getting out of the car to take a shot of the city, he takes it from the inside of the car, capturing the side-view mirror and its reflection, as well as a good part of the automobile's interior. Because one of the objects captured is of the Statue of Liberty, viewers at first think they are looking at a New York scene. But at closer inspection, it is understood that the statue is a copy.

In 2005, the Museum of Modern Art curated a retrospective of almost 500 of his photographs. It became clear that Friedlander could photograph just about any subject. Kimmelman called the artist's exhibition and his talent "big and relentless" (Kimmelman B29). In an effort to explain Friedlander's work, Kimmelman reports on a comment the artist made about a particular photograph. The photographer said, "I only wanted Uncle Vern standing by his new car (a Hudson) on a clear day. I got him and the car. I also got a bit of Aunt Jane's laundry, and Beau Jack, the dog, peeing on a fence, and a row of potted tuberous begonias on the porch and 78 trees and a million pebbles in the driveway and more" (Kimmelman B29).

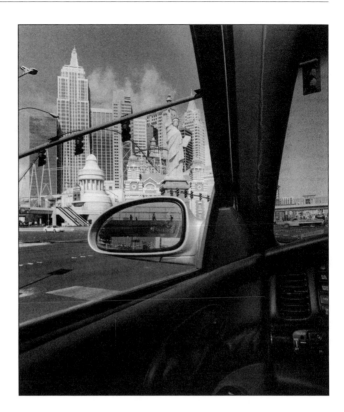

Lee Friedlander. *Las Vegas, Nevada* (2002). Sticks and stones, pl. 100, *Friedlander*, MoMA, pl. 674. © Lee Friedlander, courtesy Fraenkel Gallery, San Francisco.

In 2006, Friedlander photographed behind-the-scenes pictures of models getting prepared to show off the newest New York fall fashions for *New York Times Magazine*. In keeping with his way of working, he portrayed the cramped quarters, the hurried pace, the repetition of dressing and undressing, showing viewers the work part of looking beautiful.

Over the years Friedlander has taken his own picture many times. Using weird angles and distorting close-ups, he constructs multiple personalities. Breaking one more compositional rule, he captures his shadow as a character in a humorous shot. He also portrays himself as a stalker or ghost traversing the American landscape. By using himself as the subject, he makes commentary on the fluidity of his position as he plays both sides of the camera. His witty ambiguity extends to any subject matter. Reflecting on the kind of confusion Friedlander can create, **Jan Groover** points out that in his photograph titled *Putney, Vermont* (1972), you don't know if you are seeing snow and trees through a window, or if you are outside looking directly at the landscape and viewing into a greenhouse or the other side of the image. Playing with the idea that a photograph can be an illusion is one aspect of Friedlander's pictures that makes them so intriguing.

Lee Friedlander has authored 17 books and has won three Guggenheim Fellowships and five grants from the National Endowment for the Arts. His keen ability to compress space and organize chaos marks his long career of jam-packed images portraying everyday

Lee Friedlander. *John Coltrane* (ca. 1950s). American Musicians, plate 339. © Lee Friedlander, courtesy Fraenkel Gallery, San Francisco.

America. Reflecting on Friedlander's images, Kimmelman points out how weird a photograph can be, just like the world we live in.

Bibliography

Barrett, Terry, *Criticizing Photographs: An Introduction to Understanding Images*, 3rd ed. Mountain View, CA: Mayfield Publishing, 2000.

Browne, Alix. Photographs by Lee Friedlander. "Blush, Sweat and Tears." *New York Times Magazine*, October 15, 2006: 72–79.

Friedlander, Lee. *Cherry Blossom Time in Japan*. San Francisco: Fraenkel, 2006.

Gardner, Paul. "'The French Guy in Goggles' & Other Favorite Photographers." *Artnews* 91, no. 3 (1992): 102–107.

Johnson, Brooks. *Photography Speaks: 150 Photographers on Their Art*. New York: Aperture, 2004.

Jones, Malcolm. "The View Master." *Newsweek*, June 6, 2005: 59.

Kimmelman, Michael. "A Sly Virtuoso in Praise of Just Plain America." *New York Times*, June 3, 2005: B29, B33.

Klein, Michael. "Lee Friedlander at Janet Borden." *Art in America* 10 (1999): 168.

Pollock, Barabara. "Lee Friedlander: Museum of Modern Art." *Artnews* 104, no. 8 (2005): 126.

Places to See Friedlander's Work

Art Institute of Chicago, Chicago, Illinois
Bowdoin College Museum of Art, Brunswick, Maine
Center for Creative Photography, University of Arizona, Tucson, Arizona

Cleveland Art Museum, Cleveland, Ohio
Fogg Art Museum, Harvard University, Cambridge, Massachusetts
George Eastman House, Rochester, New York
Minneapolis Society of Fine Arts, Minneapolis, Minnesota
Museum of Contemporary Art, Los Angeles, California
Museum of Fine Arts, Boston, Massachusetts
Museum of Fine Arts, Houston, Texas
Museum of Modern Art, New York, New York
National Gallery of Art, Smithsonian, Washington, DC
New Orleans Museum of Art, New Orleans, Louisiana
San Francisco Museum of Modern Art, San Francisco, California

ANNA GASKELL

b. 1969

AS A PHOTOGRAPHER WHO QUICKLY GAINED NOTORIETY, ANNA GASKELL'S early work focuses on images that remind viewers of Alice in Lewis Carroll's book, *Alice's Adventures in Wonderland*. Through Alice, she explored the supposedly safe and tidy world of young girls that can quickly involve isolation and uncertainty. Casting young girls in the lead role of Alice, and later, teenage girls that represent more generalizable figures, Gaskell works in the traditions of **Cindy Sherman** and **Laurie Simmons** but with a more painterly approach. Her work is unsettling, not only for the sinister worlds she creates, but also because there is no easy way to read her fragmented narrative.

Gaskell was born in Des Moines, Iowa. She was exposed to ideas about the supernatural when her evangelical Christian mother took her and her three brothers to tent meetings around the Midwest. A high school art teacher introduced her to Henri Carrier-Bresson and Cindy Sherman. Gaskell went to Bennington College for two years before transferring to the Art Institute of Chicago where, in 1992, she earned her BFA. She received her MFA from Yale University in 1995.

Her two series, titled *wonder* (1996–97) and *override* (1997), brought her to the attention of the art world. Using dramatic camera angles, Gaskell flawlessly poses her model perfect subjects both singularly and together. Groups of girls, looking like they are from *Alice's Adventures in Wonderland*, are dressed in matching uniforms and placed in ambiguous configurations. These photographs are richly colored, and, like all her work, each photograph seems to be a fragmented part of a larger narrative. Instead of casting a blonde, she uses brown-haired subjects. The poses can parallel scenes from Lewis Carroll's book, but they are not precise. For instance, instead of Alice drowning in her own tears, Gaskell's fully clothed Alice treads water in a swimming pool. To mimic the idea of Alice growing larger and smaller, the photographer transforms the size of her images from 8 × 10 inches to 50 × 60 inches. In this act of changing scale, she once again disrupts ideas about linear narrative.

Both Carroll's and Gaskell's Alice character seems to be vulnerable, somewhat clumsy, and precarious in the space in which she resides. The photographs are not easily read; both the subject and the cool slick presentation entice viewers to take time with the images.

Expanding her ideas about Alice, sometimes twins are cast as Alice in the same frame. We are left to decide whether they represent two sides of the same person or different individuals who look the same. Or perhaps one twin, as she is laid to rest, represents an untimely death. What we are sure about is that Gaskell's Alice is tinged with naughtiness.

In *by proxy* (1999), an exhibition that expands on her *wonder* series, Gaskell uses models that range in age from young girls to young adults. They are dressed like nurses with caps, comfortable shoes, white stockings, and white dresses and are posed in a snowy alpine forest. The character Gaskell creates here is based on Sally Salt from Rudolf Erich Raspe's 1785 *Adventures of Baron Munchausen*. Here they created in the role of the pediatric nurse Genene Jones who, in 1984, was convicted of murdering her patients. As one nurse attends to another, it becomes clear that Gaskell has created a very unsettling and perverse universe.

In more recent years, Gaskell has analyzed another female fiction character: Rebecca in Daphne du Maurier's 1938 novel titled for the female heroine. As she prepared for the 2002 exhibition *half life* at the Menil Collection in Houston, she felt the presence of the deceased Menil family members—which made her think about du Maurier's Rebecca, who felt the lingering presence of her husband's deceased first wife. She also drew inspiration from "The Old Nurse's Story" by Elizabeth Gaskell (no relation) and Henry James's *The Turn of the Screw*. In some of these photographs, the body is segmented where only part of the figure is seen or perhaps just a shadow or a strand of hair. In these images, Gaskell's aim is to create an uncomfortable haunting space by blurring the background of the scene, which is a Victorian manor. She claims, "I'm trying to create a space where there are signs and feelings and emotions that have been there for years and that we are now trying to discover" (Hay AR37). These images present a portrait of someone confronting the personal stories of people who have been in a space before her. The idea for the *half life* came from a desire to create a film installation, and it developed into a combination of still and moving images that moves viewers into her imaginary worlds. Collectively, these photographs do what Gaskell does so well. She places us in an emotional space of uncertainty and fear, perhaps echoing some of her early experiences in religious meeting tents that her mother took her to.

In 2002, a series of her drawings and photographs were published in a book simply titled *Anna Gaskell*. While the drawings were made from 1995 to 2001, the photographs all came from work produced in 2001. The book accompanies the exhibition *Resemblance: Photographs by Anna Gaskell*, which was organized by the Addison Gallery of American Art in Andover, Massachusetts. Her line drawings are somewhat whimsical as they place young girls with cartoon-like exaggeration into gestural poses that evoke a kind of body exploration. The photographs are paired with the drawings as a camera image depicts a hand in

a measuring-like pose placed on a young girl's eye as she sleeps or lies in a hospital bed. The drawing following this image presents a girl covering her eyes. Other drawings and images explore dismembered body parts like hands grasping arms and legs and rows of bare legs cut off just above the knees.

Gaskell continues to work with video, as well as still photography. *Sybil Vane*, which refers to a character in Oscar Wilde's *The Picture of Dorian Gray*, is a video installation with three wall-size projections that portray a woman who stares into the camera with wide-eyed innocence. Here, Sybil represents not only a projection of Dorian Gray's fantasies, but she is also an actress who plays Shakespearian heroines. Although the three women are different, they have a sameness about them as they echo an ideal of beauty.

Anna Gaskell has used photographic techniques such as blurring of focus, dramatic viewpoints, bold contrasts of light and shadow, and foreshortening to evoke feelings that reflect on *film noir*. As a result, the photographs produce a psychological sense of uneasiness. Her work addresses our unconscious realms where fear and horror delightfully play with fantasy.

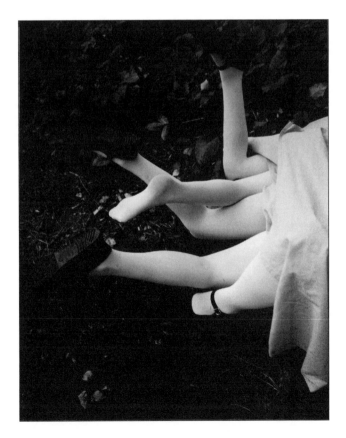

Anna Gaskell. *Untitled #25 (override)* (1997). C-print, laminated, and mounted on Sintra 19⅞ × 15½ inches (49.5 × 39.7 cm). Solomon R. Guggenheim Museum, New York. Gift, Dakis Joannou, 1998. 98.4649.

In all this complexity, the artist poses questions about female identity and sexuality. While often humorously presented, issues of incest, pedophilia, voyeurism, and homosexuality are explored. For example, in *Untitled #31 (hide)* (1998), the body of a young girl is shown from the waist down, trapped in a corner as hands from both sides of the walls pull at her tights. These actions could be playful, but we aren't sure. In all of Gaskell's photographs, we sense a world that is both familiar, and yet elusive at the same time.

Gaskell lives in New York with Douglas Gordon, an artist from Glasgow, and their son, Gray.

Bibliography

Avgikos, Jan. "Anna Gaskell: Casey Kaplan." *Artforum* 36, no. 6 (1998): 93.

Clifford, Katie. "Anna Gaskell." *Artnews* 97, no. 3 (1998): 176.

Drutt, Matthew. *Anna Gaskell: half life*. Houston: The Menil Foundation, 2002.

Galloway, David. "Anna Gaskell." *Artnews* 102, no. 8 (2003): 146, 152.

Gaskell, Anna. *Anna Gaskell*. Andover, MA: Addison Gallery of American Art, Phillips Academy, 2002.

Hay, David. "Photographs on a Wall, Doors to a Haunted Manor." *New York Times*, September 29, 2002: AR37.

Richard, Frances. "Anna Gaskell: Casey Kaplan." *Artforum* 38, no. 7 (2000): 130–131.

Places to See Gaskell's Work

Addison Gallery of American Art, Phillips Academy, Andover, Massachusetts
Des Moines Art Center, Des Moines, Iowa
Guggenheim Museum, New York, New York
Menil Collection, Houston, Texas
Museum of Contemporary Art, Grand Avenue, Los Angeles, California
Orlando Museum of Art, Orlando, Florida

NAN GOLDIN

b. 1953

THE LIFE OF INTERNATIONALLY RENOWNED ARTIST NAN GOLDIN IN MANY ways is an open book, seen through the photographic record that is her art. Nancy Goldin was born on September 12, 1953, in a suburb of Washington, DC. Goldin grew up in a liberal Jewish family with three siblings. Her mother was a social activist and often took the children with her to attend civil rights demonstrations, which instilled a strong social consciousness in Goldin. As a young girl, she looked up to her older sister Barbara Holly as a best friend and role model. Tragically, Barbara Holly committed suicide in 1965, which was a pivotal point in all of their lives and caused much distress in the family. Her parents refused to confront the reality of the event and asked the children not to talk about her death. Unable to accept the denial and secrecy, Goldin ran away to live with various foster families.

In search of an alternative to traditional high school education, she started attending the Satya Community School in Lincoln, Massachusetts, just outside of Boston. At Satya, a teacher gave her a camera; and before long, Goldin became the school photographer. At the early age of 15 years old, she began documenting her life's journey. As with most dedicated photographers, she carried a camera wherever she went. Goldin immediately began photographing her new friends who had now become her family. As the memories of her sister faded, she regretted not having photographs of Barbara Holly. Goldin saw photography as a way of documenting the lives of those around her and subsequently of making a visual diary of her own life. She spoke about the importance of memory in a 2003 interview, "It is about keeping a record of the lives I lost, so they cannot be completely obliterated from memory. My work is mostly about memory. It is very important to me that everybody that I have been close to in my life I make photographs of them" (Mazur and Skirgajllo-Krajewska, 2003, par. 5).

Having interest in fashion photography, Goldin often dressed up with her friends in glamorous costumes for staged portraits. For instance, in her work *Ivy in the Garden; back,*

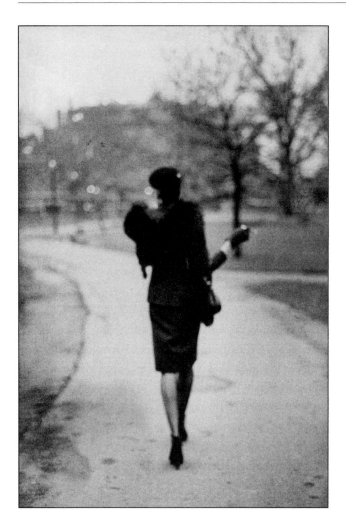

Nan Goldin. *Ivy in the Garden; back, Boston* (1973), printed later. Gelatin silver print, 18¹¹/₁₆ × 12⁷/₁₆ inches (47.47 × 31.59 cm). San Francisco Museum of Modern Art. Collection of the Prentice and Paul Sack Photographic Trust. © Nan Goldin.

Boston (1973), the central character, Ivy, is dressed in a skirt suit with hat, shawl, gloves, and pumps. In this black-and-white image, Ivy is in the forefront in clear focus walking away from the camera into a gray, fuzzy landscape of leafless trees and blurred buildings. This image along with all of her early work is done in black and white. It was only after she was in college that color photography became an integral component of her art work.

After completing her studies at the community school, Goldin enrolled at the Boston College of Art. At the Boston School of Art, she began to experiment with color, which would become a key element to the overall effect in her work. She used artificial lighting to accentuate bright colors and deep hues when making *Cibachrome* prints from slides.

Many of the people that she met while in college became her close friends and subjects for her photography, including David Armstrong, who encouraged her to change her name from Nancy to Nan. Armstrong introduced Goldin to a community of transvestites at

a local Boston nightclub, The Other Side, where she started photographing them. Goldin was enthralled with the drag queen subculture. As she made friends, they began to share secrets with her, and she was invited into their private lives to photograph every aspect of their daily existence. Influenced by fashion photography and the drag queen persona, many of these photographs have elements of glamour yet always contain sobering elements of reality. Goldin gives us a window into their world, yet the act of looking is not voyeuristic because the photographer is not looking in; she is a part of that world. Thus, Goldin gives us something beyond the superficial act of looking.

Although her subjects shift throughout her career depending on location and where she is in her life, Goldin continues to have fascination with people who transform themselves through drag. One of her most famous photographs, *Jimmy Paulette & Misty in a Taxi, New York City* (1991), was a snapshot taken on the way to a New York gay parade. Jimmy Paulette and Misty sit side by side in full drag with bright lipstick and coiffed wigs, staring directly into the camera creating a provocative and solemn composition.

After graduating from the Boston College of Art in 1978, she went to live in the Bowery of New York City. Eager for diverse experience, which she felt gave her the necessary empathy to create her work, Goldin immersed herself in a dark world of drugs, parties, abuse, and interpersonal conflict. She photographed every aspect of this life and revealed a wide complexity of emotions. That same year she spent some time in London, where she was exposed to the Punk Rock movement and the skinhead subculture. Again she immersed herself into an unknown world and had the privilege of photographing their most private moments.

Upon returning to New York City, Goldin worked nights as a bartender before her work as a photographer could provide adequate financial support. Her work schedule left little time for the dark room; however, Goldin's time in the bar exposed her to another group of subjects. She photographed in her spare time and exhibited her work in the form of slideshows that were accompanied by music. She presented these infamous slideshows anywhere she could, at her home or in punk rock clubs such as the Rafiks Underground Cinema, the Mudd Club, and Maggie Smith's Tin Pan Alley.

In the early 1980s, she started her life-long project entitled *The Ballad of Sexual Dependency*, which continues to evolve today. This work consists of thousands of images of people from Goldin's life, literally chronicling her journey through the eyes and faces of those people she spent the most time with. *The Ballad* is her ultimate slideshow with musical accompaniment ranging from classical to rock. She aims to reveal a raw and truthful state of being in each image, whether happy or tragic. From 1981 to 1984, she was in a tumultuous relationship fraught with miscommunication, drug use, and violence. The images captured from this time period are windows into this dark and lonely relationship. Goldin photographed various points in time revealing the nature of their connection. For instance, in *Nan and Brian in Bed, New York City* (1983), she reveals an unhappy couple in a state of disconnection as they share the intimacy of a bed. In another image, *Nan, one month after*

being battered, New York City (1984), Goldin exposes the harsh reality of domestic abuse as evidenced by her facial bruises and bloodshot eye. Other images show the effects of drug abuse on the couple. In 1988, Goldin entered a drug rehabilitation center during which time she took extensive self-portraits with the institutional backdrop as a constant reminder of her circumstance. These portraits represent another chapter of her life, in many ways a solitary and introspective journey, a departure from her previous work that focused almost exclusively on her relationship with others.

In the 1980s, many of Goldin's friends began to be diagnosed with AIDS and subsequently were dying from related complications. She created diaries of those suffering and dying from the disease. For example, *The Cookie Portfolio* (1976–89) is a series of photographs of Goldin's friend Cookie Mueller, who died of AIDS at the age of 40. Goldin is conscious of the political nature in her work of which she commented:

> It [art] is very political. First, it is about gender politics. It is about what it is to be male, what it is to be female, what are gender roles…Especially *The Ballad of Sexual Dependency* is very much about gender politics, before there was such a word, before they taught it at the university.…I made this slideshow about my life and my past life. Later, I realized how political it was. It is structured this way so it talks about different couples, happy couples. For me, the major meaning of the slideshow is how you can become sexually addicted to somebody and that has absolutely nothing in common with love. (Mazur and Skirgajllo-Krajewska, 2003, par. 9)

Goldin traveled the world in search of new experiences, always leading to new subject matter. In 1991, she went to Germany for three years on a study grant from the DAAD (The German Academic Exchange Service). In the mid-1990s, Goldin traveled to Tokyo where she photographed youth subcultures and worked with the Japanese photographer Nobuyoshi Araki on a book project. Goldin's work has been exhibited all over the world in venues such as the Whitney Museum of American Art in New York City, the White Cube Gallery in London, and the Institute of Contemporary Art in Boston, among others. In 2002, she badly injured her hand, which affected her ability to work. In 2006, she was granted membership to the French Order of Arts and Letters and received the grade of commandeur, which is the highest level of accommodation made by the French ministry of culture. She currently lives between Paris and London. Nan Goldin has contributed to the world of photography an expansive oeuvre that maps her complex journey into the private lives of people living on the margins of society.

Bibliography

Costa, Guido. *Nan Goldin 55*. New York: Phaidon, 2001.

Greene, D.A. "Nan Goldin: I'll be your mirror" [Whitney Museum of American Art, New York, exhibit]. *Creative Camera* 343 (December 1996/January 1997): 43.

Holert, Tom. "Nan Goldin Talks to Tom Holert." *Artforum International* 41, no. 7 (March 2003): 232–233, 274.

Lovelace, C. "Nan Goldin at Matthew Marks." *Art in America* 89, no. 6 (2001): 127–128.

Mazur, Adam, and Paulina Skirgajllo-Krajewska. *If I want to take a picture, I take it no matter what: Interview with Nan Goldin.* Warsaw: Zeta-Media, 2003. Retrieved December 19, 2006, from http://fototapeta.art.pl/2003/ngie.php.

Reid, Phyllis Thompson. "Nan Golding—Dark Diary." *Aperture* 176 (Fall 2004): 62–75.

Walsh, Maria. "Nan Goldin: Whitechapel Art Gallery, London." *Art Monthly* 254 (March 19–20, 2002).

Wolf, Matt. "Nan Goldin." *Flash Art (International Edition)* 39, no. 123 (May/June 2006).

Places to See Goldin's Work

Astrup Fearnley Museet for Moderne Kunst, Oslo, Norway
Castello di Rivoli Museum of Contemporary Art, Torino, Italy
Centre Pompidou, Paris, France
Fotomuseum, Winterthur, Switzerland
Frans Hals Museum, Haarlem, Netherlands
Guggenheim Museum, New York, New York
Harn Museum at the University of Florida, Gainesville, Florida
Harvard University Art Museums Database, Cambridge, Massachusetts
Jersey Heritage Trust, St. Helier, UK
Jewish Museum of New York, New York, New York
Ludwig Museum of Contemporary Art, Budapest, Hungary
Museum of Contemporary Art, Los Angeles, California
Museum of Fine Arts, Boston, Massachusetts
National Museum of Contemporary Art, Athens, Greece
New York University Library, New York, New York
San Francisco Museum of Modern Art, San Francisco, California
Tate Gallery, London, England
Victoria and Albert Museum, London, England

JAN GROOVER

b. 1943

JAN GROOVER'S STILL LIFE PHOTOGRAPHS ARE OF THE MOST PECULIAR and often mundane objects, such as kitchen utensils, bones, and children's toys, to create formally exquisite compositions.

She was born in Plainfield, New Jersey, in 1943. Groover attended Pratt Institute, where she earned her BFA in 1965. Directly after completing her undergraduate studies, she went on to graduate school. Groover enrolled in the art program at Ohio State University, where she received her MA in 1970. Just after graduation, she went to work as an art teacher. Classically trained as a painter, Groover taught abstract painting at the University of Hartford in Connecticut. Meanwhile, she started to experiment with photography, which quickly enraptured Groover, becoming her medium of choice.

In 1972, Groover gave up painting for good and turned her attention to photography. However, her background in painting and advanced knowledge of color theory shows through in much of her photography. Of primary concern to Groover is attention to formalist details. In an early black-and-white photograph taken in New York City, *Lower Manhattan* (1973), the frame is organized by the lines of the buildings, cars, trucks, and even the lines in the street. The balanced composition is abstract upon first glance, a study of shape, form, and rhythmic lines.

Inspired by the still life paintings of Paul Cezanne, Groover began to photograph table top compositions of fruit and other sundry objects. It was not long before Groover moved away from the usual "fruit in a bowl" still life composition. In *Untitled* (1979) a grouping of kitchen utensils and pots creates a play of light and shadow against the shiny, smooth surfaces. The close-up shot distracts from the actual objects and focuses on the smooth surfaces and reflected light off the silver shapes. In another still life with the same objects, Groover shoots the image from a bird's eye view, peeking down on top of the objects placed in a stainless steel sink. The field of silver reflection is interrupted by a smooth, green bell

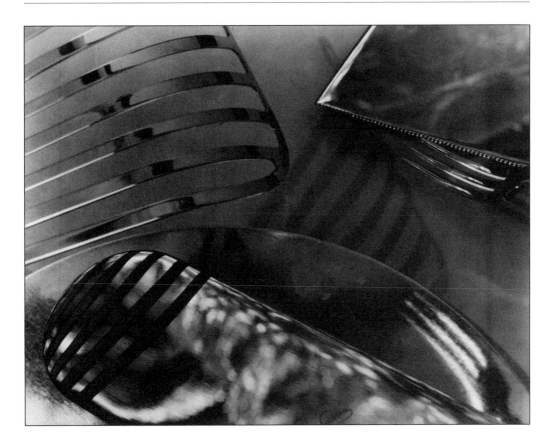

Jan Groover. *Untitled* (1979). From the series *Kitchen Still Lives.* 16 × 20 inches, chromogenic color print, KSL 069.3. Courtesy Janet Borden, Inc.

pepper resting inside the pot. In another composition, Groover adds texture with food, and the reflection of a squash in one pot. In yet another work, Groover positions large, green, organic plant leaves next to the manufactured perfection of the metal fork. An abstract close-up of the plant leaves recalls the work of **Edward Weston,** which is deliberate as Groover is constantly making reference to art history.

While living in New York City, Groover commuted to Purchase, New York, to teach at the State University of New York for a short stint. Eventually, she left New York City and moved to the Dordogne region of France. For a while she stepped out of the studio and started to photograph her home in the French countryside and the immediate natural surroundings. These photographs are a departure from her usual in-studio still life that she controls completely. Another notable series of work includes sociologically motivated images of people's yards, filled with everything from toys, swings, flowers, and yard art to barbeques and debris.

However, she eventually returned to the studio and the still life composition. She continued to explore the still life, while venturing into new technology and presentations.

In early 2001, she made a series of digital photographs, using a color inkjet printer to create pastel prints. Each composition is cluttered with items too random to not have been deliberately thrown together; part of a skull, loose bones, a toy horse, a blue plastic wine glass, a cherub, varied fabric swatches, and bits of painted and colored paper. The soft pastels give the photograph a cheerful feel that contradicts the content that is confusing and even disturbing.

Groover has achieved success evidenced by two grants from the New York State Council on the Arts, the National Endowment for the Arts grant, and a fellowship from the Guggenheim Memorial Foundation. She has published several monographs of her work and has shown her work in many exhibitions, in venues such as the Baltimore Museum of Art, the Cleveland Museum of Art, Corcoran Gallery of Art in Washington, DC, International Center of Photography in New York City, and the George Eastman House of Photography in Rochester, New York. In 1987, the prestigious Museum of Modern Art in New York City hosted a *retrospective exhibition* of her work.

Groover lives in a small village in the Dordogne region of France with her husband, artist and critic Bruce Boice. Regarded for her skills in a wide range of photographic techniques and equipment, Groover's work often makes reference to her art historical knowledge. Painter, art historian, and photographer Jan Groover merges her knowledge and skills to create inventive compositions, resulting in a fresh approach to the traditional still life.

Bibliography

Groover, Jan. *Jan Groover: Photographs*. Boston: Little, Brown, 1993.

———. *Pure Invention—The Tabletop Still Life*. Constance Sullivan and Susan Weiley, Eds. Washington, DC: Smithsonian Institution Press, 1990.

King, Sarah S. "Jan Groover at Janet Borden" [New York; exhibit]. *Art in America* 85, no, 1 (1997): 100.

Kismaric, Susan, and Jan Groover. *Jan Groover*. New York: Museum of Modern Art, 1987.

Rosen, Randy, and Catherine C. Brawer. *Making Their Mark: Women Artists Move into the Mainstream, 1970–1985*. New York: Abbeville Press, 1989.

Sullivan, Constance, Ed. *Jan Groover: Photographs*. Boston: Little, Brown, a Bulfinch Press Book, 1993.

Tuchman, Phyllis. "Jan Groover at Janet Borden." *Art in America* 90, no. 9 (2002): 131.

Places to See Groover's Work

Charles Isaacs Photographs Inc., New York, New York
Cleveland Museum of Art, Cleveland, Ohio
Janet Borden Gallery, New York, New York
Museum of Contemporary Photography, Chicago, Illinois
Photo Gallery International, Tokyo, Japan
Robert Klein Gallery, Boston, Massachusetts
San Francisco Museum of Modern Art, San Francisco, California

LEWIS HINE

1874–1940

LEWIS WICKES HINE BELIEVED THAT THE CONCERNED PHOTOGRAPHER'S role was to show things that had to be corrected and things that should be appreciated. He is best known for his compelling pictures of immigrant families on Ellis Island, his portrayal of child labor practices and the negative effects of industrialization in the early twentieth century, and his stunning images of the construction of the Empire State Building.

Hine was born in 1874 in Oshkosh, Wisconsin, where his father worked in a coffee shop and restaurant. After high school, young Hine was employed in an upholstery factory, where he made low wages for working long hours. Later, he found employment in a clothing store, a water filter company, and a local bank. By the early 1900s, both his father and mother had passed away. In 1900, he began studying at the University of Chicago. He also attended the School of Education at New York University where, in 1905, he received a PdM (education) degree. It is unclear when Hine started using the camera, but some photographs are dated 1904; he was fairly skilled by 1905.

In 1901, he came to New York City to teach at the Ethical Culture School, where morality and responsibility were foundational lessons, and the approach to teaching was experimental. He taught geography and nature study there until 1908. Coming to the city when industrialization was transforming urban spaces, he focused on the chaos and degradation it was causing. At the end of the nineteenth century, labor practices were shifting with populations who were moving from rural to urban spaces. Old and diverse ways of living were converging, creating a new America, and both hope and despair were strong and present emotions. Hine's wish was to find a new kind of humanity growing from urban industrialism, but what he saw made him angry. People were living in tenements that stank, death tolls were rising, young children were working long hours, and disease was rampant. He believed that if people learned about these shameful aspects of American society, they would want progressive reform.

Hine retuned to Oshkosh in 1904 to marry Sara Ann Rich, a teacher, and together they established their home in New York. Shortly afterward, he began photographing Ellis Island immigrants with the goal of encouraging respect for the new residents at a time when most citizens expected them to do hard, dirty, dangerous work. Hine hoped his photographs would help overcome prejudices, and in keeping with this goal, he took his students to Ellis Island to photograph with him. He approached his subjects in a polite and somewhat personal manner and attempted to give them individuality and a participatory voice by moving the camera in close. As a result, viewers often feel as if they could form a relationship with his subjects.

In 1907, Hine went to Washington, DC, to document the slum conditions in black neighborhoods. Several years later, he opened a studio. In 1907, he became a photographer for the National Child Labor Committee (NCLC). He amassed such a strong body of work on child labor practices that, in 1909 and 1910, he was able to address the membership of the NCLC at each of their annual conferences. Hine began his long-term association with the progressive journal *Survey* in 1907 when the editor, Paul Kellogg, hired him to be the photographer for a survey of social conditions in Pittsburgh. Hine sometimes referred to

Lewis Hine. *Sadie Pfeiffer, Spinner in Cotton Mill, North Carolina* (1908). Courtesy of The J. Paul Getty Museum.

himself as a spy as he gained entrance to factories and mills by pretending to be a vendor, salesman, fire inspector, or even an industrial photographer who wanted to photograph a machine, posing a child nearby for a sense of scale. Sometimes he arrived at his site very early in the morning to gain entrance; at other times he gained access to a site at lunchtime after the manager had left for a meal. *Girl Knitting Stockings in a Southern Mill* (1910) is an image of a very young girl, standing on a box in front of a knitting machine. Other workers of varying ages stand beside her, in back of her, and across from her. The perspective comes slightly from below as if Hine (and the viewer) is looking up at her as she intensely does her work.

In 1913 alone, Hine traveled twelve thousand miles throughout the United States photographing the harsh lives of hundreds of people. In 1918, he terminated his association with the NCLC and joined the American Red Cross. He had the rank of captain and a steady salary. Under their direction, he photographed Europe. His images were used to educate the public about the civilian experience during the difficult years just after the war. At the end of the 1920s, Hine again worked with the NCLC.

The *Photo-Secessionist Movement* was of interest to Hine, even if he didn't agree with it in principle. Although he knew **Alfred Stieglitz,** Hine had little interest in artfully posed nudes or retouched landscapes. Instead of spending time at the New York Camera Club and looking toward the life of an artist, he focused his attentions on those who were oppressed and disenfranchised in an effort to make people's lives better. In spite of his focus on hunger, poverty, and adverse working conditions, he depicted his subjects with respect, incorporating portrayals of hopefulness for the future.

In his later years, Hine had trouble meeting his financial obligations. His wife suffered from asthma and often had severe attacks. By 1938, he was desperately looking for work and spent his time trying to sell his photographs. Survey Graphic, an organization he worked with for three decades, could help him with only small amounts of money since they were also in difficult circumstances. He had hopes of working for the Farm Security Administration, but Roy Stryker refused to hire him. Eventually, Hine was forced to go on welfare. He was unable to pay the mortgage on his house and had to foreclose, although he was permitted to live in his home on a month-to-month basis. His situation became even worse when Sara Rich Hine died on Christmas morning of 1938. Together they had one son who was born in 1912.

While photographers and journalists rushed to his aid by writing about him and organizing an exhibition of his work at the Riverside Museum, Hine was already too impoverished and weak to regain his strength. He died in November of 1940. He left his entire oeuvre to New York's Lower East Side Photo League.

Hine's photographs were influential in the legislative battle against child labor by changing public opinion. His images were also used by the press and were displayed in numerous exhibitions. In his lifetime, he photographed the Hull House in Chicago, working conditions

Lewis Hine. *Gracie Clark, Spinner, With Her Family, Huntsville, Alabama* (1913). Courtesy of The J. Paul Getty Museum.

in Augusta and Macon, Georgia and Maryland, street trades in Delaware and Hartford and Bridgeport, Connecticut, the textile mills in New England, glassmaking in New Jersey, and the oyster packing and tobacco industries in the Gulf States. He documented children working in Illinois factories, Alabama cotton mills, varying mining operations, and canneries all over the country. Writing about his investigations in 1911 he stated:

> A line of canning factories stretches along the Gulf coast from Florida to Louisiana. I have witnessed many varieties of child labor horrors…but the climax, the logical conclusion of the "laissez-faire" policy regarding the exploitation of children is to be seen in the oyster-shuckers and shrimp-pickers in that locality. (Naomi Rosenblum 19)

Hine is perhaps the most successful and well-known photographer of social welfare work in the United States. Although he was not permitted to work for the Farm Security Administration in the 1930s, he did work with the Tennessee Valley Authority, the Works Progress Administration, and other New Deal agencies. He wanted his work to be seen as a "photo story." As a photojournalist, he gave pictorial voice to the common man, woman, and child with the intent of creating a more informed and active citizenry. He consistently

took a moral stance with his work, and his photographs have become important documents of the cultural history of progressivism. Beyond this admirable accomplishment, he was responsible for developing an audience for street photography and a modern vernacular aesthetic.

Bibliography

Guimond, James. *American Photography and the American Dream*. Chapel Hill: The University of North Carolina Press, 1991.

Gutman, Judith Mara. *Lewis W. Hine: Two Perspectives*. New York: Grossman, 1974.

Kaplan, Daile. *Lewis Hine in Europe: The Lost Photographs*. New York: Abbeville Press, 1988.

Rosenblum, Naomi. "Biographical Notes." In *American & Lewis Hine: Photographs 1904–1940*. Foreword by Walter Rosenblum; Biographical Notes by Naomi Rosenblum; Essay by Alan Trachtenberg; Design by Marvin Israel. New York: Aperture, 1977, 16–25.

Rosenblum, Walter. "Foreword." In *American & Lewis Hine: Photographs 1904–1940*. Foreword by Walter Rosenblum; Biographical Notes by Naomi Rosenblum; Essay by Alan Trachtenberg; Design by Marvin Israel. New York: Aperture, 1977, 9–15.

Westbrook, Robert. "Lewis Hine and the Ethics of Progressive Camerawork." *Tikkun* 2 (1987): 24–29.

Places to See Hine's Work

Avery Library, School of Architecture, Columbia University, New York, New York

Brooklyn Museum of Art, Brooklyn, New York

George Eastman House, Rochester, New York

Hine Collection, Local History and Genealogy Division, New York Public Library, New York, New York

J. Paul Getty Museum, Los Angeles, California

Library of Congress, Washington, D.C.

Museum of Fine Arts, Houston, Texas

San Francisco Museum of Modern Art, San Francisco, California

Willams College Museum of Art, Williamstown, Massachusetts

DOROTHEA LANGE

1895–1965

AS AN ARTIST BEST KNOWN FOR HER RESPECTFUL AND COMPASSIONATE photographs of farm workers taken during the Great Depression, many of Dorothea Lange's images are well known to the general public. In fact, Roy Stryker, who directed the *Farm Security Administration's* (FSA) Historical Section, referred to Lange's *Migrant Mother* (1936), taken in Nipomo, California, as the photograph of the FSA era. But Lange's excellent body of work extends far beyond the Depression and Dust Bowl years. She also photographed Japanese Americans who were interned during World War II, Utah's Mormon cultures, shipbuilders in Richmond, California, families in Ireland, and many other ethnic communities. At the end of her life, when illness dictated that she stay closer to home, she intimately photographed her grandchildren.

Lange was the first of two children born to a German immigrant family of lithographers in Hoboken, New Jersey. At seven she contracted polio, which left her disabled with a limp, causing her to think of herself as an outsider. When Lange was 12, her father left the family, an experience that was so painful for her that she didn't speak about it to anyone, even later on in life. Along with her mother and brother, she moved in with her maternal grandmother; although a talented dressmaker, her grandmother was a difficult woman who drank too much. Lange went to Public School 62 in New York City with Jewish children, further adding to her view of the world that she was different. Her high school experience at the Wadleigh High School for Girls was noted to be only somewhat better. Because her mother wanted her to have a career, she was sent to a teacher-training program. She soon dropped out and began working in a series of photography studios. Lange had wanted to be a photographer even before she owned a camera. In 1917, she took a course at Columbia University taught by Clarence White, but her skills were mostly learned through experience.

In 1918, she left New Jersey and settled in San Francisco. It was during this time that she dropped her father's name of Nutzhorn and took her mother's name, Lange. Her husband and children didn't discover her birth name until after her death, so determined was Lange

to remove her father's abandonment from her life. Lange's work soon attracted the admiration of Sidney Franlin, an investor, who financed her in her own studio. Success came quickly as she made portraits of wealthy people in the area. In 1920, she married painter Maynard Dixon, who was 21 years older than she. The marriage lasted 15 years and produced two sons. Her second husband, Paul Taylor, whom she married the same year she divorced Dixon, provided her with a professional companion and supporter, as well as a loving partner. Taylor was a professor of economics at the University of California at Berkeley, but he may be better described as a social scientist. A scholar with a national reputation, he recognized that the country's poverty during the Depression was partially due to the misuse of soil. Taylor and Lange often traveled together, around the country as well as to Asia, South America, Egypt, and India. Because they both had demanding full-time jobs, they sent their five children (three were from Taylor's previous marriage) off to school or elsewhere to provide freedom to work. This decision caused her great inner conflict and distress as she recognized the importance of maternal bonding but knew she had little time to practice it. When the family got together for holidays, she was often angry, demanding, or disagreeable, perhaps in part due to the beginning stages of ulcers. Trying to successfully accommodate both family and career, for Lange, was difficult.

Although Lange had financial stability in her portrait studio, she was disturbed by spending her days with wealthy people while just outside the doors of her business hungry people were desperately looking for work. Capitalizing on her ability to go unnoticed in crowds, she

Dorothea Lange. *Mexican-American, San Francisco* (1928). Courtesy of Worcester Art Museum, Worcester, Massachusetts.

began to take pictures of breadlines, May Day demonstrations, strikes, and men sleeping in parks and in unemployment lines. She was struck by the way people looked when down on their luck through no fault of their own, and she hoped that her work would temper the social injustice she was witnessing. *White Angel Breadline* (1933) was from this period, and it was the first photograph of her many images to become widely known: A hunched-over man wearing a tattered hat holds a tin cup in his hands, hoping for a handout. His back is to several other figures that are also hungry. Although the photo is formally well composed, it is primarily the content of the image that is so striking.

Her career really blossomed when she joined the FSA in 1935, taking thousands of pictures that illustrated both the poverty and dignity of her subjects. She approached oppressed farm families with both humility and respect. Holding her Rolleiflex camera at waist level, she captured a view that often looked up at her subjects, thereby giving them strength and resilience. She focused on the everyday, simple things that communicated easily and well: gestures, the ways in which her subjects stood, and close-ups of gnarled hands, bare feet, and the simple tools of the worker.

Migrant Mother, Nipomo, California (1936) is characteristic of Lange's photographs because it shows a riveting image of a woman who has clearly struggled to keep her children

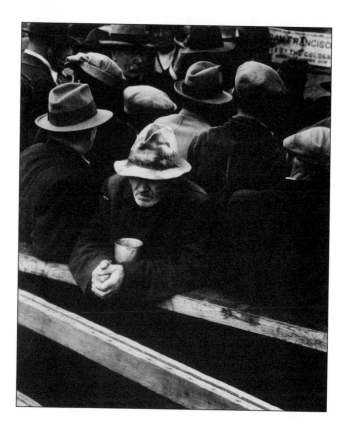

Dorothea Lange. *White Angel Breadline, San Francisco* (1933). Courtesy of Worcester Art Museum, Worcester, Massachusetts.

fed and sheltered. The way that she looks out on the world is tense with fear for the future. It is this kind of image that John Steinbeck studied as he worked on *The Grapes of Wrath*, published in 1939. *Migrant Mother* has become so well known that it has been used outside the art world, appropriated, changed, imitated, and re-contextualized. But many of her other photographs are equally as compelling. Sometimes she told her story by framing a noteworthy gesture made by one of her subjects. In *Migratory Cotton Picker, Eloy, Arizona* (1940), she captures a man as he extends his strong hand, palm out, across his mouth. It is a moment in time that is both straightforward and ambiguous. *Woman of the High Plains, Texas Panhandle* (1938) also makes use of a gesture with the hands as one long arm reaches behind the subject's neck to cup her tired head while the other hand reaches to her forehead in despair. A field looms behind her, as does the massive, open sky. Often Lange is able to communicate emotion without photographing a face. Her figures in *Back* (1935) and *Back* (1938) both show men against the sky, backs to the viewer, with hands that reach behind them in ways that express exhaustion but not resignation.

Lange had a strong, independent, and energetic make-up. She had trouble with authority, which, in her dealings with Rod Stryker who supervised her work for the FSA, got her

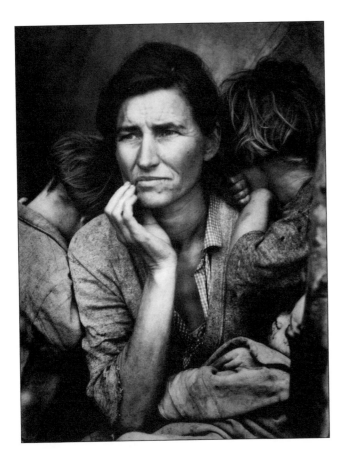

Dorothea Lange. *Migrant Mother, Nipomo* (1936). Courtesy of Worcester Art Museum, Worcester, Massachusetts.

repeatedly dismissed and rehired in the five years she worked for him. She refused to allow anyone to tamper with an image she was about to shoot, and she was furious when anyone changed or manipulated one of her photographs after they were taken. Pinned to the door in her darkroom was a quote from Francis Bacon that said:

> The contemplation of things as they are
> Without error or confusion
> Without substitution or imposture
> Is in itself a nobler thing
> Than a whole harvest of invention. (Elliott 6)

In 2006, close to 800 of Lange's images from 1942—of the internment of 110,000 people of Japanese descent—were unearthed from the National Archives. First having been impounded by the government and later neglected, they astutely depict the horrible conditions of the camps. Hired by the War Relocation Authority, she visited 21 locations. In spite of the restrictions that the government placed on her visits, with her strong determination she was able to capture a shameful time in U.S. history.

Being a photographer was sometimes physically challenging for Lange. Her limp could cause discomfort, and she was keenly aware of experiencing the world with a body that had a disability. This disability appears to have given her insight into how to understand the body and its relationship to the environment and work. Reflecting on how her limp was key to her identity, she said, "I was physically disabled, and no one who hasn't lived the life of a semi-cripple knows how much that means. I think it perhaps was the most important thing that happen[ed] to me, and formed me, guided me, instructed me, helped me, and humiliated me" (Stein 59). Her work tends to focus on the body more than other documentarians working during the 1930s, whose work is more environmentally oriented. Lange thought of the body as architecture, understanding it in a developmental way that builds and forms who we are.

Not only did Lange's work appear in newspapers and magazines, but once the halftone process was perfected, her photographs appeared in books. Published in 1939, *An American Exodus* was one of the most significant pioneering photography books. Collaboratively created, it mixed Paul Taylor's words with Lange's images. Several books followed, and in 1952, she helped found the magazine *Aperture*. In the 1950s, she began to teach her skills to others. Increasingly her health made it difficult for her to travel, and she began photographing her grandchildren in earnest, as she took her camera with her everywhere she went.

In 1964, she was diagnosed with terminal cancer of the esophagus. She used her last few months to work on a retrospective of her work for the Museum of Modern Art in New York City. A television crew shot film of her working as she selected photos for the exhibition.

Lange saw the camera as a tool. She once said, "The camera is an instrument that teaches people how to see without a camera" (Sandler 79). Lange's ability to help us see the

underclass and oppressed, as well as the strength of the human spirit, changed the political landscape of U.S. history.

Bibliography

Daniels, Roger. "Dorothea Lange and the War Relocation Authority: Photographing Japanese Americans." *Dorothea Lange: A Visual Life*, ed. Elizabeth Partridge. Washington, DC: Smithsonian Institution Press, 1994, 45–56.

Elliot, George P. "On Dorothea Lange." *Dorothea Lange*. New York: Museum of Modern Art, in collaboration with the Los Angeles County Museum of Art, the Oakland Museum, and the Worcester Art Museum, 1966, 6–14.

Martin, Elizabeth, and Vivian Meyer. *Female Gazes: Seventy-five Women Artists*. Toronto: Second Story Press, 1997.

Meltzer, Milton. *Dorothea Lange: A Photographer's Life*. New York: Frarrar Straus Giroux, 1978.

Morris, Linda. "A Woman of Our Generation." *Dorothea Lange: A Visual Life*, ed. Elizabeth Partridge. Washington, DC: Smithsonian Institution Press, 1994, 13–34.

Ohrn, Karin Becker. *Dorothea Lange and the Documentary Tradition*. Baton Rouge, LA: Louisiana State University Press, 1980.

Partridge, Elizabeth, ed. *Dorothea Lange: A Visual Life*. Washington, DC: Smithsonian Institution Press, 1994.

Sandler, Martin W. *Against the Odds: Women Pioneers in the First Hundred Years of Photography*. New York: Rizzoli International Publications, 2002.

Smith, Dinitia. "Photographs of an Episode That Lives in Infamy." *New York Times*, November 6, 2006: B1, B4.

Stein, Sally. "Peculiar Grace: Dorothea Lange and the Testimony of the Body." *Dorothea Lange: A Visual Life*, ed. Elizabeth Partridge. Washington, DC: Smithsonian Institution Press, 1994, 57–90.

Places to See Lange's Artwork

Center for Creative Photography, University of Arizona, Tucson, Arizona
J. Paul Getty Museum, Los Angeles, California
Museum of Modern Art, New York, New York
Oakland Museum, Oakland, California
San Francisco Museum of Art, San Francisco, California
U.S. Library of Congress, Washington, DC

ANNIE LEIBOVITZ

b. 1949

POSSIBLY THE MOST FAMOUS LIVING PHOTOGRAPHER IN THE UNITED STATES, Annie Leibovitz is best known for her portraits of famous people. Working in both black and white and lush color, she is known for the preparation she does for each celebrity shoot. So extensive are some of her stagings that it can seem as if she is directing a small film.

Anna-Lou was born in Waterbury, Connecticut, into a close-knit military family as one of six children. Her father was a lieutenant colonel in the U.S. Air Force, which required the family to relocate often. Leiboviz is fond of saying that she spent so much time in a car with her family that she had to be an artist because the world was already framed for her through the car window. Her mother was a modern dance instructor who took a lot of family snapshots. Leibovitz spent several months in a kibbutz in Israel in 1969 and studied painting at the San Francisco Art Institute. She began taking photographs when her family was living in the Philippines.

In 1970, she started working for *Rolling Stone* magazine. With no art world connections and still a student, she went to the magazine's office in San Francisco with her portfolio full of pictures of antiwar demonstrations. The art director, Robert Kingsbury, was immediately impressed, and she was hired. Although this publication covered all kinds of stories from political affairs to the astronauts, it is best known for its coverage of rock music. In 1973, she toured with the Rolling Stones (the rock band) after being assigned to photograph them. So good was she at becoming one of the group that they often forgot she was there to make photographs. Consequently, she was able to get a behind-the-scenes view of the band. She captured marvelous shots, but in her efforts to blend in, she engaged so fully in the band's lifestyle that drugs became a problem.

In 1974, *Rolling Stone* changed its format to full color, printing on a higher grade of newsprint. All its covers became 11" × 14" posters that were highly valued and discussed in the publishing world.

In 1980, Leibovitz photographed celebrities for American Express cards, and in 1983, she began working for *Vanity Fair*. One of her most popular images was of actress Demi Moore, who posed eight months pregnant for the 1991 cover of *Vanity Fair*. She wore only a diamond ring, sparking a great deal of controversy and debate. A year later, Leibovitz photographed her again, in commemoration of the first photograph. This time make-up artists spent 13 hours coloring her body to make it look as if she were wearing a tuxedo. As the principal photographer for *Vanity Fair*, she established herself as an artist who has the ability to persuade her famous subjects to involve themselves in outrageous or labor-intensive activities. Bette Midler lies in a bed of thousands of red roses, each one with its thorns removed. Kate Winslet was submerged in a fish tank, Clint Eastwood was tied up, and John Cleese hung from a rope, upside down. Chris Rock poses in minstrel white-face, and Roseanne Barr wrestles in the mud. Her current work can be expensive, and her crew of assistants can be large. For instance, when she recently took pictures of Angelina Jolie for *Vogue*, they spent the day in the dunes near Death Valley with a staff of 50 people and racks of clothes from New York. Her photographs of the baby Suri Cruise, child of Tom Cruise and Katie Holmes, took almost two weeks.

Oftentimes Leibovitz uses humor in her images. In her photograph of Dolly Parton, for example, the photographer poses her in front of Arnold Schwarzenegger when he was at the height of his bodybuilding years. Parton's oversized blonde wig hides Schwarzenegger's face while his muscular arms and legs frame her curvaceous body. It's a funny portrait. We quickly get the humor, as does Parton, which is evident from her broad smile.

What is surprising about Leibovitz's portraits of celebrities is that she doesn't try to portray anything new about her subject. Instead, she exaggerates what the public already understands about a person. For instance, since the world knows Jack Nicholson to have a self-satisfaction about him, she looks to exploit that aspect of his character. Meryl Streep pulls at her white rubbery face, Keith Haring poses in an environment of graffiti while painted in graffiti, and the artist Christo is completely wrapped in fabric. One must go on faith that he is underneath the wrapping. Instead of revealing something new, Leibovitz identifies an obvious characteristic about a subject and builds on it. In a Leibovitz photograph there is no puzzle, and her image is immediately understood.

Leibovitz had just begun her job at *Rolling Stone* when she took her first pictures of John Lennon. Her most famous photograph, taken in 1980, is of a nude John Lennon curled around his clothed wife Yoko Ono. Perhaps one reason why this photograph is so poignant is because he was killed just hours after it was taken. Recently, the American Society of Magazine Editors selected this image and the 1991 Demi Moore *Vanity Fair* cover as the top magazine images of the past 40 years.

Leibovitz moves in new directions to challenge herself, and she continuously tries to learn new things. She taught herself how to work in color. She explored ideas about

Annie Leibovitz. *John and Yoko* (1980). Courtesy of Annie Leibovitz/Contact Press Images, Inc.

glamour when working at *Vanity Fair*. Her friend Bea Feitler, a book and magazine designer, taught her to select the best pictures from her many photographs.

Writer and critic Susan Sontag was one of the most influential people in her life. As her companion for more than 15 years, Sontag was photographed numerous times. Leibovitz shows us Sontag eating breakfast in Venice and napping in the Hamptons. We are also privy to Sontag in a hospital as she nurses her cancer and as she lies in an open casket just after her death in 2004. They met in 1980 when Leibovitz photographed her for one of her book jackets. Although they never lived together, they traveled together extensively and had apartments that were close by. Sontag had written on photography, and she was a tough critic of Leibovitz's work, challenging her to become better at her art form. Leibovitz's father died just weeks after Sontag, events that precipitated the publication of her 2006 book, *A Photographer's Life: 1990–2005*, which includes the pictures of Sontag shortly before she died. The photographs in this book were used in an exhibition at the Brooklyn Museum of Art. This book is more personal than all the many other books she had previously published on her work. This is the body of work that she claims to care the most about.

Late in life, Leibovitz decided to become a single mother. Her daughter Sarah was born just after September 11, 2001. Her twin girls were born, via a surrogate mother, shortly after the deaths of her father and Susan Sontag. One is named Samuelle, after her father; the other is named Susan after Sontag.

Leibovitz enjoys popular culture, but she also embraces other subjects. Traveling with Sontag in Sarajevo during the Bosnian war, for example, she took a powerful yet disturbing shot of an abandoned child's bike that was smeared with blood. She traveled with Anderson Cooper from CNN after Hurricane Katrina hit New Orleans and took photographs of the damage. She repeatedly takes photos of her family.

Annie Leibovitz has a gift for color and a talent for staging people in poses and settings that solidifies and enhances our understanding of them. She has often been referred to as a perfectionist. Although she works hard to plan her pictures, she says that the right shot sometimes comes out of the blue. For example, she didn't mean to pose Bill Gates at his computer, but when he drifted away for a short while, and she found him at his desk, this was the image that worked. Because of the way that she constructs environments for her subjects, her work can be considered performance, sculpture (in the way that she dresses and poses her subjects), and installation art, as well as photography. Leibovitz has become an expert in producing theatrically defined portraits that have helped define what it means to be a star. Many of her portraits are now seen as icons of popular culture.

Bibliography

Annie Leibovitz, ed. Melvyn Bragg, dir. Rebecca Frayn. DVD. Phaidon Videer: London, 1993.

"Annie Leibovitz: Life through a Lens." *American Masters*, Public Broadcasting Station, January 3, 2007.

Bellafante, Ginia. "What Celebrity Looks Like: The Annie Leibovitz Aesthetic." *New York Times*, October 26, 2005: AR1, AR32.

Boxer, Sarah. "Annie Leibovitz." *Smithsonian* 36, no. 8 (2005): 42–43.

Hagan, Charles. "Annie Leibovitz Reveals Herself." *Artnews* 91, no. 3 (1992): 90–95.

Leibovitz, Annie. *A Photographer's Life 1990–2005*. New York: Random House, 2006.

———. *Photographs: Annie Leibovitz 1970–1990*. New York: Harper Collins, 1991.

McGuigan, Cathleen. "Through Her Lens." *Newsweek*, October 2, 2006: 44–61.

Scott, Janny. "Life, and Death, Examined." *New York Times*, October 6, 2006: B27, B38.

Smith, Roberta. "Photographer to the Stars, With an Earthbound Side." *New York Times*, October 20, 2006: B32.

Wolfe, Tom. "Introduction." *Annie Leibovitz: Photographs*. New York: Pantheon/Rolling Stone Press Book, 1983.

Places to See Leibovitz's Work

High Museum of Art, Atlanta, Georgia
Rolling Stone magazine
Smithsonian Institution, Washington, DC
Vanity Fair magazine

SHERRIE LEVINE

b. 1947

ACTING AS A PIRATE, SHERRY LEVINE INTERROGATES IDEAS ABOUT ORIGINALITY
and art. Drawing from and calling into question what makes fine art and popular culture,
she is often referred to as an "appropriationist," a term associated with many postmodern
artists who use existing imagery in their work. Because she deconstructs modernist ideas
about the origins of art, and she creates a dialogue about the identity of a copy, her art is
clearly defined as postmodern.

Levine was born in Hazelton, Pennsylvania, a place known for its production of coal.
She earned both her BFA (1969) and her MFA (1973) at the University of Wisconsin,
Madison. As an undergraduate, she painted in the minimalist style; she studied printmak-
ing in her graduate work. Living in Wisconsin, Levine admits that she often felt outside
the art world. This positioning of herself forced her to rely on reproductions of artworks
and secondary sources. When she moved to New York City in 1975, she met artists David
Salle and Matt Mullican, who were also interested in issues related to representation and
reproductions.

Little biographical information is known about Levine. When asked about her life, she
claims that she does not want to involve herself in the "myth-making" that goes along with
making art. However, we know that she feels as if the world is too full of images and things.
She remarks, "The world is filled to suffocating. Man has placed his token on every stone.
Every word, every image, is leased and mortgaged. We know that a picture is but a space in
which a variety of images, none of them original, blend and clash. A picture is a tissue of
quotations drawn from the innumerable centers of culture" (Levine 379).

She was also keenly aware of the fact that the established art world was full of master-
pieces made by men and not women. Consequently, she found herself in a space that was
established by male desires and visual expressions. Acting on these concerns, her first pro-
fessional work took place in 1977 at the 3 Mercer Street store, an art space in New York

City, where she sold 35 pairs of black shoes for children, all of the same style. Titled *Shoe Sale*, it focused on the idea of art as a commodity and a fetish, while raising the issue of originality.

Calling into question the modernist idea that if you are a great artist, you must create something new, in the late 1970s Levine began taking photographs of famous photographer's photographs. Her best-known series is *Untitled (After Edward Weston)* (1981). These images include nude photographs of **Edward Weston's** son, Neil, taken in 1925. Presenting them as her own work, she turns the idea of novelty on its side. Levine made no effort to make her photograph look different from Weston's photographs. By this action, she demonstrates, or at least raises the issue, of whether new work has to be original, and if anyone's work can be considered original. Attorneys for Weston's estate felt she had violated copyright laws and protested, increasing the level of debate over what constitutes originality and ownership in art.

The importance of originality in art, however, is not the only question Levine's work addresses. Working at a time where photography was accepted as an art form, she revisits the question of photography (in general) as being a copy of something else, and therefore,

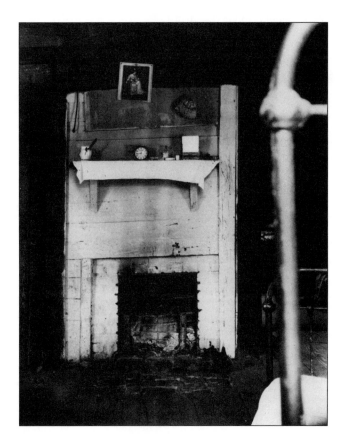

Sherrie Levine. *After Walker Evans* (1981). Gelatin silver print, 9⅜ × 7½ inches (23.81 × 19.05 cm). San Francisco Museum of Modern Art. Accessions Committee Fund: gift of Evelyn and Walter Haas, Jr., Mr. and Mrs. Donald Fisher, Mrs. George Roberts, and Helen and Charles Schwab. © Sherrie Levine. Courtesy of the artist and The Paula Cooper Gallery, New York.

unoriginal. From this perspective Levine's work becomes conceptual, in that it elicits from philosophical questions from viewers about the nature of photography. Additionally, the artist makes visible how important photographs are to our knowledge about the world. In other words we know a lot about people and places, not because we have personally experienced a site or met a certain person; rather, we "know" about them through text and photographs. That is our experience and our reality.

Levine's act of taking a photograph of a photograph and calling it her own further complicates the discussion by posing a question about theft or plagiarism. Did she take something that was not hers and call it her own work? When is it acceptable to reproduce an image or an idea and call it your own? These are questions that have increasingly been raised with technology and the Internet making it so easy to appropriate images, sound, and text. In the case of Weston's photographs of his son, they were purchased by New York's Witkin Gallery in 1977. George A. Tice was commissioned to make new prints from the negatives the gallery now owned. A portfolio was made of the new prints in a limited edition of 25. Although Weston had cropped his images, Tice developed his series from the full negative. A poster was also made of the full image. Levine's photographs came from the poster, evoking an even more delicious debate for philosophers and art critics. But the ethical issue of appropriating images can also be asked of Weston since he drew his inspiration for his photograph from the work of Praxiteles, a Greek sculptor.

Although her photographs of Weston's photographs are most often referenced in books, she also appropriated photographs from other well-known photographers such as **Eliot Porter** and **Walker Evans.** To understand what Levine has done, a viewer needs to have some understanding of art theory. Otherwise, the reaction to her work can be outright dismissal, apathy, or maybe anger that she would do such a thing and call herself an artist after doing it. According to Levine, "The discomfort that you feel in the face of something that's not quite original is for me the subject matter" (Stein and Wooster 143).

Levine continues to call into question ideas about originality, as do many other artists such as Jeff Koons and Barbara Kruger. Her work is repeatedly cited in discussions about postmodernism. At a 1997 exhibition in New York at Margo Leavin, Sherry Levine responded to four artists from a modern art catalog. Among her artworks were computer-generated prints based on Claude Monet's paintings of cathedrals and six unfinished ash sculptures that reference Gerrit Rietveld's furniture. In a 2003 exhibition at Paul Cooper in New York, titled *Avant-garde and Kitsch* and *Repetition and Difference*, she shows three recasts of inexpensive lawn ornaments and six repetitive cast bronze skulls of a steer, referencing the work of Georgia O'Keeffe.

While Levine works with various media, it is the photographic medium that first gave her notoriety. In her case it is ideas and questions about how we value that which is original or seems to be original that drives her work. In the history of photography, she will be remembered for raising difficult and puzzling questions about the role of photography in art

as well as the prevalence and role of simulated or reduplicated works in our everyday experiences. Confounding cultural categories, she examines representations of power as she recognizes, along with several contemporary philosophers, that a copy can become that which is real, and therefore not a copy at all.

Bibliography

Barrett, Terry. *Criticizing Photographs: An Introduction to Understanding Images*, 3rd ed. Mountain View, CA: Mayfield, 2000.

Hess, Barbara. "Originality According to Sherrie Levine." *Women Artists in the 20th and 21st Century*, ed. Uta Grosenick. New York: Taschen, 318–323.

Krauss, Rosaline. "Rosalind Krauss (b.1941) from 'The Originality of the Avant-Garde.'" In *Art in Theory 1900–1990: An Anthology of Changing Ideas*, ed. Charles Harrison and Paul Wood. Cambridge, MA: Blackwell, 1992, 1060–1065.

Levine, Sherrie. "Five Comments (1980–85)." *Theories and Documents of Contemporary Art*, ed. Kristine Stiles and Peter Selz. Berkeley: University of California Press, 1996, 379.

Rutledge, Virginia. "Sherri Levine at Margo Leavin." *Art in America* 1 (1998): 106.

Stein, Judith E., and Ann-Sargent Wooster. "Making Their Mark." In *Making Their Mark: Women Artists Move into the Mainstream, 1970–85*, ed. Nancy Grubb. New York: Abbeville Press, 1989, 51–185.

Stiles, Kristine. "Material Culture and Everyday Life." In *Theories and Documents of Contemporary Art*, ed. Kristine Stiles and Peter Selz. Berkeley: University of California Press, 1996, 282–295.

Taplin, Robert. "Sherry Levine at Paula Cooper." *Art in America* 7 (2003): 87.

Weintruaub, Linda, Arthus Danto, and Tomas McEvilley. *Art on the Edge and Over: Searching for Art's Meaning in Contemporary Society, 1970s–1990s*. Litchfield, CT: Art Insights, 1996.

Places to See Levine's Work

Butler Institute of American Art, Youngstown, Ohio
Museum of Contemporary Art, Chicago, Illinois
Philadelphia Museum of Art, Philadelphia, Pennsylvania
San Francisco Museum of Art, San Francisco, California
Whitney Museum of Art, New York, New York

DAVID LEVINTHAL

b. 1949

MULTIMEDIA ARTIST DAVID LEVINTHAL HAS BECOME WIDELY KNOWN FOR photographing his tiny world constructions that provoke thoughts about the role of American pop culture, myths, and icons in our lives. Born in San Francisco in 1949, he grew up in California in a Jewish family full of successful people in academia, business, science, and sports. At the age of 17, Levinthal borrowed his father's Nikon to take a course at Stanford's Free University. There, he gravitated toward learning documentary photography under the direction of filmmaker Dwight Johnson. In 1970, he graduated from Stanford University with a bachelor's degree in studio art. Directly after college he went on to pursue his MFA in photography at Yale University and graduated in 1973. Levinthal experienced an intense pressure to perform and measure up to his family. The stress of being a part of a successful family and producing great work took a physical toll on him, resulting in a diagnosis of colitis, which he coped with throughout graduate school.

Levinthal developed his distinctive style of photographing dolls and toys in tiny environments during graduate school. He described the process of how he started creating these artificial environments as an unconscious one. Levinthal began manipulating crude materials, such as foam core, shoeboxes, and cardboard to create interior spaces and stages for small toys, action figures, and Barbie dolls. Delighted with the prospect of constructing these theatrical sets, he started searching hobby shops for miniature furniture and objects that created an illusion of bathrooms, diners, hotel rooms, foyers, and pool halls. He was drawn to the idea of creating a narrative that evokes a collective consciousness about our lives, touching on topics such as American pop culture, romance, love, and sexuality, and more serious topics such as Hitler and the Nazi regime, and religion. Likewise, these tiny narratives are open-ended and allow the viewer to intertwine their own personal story.

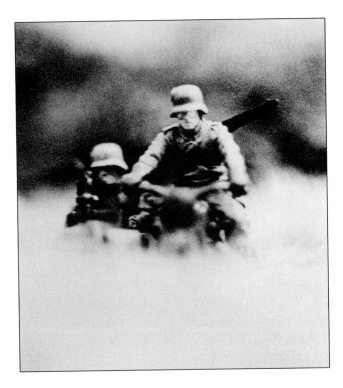

David Levinthal. *Hitler Moves East (033) Untitled* (1976). Courtesy of the artist.

His first series of work that was published, *Hitler Moves East*, was completed with a friend and colleague from graduate school, Garry Trudeau, the artist who created the long running *Doonesbury* cartoon. In an example from the *Hitler Moves East Series* (1976), the blurred black-and-white image of two soldiers on a motorcycle is lifelike. The out-of-focus quality of the image leads one to believe that the figures were in motion as the photograph was taken, and that it is an authentic historical document. Only on close inspection does the image come under suspicion for being something other than reality. Levinthal wrote about his work:

> For more than thirty years I have arranged toy figures in studio-constructed situations that mimic representations of contemporary myths and American icons. Doing so I have tried to elaborate an aesthetic of fabrication rather than of realism.
>
> I first began to sense how powerful these images could be, or rather could become when I was making photographs of small-scale toy soldiers for my graduate thesis project during my second year at Yale. Shortly after I finished my M.F.A. program in 1973, I began collaborating with my classmate Garry Trudeau on a book project. The result of our almost four year joint effort was the book, *Hitler Moves East*, first published in 1977. (Levinthal 2007)

On the surface, his work is playful and sometimes not taken seriously, which does not seem to bother Levinthal as he feels that the final interpretation is up to the viewer. Trudeau spoke about Levinthal's attitude toward his art:

> To hear David Levinthal talk about his art is to sometimes come away with the impression that he couldn't possibly be up to anything consequential. He smiles too much. He's too self-effacing, too slow to rationalize any ambiguities in his work. He actually respects his audience, believing them capable of processing powerful, provocative images on their own. This child-artist with his toys expects the rest of us to act like grown-ups. (Parry, par. 58)

Not long after the completion of this first major project, Levinthal backed away from the arts to pursue a more "respectable" line of study and career. Although his family supported whatever he chose to do, whether study or play, he felt the intense pressure to succeed. So much so that he pursued a masters of science degree from the prestigious Massachusetts Institute of Technology, which he completed in 1981. He also co-founded and co-directed a public relations firm in Menlo Park, California. However, feeling unsatisfied with a life in business, he soon turned back to the arts. Again, he resumed creating tiny environments that alluded to fragments of a larger reality. For his next series he experimented with larger cameras and film types to create his desired effect. He wrote about working with the Polaroid camera:

> In 1986 I began to work with the large Polaroid Camera. The large-scale color photographs that I generate with the 20 × 24 Polaroid Land Camera give my effigies a seductive grandeur: at the same time, I am careful to make visible the seams of simulation. Probing the nature of such pervasive imagery, as it has been transmitted, filtered, and blurred in films, televisions, books, and magazines, I nevertheless try to evoke the genuine emotions that any of us can attach to an entirely artificial world. (Levinthal 2007)

In an untitled work from the *Wild West Series* (1988), the cowboy toy figure dons chaps, handkerchief, and western hat as he lassoes a white horse reared up on back legs. At first glance this blurred image appears to genuinely be a photograph of a cowboy working on a horse ranch. This scene from the Wild West conjures thoughts about American western movies and television shows, such as *Gunsmoke* and the *Lone Ranger*. Here again the line between reality and fantasy is distorted.

In another series, *Modern Romance* (1984–1986), Levinthal illustrated the typical dating rituals between men and women. In *American Beauties* (1989–1990), Barbie is the central figure representing the ultimate myth of femininity and American beauty. Here Barbie is in sharp focus modeling her fashions from swimsuits to evening gowns, questioning the role of Barbie as the epitome of American beauty. Other works are more controversial, such as *Desire*

(1990–1991) where images of nude Barbie dolls are positioned in sexually explicit poses, and *Blackface* (1995–1998) with retro images of black characters in American culture. His most recent work, *Jesus* (2005), shows various biblical scenes where Jesus is the central figure.

In addition to his independent art work, Levinthal has completed numerous commercial contracts for IBM, Spike Lee, *Entertainment Weekly*, *GQ Magazine*, *New York Time Magazine*, and Absolut Vodka to name just a few. At mid-career Levinthal has an extensive exhibition record longer than that of the list of museum collections that include his work. His work has been shown in venues such as the Yogi Berra Museum at Montclair State University in Little Falls, New Jersey; Gerald Peters Gallery in Dallas, Texas and in Santa Fe, New Mexico; Milwaukee Art Museum; San Jose Museum; and Philadelphia Museum of Judaica, among many others across the United States. He has published nearly a dozen monographs of his work.

Today, he lives and works in New York City. David Levinthal is a magician of sorts, offering the groundwork for narratives that evoke historical events, American pop culture, and our relationships with each other and society.

Bibliography

"Biography." *David Levinthal Web site*. Retrieved November 15, 2006, from http://www.davidlevinthal.com/bio.html.

Brooks, Rosetta. "David Levinthal [Craig Krull Gallery, Los Angeles; exhibit]." *Artforum International* 33 (Summer 1995): 112.

Greenstein, M.A. "David Levinthal at Mark Moore." *Art Issues* 56 (January/February 1999): 44.

Levinthal, David. "Artist Statement." Correspondence with author Kara Kelley Hallmark, January 7, 2007.

———. *Small Wonder: Worlds in a Box*. Washington, DC: National Museum of American Art, Smithsonian Institute, 1995.

———. *The Wild West*, ed. Constance Sullivan, essay by Richard Woodard. Washington, DC: Smithsonian Institute, 1993.

Levinthal, David, and Gary Trudeau. *Hitler Moves East: A Graphic Chronicle, 1941–1943*. Kansas City, MO: Sheed, Andrews, and McMeel, 1977.

Loke, Margaret. "David Levinthal [International Center of Photography, New York, exhibit]." *Artnews* 96, no. 3 (1997): 108.

Parry, Eugenia. "David Levinthal: The Great Pretender." In David Levinthal, *Modern Romance*, New York: St. Ann's Press, 2001. Reprinted online at http://www.davidlevinthal.com/article_Stranger.html.

Turner, Grady T. "David Levinthal at Paul Morris, exhibit." *Art in America* 91, no. 5 (2003): 149–150.

Places to See Levinthal's Work

Amon Carter Museum, Fort Worth, Texas
Art Institute of Chicago, Chicago, Illinois
Augen Gallery, Portland, Oregon
Baldwin Gallery, Aspen, Colorado

BankAmerica Corporation, San Francisco, California
Birmingham Museum of Art, Birmingham, Alabama
Brooklyn Museum of Art, New York, New York
Conner Contemporary Art, Washington, DC
Corcoran Gallery of Art, Washington, DC
Daniel Azoulay Gallery, Miami, Florida
David Levinthal Web site: www.davidlevinthal.com
Fay Gold Gallery, Atlanta, Georgia
Fred Jones Jr. Museum of Art at the University of Oklahoma, Norman, Oklahoma
Gene Autry Western Heritage Museum, Los Angeles, California
Georgia Museum of Art, Athens, Georgia
Gerald Peters Gallery, Santa Fe, New Mexico
Grand Rapids Art Museum, Grand Rapids, Michigan
Hallmark Collection, Kansas City, Missouri
High Museum of Art, Atlanta, Georgia
International Center of Photography, New York, New York
Kidder Smith Gallery, Boston, Massachusetts
Lisa Sette Gallery, Scottsdale, Arizona
Los Angeles County Museum of Art, Los Angeles, California
Metropolitan Museum of Art, New York, New York
Milwaukee Art Museum, Milwaukee, Minnesota
Modern Art Museum of Fort Worth, Fort Worth, Texas
Modernism Gallery, San Francisco, California
Museum of Contemporary Photography, Columbia College, Chicago, Illinois
Museum of Fine Arts, Houston, Texas
Museum of Modern Art, New York, New York
New Orleans Museum of Art, New Orleans, Louisiana
New York Public Library, New York, New York
Ochi Fine Art, Ketchum, Idaho
Paul Morris Gallery, New York, New York
Polaroid Collection, Cambridge, Massachusetts
Progressive Art Collection, Mayfield Heights, Ohio
San Jose Museum of Art, San Jose, California
Smithsonian American Art Museum, Washington, DC
Stellar Somerset Gallery, Palo Alto, California
The Jewish Museum, New York, New York
University Art Museum, California State University, Long Beach, California
University of Virginia Art Museum, Charlottesville, Virginia
Whitney Museum of American Art, New York, New York

HELEN LEVITT

b. 1913

HELEN LEVITT DOES NOT THINK SHE SHOULD HAVE TO SAY MUCH ABOUT HER work. Instead, she believes that photography can capture and communicate a direct expression of feeling. She is best known for her black-and-white photographs of children in New York City playing games in the streets. Successful not only at making still photographs, Levitt has also made films.

Born in Brooklyn, Helen Levitt had an older and younger brother. She doesn't readily speak about her personal past since she believes that her biography is irrelevant to understanding her work. However, we do know that she was born to a Russian and Jewish family, although neither culture played a big part in her upbringing. Her father immigrated when he was 16 and eventually established a successful business in wholesale knit goods. She loved music, which she claims helped her become attuned to herself. Helen was smart and independent and enjoyed roller skating, riding her bicycle, swimming, tennis, and horseback riding because she felt great pleasure in the movement of her body when she was physically active. Although she was smart, she didn't enjoy high school; she dropped out one semester before graduating. She took dance lessons as a child and continued this interest as an adult. Throughout her life she loved to read and watch movies. Levitt had leftist tendencies and remembers joining a group to picket D. W. Griffith's 1915 film *The Birth of a Nation* because of the racist way it depicted blacks. Characteristically, however, Levitt has not been a joiner.

When she was 18, she went to work in a portrait studio in New York where she learned basic skills in camera shots and darkroom techniques. By 1934 she had her own camera, a second-hand Voigtlander that she used to take pictures of family and friends. In 1935, she met famed photographer Henri Cartier-Bresson. He was not interested in conventional ways of defining or presenting beauty. She liked the way he talked about photography, and following his lead she began looking for subtlety and indirection in her work. His influence can also be seen in the way that she freezes a coherent, specific moment in time. As a result,

her images do not tell a story as they are ambiguous and reveal no clear reading. But she does have a clearly defined focus for her work, which always has been urban. She looked for children playing and people daydreaming. She was intrigued by people sitting and standing on the stair-steps by a front door or window. Sometimes she shot images in the subway and has often captured graffiti in background scenes. Her subjects are shot up-close, and her approach is cool and somewhat detached but not uncaring. She looks for the surprise moment but does not represent her subjects in a freakish manner. Some critics see whimsy in her work, while others suggest that her images analyze the isolation and possibility of urban violence.

Levitt visited the Museum of Modern Art to educate herself in basic rules of composition. She viewed works by Matisse, Van Gogh, Gauguin, and Cézanne until she understood their way of composing. Moving from the silent films of her youth to Russian and French films, she was most inspired by Dziga Vertov's *Man with a Movie Camera*, which presented close-up shots of everyday people moving around the city. By the age of 23, Helen Levitt no longer thought of herself as an apprentice. She had rapidly established her way of seeing. Although many of her contemporaries took documentary pictures to point out poverty or oppression, Levitt's images were not aimed at social issues. She titles them simply by their location.

In 1937, she briefly taught school in East Harlem as part of a Federal Arts Project program. Walking to school, she took pictures of the children's chalk drawings on the street. From there she became fascinated by moments when children are so involved in play that they lose their inhibitions and self-consciousness. It was not organized play that attracted her, but imaginative play.

In 1936, she purchased a Leica camera that worked well for photographing on the street. She used a right-angle viewfinder, which **Walker Evans** introduced her to, that allowed her to shoot her subjects without directly facing them. Because they didn't know they were being framed for a photograph, she was able to more easily capture candid shots.

As a native New Yorker, she seldom left the city, although she did travel to Mexico in 1941 and went to Florida to visit her parents a few times. After the trip to Mexico, she found work as a film cutter and was soon editing American propaganda films that were being sent to South America. Soon after, she was commissioned to make a film about China from stock footage. From 1944 until the end of the war, she worked in the Film Division of the Office of War Information.

The image that she is best known for is simply titled *New York* (*three kids with masks*) (ca. 1940). Three young children have just stepped out of their house. Two boys wear Halloween-type masks, and the girl behind them is just placing her mask on her face. Perhaps because of their youth, their gait looks awkward, which, coupled with the hidden faces, makes the picture rather unsettling. Levitt would have us believe that she did not create this scene, that the aesthetic came from life itself. Her claim is that the composition could

not have been arranged or staged. Critic Katherine Dieckermann disagrees with this assessment, however, questioning how so many of Levitt's images, like this one, could have such a similar feel to them if they weren't reflective of the artist's intellectual process and therefore composed in the photographer's mind.

However, in James Agee's introduction to a book of her 1940s photographs, titled *A Way of Seeing*, he suggests that Levitt's work is not hampered by intellectual control. He claims that she works in a spontaneous manner, in which she looks without thinking. This was an admirable trait in the art world at the time. In 1946, he wrote, "Well used, the camera is unique in its power to develop and to delight our ability to see" (Agee vii). Agee believed that only in a few cases were photographers capable of using the camera as an artist. As one of the few photographer/artists, Levitt's "task is not to alter the world as the eye sees it into a world of aesthetic reality, but to perceive the aesthetic reality within the actual world, and to make an undisturbed and faithful record of the instant in which this movement of creativeness achieves its most expressive crystallization" (Agee viii).

What is consistent about Levitt's work is that it is carefully framed. Some could say this shows intention on her part. The color photographs that she took later in her life make it clear that she understands the power of color. Knowing that saturated color can communicate

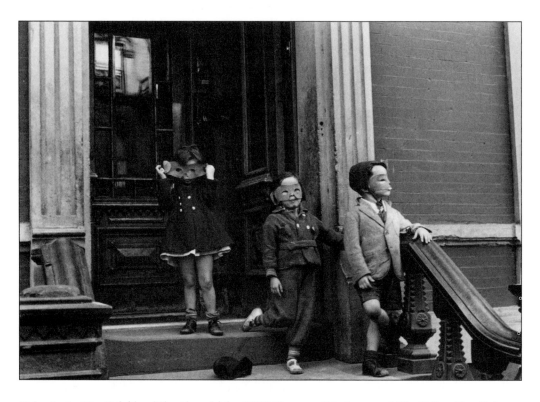

Helen Levitt. *New York (three kids with masks)* (ca. 1940). Courtesy of the Laurence Miller Gallery, New York.

on its own, she uses it to portray a world that is more optimistic and bright, as well as one that can be disturbing. Therefore, some of her color photographs come across in a more threatening way than they might have in black and white. For example, her 1972 image (titled, like so many other images, *New York*) of a red car with a broken window, a bloody cat, and an isolated old woman bathed in shades of blue evokes an uncomfortable threatening feeling that danger may still be lurking, and the moment of trauma has not passed.

Levitt continues to have an interest in the kinds of poses her subjects take. She uses the space around her subjects consistently to project a kind of isolation and aloneness that can occur in a big city. Even when two figures share the same photographic space, they often remain occupied in their own separate worlds.

James Agee, who along with Walker Evans created the book *Let Us Now Praise Famous Men* (1941), was so taken with her photographs that he, along with several others, collaborated with her on two films, one focusing on children playing in the streets, the other on a young child from Harlem who ran away from home.

In 1992, the San Francisco Museum of Modern Art, in collaboration with the Metropolitan Museum of Art in New York, curated Levitt's first retrospective, although she had had three previous exhibitions at the Museum of Modern Art in New York. At that time she had been photographing for 50 years.

As an avid poker player, she demonstrates that she can be in the moment in situations other than when taking photographs. But even when playing poker, she claims that the game is not about intellect, but about touch and feel, and it is luck that makes the winning hand. The player, or the photographer, uses one's wits to see what's taking place. When luck is working for you and skill in reading the environment is in play, the results come out in your favor. While playing poker is purely play for Levitt, making photographs is serious play, and the streets of New York are her chosen playground.

Bibliography

Agee, James. "Introduction." In *Helen Levitt: A Way of Seeing*, 3rd ed. Durham, NC: Duke University Press, in association with the Center for Documentary Studies at Duke University, 1989, vii–viii.

Baker, Kenneth. "Helen Levitt." *Artnews* 91, no. 3 (1992): 138.

Dieckmann, Katherine. "Mean Streets." *Art in America* 78, no. 5 (1992): 222–229, 263.

Gopnik, Adam. "Foreword." In *Helen Levitt: Here and There*. New York: powerHouse Books, 5–11, 2003.

Hambourg, Maria Morris. "Helen Levitt: A Life in Part." In *Helen Levitt*, ed. Sandra S. Phillips and Maria Morris Hambourg. San Francisco: San Francisco Museum of Art, 1991, 45–63.

Johnson, Brooks. *Photography Speaks: 150 Photographers on Their Art*. New York: Aperture, 2004.

Levitt, Helen. Foreword by John Szarkowski. *Slide Show: The Color Photographs of Helen Levitt*. New York: powerHouse Books, 2005.

Sandler, Martin W. *Against the Odds: Women Pioneers in the First Hundred Years of Photography*. New York: Rizzoli, 2002.

Places to See Levitt's Work

Art Institute of Chicago, Chicago, Illinois
Center for Creative Photography, University of Arizona, Tuscon, Arizona
Cleveland Museum of Art, Cleveland, Ohio
Corcoran Gallery of Art, Washington, DC
Jewish Museum, New York, New York
San Francisco Museum of Modern Art, San Francisco, California
Smithsonian Institution, Washington, DC

CARM LITTLE TURTLE

b. 1952

CARM LITTLE TURTLE SPEAKS TO THE MULTI-FACETED LIVES AND EXPERIENCES of Native American women in her vibrantly painted, storytelling photographs. Little Turtle works from a feminist perspective that art is political and should be used as a vehicle to express social concerns.

She was born in Santa Maria, California, in 1952 to the Apache and Tarahumara Nations. Growing up in a multicultural and creative home with artist parents, art has been a way of life for Little Turtle from the start. Her mother was always painting, which greatly influenced Little Turtle's early experience with the medium. It was a natural decision for her to study art in college. She started out at the Navajo Community College in Tsaile, Arizona; then she studied photography at the University of New Mexico and then at the College of Redwoods in Eureka, California.

Although she formally studied photography in college, she did not abandon painting; rather, she married the two media into what has became her mature style. Her work successfully fuses painting and photography to produce energy-filled portraits of contemporary Native American life. She sets the stage, posing the actors with specific props that recall traditional Native American culture, such as moccasins, hand-woven baskets, and cowboy hats. She explained:

> The props and costumes in my work are icons in my private symbolism. I'm not interested in the prettified mythology that Euroamerican culture glues to indigenous people. Fake images of native nobility might salve a troubled collective consciousness, but it's a salve that doesn't heal, it only sooths. Trying to anesthetize a pattern of genocide, appropriation, and racism might be comforting, but it doesn't erase. Isn't the dominant culture still dominating today? (Little Turtle 2007)

She paints selective areas of the photograph to create tension between figures, highlight certain symbols, or just to make the image aesthetically pleasing. The brightly painted sepia tone images are visually interesting without explanation. However, the artist leads us into the story with the title. For instance, in *She Wished for a Husband, Two Horses and Many Cows* (1989), the viewer can surmise by the title the purpose of the woman we see sitting on top of her car looking out into the distance of a wide open desert. Little Turtle continues the story with another frame showing a cowboy offering the woman money. The people play a part in her drama—they are just bodies with faces and identities concealed. Little Turtle wrote:

> In my work composition, balance in the painted surface, and aesthetics are more important than the articulation of meaning. If an image succeeds in making a statement—exciting. In order to [keep] a narrative piece open-ended, I commonly shoot images so that the models' faces are not seen. Viewers are allowed to make their own interpretation. I try not to capitalize on the spiritualism of my heritage by giving the impression that I have, through images, a monopoly on the spirit world. My work is down to earth and dirty: it deals with sex, food, and money, the politics between men and women, the human spirit, the need to communicate, and the importance of humor in that quest. (Little Turtle 2007)

In another work, *She traded her Storm Pattern for a Bull* (1994), a woman sits behind a man driving a van or a small bus. Sitting in the driver's seat with his back turned, his primary shape is the silhouette of the cowboy hat he wears, signifying masculinity. We see the profile and gleeful expression on the woman's face as she rests one hand on the back of his seat; did she lose her balance on a bumpy road or is she trying to reach out to the man? Black cows are visible outside the truck window, suggesting that they are driving through a field or rural area. Did she choose one of those bulls in the field or is the man inside the truck the metaphorical bull of her choice? Little Turtle creates the setting, impressions of characters, gives a one line opener, and then lets the viewer narrate the rest of the story.

Little Turtle works from a feminist perspective deeply rooted in her Native American culture and heritage. While much of her work has an element of humor, the message is political, typically pointing to the oppression of the Native American community, particularly in the United States. In *Nahuatl, Paid Companion* (2003), a young girl is walking alongside an old stone wall and glances over her shoulder at us. Little Turtle painted her shawl, simple skirt, and moccasins, and what looks like huge red chili peppers at the top of the stone wall. With the title, Little Turtle is alluding to the sex trade dealing young Native American girls that dates back to the Lewis and Clark Expedition more than 200 years ago. In a broader sense the young girl represents the labor exploitation of Native American children for hundreds of years and is ongoing today.

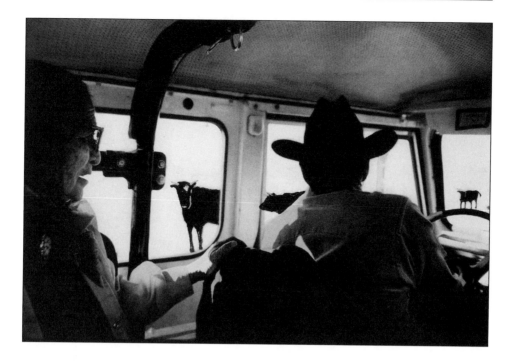

Carm Little Turtle. *She traded her Storm Pattern for a Bull* (1994). Black and white photo, sepia toned, oil paint. Courtesy of the artist.

Her work has been exhibited in more than 60 exhibitions throughout the Southwest, California, New York City, Boston, Washington, DC, Glasgow, and Scotland, in venues such as the Montana Museum of Art and Culture; the Museum of Indian Arts and Culture in Santa Fe, New Mexico; the Silver Image Gallery in Seattle, Washington; and at the Hood Museum in Hanover, New Hampshire. She has lectured at many academic and arts institutions across the country. In addition to her photographic series, Little Turtle has produced two documentary films and often works collaboratively with her husband, painter Ed Singer.

Today, she lives in Cubero, New Mexico. Using props, costumes, and characters, Carm Little Turtle sets the stage for open dialogue about sociopolitical issues, such as the oppressive conditions that Native Americans have endured and the relationships between women and men.

Bibliography

Abbott, Lawrence. "Interview with Carm Little Turtle." In *I Stand at the Center of the Good: Interviews with Contemporary Native American Artists.* Lincoln: University of Nebraska Press, 1994, 137–147.

Little Turtle, Carm. "Artist Statement." Correspondence with author Kara Kelley Hallmark, February 14, 2007.

Pontello, Jacqueline M. "Carm Little Turtle." *Southwest Art* 20 (April 1999): 120.

Rushing, W. Jackson, III, ed. *Native American Art in the Twentieth Century: Makers, Meanings, Histories.* London: Routledge, 1999.

Skoda, Jennifer R. "Image & Self in Contemporary Native American Photoart: An Exhibition at the Hood Museum of Art. American Indian." *Art Magazine* 21 (Spring 1999): 48–57.

Smith, Caroline. "Across the Great Gender Divide (Interview)." *Women's Art Magazine* 61 (November/December 1994): 18–19.

Places to See Little Turtle's Work

Center for Creative Photography, University of Arizona, Tucson, Arizona

Museum of Indian Arts and Culture, Santa Fe, New Mexico

Native American Women Photographers as Storytellers, Women Artists of the American West: http://www.cla.purdue.edu/WAAW/Jensen/NAW.html

Rockwall Museum, Corning, New York

Southwest Museum, Los Angeles, California

Western Arts Americana Library, Princeton University, Princeton, New Jersey

MAN RAY

1890–1976

ONE OF THE MOST FAMOUS SURREALIST AND DADA MULTIMEDIA ARTISTS
of the twentieth century, Man Ray is perhaps best known for his experimental photography. Emmanuel Radnitsky was born on August 27, 1890, in Philadelphia, where he spent his early childhood until the family moved to Brooklyn in 1897. Both of his parents were Russian immigrants and worked hard to support their family. His father worked two jobs; he was employed at a garment factory and operated a private tailoring business out of the family home on the side. All four of the children worked for the family business from very young ages. His mother took pride in her design and construction of all the family's clothes. The influence of this early experience is present in his work on and off throughout his career; images of sewing paraphernalia are frequently present in his collages, paintings, and photography.

From an early age, Man Ray was interested in becoming an artist. He learned basic art and drafting techniques during the years he attended the Boys High School from 1904 to 1908. He also educated himself by frequenting the local art museums. After high school he declined a scholarship to study architecture and decided instead to pursue an artistic career. Although his parents were disappointed, they accommodated their son by making room in the small house for a painting studio. During the next several years, he worked commercially as an artist and took some classes at the National Academy of Design and at the Art Students League in New York City. Very little of his paintings remain from this time period. At the persuasion of one of his brothers, the family changed their name from Radnitsky to Ray in 1912 to protect themselves against anti-Semitism. The young Emmanuel was nicknamed Manny, and he soon shortened it to Man and later began to refer to himself with one name, Man Ray.

Later that same year he attended the Modern School in New York City, which was commonly referred to as a *Ferrer* school for its liberal socialist theory and avant-garde ideas. The education that he received there is regarded as a pivotal time in his artistic development.

As a student, Man Ray painted compositions inspired by the leading artists of the day, such as Paul Cézanne and other *cubist* and *fauvist* artists. In 1913, he met the Belgian poet, Adon Lacroix, and the two married in 1914. Lacroix was a recurring subject in his early photography. Their relationship was tumultuous, and eventually they separated in 1919 but did not officially divorce until 1937.

By 1918, Man Ray started photographing his paintings and that of his artist friends as a means of documentation, and gradually his photography evolved into the art itself. Man Ray began to experiment with photography by making images without a camera. He created what is referred to as a *photogram*, where the object is placed directly on the photographic paper and then exposed to light. The result is an image that resembles something like an x-ray with a dark background and the negative of the recognizable objects in white with soft edges. In one untitled example from 1922, the image of a dangling key is the focal point whereas the other objects are blurred beyond recognition. He called these works "rayographs." Other rayographs include everyday objects such as rope, light bulbs, scissors, and tailoring tools and materials.

While living in New York, he met artist, Marcel Duchamp, and the two became close collaborators and friends. Inspired by the *Dada* art movement in Paris, which rejected the

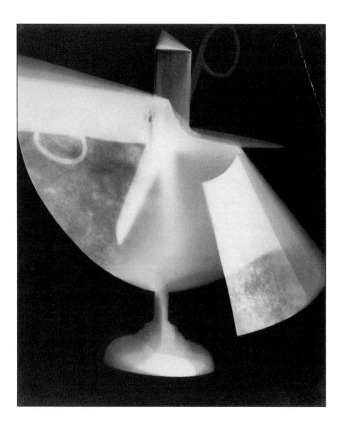

Man Ray. *Untitled Rayograph (Scissors and Cut Paper)* (1927). The J. Paul Getty Museum. © 2007 Man Ray Trust / Artists Rights Society (ARS), NY / ADAGP, Paris.

traditional art object, Man Ray and Duchamp pioneered the movement in New York City. Initially a political movement in Europe to protest against World War I and the bourgeois, Dada eventually evolved into a philosophy about the arts. Dada represented everything opposite from the traditional; whereas art was concerned with aesthetics, Dada rejected aesthetics. However, Man Ray and Duchamp felt that their collaborations were unsuccessful, and after several attempts at introducing Dada to the United States, they both returned to Paris. Man Ray was quoted several times as saying that he felt that Dada was unable to survive in New York and indeed that New York itself *is* Dada.

In 1921, he left New York for Paris and settled in Montparnasse, an area populated with artists, writers, and philosophical thinkers. Man Ray did not speak French at first but was quickly accepted into the inner circle with artist Salvador Dali, and writers Ernest Hemingway and James Joyce. Not long after he met model Kiki de Montparnasse (Alice Prin), with whom he was involved throughout the 1920s. She was the subject of much of his photography and experimental films during that time. He became well known for shooting portraits of artists and socialites in Paris and working as a fashion photographer for *Harper's Bazaar*, *Vanity Fair*, and *Vogue*. Man Ray lived in Montparnasse for the next 20 years.

Along with Duchamp, Man Ray was close friends with many other artists including Pablo Picasso and Andrè Breton. Man Ray embraced *surrealism*. Surrealist artists were attracted to African cultures, where art objects are linked to the spiritual and mystical worlds. Focused on the subconscious, dream state of being, surrealist artists became inspired by African art and how integral the art is with their culture. Artists such as Pablo Picasso introduced African art to the Western public by way of inserting African symbols and imagery into their work. Man Ray inadvertently became a part of integrating African art objects into Western *Modern* art when he was commissioned to photograph some commercial advertisements. He was hired by art dealer Paul Guillaume to photograph African art objects with models to promote sales in the Western market. In July 1924, Man Ray's black-and-white photograph of a model with an African art object graced the cover of the journal *391*, published by artist Francis Picabia. Today, this photograph is recognized as one of Man Ray's most famous artworks. In another work, *Tears* (1930), Man Ray has given the illusion that the tears are glass beads resting perfectly on her cheek.

At the onset of World War II, Man Ray left Paris and returned to New York City in 1940 briefly before moving to Los Angeles. Several expatriates returned to the United States during the war and took up residence in Hollywood. There, he met dancer and model Juliet Browner, who was on vacation at the time. After living together for six years, they were married in a double wedding ceremony with artists Max Ernst and Dorothea Tanning. In 1951, Man Ray and Juliet moved to Paris, where they lived until his death in 1976.

Man Ray died in Paris on November 18, 1976. Without children to endow his art and money, he left everything to his wife, Juliet Man Ray. The Man Ray Trust was established

Man Ray. *Tears* (1930–1932). The J. Paul Getty Museum. © Man Ray Trust ARS-ADAGP.

by Juliet to promote his work throughout the world. Indeed his reputation, particularly in the United States, has since heightened, and the value of his art work has skyrocketed. In 1999, *Artnews* named him one of the most influential artists of the twentieth century. Painter, sculptor, filmmaker, poet, philosopher, and perhaps most notably, a photographer, Man Ray left an indelible mark on the art world as an artist pushing the parameters of what is accepted as art.

Bibliography

"Between You and Me: Man Ray's Object to Be Destroyed." *Art Journal* 63, no. 1 (2004): 4–23.

Browner, Eric. "The Trouble with Man Ray." *Art News* 101, no. 11 (2002): 20.

Gilmore, Jonathan. "Man Ray in American at Francis M. Naumann." *Art in America* 90, no. 5 (2002): 151–152.

Grossman, Wendy A. "Man Ray: Objects and Images." *Tribal (San Francisco, CA)* 10, no. 2 (2005): 150–159.

Leffingwell, Edward. "Becoming Man Ray." *Art in America* 92, no. 3 (2004): 100–103.

———. "New York: Marcel Duchamp/Man Ray at Sean Kelly." *Art in America* 88, no. 4 (2000): 153–154.

Lottman, Herbert R. *Man Ray's Montparnasse.* New York: Harry N. Abrams, 2001.

Naumann, Francis M. *Conversion to Modernism: The Early Work of Man Ray.* New Brunswick, NJ: Rutgers University Press, 2003.

Ray, Man. *Man Ray: Photographs from the J. Paul Getty Museum.* Los Angeles: J. Paul Getty Museum, 1998.

Thomas, Kelly Devine and Nicholas Powell. "The Surreal Legacy of Man Ray." *Artnews* 101, no. 6 (2002): 100–112.

Places to See Man Ray's Work

Allen Art Museum at Oberlin College, Oberlin, Ohio
Amon Carter Museum, Fort Worth, Texas
Art Institute of Chicago, Chicago, Illinois
Block Museum of Art at Northwestern University, Evanston, Illinois
Chrysler Museum, Norfolk, Virginia
Corocoran Gallery of Art, Washington, DC
Currier Gallery of Art, Manchester, New Hampshire
Eastman House Museum of Photography & Film, Rochester, New York
Fine Arts Museum of San Francisco, San Francisco, California
High Museum of Art, Atlanta, Georgia
Hirshhorn Museum and Sculpture Garden, Washington, DC
International Center of Photography, New York, New York
J. Paul Getty Museum, Los Angeles, California
Los Angeles County Museum of Art, Los Angeles, California
Man Ray Trust Website: www.manraytrust.com
McMullen Museum of Art at Boston College, Boston, Massachusetts
Menil Collection, Houston, Texas
Metropolitan Museum of Art, New York, New York
Minneapolis Institute of Arts, Minneapolis, Minnesota
Montclair Art Museum, Montclair, New Jersey
Museum of Fine Arts, Boston, Massachusetts
Museum of Fine Arts, Houston, Texas
Museum of Fine Arts, Santa Fe, New Mexico
Museum of Modern Art, New York, New York
National Galleries of Scotland, Edinburgh, Scotland
National Gallery of Art, Washington, DC
New York Public Library Digital Gallery, New York, New York
Newark Museum, Newark, NJ
Phillips Collection, Washington, DC
Pomona College Museum of Art, Pomona, CA
Rijksmuseum, Amsterdam, Holland
Sheldon Art Gallery, Lincoln, NE
Smithsonian American Art Museum, Washington, DC
Solomon R. Guggenheim Museum, New York, New York
Whitney Museum of American Art, New York, New York
Williams College Museum of Art, Williamstown, Massachusetts
Yale University Art Gallery, New Haven, Connecticut

SALLY MANN

b. 1952

ALTHOUGH CONTROVERSY FOR PHOTOGRAPHING HER OWN CHILDREN IN intimate poses helped make Sally Mann's reputation, her subjects are far more extensive, yet always personal and edgy. Likening her work to that of Flaubert's, she claims that she wants to expose the antithetical aspects of a situation. Her photographic techniques, which echo the way in which photographers worked 150 years ago, as well as her subject matter, sets her apart from other photographers working today. She has won numerous awards, including Guggenheim and National Endowment for the Arts Fellowships. In 2001, *Time Magazine* named her "America's Best Photographer."

Mann grew up in rural Lexington, Virginia, where she was born—in Stonewall Jackson's house. Her father was a physician, a civil rights supporter, and a legendary free spirit. She studied literature and writing at Hollins College where she earned her BA and MA degrees and later attended photography workshops lead by such notable figures as **Ansel Adams** and George Tice. When she was 17, her father gave her a camera and informed her that photographic subjects worthy of becoming art should focus on love, death, and whimsy. She continued to live on the farmland of her birth when she married Larry Mann, a metalworker, sculptor, city councilman, and lawyer. Her farm is a protected space with pastures, a wood that runs into the Maury River, and a well-tended vegetable garden. Inspired by photographers like **Diane Arbus** and **William Christenberry,** Mann's work has always been about her place. She identifies herself as a Southern photographer, as her photos display an obsession with her own place, family, and personal and social past. There is also an acceptance of myth, an experimentation with romance, and the presence of humidity.

Although Mann had already established a reputation for herself before she began making images of her three children Emmett, Jessie, and Virginia, it was this series that created an explosion of interest. Her choice of subject, she claims, was convenient. She had had

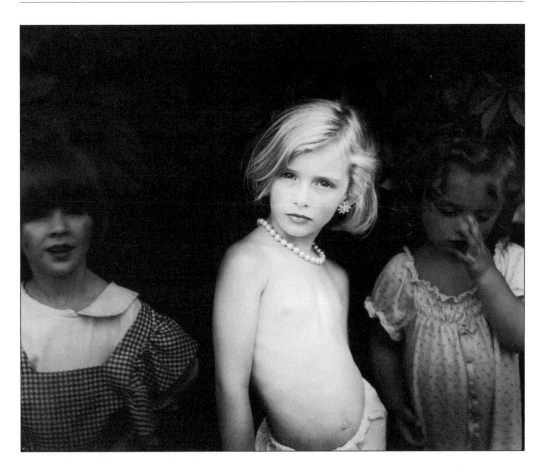

Sally Mann. *Jessie at Five* (1987). Gelatin silver print, 19⅝ × 23¾ inches (49.85 × 60.33 cm). San Francisco Museum of Modern Art. Purchase. © Sally Mann.

three children in five years, and having them as subjects was a good way to use her time as an artist and a mother wisely.

Published in 1992, her third book titled *Immediate Family* depicted numerous photographs, taken over eight years, of her children playing and posing for the camera. In the same year these photographs were exhibited in a one-person show at the Houk Friedman Gallery in New York City. Speaking about these images she explained: "Many of the pictures are intimate, some are fictions and some are fantastic but most are of ordinary things every mother has seen; a wet bed, bloody nose, candy cigarettes. They dress up, they pout and posture, they paint their bodies, they dive like otters in the dark river. They have been involved in the creative process since infancy. At times, it is difficult to say exactly who makes the pictures" (Johnson 290). It was the children's nudity that struck a vein. When the *Wall Street Journal* published an image of 4-year-old Virginia, black bars censored her breasts,

genitals, and eyes. The more liberal journal *Artforum* refused to print a picture of Jessie swinging on a hay hook. So troublesome to some critics were images of nosebleeds and other childhood injuries that journals wrote articles questioning Mann's parenting. These photographs raised questions about boundaries between pornography and art and the risk of sending out nude images of children in a world populated by pedophiles. Others questioned whether children could ever freely give adequate photographic consent, especially when the artist is a parent. Many art critics countered that the photographs were neither erotic nor pornographic. Mann's goal was to portray children as they experience and discover their world in a harmless, playful manner.

The children, now adults, are perplexed by the many unsettling responses that came from their mother's photographs of them when they were young. They saw themselves as collaborators in their mother's work. Jessie Mann, now an artist in her own right, claims that the experience gave her a desire to be a "part of some story" and to "to *make art by being in* art" (Jessie Mann 28).

When her children grew older, Mann moved to photographing landscapes of the American South and Civil War battlefield using a damaged lens and a large-format bellow camera that required her to use her hand as shutter. She took ethereal images of her ancestral home in Virginia that look as if they could have been taken in the nineteenth century. Leaks of light, scratches, and focal shifts all refer to earlier photographic processes. These landscapes have a soft, undetailed presentation that evokes the past as the present of an unpopulated territory. Using an old lens that didn't cover the entire photographic plate, she was able to get a clearer focus to the outside edges, which functions something like a frame. Mann's Georgia landscapes are displayed in shadowbox frames unlike the photographs from Virginia, which are dry-mounted. Another series, titled *Deep South: Landscapes of Mississippi and Louisiana*, depict swamps and bayous as well as old plantation ruins, evoking the lushness of the present and the horror of a past history of slavery.

Her more recent work on marriage, like the photographs of her children, is deeply intimate. While she began exploring this subject in the 1970s, she didn't show the work until later in her career. Many pictures in this series are of everyday events and include scenes like light streaming through a window or water pouring from a bathroom shower. But there are also scenes of lovemaking, bathing, menstruation, as well as quiet and repose. Mann wanted to show all aspects of married life. If critics had previous questioned her for violating childhood innocence, questions were again raised about whether or not Mann had pushed her images into the realm of indecency.

Feminist critics have questioned what the commotion over this series is all about since male photographers like **Alfred Stieglitz** and **Harry Callahan** have repeatedly photographed women in erotic poses. In this case, however, a woman has captured candid images of a man. Mann claims that what she has done is portrayed the glue that holds a long-term marriage together. Sometimes it's messy, and it can be embarrassing. In 1997, Larry Mann

was diagnosed with muscular dystrophy. With his permission and encouragement, Sally Mann documented the progression of the disease in an effort to give it meaning.

Loss and death are recurring themes in Mann's work. Her landscapes, especially those of Civil War battlefields, echo loss as do memorial photos of the family's beloved greyhound dog, Eva, who died in 1999. After she died, Eva was skinned; later her skeleton was laid above ground in a protected setting. Over the course of a year, Mann documented the changes. She wanted to see how the bones would turn into earth. Her interest was in the merging of life and decay along with beauty and that which is gruesome. These themes are also explored in her images of decomposing bodies at a forensic laboratory, an assignment for the *New York Times*. Working with a collodion-wet-plate process developed in the 1850s that causes chemical actions to flow over the surface of the images, she further communicates ideas of tenuousness and corrosion. Antietam, the battlefield just hours from Mann's farm, is a place where more than 23,000 people died on the worst day of killing in American history. Her photographs of this place are filled with memories so strong that they almost resurrect into the present. Ghosts fade but make their presence known. What might at first seem like a serene landscape turns dark and becomes a wasteland. This exploration of death and decay resulted in the series and book titled *What Remains*.

Mann believes that you have to work hard to make something beautiful. She also believes in what she calls "the Angel of Chance," a state in which grace falls upon her and an artful experience takes place. During these moments a kind of truth can be conveyed, but it is a truth that is complex, ambiguous, and grand. As Mann says, "we see the beauty and we see the dark side of things; the cornfields, the full sails, but the ashes as well." It is "beauty tinged with sadness" (Johnson 290). Like Diane Arbus, Mann places you in the position of a voyeur. The uneasiness you feel tells you that you should look away, but the work is so compelling, you become captive in her world.

Bibliography

Corn, Alfred. "Photography Degree Zero." *Art in America* 1 (1998): 88–91.

Hock, Edwynn. "Sally Mann." *Artnews* 102, no. 11 (2003): 118–119.

Johnson, Brooks. *Photography Speaks: 150 Photographers on Their Art*. New York: Aperture, 2004.

Jones, Malcolm. "Love, Death, Light." *Newsweek*, September 8, 2003: 54–56.

Mann, Jessie. (Photographed by Len Prince.) "Self-Possessed." *Aperture* 183 (Summer 2006): 28–39.

Mann, Sally. *Deep South*. New York: Bulfinch Press, 2005.

———. *What Remains*. New York: Bulfinch Press, 2003.

———. "Southern Obsessions, Southern Exposure." *The Chronicle of Higher Education*, May 21, 1999: B72.

———. *Immediate Family*. New York: Aperture, 1992.

Pollock, Barbara. "Sally Mann." *Artnews* 99, no. 2 (2000): 162.

Rexer, Lyle. "Marriage Under Glass: Intimate Exposures." *New York Times*, November 19, 2000: AR1, AR42.

Roberts, Molly. "Model Family." *Smithsonian* 36 (2005): 18, 20.

Woodward, Richard B. "The Disturbing Photography of Sally Mann." *New York Times Magazine*, September 27, 1992: 28–36, 52.

Places to See Mann's Work

Cleveland Museum of Art, Cleveland, Ohio
Corcoran Gallery of Art, Washington, DC
Harvard University Art Museums, Cambridge, Massachusetts
High Museum of Art, Atlanta, Georgia
Hood Museum of Art, Dartmouth College, Hanover, New Hampshire
Metropolitan Museum of Art, New York, New York
Modern Art Museum of Fort Worth, Texas
Museum of Fine Art, Boston, Massachusetts
Museum of Modern Art, New York, New York
San Francisco Museum of Art, San Francisco, California
Smithsonian American Art Museum, Washington, DC
Sweet Briar College of Art Gallery, Sweet Briar, Virginia
Whitney Museum of Art, New York, New York

ROBERT MAPPLETHORPE

1946–1989

PERHAPS MOST WELL KNOWN FOR THE SCANDAL THAT HIS HOMOEROTIC photographs caused at the Cincinnati Contemporary Arts Center, Robert Mapplethorpe produced an impressive oeuvre of classically beautiful pictures in his short career. Since Mapplethorpe had been honored with a National Endowment for the Arts grant, questions were raised by politicians and the general public as well as the art world about what constitutes art and what kinds of projects should be funded with federal money.

Born on Long Island, New York, in 1946, he was the third of six children in a Roman Catholic family. As a child, Mapplethorpe attended his local Catholic parish regularly in the Floral Park neighborhood in Long Island. He showed an early aptitude for art and spent much time learning traditional art techniques. After high school Mapplethorpe attended Pratt Institute in Brooklyn, where he studied painting and sculpture for seven years before graduating with his BFA. Initially Mapplethorpe did not view photography as a fine art medium and subsequently did not pursue photography. Rather, he was inspired by Marcel Duchamp's *readymades* and Joseph Cornell's collage boxes. Mapplethorpe's first mature work was a series of collages that were loaded with imagery and symbolism from his Roman Catholic upbringing and his curiosity of black magic. He incorporated photographs cut from magazines and books that added an element of *popular culture*. Although he was still reluctant to accept photography as art, he had a sense about the role of the photographic image in pop culture and in his own art. Mapplethorpe was also influenced by *pop artist* Andy Warhol. The two eventually became friends, and Mapplethorpe photographed him on several occasions.

In 1970, Mapplethorpe was living at the Chelsea Hotel in New York City. There he met photographer Sandy Daley, who gave him his first *Polaroid* camera. This was about the time that Mapplethorpe went public with his homosexuality, which reflected in this early work. The first photographs he took were self-portraits that are self-confident, sexually assertive, and at times, tantalizingly explicit.

John McKendry introduced Mapplethorpe to the world of photography and mentored his entrance into the photography market. McKendry was the curator of prints and photography at the Metropolitan Museum of Art and invited Mapplethorpe to the museum for a private showing of the photography collection. This experience was a turning point in Mapplethorpe's acceptance of photography as a fine art medium and photographers as artists, for which he said, "Looking at those photographs made me think that photography maybe could be art. I had never thought about that before, but now I found myself getting excited about the possibilities" (Danto 2001: 52–53). McKendry showed Mapplethorpe how to market his art work and was soon living financially independent from the sale of his work.

After acquiring a large format camera, he started taking photographs of friends including artists, socialites, celebrities, pornographic film stars, and music composers. He gained widespread attention for the images of young attractive homosexual men in classical nude poses. Mapplethorpe was aiming to show the public a beautiful and genuine image of homosexual love, as in *Untitled (Charles and Jim)* (ca. 1974). The two men sit calmly side by side with a mutual admiration for one another. Other images are skillfully rendered with attention to the same formal elements but contain what has been considered inflammatory content, with nude males together in sexually explicit poses and at times with sexually oriented props. These images caused much controversy and fame for the artist. The first exhibition of these photographs was held at the Light Gallery in New York City in 1973.

In the 1980s Mapplethorpe started to photograph statuesque nude male and female figures. In the black-and-white portrait *Ken Moody* (1983), the sitter is shown from the chest up with bare skin glistening. This close-up shot is a balanced and formally exquisite composition. Possibly some of the most benign of Mapplethorpe's subjects was the series of flowers, for which he received much attention. Like his portrait series Mapplethorpe worked exclusively in the studio, controlling light and eliminating distracting background imagery. Delicate and precise images in both black-and-white and color prints of irises, violets, and hyacinths are photographed close-up and in glass vases with solid backgrounds. Mapplethorpe gave great attention to the details of each flower, highlighting the delicate yet strong with clarity of line and form.

With Mapplethorpe's previous reputation, it did not take critics long to suggest sexual analogies with various images from the floral series. In *Calla Lily* (1988) the blossom fills more than half of the frame with an erect stamen pointing upward. The flower blossom, which is typically compared to female genitalia, is subordinate in this image to the phallic symbol that centers the composition. Through the lens of Mapplethorpe's camera, what may have been perceived as a symbol of femininity now emerges as inner male strength.

In 1990, the Cincinnati Contemporary Arts Center (CAC) opened the exhibition *Robert Mapplethorpe: The Perfect Moment*. The show was met with strong critiques from conservatives who charged that the museum's director, Dennis Barrie, was pandering obscenity and illegally using children. They were formally sued, and seven photographs went up for

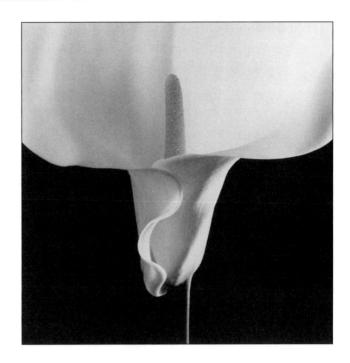

Robert Mapplethorpe.
Calla Lilly (1988).
© Copyright The Robert
Mapplethorpe Foundation.
Courtesy Art + Commerce.

judgment, including homoerotic imagery and separate nude photographs of boys. The trial put the Cincinnati CAC on the map and turned Mapplethorpe into an instant artist celebrity. When the judge ruled that the images were not obscene, the CAC, Barrie, and Mapplethorpe had succeeded in pushing the limits of contemporary art and in sparking a public debate about censorship and the definitions of art and obscenity. Barrie was acquitted of all charges.

The high-profile controversy heightened exposure to Mapplethorpe's art work, which has been exhibited all over the world. Mapplethorpe's work is often considered provocative and even shocking, yet formalist qualities such as line, form, shade, and balance are present in all of his work and hold equal importance to the success of the composition. Throughout his career he experimented with color Polaroids, *photogravures*, platinum prints on paper and linen, *cibachromes*, dye transfer color prints, and black-and-white gelatin silver prints.

Mapplethorpe established The Robert Mapplethorpe Foundation in 1988 to care for his estate after his death and to promote photography, support museums that exhibit photographic art, and to fund medical research and finance projects in the fight against AIDS and HIV-related infection. Mapplethorpe was stricken with the AIDS virus at the peak of his career. He died from complications related to AIDS on March 9, 1989, in a Boston hospital.

The work of Robert Mapplethorpe caused one of the most sensational debates about the meaning of art and how federal funds should be spent; for this he may be most well

known forever. Although he came to photography as an adult, and his life was cut short, Mapplethorpe left a notable photographic oeuvre with some of the most formally beautiful pictures taken in the twentieth century.

Bibliography

Alexander, Paul. "What Price Mapplethorpe?" *Artnews* 98, no. 1 (1999): 112–116.

The Robert Mapplethorpe Foundation, Inc. "Biography." Retrieved February 3, 2007, from www.mapplethorpe.org/biography/html.

Cembalest, Robin. "Who Does It Shock? Why Does It Shock? [Controversy of Art Journal's decision to publish the X Portfolio by Robert Mapplethorpe]." *Artnews* 91, no. 3 (1992): 32+.

Danto, Arthur. *Playing with the Edge: The Photographic Achievement of Robert Mapplethorpe.* Berkeley: University of California Press, 1996.

———. "Instant Gratification: Robert Mapplethorpe's Polaroids 1970–1976." *Aperture* 163 (Spring 2001): 44–53.

Heartney, Eleanor. "Postmodern Heretics [Catholic influences in the work of four contemporary Artists]." *Art in America* 85, no. 2 (1997): 32–35.

Levas, Dimitri, ed. *Pictures: Robert Mapplethorpe.* New York: Arena Editions, 1999.

Mapplethorpe, Robert. *Robert Mapplethorpe and the Classic Tradition: Photographs and Mannerist Prints.* Berlin: Deutsche Guggenheim, 2004.

Merkel, Jayne. "Report from Cincinnati: Art on Trial [decision reached on the Contemporary Arts Center's Mapplethorpe Exhibit]." *Art in America* 78, no. 11 (1990): 41–46.

Weiley, Susan. "Prince of Darkness, Angel of Light [Robert Mapplethorpe]." *Artnews* 87, no. 11 (1988): 106–111.

Places to See Mapplethorpe's Work

Art Gallery of New South Wales, Sydney, Australia
Baldwin Gallery, Aspen, Colorado
Brooklyn Museum of Art, New York, New York
Dallas Museum of Art, Dallas, Texas
Denver Art Museum, Denver, Colorado
Fay Gold Gallery, Atlanta, Georgia
John & Mable Ringling Museum of Art, Sarasota, Florida
Kemper Museum of Art, Kansas City, Missouri
Los Angeles County Museum of Contemporary Art, Los Angeles, California
Marc Selwyn Fine Art, Los Angeles, California
Massachusetts Institute of Technology, Cambridge, Massachusetts
Miami Art Museum, Miami, Florida
National Gallery of Art, Washington, DC
Robert Mapplethorpe Foundation, Inc.: www.mapplethorpe.org
Sean Kelly Gallery, New York, New York
Smith College Museum of Art, Northampton, Massachusetts
Solomon R. Guggenheim Museum, New York, New York
University of South Florida Contemporary Art Museum, Tampa, Florida

Meghan Boody. *Fire* (2006). Fuji-flex print, 50 × 71 inches. Courtesy of Sandra Gering Gallery, New York.

Esther Bubley. *The El Platform, New York City* (1951). Courtesy of Jean Bubley. © Esther Bubley Estate.

James Casebere. *Monticello #3* (2001). Digital chromogenic print, 24 × 30 inches and 48 × 60 inches, edition of 5. Courtesy of the artist and Sean Kelly Gallery, New York.

Sarah Charlesworth. *Figures* (1983–1984). Cibachrome laminated with lacquer frame, 62 × 42 inches. Courtesy of the artist.

Bill Coleman. *Amish #437: Henry with Friends* (n.d.). Courtesy of Bill Coleman. www.Amishphoto.com.

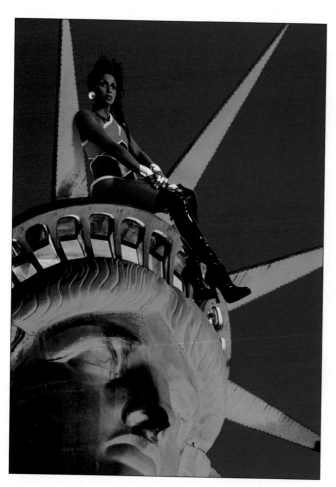

Renee Cox. *Chillin with Liberty* (1998). Cibachrome print. © Renee Cox. Courtesy Robert Miller Gallery, New York.

Gregory Crewdson. *Untitled (Maple Street)* (Summer 2003). Digital C-Print, 64¼ × 95¼ inches (163.2 × 241.94 cm). Courtesy of the artist and the Luhring Augustine Gallery, New York.

Gregory Crewdson. *Winter (Bed of Roses)* (2005). 64¼ × 94¼ inches (163.2 × 239.4 cm). Courtesy of the artist and Luhring Augustine Gallery, New York.

Judy Dater. *Death By Ironing* (1982). Courtesy of the artist.

Jeanne Dunning. *Hand Hole* (1994). Cibachrome photograph mounted to plexiglass and frame, 19½ × 27½ inches. Courtesy of the artist & Kinz, Tillou + Feigen, New York.

Anna Gaskell. *Untitled #5 (wonder)* (1996). C-print, laminated and mounted on Sintra, 48 1/16 × 40 1/4 inches (122.1 × 102.2 cm). Solomon R. Guggenheim Museum, New York. Purchased with funds contributed by the Young Collectors Council. 97.4580.

Nan Goldin. *Jimmy Paulette & Misty in a Taxi, NYC* (1991). Dye destruction print, 26½ × 39½ inches (67.31 × 100.33 cm). San Francisco Museum of Modern Art. Accessions Committee Fund: gift of Collectors Forum, Pam and Dick Kramlich, Norah and Norman Stone. © Nan Goldin.

David Levinthal. *Wild West (88-PC-C-8) Untitled* (1988). Courtesy of the artist.

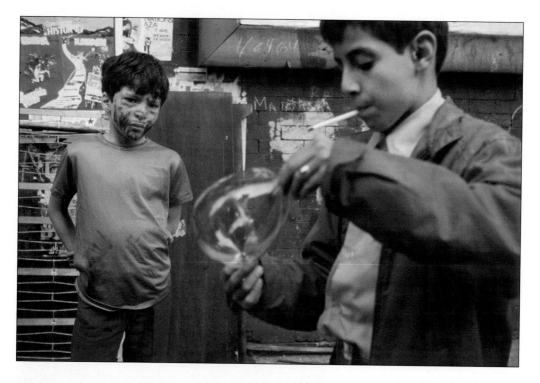

Helen Levitt. *New York (boys with bubbles)* (1972). Courtesy of the Laurence Miller Gallery, New York.

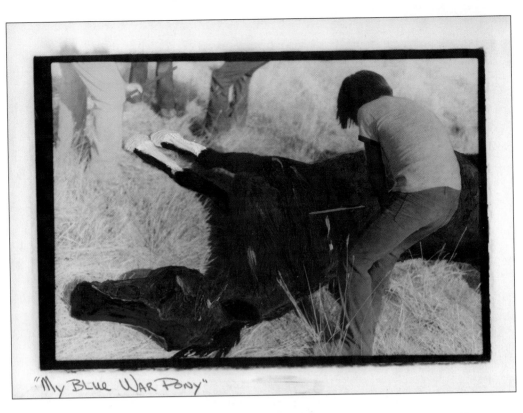

Carm Little Turtle. *My Blue War Pony* (1993). Black and white photo, sepia toned, oil paint. Courtesy of the artist.

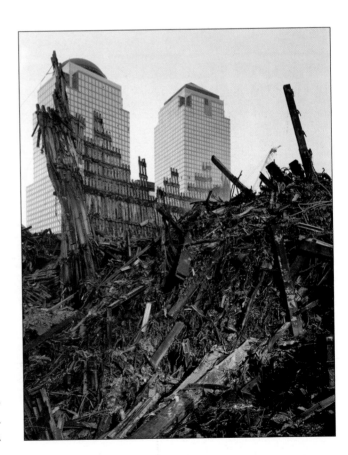

Joel Meyerowitz. *The South Tower* (2001). © Joel Meyerowitz. Courtesy Edwynn Houk Gallery.

Joel Meyerowitz. *Bay/Sky, Provincetown* (1977). © Joel Meyerowitz. Courtesy Edwynn Houk Gallery.

Richard Misrach. *Open Dining, Bonneville Salt Flats* (1992). © Richard Misrach, courtesy Fraenkel Gallery, SF, Pace MacGill Gallery, NY and Marc Selwyn Fine Arts, LA.

Eliot Porter. *Black-Chinned Hummingbird* (August 4, 1956). Dye imbibition (Kodak dye transfer). © 1990 Amon Carter Museum, Fort Worth, Texas, Bequest of the artist.

Martha Rosler. *House Beautiful* (*Giacometti*) (1967–1972). Photomontage, 24 × 20 inches. © Martha Rosler, courtesy of Mitchell-Innes & Nash, New York.

Martha Rosler. *JFK, TWA Terminal* (1990). C-Print, 26½ × 40 inches. © Martha Rosler, courtesy of Mitchell-Innes & Nash, New York.

Lucas Samaras. *Photo-Transformation* (July 6, 1976). Courtesy of The J. Paul Getty Museum. © Lucas Samaras.

Andres Serrano. *Nomads (Bertha)* (1990). Cibachrome, silicone, plexiglass, wood frame. 60 × 49½ inches (152.4 × 125.7 cm); framed: 65 × 54½ inches (165.1 × 138.4 cm). Edition 1 of 4. © Andres Serrano. Courtesy Paula Cooper Gallery, New York. Collection of the Modern Art Museum of Fort Worth, Museum purchase made possible by a grant from The Burnett Foundation.

Cindy Sherman. *#193 Untitled* (1989). Courtesy of the artist and Metro Pictures.

Sandra Louise Skoglund. *Fox Games* (1989). Cibachrome photograph, 46 × 62 inches. Collection of the Lowe Art Museum, University of Miami. Gift of The Francien and Lee Ruwitch Charitable Foundation, Inc., 91.0477. Copyright © 1989 by Sandy Skoglund.

Doug and Mike Starn. *Alleverythingthatisyou* (2006–2007). 28 × 142 × 45 inches. Archival inkjet print on photo paper, diasecface mount to acrylic. Edition: unique. © 2007 Doug and Mike Starn/Artists Rights Society (ARS), New York.

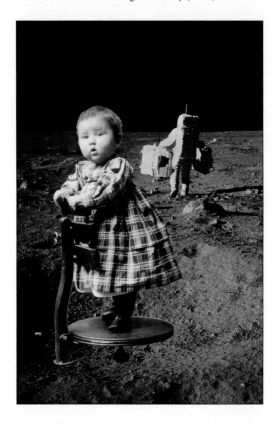

Hulleah Tsinhnahjinnie (Seminole/Muscogee/Diné). *Hoke-tee,* from the series *Portraits Against Amnesia* (2003), platinum lambda print. Courtesy of the artist.

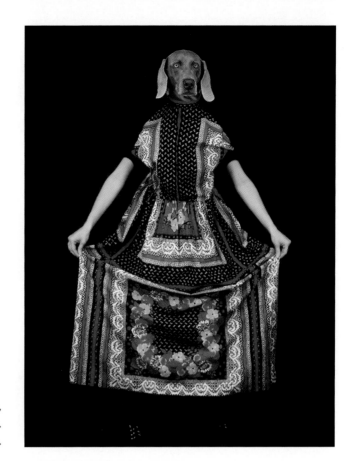

William Wegman. *Lap Dog* (1989), color Polaroid, 24 × 20 inches. Courtesy of the artist.

Hannah Wilke. *February 19, 1992 #6* from INTRA-VENUS Series (1992–1993). Performalist Self-Portrait with Donald Goddard, chromagenic supergloss print, 47½ × 71½ inches. Copyright © 2007 Donald Goddard. Courtesy Ronald Feldman Fine Arts, New York.

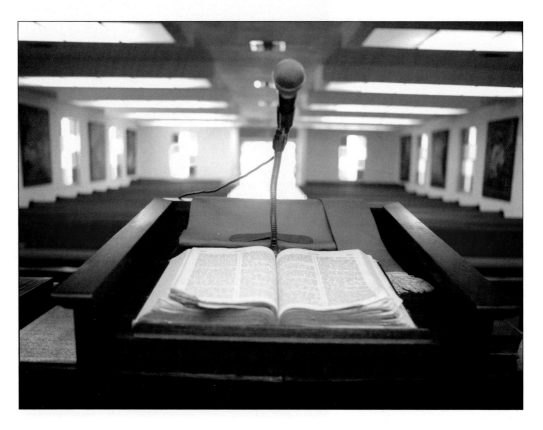

Deborah Willis. *Pulpit, Interior Church* (n.d.). Courtesy of Deborah Willis and Bernice Steinbaum Gallery, Miami, FL.

Deborah Willis. *Body Building Series* (n.d.). Courtesy of Deborah Willis and Bernice Steinbaum Gallery, Miami, FL.

MARY ELLEN MARK

b. 1940

MARY ELLEN MARK IS PERHAPS BEST KNOWN FOR HER PHOTOJOURNALISM work in less advantaged areas of the world, from India and Turkey to the poorest streets in the United States.

She was born on March 20, 1940, in Philadelphia, Pennsylvania. Mark had an early interest in art and photography and started making pictures with a *Brownie* box camera by the age of nine. She was active in extracurricular activities in high school as a cheerleader, and in art, where she developed a strong foundation in painting and drawing. After high school she enrolled at the University of Pennsylvania in Philadelphia. She graduated with her BFA. in art history and painting in 1962. Mark went on to pursue graduate work in photojournalism at the Annenberg School for Communication, earning her MA in 1964.

In 1965, Mark traveled to Turkey for one year funded by a Fulbright Scholarship. It was during this trip that Mark took what she has called her first successful photograph, *Street Child Trabzon, Turkey* (1965). Although they did not speak each other's language, the young girl poses knowingly for Mark in a direct and charming way. Her "little girl" shoes and large hair bow tell us that she is young, but her sassy pose suggests that she is aware of her emerging sexuality.

Mark easily found work as a freelance photographer in the commercial market after college. She has published photo essays in *Life*, *The New York Times* magazine, *Rolling Stone*, *Esquire*, *Look*, *Holiday*, and *Vanity Fair*. Today, she is a contributing photographer at *The New Yorker*. Mark has been commissioned to work on several advertising campaigns for companies such as Barnes and Noble, Coach Bags, Heineken, Keds, and Nissan. This commercial work has been lucrative for Mark, giving her the financial freedom for her humanitarian photojournalist projects. She has simultaneously managed careers in two worlds, much the way photographer **Richard Avedon** had one foot in the commercial photography world and the other in the art world.

In her independent projects Mark works with a socially conscious lens, seeking to document the lives of the unseen and forgotten populations throughout the world. She has garnered much attention for the color portraits that she took in Bombay, India, of the prostitutes of Falkland Road. When she took those pictures from 1978 to 1979, Mark had already been visiting Falkland Road for almost 10 years, which is how long it took to earn the respect and trust from the girls and women working the sex trade there. Mark captured them on display in the red light district and in everyday life, playing, washing, crying, and inside the small bedrooms that function as their work spaces. Unlike most of Mark's other work, these photographs are in color. The portraits come alive with brightly hued and patterned clothing, blankets on beds, and boldly painted walls, creating a fairy tale set inside this darker side of life. The prostitutes wear hot pink lipstick and adorn themselves with jewelry, hair pens, and flowers, masking their identities and transforming themselves into pure sex objects.

In the early 1980s after a project with *Life* magazine featuring Seattle's street children, Mark was compelled to do her *Streetwise* series. This project gave her the insight to recognize that being a woman made it easier for her to access children and vulnerable members of society. She photographed working-class neighborhoods of Seattle and the homeless and low-income population, focusing primarily on children and teenagers. She is attracted to the raw emotion and energy of children and especially of teenagers who are undergoing physical, emotional, and intellectual changes. Mark interviewed the children about their lives and in the final project *Streetwise* (1988), she included direct quotes to accompany each portrait, adding another layer of meaning and depth to each image.

The portraits are varied; some people appear happy as they stop and smile for the camera, while others are less willing to put up a front. For instance, Tiny, a young girl who was a recurring subject in the series, was often sullen faced with a look of desperation in her eyes. In one photograph Tiny clutches a small kitten close to her as she looks forlornly down at the ground, with the caption, "I want a baby. But not by a new trick though" (Mark 1988: caption). Her words transform the photograph from a picture of a sad little girl into a narrative about innocence lost and a longing for love.

Mark is an activist through her photography by portraying individuals as they really are in their natural surroundings. Although her work may not directly benefit those she photographs, Mark is exposing another side of life and challenging the viewer to the social circumstance that led to poverty, desperation, drugs, or prostitution. *Streetwise* was well received and was made into a film, directed and photographed by her husband, filmmaker Martin Bell.

She has a special affinity for animals and for the relationship between animals and humans, which inspired her projects photographing circus performances in India and Vietnam and rodeos in Texas. In *Rodeo, Leakey, Texas* (1991), three rodeo patrons are seen showing their spirit and support for the community event. This black-and-white photograph is a

portrait of two elderly women and one man, all three sitting in wheelchairs donning their cowboy hats and clutching small American flags waiting for the cue to wave them. In small town America events such as the rodeo are community gatherings that still attract all ages. In another portrait, *Craig Scarmardo and Cheyloh Mather at the Boerne Rodeo, Texas* (1991), two young patrons dressed in fine cowboy regalia from head to toe proudly pose for Mark.

Mark is fascinated with twins. She photographed countless sets of twins. Many of the portraits are fun and funny as twins often cause attention, especially when they are dressed alike or posing for the camera. Other twins' portraits are more serious. For instance, in the portrait with twins Bruce and Brian Kuzak, they pose with their nurses, Teresa and Til-lie Merriweather, who are also twins. The young strong women hold Bruce and Brian in their laps, who both suffer from severe physical disabilities. In the portrait of two beautiful girls, *Vashira and Tashira Hargrove, twins H.E.L.P. Shelter, Suffolk, NY* (1993), the setting informs us of the harsh circumstances that the children are surviving.

Mark is an accomplished artist. Her work has been exhibited all over the world in art galleries, museums, and spaces such as the Photographers Gallery in London; the Santa Barbara Museum of Art in California; at the Museum of Art at the University of Oregon in

Mary Ellen Mark. *Craig Scarmardo and Cheyloh Mather at the Boerne Rodeo, Texas* (1991). © Mary Ellen Mark.

Eugene; Allen Street Gallery in Dallas, Texas; Friends of Photography in Carmel, California; California Museum of Photography in Riverside; International Center for Photography in New York City; Richard Gray Gallery in Chicago; George Eastman House of Photography in Rochester, New York; Seattle Art Museum in Washington; and the Honolulu Academy of Arts in Hawaii. Over the past three decades, Mark has been invited to speak and give lectures at numerous academic and arts institutions, such as Temple University in Philadelphia; U.S.I.A. Photography Workshop in Yugoslavia; Brooks Institute in Santa Barbara, California; Women's Interart Center in New York City; Massachusetts Institute of Technology in Cambridge, Massachusetts; and the **Ansel Adams** Workshop in Carmel, California.

She has won many awards including the Cornell Capa Award given by the International Center of Photography, Infinity Award for Journalism, Erna and Victor Hasselblad Foundation Grant, Guggenheim Fellowship, three National Endowment for the Arts grants, and Photographer of the Year Award from the Friends of Photography. Mark has received five honorary doctorate degrees from various institutions including her alma mater, the University of Pennsylvania. She has published more than a dozen books on her work. In 2000, *Artnews* named Mark as one of the world's top art collectors. Hundreds, perhaps more than one thousand artworks fill her New York apartment; a collection that represents many of the most prominent artists to the anonymous crafts person.

The relationship between Mark and the subject, however short lived or intimate it may be, affects the outcome of every portrait. She says that if you care enough about your work, you cannot help but become a part of it; the work is completely subjective and visceral. She said, "When I see something that registers, and I feel that it's worth photographing…all of the little things in my past and my present are making me believe. It's emotional. And I respond" (Panzer, in Mark 1995: foreword). A successful commercial artist in her own right, Mary Ellen Mark is dedicated to her work in photojournalism, exposing the underbelly of society as an offering toward changing those very conditions that she is documenting.

Bibliography

Clifford, Katie. "Souvenirs of a Career." *Artnews* 99, no. 7 (Summer 2000): 166–167.

Fulton, Marianne. *Mary Ellen Mark: 25 Years*. Boston: Little, Brown, 1991.

Kleh, Elizabeth. "Mary Ellen Mark: Yancey Richardson and Marianne Boesky." *Artnews* 105, no. 3 (2006): 132.

Lahs-Gonzalez, Olivia, and Lucy Lippard. *Defining Eye: Women Photographers of the 20th Century*. St. Louis, MO: St. Louis Art Museum, 1997.

Mark, Mary Ellen. *The Photo Essay: Photographs by Mary Ellen Mark*. Washington, DC: Smithsonian Institution Press, 1990.

———. *Mary Ellen Mark: Portraits*. Foreword by Mary Panzer. Washington, DC: Smithsonian Institution Press, 1995.

———. *Streetwise*. New York: Aperture, 1988.

Pagel, David. "Mary Ellen Mark at Fahey/Klein." *Art Issues* 65 (November/December 2000): 45.

Places to See Mark's Work

American Museum of the Moving Image, Astoria, New York
Australian National Gallery, Canberra, Australia
Baltimore Museum of Art
Bibliothèque national de France, Paris, France
Boca Raton Museum of Art, Boca Raton, Florida
California Museum of Photography, University of California Riverside, Riverside, California
California State University Library, Long Beach, California
Center for Creative Photography, University of Arizona, Tucson, Arizona
Centro Fotografico Alvarez Bravo, Oaxaca, Mexico
Chrysler Museum of Art, Norfolk, Virginia
Cleveland Museum of Art, Cleveland, Ohio
Corcoran Gallery of Art, Washington, DC
Detroit Institute of Arts, Detroit, Michigan
El Centro de la Imagen, Mexico City, Mexico
George Arents, Jr. Collection, New York Public Library, New York, New York
George Eastman House of Photography, Rochester, New York
Herbert F. Johnson Museum of Art, Cornell University, Ithaca, New York
Honolulu Academy of Art, Honolulu, Hawaii
International Center of Photography, Rochester, New York
Iris & B. Gerald Cantor Center for Visual Arts, Stanford, California
J. Paul Getty Museum, Los Angeles, California
Leo Castelli, New York, New York
Library of Congress, Washington, DC
Los Angeles County Museum of Art, Los Angeles, California
Mary Ellen Mark's Web site: www.maryellenmark.com
Mead Art Museum at Amherst College, Amherst, Massachusetts
Minneapolis Institute of Arts, Minneapolis, Minnesota
Museum Ludwig, Cologne, Germany
Museum of Contemporary Photography, Chicago, Illinois
Museum of Fine Arts, Houston, Texas
Museum of Photographic Arts, San Diego, California
National Millennium Survey, College of Santa Fe, Santa Fe, New Mexico
National Portrait Gallery, Washington, DC
Neuberger Museum, Purchase, New York
Philadelphia Museum of Art, Philadelphia, Pennsylvania
Portland Museum of Art, Portland, Maine
St. Louis Art Museum, St. Louis, Missouri
San Francisco Museum of Modern Art, San Francisco, California
Santa Barbara Museum of Art, Santa Barbara, California
Seattle Art Museum, Seattle, Washington
Smith College, Northampton, Massachusetts
Southeast Museum of Photography, Daytona Beach, Florida
Sweet Briar College, Sweet Briar Virginia
Tokyo Metropolitan Museum of Photography, Tokyo, Japan
Toledo Museum of Art, Toledo, Ohio
University of Colorado, Boulder, Colorado

University of New Mexico Art Museum, Albuquerque, New Mexico
University of Oklahoma Museum of Art, Norman, Oklahoma
University of Oregon, Eugene, Oregon
Whitney Museum of American Art, New York, New York
Yale University Art Gallery, New Haven, Connecticut

RALPH EUGENE MEATYARD

1925–1972

WHILE LIVING IN AN ISOLATED PART OF LEXINGTON, KENTUCKY, AND WORK-ing as an optician, Ralph Eugene Meatyard became interested in photography. He took pictures as he roamed around the rural areas of his hometown. As an avid reader, he has sometimes collaborated with writers such as Wendell Berry. His photographs are disturbing, full of surprise, and often cryptic. They tell shorts stories or can be seen as narrative fragments that reflect on his literary and philosophical interests.

Born in Normal, Illinois, Meatyard joined the navy to fight in World War II. After his discharge in 1946, he trained to be an optician, and in 1950, he joined the firm of Tinder-Krauss-Tinder in Lexington. For a short time he studied philosophy on the G.I. bill. He married and had three children, two boys and girl. Working full-time as an optician in a small suburban shopping center, he was always a weekend photographer. In the unassuming brick building where he worked, he displayed his photographs for customers to enjoy. In the back room was a darkroom and a space where he planned his trips. Maps covered the wall. He was a man who packed a lot into his life besides his paying job, photography, and family. He also made sculptures, he coached little league, and he engaged in Buddhist-style meditation with other shop owners on a regular basis. He had a keen interest in literature, poetry, and philosophy, and he read continuously.

Meatyard was not academically trained in photography. He purchased his first camera to document family life in 1950 after the birth of his first child. He taught himself what he could and learned the rest from the Lexington Camera Club, which he belonged to, and from taking workshops with notable photographers, including **Minor White** and **Aaron Siskind.** Learning about Zen from White, he began applying Zen ideas to landscapes and later to images of people. With this approach he wanted to let things happen rather than trying to fully control a picture. He didn't believe that a photograph could objectively portray truth. Consequently, the messages he communicates are never resolved or complete.

In the late 1950s Meatyard abstractly explored light as it hit the water and made a series on *Zen Twigs*, where most of the image was out of focus. Blurring parts of a photograph is an approach used by other photographers, such as **Lucas Sarmaras,** Mary Beth Edelson, and Duane Michals. By making certain parts of an image fuzzy, time is called into question. Instead of presenting Henri Cartier-Bresson's idea of capturing the decisive moment, Meatyard re-made reality by distorting time. These images, therefore, are indecisive and not frozen. What is portrayed is a feeling of change and continuous flow. In this way our photographic sense of reality is shaken.

As a photographer, Meatyard was especially interested in abandoned buildings. His son, Christopher Meatyard, remembers that the family would drive around the rural countryside looking for places that evoked the past: "There were lots of them around Lexington—mansions, a whole Shaker village about 20 miles away. If a house didn't have an antenna on the roof or a mailbox, then he figured it was unused. If there was a door ajar he would survey it to see whether there was enough interesting texture or light to make it worth working there. If not, we would look for someplace else" (Grant: AR 37). When Meatyard found a place that intrigued him, he would ask his children to pose on what became his southern-gothic setting.

Many of his photographs are staged. In his series titled, *Romances,* he carefully posed his subjects in such a way that they could symbolically communicate what he wanted to say. Interested in surrealism, he enjoyed playing with ideas and creating narratives that questioned ideas about reality. Sometimes he placed dolls in his scenes and he liked to use costumes and masks. He liked to experiment with various techniques such as playing with long exposures. Or he would tightly focus on one aspect of a scene while letting the surrounding parts of the composition become hazy. His double-exposed landscapes read like visual sound and motion. They are fractured and vibrating. They remind us that nature has a pulse. There is action and there is stasis. Oppositions exist and play off of each other.

Perhaps the pictures that he took using dime-store masks are the most memorable. He purchased thirty to forty different masks one day on a whim, and began placing them on his subjects. In *Romances,* he used the masks to create what he thought of as Zen riddles that were intended to make viewers think about identity, time, and memory. These photographs have a surreal effect as they combine real setting with manipulated techniques that create a documentary fiction. Like much of his other work, these photographs are dark, moody, and filled with emotion. *New York Times* writer Annette Grant claims that Meatyard "conjured ghosts of the past from his flesh-and-blood present" (AR37). About his work, Meatyard explains, "I have always tried to keep truth in my photographs. My work, whether realistic or abstract, has always dealt with either a form of religion or imagination" (Johnson 208).

His last major series, *The Family Album of Lucybelle Crater,* was made in the two years before he died and published posthumously in 1974. It is full of images with masks. Named

Ralph Eugene Meatyard. *Lucybelle Crater and her 20 year old son* (ca. 1971). © The Estate of Ralph Eugene Meatyard, courtesy Fraenkel Gallery, San Francisco.

after a character in a Flannery O'Connor short story, all the characters in this series have the same name. These images work with the idea of the family snapshot.

Meatyard understood and enjoyed children. He liked their awkwardness and found their posturing charming. So compelling are his photographs of them that we wonder what becomes of them as they enter adulthood. His ability to draw us into his subjects functions somewhat like a writer who describes a wonderful character so well that we want to know more. Symbols like doors, darkness, and decay give us clues. In many of his pictures of children, he poses two who contrast each other in some way. For example, one may wear a mask or one may be out of focus.

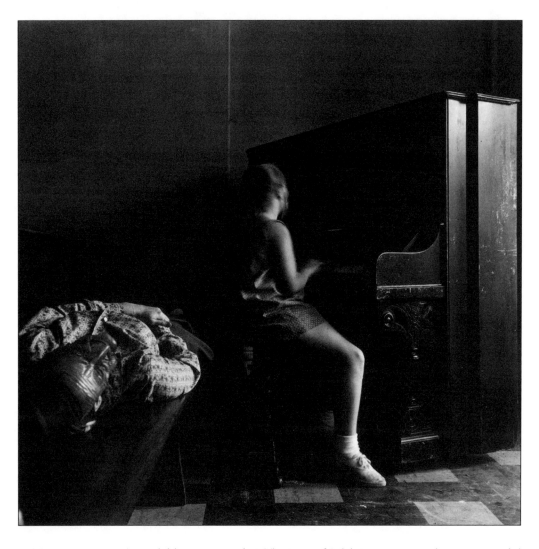

Ralph Eugene Meatyard. *Untitled* (ca. 1968–1969). © The Estate of Ralph Eugene Meatyard, courtesy Fraenkel Gallery, San Francisco.

In 2004, the International Center of Photography curated a retrospective of Meatyard's work. Before this time he had published his work in art magazines and had been exhibited in some important group shows. His 2004 retrospective, however, brought his photographs increased attention.

During his lifetime Meatyard had many illustrious friends who influenced his work. Among them were the writer and monk Thomas Merton and the poet Guy Davenport. It was Davenport who chose the pictures for his 2004 retrospective.

Ralph Eugene Meatyard died of cancer at the age of 46. He is remembered for his technical experimentation and the intellectual genius of his work.

Bibliography

Barrett, Terry. *Criticizing Photographs: An Introduction to Understanding Images*, 3rd ed. Mountain View, CA: Mayfield, 2000.

Davis, Keith, F. Foreword by Donald J. Hall. *An American Century of Photography: From Dry-Plate to Digital: The Hallmark Photographic Collection*. New York: Harry N. Abrams, 1995.

Gowin, Emmet. *Ralph Eugene Meatyard: A Fourfold Vision*. Tucson: Nazraeli Press, 2005.

Grant, Annette. "The Photographer Who Masked His Subjects." *New York Times*, December 5, 2004: AR37.

Johnson, Brooks. *Photography Speaks: 150 Photographers on Their Art*. New York: Aperture, 2004.

Stevens, Mark. "His Old Kentucky Home." *New York* 38, no. 2 (January 17, 2005): 64–65.

Places to See Meatyard's Work

Center for Creative Photography, University of Arizona, Tucson, Arizona

George Eastman House, International Museum of Photography and Film, Rochester, New York

Massachusetts Institute of Technology, Cambridge, Massachusetts

Metropolitan Museum of Art, New York, New York

Museum of Modern Art, New York, New York

Smithsonian Institution, Washington, DC

University of Kentucky Art Museum, Lexington, Kentucky

RAY K. METZKER

b. 1931

HERALDED FOR HIS EXPERIMENTATION WITH FORMAL COMPOSITION IN black-and-white photography, Ray K. Metzker is considered to be one of the most prominent photographers of the twentieth century.

He was born during the Great Depression in Milwaukee, Wisconsin, on September 10, 1931. At the age of 12, he received his first camera. He constructed a makeshift darkroom in the family's basement and set about teaching himself to take pictures. Promptly after high school, Metzker enrolled in art classes in college and graduated in 1953 with a BA from Beloit College in Wisconsin. However, his development as an artist was put on hold in 1954 when Metzker was drafted into the U.S. Army. He was deployed to Korea and served until 1956.

After coming home from Korea, he enrolled in graduate courses at the Institute of Design in Chicago at the Illinois Institute of Technology. The program was centered on *Bauhaus* principles of design that supported the merging of art and design with modern technology. There he studied with famed photographers **Aaron Siskind** and **Harry Callahan** and became one of Callahan's most famous students. For his senior project Metzker photographed the city streets of Chicago with an emphasis on the formal elements of art, such as line, shape, light, and dark. The project resulted in his graduation in 1959, inclusion in an exhibition at the Art Institute of Chicago, and mention in a 1961 issue of *Aperture* magazine, which featured professors and students from his school.

After graduation Metzker moved to Philadelphia for a teaching job at the Philadelphia College of Art. Once there he started to photograph the streets of Philadelphia in the same style and format as his work in Chicago. In *Philadelphia* (1963) the passersby that stop to read a public sign are the central figures. Metzker darkened the city buildings around them, minimizing the importance of the specific place or the grandeur of the architecture. The strong contrast between light and dark create an air of mystery or doom, recalling the

Ray Metzker. *Philadelphia* (1963). Courtesy of the Laurence Miller Gallery, New York.

brooding mood of *film noir*; perhaps the people are lost in the city and frantically searching for the right address or direction in which to continue their journey.

In the early 1970s Metzker went to Atlantic City, where he became fascinated with the beach goers. In an untitled image from 1973, a couple is lying together on a wrinkled blanket squished in the sand. They lie on their stomachs with the back of their legs exposed beneath their summer shorts. The woman has her arm around the man's waist comfortably. Love exudes from this image; even though they are anonymous, we can feel that they are happy and relaxed. Metzker wrote about the Atlantic City sun bathers, who he later called sand creatures:

> Surrendering to the heat, some doze; others abandon themselves in deep slumber. Arms embrace, legs entangle, hands move with or without purpose in endless variation. The ones who make periodic forays to cool themselves in the surf, return falling on their blankets. Long before the day is out, they become inhabitants of the beach—creatures of the sand. (Metzker 1979: 7)

Metzker was an educator for more than 20 years. He started teaching at the Philadelphia College of Art (now the University of the Arts) in 1962 and taught there until 1980. He also held short-term positions at the University of New Mexico from 1970 to 1972 and at

the Rhode Island School of Design in 1977. After he left the Philadelphia College of Art, he moved to Chicago to teach at Columbia College from 1981 to 1983. In 1987, he taught at the George Washington University in Washington, DC. Metzker eventually decided to retire from teaching to pursue his art full time.

Metzker has enjoyed success as an artist. His work has been honored with many awards and distinctions, including two Guggenheim Fellowships, two National Endowment for the Arts grants, and the Mayor's Art and Culture Award in Philadelphia. In 2000, the Royal Photographic Society proclaimed that Ray K. Metzker to be one of the most inventive and pioneering contemporary photographers and honored him with a Centenary Medal. There are half a dozen monographs of his work and surely more to come. Metzker mingles with other photographers and has exhibited with artist **Lee Friedlander** on occasion. His work has been shown in more than four dozen solo exhibitions in venues including the High Museum of Art in Atlanta, Georgia; the Museum of Modern Art in New York City; the San Francisco Museum of Modern Art; the Los Angeles County Museum of Art; and the Center for Creative Photography at the University of Arizona in Tucson.

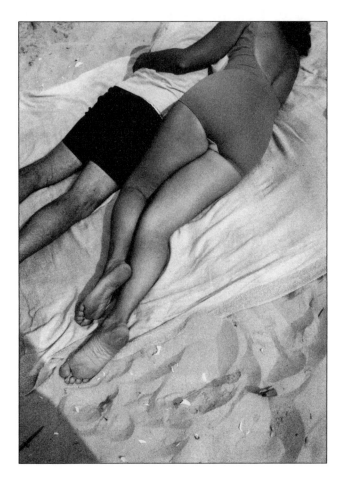

Ray Metzker. *Untitled (Atlantic City)* (1973). Courtesy of the Laurence Miller Gallery, New York.

Metzker is noted for his experimentation with formal elements in black-and-white photography. Although he often manipulates pattern, lighting and exposure to create a formally exquisite composition, the actual subject matter that he photographs is spontaneous and natural. His subjects ranged from beach scenes and city landscapes to pure abstractions. Metzker also experimented with presenting multiple images together, often positioning the images so that one informs the meaning of the other. Other notable projects include portfolios from his travels to Turkey, Tuscany, Southern France, Louisville, Kentucky, Tennessee, Wisconsin, North Carolina's Outer Banks, and Virginia. In 1994, he purchased a house in Moab, Castle Valley, Utah and has been taking pictures there ever since.

Today, he lives between his homes in Philadelphia, Pennsylvania and Moab, Utah. Ray K. Metzker is considered to be one of the most influential artists working with black-and-white photography of the twentieth century. With a full career behind him, it will be exciting to see what else he has in store for us.

Bibliography

Greene, Kendra. *Ray K. Metzker, biography.* Museum of Contemporary Photography. Retrieved February 5, 2007, from http://www.mocp.org/collections/permanent/metzker_ray_k.php.

Grundberg, Andy. "Elegant & existential: Museum of Fine Arts, Houston; traveling exhibit." *Art in America* 73, no. 5 (1985): 152–159.

Hill, Ed, and Suzanne Bloom. "Ray K. Metzker: Museum of Fine Arts, Houston; exhibits." *Artforum International* 23 (May 1985): 114.

Loke, Margaret. "Photography Review; City Scenes That Evoke A Hopperesque Mood." *New York Times,* June 18, 1999. Retrieved from the *New York Times* online database at http://query.nytimes.com/gst/fullpage.html?res=9405E6D7163BF93BA25755C0A96F958260.

Longmire, Stephen. "Callahan's Children: Recent Retrospectives of Photographers from the Institute of Design." *Afterimage* 28, no. 2 (September/October 2000): 5–8.

Metzker, Ray K. *Sand Creatures.* Millerton, NY: Aperture, 1979.

———. *Landscape.* New York: Aperture, 2000.

———. *City Stills.* Munich: Prestel, 1999.

RPS Annual Awards 2000. *RPS Journal* 140, no. 8 (October 2000): 365–368.

Tucker, Anne Wilkes. *Unknown Territory: Photographs by Ray K. Metzker.* Millerton, NY: Aperture and Houston, TX: Museum of Fine Arts, 1984.

Turner, Evan H. *Ray K. Metzker: Landscapes.* New York: Aperture, 2000.

Places to See Metzker's Work

Addison Gallery of American Art, Andover, Massachusetts
Allen Art Museum, Oberlin College, Oberlin, Ohio
Allentown Museum, Allentown, Pennsylvania
Art Institute of Chicago, Chicago, Illinois
Australian National Gallery, Canberra, New South Wales, Australia
Baltimore Museum of Art, Baltimore, Maryland
Beloit College, Beloit, Wisconsin
Bibliotheque Nationale, Paris, France

Center for Creative Photography, University of Arizona, Tucson, Arizona
Chrysler Museum, Norfolk, Virginia
Cleveland Museum of Art, Cleveland, Ohio
Davison Art Center, Wesleyan University, Middleton, Connecticut
Detroit Institute of Arts, Detroit, Michigan
Fogg Art Museum, Harvard University, Cambridge, Massachusetts
George Eastman House of International Photography, Rochester, New York
High Museum of Art, Atlanta, Georgia
Jackson Fine Art, Atlanta, Georgia
Laurence Miller Gallery, New York, New York
Los Angeles County Museum of Art, Los Angeles, California
Metropolitan Museum of Art, New York, New York
Milwaukee Art Museum, Milwaukee, Wisconsin
Museum of Art, Rhode Island School of Design, Providence, Rhode Island
Museum of Fine Arts, Boston, Massachusetts
Museum of Modern Art, New York, New York
National Gallery of Art, Washington, DC
National Gallery of Canada, Ottawa, Canada
Philadelphia Museum of Art, Philadelphia, Pennsylvania
Princeton University Art Museum, Princeton, New Jersey
San Francisco Museum of Modern Art, San Francisco, California
Smithsonian American Art Museum, Washington, DC
St. Louis Museum of Art, St. Louis, Missouri
Whitney Museum of American Art, New York, New York

JOEL MEYEROWITZ

b. 1938

AS ONE OF THE BEST-KNOWN COLOR PHOTOGRAPHERS, JOEL MEYEROWITZ was instrumental in changing the way the public feels about color photographs. He has published numerous books; perhaps the most well known are *Cape Light*, images taken at Cape Cod, and *The Aftermath*, a photographic history of the Twin Towers after the September 11, 2001, attack. He has had many awards from such prestigious places as the Guggenheim Foundation, the National Endowment for the Arts, and the National Endowment for the Humanities.

Meyerowitz was born in New York City. He claims his confidence to experience what is around him came from his father, a natural comic who used to imitate Charlie Chaplin in vaudeville. His father also taught him how to box at a young age, giving him lessons on how to carefully watch an opponent, an important boxing skill. Street gangs were prevalent in the Bronx when Meyerowitz was growing up and being skilled at both humor and boxing helped him know how to face difficult situations and feel comfortable in negotiating the streets. Living in a ground-floor apartment, Meyerowitz enjoyed looking out the window for entertainment. He graduated from Ohio State University in 1959 where he studied painting and medical illustration. After he graduated he worked in New York as an art director-designer.

Influenced by comic books and the movies, Meyerowitz also learned lessons from watching films by the famous Italian filmmaker Frederico Fellini. From him he studied how to organize chaos and to be able to see everything that came in front of the lens; he then learned to turn away from it. Meyerowitz explains that this lesson is about understanding a kind of jolt that crosses your awareness.

His work as a photographer began by shooting on the street with a 35mm camera in the traditions of Henri Cartier-Bresson and **Robert Frank.** By the late 1960s he switched to color film. He explains that he saw the ability for color to give greater description to his

images: "Color plays itself out along a richer ban of feelings—more wavelengths, more radiance, more sensation....Color suggests more things to look at [and] it tells us more. There's more content [and] the form for the content is more complex" (Davis 301). He continued his work as a street photographer making some impressive images that capture what can best be described as unfolding adventures. Moving quickly was important for Meyerowitz when working on the streets. He was so physically skilled at watching, moving, and shooting images that he referred to himself as a visual athlete. He often had to throw his entire body into a subject. He explains, "Photographers deal with things that are always disappearing. We're on the edge of knowing, and then only by a shred for feeling of almost no duration" (MacDonald and Meyerowitz, no page numbers).

In 1976, Meyerowitz changed both subject and format. He began using an 8 × 10-inch camera and started photographing activities surrounding his family's Cape Cod cottage. His focus shifted to a poetic way of seeing that celebrates the changing time of day and seasons. The light in this series, published in a popular book titled *Cape Light* (1978), is striking. Ninety-five images were selected from this series of work and placed on exhibition at the Museum of Fine Arts in Boston. This publication created public interest in color photography, which had previously been seen as disruptive and cosmetic, something that masked the original truth of the black-and-white image.

His photographs from the late 1970s and early 1980s captured a nostalgic mood in the streets of New York City and the eastern seaboard's vacation spots from Florida to Maine that were populated by New Yorkers. Evoking a simplicity that seems rather remote today, these images present classic American scenes of drugstores, suburban streets, and neon signs.

In the late 1970s, the St. Louis Art Museum commissioned Meyerowitz to photograph the St. Louis Arch. Instead of being seduced by the surface of the arch like most photographers, he contextualized it in its environment. Images of the arch, along with other photographs of St. Louis, were published in his book *St. Louis & the Arch* in 1980. Shortly afterwards, in 1983, he compiled dozens of photographs of flowers for the publication *Wild Flowers*. Taken over a period of 20 years, he was drawn to flowers on the avenues and boulevards of the main streets in the world. Meyerowitz claims that it is the continuity of the images, as opposed to the single photograph, that he enjoys. The flowers he likes best are the ones that, as he says, have "gone somewhat berserk." People plant flowers, hold them, and wear them. Flower images are made into lace and printed on blouses. They adorn hats and are used in celebrations. They give joy to the gardener and comfort to those who mourn when used to decorate graveyards. Meyerowitz does not want to distinguish between weeds and flowers, but he does want viewers to understand the events of life, adorned by wild flowers, that are beautiful.

On September 11, 2001, the United States experienced its greatest terrorist attack on U.S. soil. Standing in a crowd of people just days after the collapse of the Twin Towers,

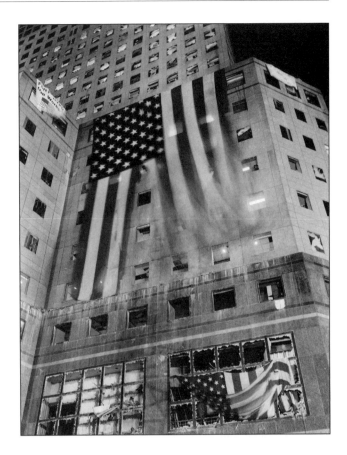

Joel Meyerowitz. *Flag at Midnight* (2001). © Joel Meyerowitz. Courtesy Edwynn Houk Gallery.

Meyerowitz noted that it was a crime scene, and no photographs were allowed. From his perspective no photographs meant that there would be no historical documentation. He immediately decided that it was his job to photograph the aftermath of the disaster, thereby providing the world with a photographic history. Partly through connections and partly through sheer determination, Meyerowitz gained permission to photograph the clean-up efforts. Using a large format wooden camera, he shot thousands of pictures on the 16-acre site. In 2006, the book titled *Aftermath: World Trade Center Archives* was published with several hundred of these images. Although he had not thought of himself as a photojournalist, on this project he saw himself working much as **Walker Evans** and **Dorothea Lange** had done during the Depression. Images ranged from mountains of rubble against the sky to a melted and twisted parking meter on Barclay Street. He also photographed the workers, the tireless volunteers, engineers, firefighters, clergy, and iron workers. The series readily communicates the country's collective grief and focused effort to restore order with dignity. The result is heartening in the midst of utter devastation. The images have been on exhibit in more than 60 countries and more than 200 cities.

Since the 9/11 attack, Meyerowitz has taken up documenting other topics, such as Buonconvento, a small Italian town. Emphasizing food, this was a partnership with his wife Maggie Barrett that was published in the *New York Times Magazine* in 2006.

Meyerowitz is also a filmmaker. His first film, titled *Pop*, won the "Best of Festival" award at the Chicago Windy City Film Festival in 1998 and the "Best Documentary in the Humanitarian Tradition" at the Athens International Film and Video Festival. A film about a road trip with a father and son, it examines old age and the significance of memory.

Although guided by formal qualities, Meyerowitz's vision is inspired by the human content related to a subject. Taking cues from the painter Edward Hopper, he claims that it is his intimate reaction that he most wants to portray.

Bibliography

Barrett, Maggie. Photographs by Joel Meyerowitz. "It Takes Over a Village." *New York Times Magazine*, November 19, 2006: 95–97.

Davis, Keith F. Foreword by Donald J. Hall. *An American Century of Photography: From Dry-plate to Digital: The Hallmark Photographic Collection*. Kansas City, MO: Hallmark Cards, in association with Harry N. Abrams, 1995.

Hirsch, Robert. *Exploring Color Photography: From the Darkroom to the Digital Studio*. 4th ed. New York: McGraw-Hill, 2005.

MacDonald, Bruce K., with Joel Meyerowitz. "A Conversation: Bruce K. MacDonald with Joel Meyerowitz, July 22–26, 1977." In Joel Meyerowitz, *Cape Light: Color Photographs by Joel Meyerowitz*. Foreword by Clifford S. Ackley, Interview by Bruce K. MacDonald. Boston: Museum of Fine Arts, 1978.

Mahler, Jonathan. "The Unbuilding." *New York Times Book Review*, September 3, 2006: 11.

Meyerowitz, Joel. *Aftermath: World Trade Center Archive*. New York: Phaidon Press, 2006.

———. *Joel Meyerowitz Photographs: Wild Flowers*. Boston: Little, Brown, 1983. A New York Graphic Society Book.

———. Preface by James N. Wood. *St. Louis & the Arch: Photographs by Joel Meyerowitz*. Boston: New York Graphic Society, in association with the St. Louis Art Museum, 1980.

———. Foreword by Clifford S. Ackley, Interview by Bruce K. MacDonald. *Cape Light: Color Photographs by Joel Meyerowitz*. Boston: Museum of Fine Arts and New York Graphic Society, 1978.

Sheets, Hilarie M. "Joel Meyerowitz." *Artnews* 105, no. 9 (2006): 178, 180.

Places to See Meyerowitz's Work

Art Institute of Chicago, Chicago, Illinois
Museum of Fine Arts, Boston, Boston, Massachusetts
Museum of Modern Art, New York, New York
St. Louis Museum of Art, St. Louis, Missouri
San Francisco Museum of Modern Art, San Francisco, California

RICHARD MISRACH

b. 1949

RICHARD MISRACH IS WELL KNOWN FOR HIS LARGE FORMAT, COLOR PHOTO-
graphs of the American desert bombed by U.S. military forces on test missions in the 1980s
and 90s. His images, which focus on the American West, function as political activism as
they involve antiwar and antinuclear messages. They depict flooded landscapes, damaged
cacti, burning deserts, hazy polluted skies, and dead animals. Formally, they are beautiful
pictures that paradoxically depict terrible devastation. His collection of photographic books
includes *Desert Cantos* (1987), *Richard Misrach 1975–1987* (1988), *Bravo 20: The Bombing
of the American West* (1990), *Violent Legacies: Three Cantos* (1992), *Crimes and Splendors*
(1996), *The Sky Book* (2000), *Richard Misrach: Golden Gate* (2001), *Pictures of Paintings*
(2002), and *Chronologies* (2005). He has won many prestigious awards and fellowships.

Misrach was born in Los Angeles. In 1971, he graduated from the University of Califor-
nia at Berkeley in psychology. Married to Debra Bloomfield, a photographer who teaches at
San Francisco Art Institute, they live in Berkeley, California, with their son Jacob.

When he was 22, Misrach became fascinated with people wandering in the night on
Telegraph Avenue in Berkeley. He set up a camera on a tripod and began shooting portraits.
In 1972, this series of black-and-white images was published in his first book, *Telegraph
3 A.M.* In 1975, the images were exhibited at the International Center of Photography in
New York. Wanting to raise money for poor people, he pledged 5 percent of his earnings to
a local food bank. But he was disturbed by the idea that pictures of poor people became a
coffee-table book, and he recognized that his efforts had no social impact.

Misrach then created a series of nighttime photos on Stonehenge and the Hawaiian rain-
forest. The flash captured the lushness of the Hawaiian forest, but it seems to be a disor-
derly lushness. He then went to the deserts that are least photographed and most sparsely
populated to explore what he thought would be somewhat of be a wasteland. What he
found was a landscape that both captured his imagination and deeply disturbed him.

After he published his second book, *Desert Cantos*, the art world took notice and his reputation was established. The idea of a cantos was inspired by Ezra Pound who spent half a century working on one long poem made of several cantos. Pound connected varying sections of writing together and referred to the entire piece as a cantos. Misrach decided to work this way with his images about place. Focusing on dry expanses of land that extend though California, Oregon, Idaho, Utah, Colorado, Arizona, New Mexico, Texas, and Nevada, his subject matter varies from cloud formations, to tourists and desert fires. His work is to be seen as a narrative and not isolated images.

Perhaps his most powerful photographs are those that document the results of our military's secretive practices in the desert. Rotting animals, open pits, toxic sites, and leftover debris marks the landscape as many of the images look at the destruction caused by human intervention. He explains, " Putting my pictures of skies next to those of a military bombing range allows for a conceptual reading" (Keats 106).

Bravo 20: The Bombing of the American West, a photography book published in 1990, contains a series of photographs that explores a specific part of the Nevada desert that the U.S. Navy used as a bombing range. He began this project in 1986 when he learned that the peacefulness of rural residents of Gabb's Nevada was repeatedly being invaded by loud supersonic flights, the bombing of historical towns, and laser-burning of cattle. The landscape was marred by bombs, polluted with artillery shells, and environmentally devastated. For five years Misrach not only documented the military maneuvers, but he actively worked with residents to stop the devastation. At the end of the book, he proposed that when the government contract expires (which happened in 2001), a national park be established on 64 square miles or the desert land that was bombed to show the environmental history of the place.

Misrach's large-format camera has the ability to give his images a cinematic quality as it picks up myriad kinds of details. So adept is he at making devastation look aesthetically appealing, that even dead animals with maggots eating them can, at least at first, seem compelling. However, it is the lingering discomfort that Misrach hopes will lead viewers to action.

In recent years Misrach has extended his cantos to more directly examine the psychological make-up of our relationship to the earth. For example, he created a cantos called *The Playboys*, focusing on images from *Playboy* magazine that were used for target practice at the Nevada Nuclear Test Site. In his series *Pictures of Paintings*, Misrach centered his energy on analyzing the odd fit of various paintings that were brought to the West. To make viewers reflect on the power of these paintings, he took photographs of parts of them as they hung in hotels or museums, usually leaving one part of the frame visible. Recognizing that they exist in a certain place, he captures surface glare, bits of wallpaper, and the dimness of a room's light. He recognizes that since he didn't study art in college, the way he sees the images has more to do with exploring symbolism than the quality of the painting. After photographing several hundred images for this series, he selected 35. Each image is titled with the

place where it was photographed. According to Misrach, these photographs are about our imported culture. Coupled with his other work, this series leads the viewer to think about how things change, and what belongs and doesn't belong in a space. Misrach refers to these images as "photographs of geographies" (Keats 107). If the history of the paintings and the place where they exist is examined, viewers have the opportunity to uncomfortably reflect on art as our civilization's marker. Images in this cantos also cause viewers to think about the place of reproductions in the history of art. For example, one image titled *San Antonio, Texas* (1995) is a detail from a Thomas Eakins' mid-1880 painting titled *The Swimming Hole*, based, ironically, on a photograph.

Critics have raised concerns about Misrach's work, wondering if such beautifully striking images should be made about such horrific environmental destruction. He responds that beauty captures people's attention and allows them to engage in difficult ideas. In this way the landscape is read as text. It can tell us about our past and our present as it signals what

Richard Misrach. *Golden Gate Bridge, 2.21.98 4:45 p.m.* (1998). © Richard Misrach, courtesy Fraenkel Gallery, SF, Pace MacGill Gallery, NY and Marc Selwyn Fine Arts, LA.

we need to pay attention to in the future. Misrach's photographs show us how fragile the earth is, and they compel us to map out a better way to living in it.

Bibliography

Baker, Kenneth. "Richard Misrach." *Artnews* 94, no. 10 (1995): 156

Davenport, Bill. "Richard Misrach." *Artnews* 95, no. 10 (1996), 137–138.

Friedman, Martin. "As Far as the Eye Can See." In *Visions of America and Landscape as Metaphor in the Late Twentieth Century*. New York: Harry N. Abrams and the Denver Art Museum, 1994, 10–33.

Keats, Jonathan. "How Cupid Lost His Head." *Artnews* 102, no. 3 (2003): 106–107.

Lippard, Lucy. *The Lure of the Local: Senses of Place in a Multicentered Society*. New York: The New Press, 1997.

Misrach, Richard. *Chronologies*. San Francisco: Fraenkel Gallery, 2005.

Solnit, Rebecca. "Richard Misrach." In *Visions of America and Landscape as Metaphor in the Late Twentieth Century*. New York: Harry N. Abrams and the Denver Art Museum, 1994, 130–135.

Steinman, Susan Leibovitz. "Compendium." In *Mapping the Terrain: New Genre Public Art*, ed. Suzanne Lacy. Seattle: Bay Press, 1995, 193–285.

Tuchman, Phyllis. "Richard Misrach at Robert Mann." *Art in America* 11 (2002): 162.

Places to See Misrach's Work

Art Institute of Chicago, Chicago, Illinois
Brigham Young University Museum of Art, Provo, Utah
California Museum of Photography at University of California, Riverside, California
Center for Creative Photography, Tuscon, Arizona
High Museum of Art, Atlanta, Georgia
International Museum of Photography at the Eastman House, Rochester, New York
Library of Congress, Washington, DC
Metropolitan Museum of Art, New York, New York
Museum of Fine Arts, Boston, Massachusetts
San Francisco Museum of Modern Art, San Francisco, California
Smithsonian Institution, Washington, DC
Whitney Museum of Art, New York, New York

ANDREA MODICA

b. 1960

ONE OF A SERIES OF PHOTOGRAPHERS WHO HAS REVITALIZED INTEREST IN the social documentary process, Andrea Modica is known for her photographs of family members living in a small community in upstate New York. She became so drawn to these individuals that she continued to photograph them when they moved out of the area. Her interest is in how families change over time and place. Using an 8 × 10-inch view camera, her black-and-white images are meticulous, deliberate, and finely textured.

Born in Brooklyn to Italian parents and raised as a Catholic, she attended the Brooklyn Museum Art School where she won the Alfred Harcourt Foundation Scholarship in Fine Arts. In 1982, she earned her BFA in visual arts and art history from State University of New York at Purchase. The formal nature of Egyptian art and the drama of Italian painting attracted her. Graduating with honors, her focus was on painting and sculpture. However, it was photography that gave her the control and technical limitations that eventually held her interest. In 1985, she received her MFA in photography from Yale University School of Art, earning the Cheney Award for Outstanding Achievement. She has taught at the college level at Parsons School of Design in New York City, at Colorado College in Colorado Springs, and at the State University of New York College at Oneonta, where she began photographing in Treadwell, a town of 200 people. She currently teaches photography at Drexel University in Philadelphia. In 1998, she married Paul Myrow.

Because Modica photographed the same people over time, her images can be read as narrative. She captures the rhythms of family lives as opposed to static representations as she documents the changes that children go through moving from childhood to adolescence. Children rumble in the grass, roll around on the floor, peek out from under curtains, and are cared for by adults and older siblings. One child in particular stands out. Barbara became Modica's main subject in 1986 when she was seven years old. Modica first met her when she was sitting on a farmhouse porch with her siblings in Treadwell, New York. The two

Andrea Modica. *Treadwell, New York* (1986). Courtesy of the artist.

became friends. Barbara had many ideas about how to make pictures, and her suggestions helped form the publication and series titled *Treadwell*. In the photographs she is easily identifiable as a chubby child who lounges on beds, playfully wears paper bunny ears, and looks defiant as she passes through a doorway. Modica captures sunlight on her fleshy arm as she rests on a pillow and blanket worn with use. The most well-known photograph from the *Treadwell* series depicts two young girls, one of them Barbara, being touched by adult hands. Viewers are not sure whether they are being restrained or caressed. This image was one of her first photographs taken for the series.

There is an adventurous playfulness within the rural environment that comes across in many of the images. Lives are experienced in-the-moment. The many pictures of children resting, melding into nature, and exploring and celebrating objects in their spaces seem somehow placed in a past that is now all too rare. Instead of boredom, these children have the space to look, find, imagine, and discover. Consequently, there is a moral freshness to this work. We see the environment through the interactions of the children who perform

in the space. They interact with animals, and they sacrifice them. These family members gather their identities from each other and from nature. They use their imaginations to reveal truths.

Modica follows the same Treadwell people over a ten-year period. They move from one dilapidated farmhouse to another. While the family seems to live a life with few monetary possessions, the story that is told is not one of despair. Barbara and the rest of the children grow older, pass through adolescence, and remain hopeful. There is beauty in the relationships, in the environment, and in the experiences that are created from rich imagination. But it is not simplicity that is portrayed in Modica's compositions. Rather, complexity runs deep. There are scenes that feel like graveyards as a young boy lies half submerged in a dugout hole with stones of varying shapes randomly placed around him. A severed deer head, placed as a trophy, hangs from a tree branch in one image, and a horse's skeleton melds with the trees and leaves, while a wispy image of a white horse stands ghost-like in the background in another. A young girl is seen dressed up in one image, as she perches on a worn mattress gripping a handgun and pointing it at the camera. The same girl appears filthy

Andrea Modica. *Fountain, Colorado* (2003). Courtesy of the artist.

dirty, yet meditative and wholly present, in another. She sits cross-legged, arms crossed at the wrists, looking up at the sky. Both have an odd sense of wonder about them. A boy balances on the back of a sofa, framed in a window, while Barbara playfully tortures a cat. There are strong contrasts of lights and darks in these photographs, with rich textures that range from soft skin to crumply leaves and brambles.

This story is about making a place in the world through discovery, mindfulness, ingenuity, and resourcefulness. It is also a story about Modica as much as it is about Barbara and the family she follows so carefully. She explains her need to learn about her environment when, as a person used to urban living, she relocated to upstate New York to teach college. She writes, "I was young, driving a car for the first time, living in a place that was as foreign to me as another country. I was desperately searching for others in this sparsely populated, rural landscape" (Modica, no page numbers). As she documents the world created by Barbara and her family, her awareness is heightened and her own world comes into focus.

In 2004, Modica published the book titled *Barbara*. As the main subject in her *Treadwell* series, she is the person who most captured Modica's attention. This series of photographs includes a number of blurred facial close-ups of Barbara. In spite of the indistinct approach to her, she is easily recognizable as a key subject from Modica's earlier work. The pictures in *Barbara* were taken of her during the last year of her life. In 2001, she died from complications of juvenile diabetes. Some images focus on her mouth, others her torso, but most capture a fleshy face that melds into the film of the photograph through shadowy grays.

Andrea Modica has exhibited her work in various prestigious places and in numerous museum collections. She has lectured and taught at several universities, and her work is increasingly gaining attention as important work in social documentary.

Bibliography

Davis, Keith, F. Foreword by Donald J. Hall. *An American Century of Photography: From Dry-Plate to Digital: The Hallmark Photographic Collection*. New York: Hallmark Cards, in association with Harry N. Abrams, 1995.

Hambourg, Maria Morris. "Preface." In *Treadwell: Photographs by Andrea Modica*. Essay by E. Annie Proulx. San Francisco: Chronicle Books, 1996, 6–7.

Modica, Andrea. *Barbara*. Tuscon: Nazraei, 2004.

Proulx, Annie E. "Reliquary." In *Treadwell: Photographs by Andrea Modica*. San Francisco: Chronicle Books, 1996, 9–12.

Rosenblum, Naomi. *A History of Women Photographers*, 2nd ed. New York: Abbeville, 2000.

Places to See Modica's Work

Boca Raton Museum of Art, Boca Raton, Florida
Bowdoin College Museum of Art, Brunswick, Maine
Brooklyn Museum of Art, Brooklyn, New York
Center for Creative Photography, Tucson, Arizona

Cleveland Museum of Art, Cleveland, Ohio
Corcoran Gallery of Art, Washington, DC
Davis Museum and Cultural Center, Wellesley College, Wellesley, Massachusetts
Ellis Island Immigration Museum, Ellis Island, New York
Hood Museum of Art, Dartmouth College, Dartmouth, New Hampshire
International Center of Photography, New York, New York
International Museum of Photography at George Eastman House, Rochester, New York
Metropolitan Museum of Art, New York, New York
Mint Museum, Charlotte, North Carolina
Munson-Williams-Proctor Institute Museum of Art, Utica, New York
Museum of Fine Arts, Houston, Texas
Museum of Fine Art, New York, New York
National Gallery of Art, Washington, DC
National Museum of American Art, Smithsonian Institution, Washington, DC
New York Public Library, New York, New York
Polk Museum of Art, Lakeland, Florida
Princeton University Art Museum, Princeton, New Jersey
Ringling Museum of Art, Sarasota, Florida
Rochester Institute of Technology, Rochester, New York
San Diego Museum of Photographic Art, San Diego, California
San Francisco Museum of Modern Art, San Francisco, California
Santa Barbara Museum of Art, Santa Barbara, California
Savannah College of Art and Design, Savannah, Georgia
Taylor Museum, Colorado Springs, Colorado
Whitney Museum of American Art, New York, New York
Yale University Sterling Library, New Haven, Connecticut

BARBARA MORGAN

1900–1992

PAINTER, PRINTMAKER, AND PHOTOGRAPHER, BARBARA MORGAN WAS FAS-
cinated with the energy and movement of dance, resulting in a stunning body of work for
which she has received the most notoriety. At the age of five, she was inspired by her father's
words that "everything in the world is made of atoms and all the atoms are dancing inside
of everything" (Morgan 1972: 154). It was then that she decided to become an artist with a
lifelong pursuit to express those dancing atoms.

Barbara Brooks Johnson was born an eleventh-generation American on July 8, 1900, in
Buffalo, Kansas. That same year the family moved to a peach ranch in California, where
she spent her childhood. She developed an early interest in art and painted regularly as
a child. It was an easy decision for Morgan to study art in college. From 1919 to 1923
she was an art student at the University of California in Los Angeles. She was a strong
student and soon began to exhibit her paintings and woodcuts in local art society exhibi-
tions. Along with her studio classes, she had informal instruction in theater lighting and
puppetry. After graduation she became an art teacher at San Fernando High School from
1923 to 1925.

In 1925, she married Willard D. Morgan, who was a freelance photographer at the
time. Later he would establish Morgan & Morgan, Inc. Publishers, which produced sev-
eral monographs of her photographs. Willard also would become the first editor of *Life*
magazine and then later the first director of the Photography Department at the Museum
of Modern Art in New York City. Indeed, Willard was something of a pioneer in the field
himself. Although not mentioned in other publications, it is notable that she married a
man working in the photographic arts. However, she did write that Willard prophesied
that photography would be the new medium of the twentieth century and that she should
give it a try. Perhaps his passion and interest was not only influential in Morgan's eventual
shift from painting to photography, but also that his emotional support surely aided in her

success. However, when they first married, she was still not convinced that photography could be art and remained devoted to her paint brush and canvas.

In 1925, she left the public school system and accepted a teaching position at her alma mater, the University of California in Los Angeles. There she taught design, landscape painting, and wood cut printmaking. Morgan was an active faculty member beyond teaching her assigned classes. She organized a student publication of wood cut prints, and as a member of the UCLA Arthur Wesley Dow Association, she was closely involved in the group's publication *Dark and Light Magazine,* writing, editing, and managing. During the summer months Morgan painted and made wood cuts while on vacation with Willard. They traveled throughout the Southwest while Willard documented the ghost towns, Native American ceremonies, and natural landscape. She was greatly influenced by the Native American dance ceremonies, such as the Pueblo Indian Corn Dance, Rain Dance, and the Snake Dance. Morgan created many paintings and prints of the dancers that are vibrant and evoke a celebratory and ritualistic sense of dance and motion. It was during these summer excursions that Morgan learned the mechanics of photography while assisting Willard on his photo shoots.

When the University art gallery hosted an exhibition for a fledgling photographer **Edward Weston,** Morgan was astonished at his abstract and expressive photographs. It was then that she decided that photography can be art. Although she continued to pursue painting at this time, Weston's exhibition made a lasting impression on Morgan. After five years of teaching at UCLA, Morgan resigned when Willard was offered a position in New York City in 1930.

Rather than looking for a teaching job, she joined Willard on his business trips to lecture about Leica cameras. Back in the city she painted, made wood cuts, and started to experiment with photography by taking pictures of the city's skyscrapers. She also photographed the Barnes Foundation art collection in Merion, Pennsylvania, as a learning exercise. In 1931, Morgan opened a studio in painting and lithography and began to establish herself in the New York gallery exhibition circuit. Morgan exhibited her paintings in various galleries and her graphics at the Weyhe Gallery in New York City.

In 1932, her first son, Douglas, was born. After his birth she continued to paint and had her first solo exhibition at the Mellon Gallery in Philadelphia in 1934. Her second son, Lloyd, was born in 1935, which broadened the scope of her daily responsibilities and made it extremely difficult to paint. However, Morgan yearned to continue working creatively. It was at this time that she turned to photography as she was able to work in the dark room after the boys went to sleep at night.

In early 1935, she attended a performance by Martha Graham, *Primitive Mysteries.* Unlike that of traditional ballet dance, Graham's *Modern* dance movements reminded Morgan of the Southwestern Native American ceremonial dances. Whereas before Morgan was inspired to make drawings and paintings of the tribal ceremonies, now she wanted to capture

Barbara Morgan. *Martha Graham. Lamentation* (1935). Library of Congress, Prints and Photographs Division, Barbara Morgan Collection. © The Barbara Morgan Archive. Reproduction number: LC–USZ 62–92948.

the essence of the dance with her camera. In 1936, she was commissioned by the Martha Graham Dance Company. She photographed Martha Graham and other leading Modern dancers of the day, such as Merce Cunningham, Anna Sokolow, Erick Hawkins, and José Limón.

One of her most famous portraits from this period is of Martha Graham in various poses from Graham's dance *Letter to the World* (1940). Morgan went to great lengths to create the precise image that she wanted. To ensure a well-executed plan, she used several assistants, additional lighting to emphasize the dancer and to fade the surroundings completely into the darkness, and relied on Graham's patience for repetitive dance movements until she captured just the right moment. Morgan wrote about her process photographing motion:

> To prepare for actual shooting I watch breathing rhythms and other changes of mental states which catalyze physical exertion, for the body is an external vehicle of mood and will. But to portray the emotional-mental-spiritual expression is usually

a more subtle problem that requires more empathy with the subject and more skill in pre-visioning the technical linkage. (Morgan 1972: 155)

Morgan's photographs of Graham are compositionally framed by light and dark, line and form. Her work, *Martha Graham:* Lamentation (1935) illustrates Morgan's attention to formal details and Graham's flair for the dramatic. The portraits are the result of two artists working collaboratively and representative of both of their creativity and skills; Graham's stunning and precise movements and Morgan's vision and technical abilities. The two women were artistic collaborators for several years and afterward remained lifelong friends.

Throughout her career she maintained the view of photography as art and continued to seek new ways to create expressive and artistic imagery with photography. Although she is most famous for her dance portraits, Morgan experimented with other subject matter, including children and animals. She even photographed plants for a while much like that of **Edward Weston**'s abstract photographs of vegetation. Morgan's photomontage series is another notable body of work. Here she worked with double and extended exposure time to create a collage effect.

Her spouse, Willard Morgan, died in 1967. She spent the remaining 23 years of her life dedicated to producing, exhibiting, lecturing, and publishing books about photography. She lectured at academic and art institutions such as the Brooklyn Museum of Art, the Photo League in New York City, the Manhattan Camera Club, the Museum of Modern Art in New York City, the New School for Social Research in New York City, and Bennington College in Bennington, Vermont. Her work has been exhibited at the AfterImage Gallery in Dallas, Texas; the University of California in Riverside; the Museum of Modern Art in New York City; the Photo League in New York City; and the George Eastman House of Photography in Rochester, New York among many others.

She died on August 17, 1992, at Phelps Memorial Hospital in North Tarrytown, New York. Artist Barbara Morgan had an exhaustive art career, initially as a painter and then more than 60 years as a photographer who may well best be known as the artist who captured the essence of Modern dance as interpreted by the legendary Martha Graham.

Bibliography

Morgan, Barbara Brooks, and Deba P. Patnaik. *Barbara Morgan.* New York: Aperture, 1999.
————. *Barbara Morgan Photomontage.* Dobbs Ferry, NY: Morgan & Morgan, 1980.
————. *Barbara Morgan.* Hastings-on-Hudson, NY: Morgan & Morgan, 1972.
————. *Martha Graham: Sixteen Dances in Photographs.* New York: Duell, Sloan, and Pearce, 1941.
————. *Prestini's Art in Wood.* Text by Edgar Kaufmann, Jr. Lake Forest, IL: Pocahontas Press, 1950.
————. *Summer's Children: A Photographic Cycle of Life at Camp.* Dobbs Ferry, NY: Morgan & Morgan, 1951.
Sheets, Hilarie M. "Barbara Morgan at Silverstein Photography." *Artnews* 106, no. 1 (2007): 134.

Places to See Morgan's Work

Addison Gallery of American Art, Andover, Massachusetts
Bennington College Library, Bennington, Vermont
Chicago Exchange National Bank, Chicago, Illinois; and Tel Aviv, Israel
Cincinnati Art Museum, Cincinnati, Ohio
DePaul University Museum, Chicago, Illinois
Detroit Public Library, Detroit, Michigan
Fred Jones Jr. Museum of Art, University of Oklahoman, Norman, Oklahoma
Haggerty Museum of Art, Marquette University, Milwaukee, Wisconsin
History of Photography Collection, Smithsonian Institution, Washington, DC
International Museum of Photography, Rochester, New York
Library of Congress, Prints and Photographs Division, Washington, DC
Lincoln Center Library and Museum of Performing Arts, New York, New York
Los Angeles County Museum of Art, Los Angeles, California
Metropolitan Museum of Art, New York, New York
Museum of Contemporary Photography, Chicago, Illinois; *Martha Graham, Letter to the World* (1940)
Museum of Fine Arts, Boston, Massachusetts
Museum of Fine Arts, St. Petersburg, Florida
Museum of Modern Art, New York, New York
National Portrait Gallery, Washington, DC
Philadelphia Museum of Art, Philadelphia, Pennsylvania
Smithsonian American Art Museum, Washington, DC
University of California, Los Angeles Library, Los Angeles, California
Utah State University Galleries, Logan, Utah
Williams College Museum of Art, Williamstown, Massachusetts

ARNOLD NEWMAN

1918–2006

ARNOLD NEWMAN WILL BE REMEMBERED MOST FOR ENVIRONMENTAL POR-
traits, where he situated people in their natural surroundings, alluding to their personalities
and professions. This was significant during a time when well-known photographers such
as **Richard Avedon** and Irving Penn were working in a controlled studio setting against a
solid backdrop.

Arnold Abner was born on March 3, 1918, in New York City, the second of three sons to
Isidor and Freda Newman. His father worked in New York City as a clothing manufacturer
until he was laid off, which led to a job managing hotels in Atlantic City. The family moved to
New Jersey where Newman attended elementary school. During these early years he spent
time as a Boy Scout and started to develop an interest in art. Since his father's business was
dependent on seasonal tourism, he had to seek supplemental income managing a string of
hotels in Miami Beach during the winter. The Newman family moved to Miami Beach for
winters and then back to Atlantic City for summers. Since they were living in Florida during
the school year, Newman and his brothers transferred to the public school system in Dade
County. He graduated from high school in Miami Beach in 1936. Throughout his high
school years, Newman participated in art activities at school and painted in his free time.
After high school he received a working scholarship to study art at the University of Miami.
For two years he studied painting and drawing and was introduced to *Modernism*.

Unfortunately, he was forced to withdraw from school when he was unable to pay the
private tuition fees at the end of his scholarship. Newman moved to Philadelphia where he
got a job at a portrait studio. While living in Philadelphia, he became socially involved with
local students from the Philadelphia School of Industrial Arts. Newman was influenced by
these relationships and learned a great deal about the teachings of their instructor, Alexey
Brodovitch. Brodovitch was a teacher at the Philadelphia School of Industrial Arts and the
art director of *Harper's Bazaar*. This early exposure to Brodovitch's ideas and approach would
prepare Newman for his entrance into the world of commercial photography at a later date.

When he was not working at the portrait studio, Newman spent time experimenting with social documentary photography in the spirit of the work of artists **Walker Evans** and **Dorothea Lange.** This early experimentation with photographing out in the field led to Newman's interest in photographing outside of the studio.

In 1939, he moved back to Florida to manage a portrait studio in West Palm Beach and eventually opened his own studio in Miami Beach. At the onset of World War II, Newman enlisted in the military but was deferred for unknown reasons and returned to work in his studio. During the early 1940s he made frequent trips to New York City, where he met the leading photographers of the day, including well-renowned artists **Alfred Stieglitz** and **Ansel Adams.** He also met Beaumont Newhall, the curator of the newly formed department of photography at the prestigious Museum of Modern Art in New York City. Meeting Stieglitz and Newhall was a turning point for Newman's career and instrumental in the heightened exposure of his photography in the world of art and museum exhibition.

He became an established artist and recognized for his portraits of artists, architects, musicians, and other notable figures that he routinely photographed. Most notably, he became known for creating environmental portraits. To work with his subjects in the place where they lived or worked, Newman always traveled to their space. He wanted to portray

Arnold Newman. *Stieglitz and O'Keeffe* (1944). Gelatin silver print, 9⅛ × 7¾ inches (23.2 × 19.7 cm). Gift of Arnold Newman. Courtesy of Worcester Art Museum, Worcester, Massachusetts.

the person in the setting that illustrated who they were and what they did. Using a large format camera set on a tripod, he worked meticulously to capture every detail of the individual and their surroundings. Despite the sitter's fame or stature, he wanted to create an interesting and intriguing image for the sake of art. His portrait of musician Igor Stravinsky is perhaps one of his most well-known photographs. The grand piano is center stage here, as Stravinsky casually sits off to the side, with his elbow resting on the piano and his head leaning in his hand. An outdoor portrait of Georgia O'Keeffe shows the artist in the great Southwest, for which she remarked many times, was where she felt most at home. A skull with long, curly horns is situated above her head against a bright blue sky, recalling the strong color and subject matter that are both signature elements in O'Keeffe's paintings. In another portrait, Alfred Stieglitz is seen with Georgia O'Keeffe; here they are seen as husband and wife. In another site-specific portrait, he photographed artist Frank Lloyd Wright at Taliesen East in Wisconsin at the location of one of his residential architectural designs.

Although he was widely known for the site specific nature of his work, Newman remarked that he felt most people overlooked the rest of his process. He went to great lengths to photograph a spontaneous moment within a choreographed setting and mood. Newman often talked to the sitters to elicit a certain response or expression. He felt that his ability to do this was an important element in his art.

In 1946, he moved his studio to New York City, where he opened the Arnold Newman Studio. By this time his work had been exhibited and purchased by both the Museum of Modern Art in New York City and the Philadelphia Museum of Art; Newman was indeed making a name for himself. By this time, Brodovitch knew of Newman's work and hired him for several assignments at *Harper's Bazaar*. It was not long before he was contracted as a freelance photographer for magazines such as *Fortune*, *Life*, and *Newsweek*. Along with standard assignments, Newman's work graced the cover of these magazines many times over. In 1949, he married Augusta Rubenstein. That summer they spent the first of 25 summers in Provincetown, Massachusetts, where Newman photographed many artists.

For the remainder of his life, Newman was an active artist and scholar, traveling around the world with his wife in search of new material. He frequently went on assignment for *Travel & Leisure* magazine. He gave guest lectures at universities around the world; and in 1968, he was hired to teach photography at Cooper Union in New York City. In 1976, he started teaching summer sessions at the Maine Photographic Workshop, which he did until his death in 2006. In addition to his illustrious career as a portrait and commercial photographer, Newman's work was exhibited in art museums including the Philadelphia Museum of Art; the Museum of Modern Art in New York City; the George Eastman House in Rochester, New York; and the Art Institute of Chicago. His work was purchased by many museums and published in numerous monographs. A poll published by *Popular Photography* magazine named Arnold Newman one of the ten best photographers. In 1999, he celebrated his fiftieth wedding anniversary with Augusta. Also in 1999, the exhibition

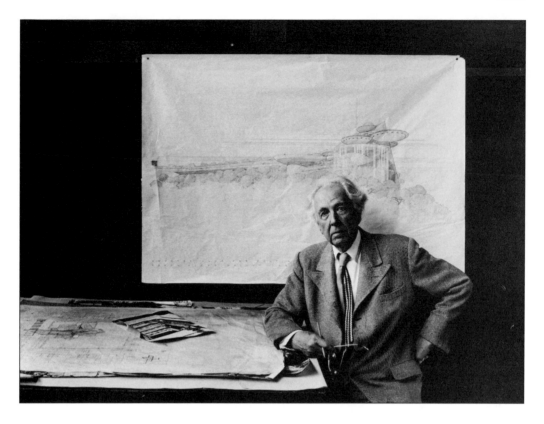

Arnold Newman. *Frank Lloyd Wright, Taliesin East, Wisconsin* (1947, printed later). Gelatin silver print, 10 × 13⅝ inches (25.4 × 34.61 cm). San Francisco Museum of Modern Art. Collection of the Prentice and Paul Sack Photographic Trust.

Arnold Newman's Gift: 60 Years of Photography opened at the International Center of Photography in New York City.

Arnold Newman died on June 6, 2006, in New York City. He is survived by his wife, Augusta, their two sons, Eric and David, and their four grandchildren. Newman photographed hundreds of prominent and famously known people. however, he shied away from photographing actors and rock stars, anyone who he said was "famous for being famous" (Grundberg). Possibly best known for his contribution to environmental photography, Newman flourished as a freelance photographer in both the commercial and art sectors of the market for more than 60 years.

Bibliography

Grundberg, Andy. "Arnold Newman, Portrait Photographer Who Captured the Essence of His Subjects, Dies at 88." *New York Times*, June 7, 2006. Reprinted online at http://www.nytimes.com/2006/06/07/arts/07newman.html?ei=5090&en=e9e650a350b6a6e7.

Hurwitz-Attias, Laurie. "Arnold Newman: Hotel de Sully" [exhibit]. *Artnews* 101, no. 11 (2002): 125, 136.

Loke, Margaret. "Arnold Newman: International Center of Photography" [exhibit]. *Artnews* 98, no. 5 (1999): 164.

Newman, Arnold. "Newman on Mondrian." *Artnews* 95, no. 20 (1996): 28.

———. *Arnold Newman with Essay by Philip Brookman*. Hong Kong: Taschen, 2006.

Robertson, Rebecca. "A Pioneer of Portraiture" [Obituary]. *Artnews* 105, no. 7 (Summer 2006): 64.

Weiley, Susan. "Newman's People" [Work of A. Newman]. *Artnews* 86, no. 11 (1987): 128–134.

Places to See Newman's Work

Cincinnati Art Museum, Cincinnati, Ohio
Fred Jones Jr. Museum of Art at the University of Oklahoma: *George Grosz* (1942)
Library of Congress, Washington, DC
Museum of Contemporary Art, Los Angeles, California
Philadelphia Museum of Art, Philadelphia, Pennsylvania
San Francisco Museum of Modern Art, San Francisco, California

BILL OWENS

b. 1938

BILL OWENS IS A DOCUMENTARY PHOTOGRAPHER WHO IS WIDELY KNOWN for his work recording the most mundane, ordinary, and average moments of life in the suburbs, portraying an easy free existence, one that is familiar and just out of reach at the same time.

Born during the economic depression in San Jose, California in 1938, his family endured economic hardship as his father was intermittently employed first as a coal miner and then a construction worker. His mother worked as a nurse's aid and in an aircraft factory during World War II. They were a close family who worked hard to make ends meet by growing their own vegetables and raising a few livestock. He grew up in a loving family. The young Bill was considered to be a late bloomer and struggled with his schoolwork.

As a young man, Owens volunteered for the Peace Corps. He was assigned to Jamaica, where he developed an interest in photography. When he returned to California in 1966, Owens enrolled at San Francisco State University where he took visual anthropology and photography courses. He studied dozens of photography magazines and was particularly taken with the documentary work of the *Farm Security Administration* photographers of the 1930s that he learned about in his photography classes. He was particularly impressed with the work of **Dorothea Lange** and **Margaret Bourke-White.** Owens learned basic photography skills quickly and landed a job as a photographer for the school newspaper. He said later that working for the paper taught him more about photography than he ever learned in a classroom. This job proved to be a turning point in his development as a documentary photographer, where he got his first experiences in the field by covering civil rights demonstrations.

In 1967 after graduation, Owens went to work as a staff photographer for *The Independent*, a small newspaper in Livermore, California. He was 29 years old. He was inspired by the seemingly easy lifestyle of the Livermore community that he observed while out on various assignments. Owens remarked about Livermore, "Everyone there lives 'the good life,'

which means having attractive homes, high paying jobs, swimming pools and shiny cars. I decided to do a documentary project on the suburbs—a visual/anthropological view of America" (Owens, *Documentary Photography*, 15). He took pictures for the paper Monday through Friday using a 35mm camera, and on Saturdays he worked on his documentary using a Pentax 6 × 7 and a Brooks Veriwide 6 × 9 camera. With a few hundred dollars from a Livermore council grant, he went about photographing his family and friends and a few of the people from town that he had worked with for *The Independent*.

The project escalated, and Owens started advertising for local people who would be willing to be photographed in their homes. Many people responded to his ad, and he went to their homes to photograph typical domestic scenes in kitchens, living rooms, and bedrooms, as well as social family gatherings such as barbecues, birthday parties, and celebrations. He photographed local public events such as the town's annual events, including Christmas, Fourth of July, and parades. For instance, in *Fourth of July Block Party* (ca. 1972), family and friends are crowded around the picnic table littered with paper plates, Styrofoam cups and half-eaten food as they eat and visit with each other and neighbors passing by. It is a

Bill Owens. *Untitled from Working Series* (ca. 1970s). Courtesy of the artist.

conventional scene, if not like your own family, one that you have seen on television. In *Untitled* (ca. 1970), a family portrait is taken just as they are leaving for vacation; their group is complete with father, mother, daughter, two sons, and even the family dog. Standing in front of their packed-up station wagon with a boat hitched to the back, the usual signs of a happy family and of life in the suburbs are present.

The portraits of Livermore's citizens resulted in his monograph, *Suburbia* (1972), which was well received and brought Owens a higher level of recognition as a leading contemporary documentary photographer. Due to successful sales, this book was printed in four separate editions. His work was heralded, in part, for the everyday nature of this work and that the images were of ordinary people and activities. While most audiences could relate to something about the imagery, there was always something that was too perfect and not quite attainable.

During Owens's stint as a newspaper photographer, he was exposed to local businesses on a regular basis. He became intrigued with the diverse job market and began to wonder how people felt about their jobs and how they felt it shaped their identity. Not long after he started to photograph people in their work places in Livermore, the project quickly expanded to include locations throughout California and then across the United States. When he met people for the first time, he would ask, "What do you do for a living?" Owens explained what this question answers for him:

> The answer allows me to make certain assumptions not only about that person's life-style but also about their background, their education, their opinions, their dreams and aspirations. Immediately we have something to talk about, but more important, I know whom I'm talking to. (Owens 1997: preface)

The project resulted in a monograph, *Working (I Do It for the Money)*, that was published by Simon and Schuster in 1977. Owens included a statement written by each subject to accompany their portrait. The narrating statement gives insight into the person's job and often into their personal lives. For instance, one photograph shows two young women sitting side by side at their desks in a shared office space. Above their heads a portrait of an older gentleman dominates the wall behind them, representing perhaps the company founder or president. The statement below the photograph reads:

> Being a receptionist is a catch-all job; you do everything. Mostly we're dealing with salesmen and they like to see young women. I've stayed here six years because I got married and my husband didn't want me to commute to a better-paying job. (Owens 1977: no page numbers)

She is aware of her role as a sex object in the work place and of the oppression she is living under in her marriage, yet she submits to survive. Her words represent, in part, the very dilemma that the 1970s feminist movement addressed, recalling women's fight for equal

rights in marriage and at work. Owens photographed a wide range of people and professions for his project, including a podiatrist, painter, lawyer, hooker, public school cook, veterinarian, factory worker, newspaper editor, Native American fisherman, roofer, nude art model, and baker.

In a recent project, *Food*, Owens investigated the food we eat. In an untitled color image from the series, a hamburger complete with melted yellow cheese, beef patty, crisp light green iceberg lettuce, and soft bun fills the left side of the frame with diner-style salt and pepper shakers in the background; perhaps the French fries are around the corner out of sight. As if just served up, the perfect sandwich is ready to be eaten. Here, the hamburger is elevated to an iconic representation of American food.

After he was unable to find a publisher for his series *Leisure*, Owens decided to leave photography and sold his camera equipment, which helped finance a trip to England. After he returned to the United States, he founded Buffalo Bills, a micro-brewery in Hayward, California, about ten miles outside of Livermore. During this time he continued to write and founded the *American Brew Magazine*, which he published for 17 years, and authored *How to Build a Small Brewery*. He has many interests and hobbies. Owens says that he is trying to recapture his childhood through his playful collections of wheelbarrows, Radio Flyer wagons, whirligigs, antique lawn sprinklers, and folk art carvings (Owens, "Bio," secs. 2 and 3).

After a fifteen-year absence from photography, Owens returned after much urging and encouragement by his friend and agent Robert Shimshak. Owens returned to photography with the debut of the fourth release of his book *Suburbia*. He says that his next project will be to revisit the contemporary suburbia of America; Starbucks will be his first stop (Owens, "Bio," sec. 4). He feels that the average American town changes so frequently that they should be documented regularly to capture the ever-changing architecture and the shifts in how people work and play.

Despite his hiatus from the world of photography, Owens has enjoyed a revival of a successful career, evidenced by seven monographs, dozens of exhibitions in both solo and group shows, and receipt of the prestigious Guggenheim Fellowship award. To photography students, Owens wrote his philosophy about photography, "Photography resembles sex: reading and talking about it is great, but doing it counts. Get out there and do it" (Owens, *Documentary Photography*, 7). Today, documentary photographer Bill Owens can be found at his brewery or on the road documenting our lives: where we work, the food we eat, the cars we drive, the streets we live on, and the buildings we live in.

Bibliography

Albiani, Rebecca. "Bill Owens at Greg Kucera Gallery." *Artweek* 30, no. 6 (June 1999): 29.
James, Simon. "From Photography to Brewing and Back." *RPS Journal* 140, no. 6 (July/August 2000): 269–271.

Lang, Doug. "Photographer, Brew Master, Publisher: Bill Owens Comes Full Circle." *Artagogo*. Retrieved online at http://www.artagogo.com/interview/owensinterview/owensinterview.htm.

Owens, Bill. *Working (I Do It for the Money)*. New York City: Fireside published by Simon & Schuster, 1977.

———. "Bio." *Bill Owens Photography*. Retrieved May 17, 2007, from http://www.billowens.com/detected.php?page=&pass=.

———. *Documentary Photography: A Personal View*. Danbury, NH: Addison House Publishers, 1978.

———. *Suburbia*. New York: Fotofolio, 1999.

Owens, Bill, and Robert Harshorn Shimshak. *Leisure*. New York: Fotofolio, 2005.

Sultan, Larry. "Bill Owens." *Bomb* 77 (Fall 2001): 2–3.

Westbrook, Lindsey. "Bill Owens at Robert Koch Gallery." *Artweek* 36, no. 4 (May 2005): 16.

Places to See Owens' Work

Berkeley Art Museum, Berkeley, California
Bibliotheque Nationale, Paris, France
Bill Owens Photography (Web site): www.billowens.com
Center for Creative Photography, New York, New York
Los Angeles County Art Museum, Los Angeles, California
Museum of Modern Art, Stockholm, Sweden
National Museum of American Art Museum of Modern Art, New York, New York
Oakland Museum, Oakland, California
San Francisco Museum of Modern Art, San Francisco, California
San Jose Museum of Art, San Jose, California

GORDON PARKS

1912–2006

CRITICALLY ACCLAIMED ARTIST GORDON PARKS HAD A PROLIFIC CAREER as a writer, composer, film director, and perhaps most notably as a photographer of the African American experience in the twentieth century. He was born on November 30, 1912, the youngest of 15 children to a poor African American family in the segregated area of Fort Scot, Kansas. Growing up in segregation was difficult, and Parks often experienced hostility and was refused services in local shops and stores based on the color of his skin. With the love and support of his mother, who always encouraged her children to hold their heads high despite racial and economic limitations, Parks worked hard to overcome the circumstances into which he was born. At the age of 15, his mother died, and he was sent to live with his sister and her husband in St. Paul, Minnesota. These were hard years for the young Parks, as his presence was not welcomed by his brother-in-law. After a fight between the two, Parks was banished from the house, and he became homeless. Rather than spending time in high school classrooms and going to school dances and team sporting events, Parks was faced with surviving the urban streets of St. Paul.

His *self-taught* musical skills were strong enough to get him a piano-playing gig at a St. Paul nightclub. The club's regular band invited Parks to join their musical group and to go on tour with them. However, at the end of the tour, the group disbanded. Parks went to work with the railroad as a porter. During a routine trip he picked up a magazine that was filled with photographs of migrant workers taken by *Farm Security Administration* (FSA) photographers Ben Shahn, **Arthur Rothstein,** and **Dorothea Lange.** Parks was impressed with the direct honesty of the image—one that was not about glamour, but showed a harsh reality about the struggle to survive in rural America. These photographs gave him the idea that the camera was a weapon that could be used to fight racism and bigotry. He promptly went to a pawn shop and bought himself a Voightlander Brilliant camera for $12.50. Without the finances for a formal education, he was primarily a self-taught photographer. The

lab technician who developed Parks's first roll of film was impressed and suggested that he pursue freelance work with Frank Murphy's women's clothing store in St. Paul, Minnesota.

Parks followed this advice and soon was working as a freelance photographer for the local department store. After seeing Parks's images at Frank Murphy's store, Marva Louis, the wife of boxer Joe Louis, approached him with the idea of moving to Chicago and opening a portrait studio. He did just that and started to develop a reputable following by photographing African American women. It was not long before Parks went out into the streets and photographed African American communities in Chicago. In 1941, he received attention for his photographs of the ghettos in Chicago, for which he was granted a Julius Rosenwald Fellowship.

An important theme that Parks revisited throughout his career was the underprivileged hardships of the African American community. He felt great empathy as he was an African American man who was working to succeed in the predominantly Caucasian field of photography. In his work *American Gothic (Ella Watson)* (1942), Parks draws from the popular painting *American Gothic* (1930) by Grant Wood for inspiration. Wood's work has been critiqued as representing the white Midwestern family and the prosperity of American farms. In Parks's black-and-white photograph, Ms. Watson, an African American woman, stands solemnly in front of the American flag dressed in housecoat with broom in one hand and mop in the other, symbolizing the oppressive condition of her labor and the limitations she faced in society.

In 1942, Parks was the first African American to be hired by Roy Stryker to work at the FSA as a documentary photographer. In 1943, the organization dissolved, and Parks was transferred to the *Office of War Information* (OWI). He was assigned to photograph the 332nd Fighter Group, an all African American pilot unit. Once the unit was deployed to Europe, Parks returned to fashion photography. He worked as a freelance photographer for *Vogue* over the next several years.

In 1944, he was hired by Standard Oil as a documentary photographer, where he worked until he was hired by *Life* magazine in 1948. Parks received critical acclaim for his photojournalism that he did for this widespread publication. He worked for *Life* magazine over the next 20 years. As the only African American photographer for *Life*, Parks was breaking historical ground as a black man succeeding in a predominantly white male profession. He was often given field assignments that might otherwise be difficult for a white photographer, such as photographing the Black Panther Rallies, Civil Rights gatherings, riots in Harlem, and portraits of dead and alive gang members. Parks, himself, was a prominent social activist and civil rights worker. Arguably, his photographic work that brings to light the lives and culture of the historically underprivileged is in and of itself a form of social activism. His work has been likened to that of a Blues song—empathetic, storytelling in a lyrical way, transcending the specific into universal themes. His work *Untitled (Black Man Behind Window Pane)* exemplifies the narrative quality of his photographs of the African American experience.

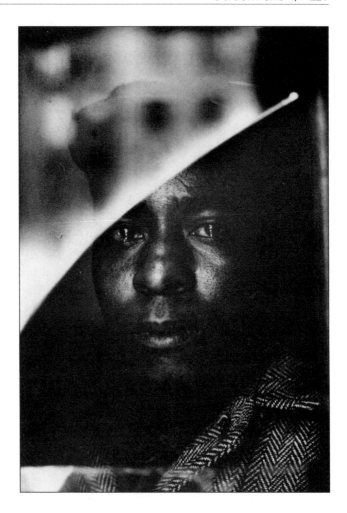

Gordon Parks. *Untitled (Black Man Behind Broken Window Pane)* (1968). Gelatin silver print, 9½ × 6½ inches (24.2 × 16.5 cm). Sarah C. Garver Fund. Courtesy of Worcester Art Museum, Worcester, Massachusetts.

Parks was also a writer and published numerous works of fiction, nonfiction, and poetry. His first autobiographical work, *The Learning Tree* (1963), was made into a movie, which was also his directorial debut. Other films include *Shaft* (1971), *Shaft's Big Score!* (1972), and the controversial film *Leadbelly*. *Leadbelly* is the story of the African American Blues singer Huddie Ledbetter. Initially, the film was advertised portraying Ledbetter as a negative character for his criminal life rather than for his musical accomplishments and contribution to the genre of Blues music. Eventually, the film received critical acclaim, although it remains one of Parks's most misunderstood works.

Parks has been honored for his artistic achievements in many ways. In 1998, the Corcoran Gallery of Art in Washington, DC, held a retrospective of his photographs. For this exhibition many of his civil rights images were displayed, such as the portrait of black Muslims in Chicago in 1963 and that of Malcolm X speaking at a rally. In 2004, the Gordon Parks Center for Culture and Diversity was established at the Fort Scot Community College in

Kansas, Parks's birth place. The Center focuses on the life and legacy of Gordon Parks, who despite confronting extreme racism, discrimination, and poverty, persevered as a successful artist and prominent figure in recording the history of the African American people in the twentieth century. Just before his death, Parks had the pleasure of attending a 60-year retrospective of his work, *Moments Without Proper Name*, which opened on January 27, 2006, at the Howard Greenberg Gallery in New York City.

Parks experienced love and happiness as well as sorrow and tragedy in his personal life. In 1933, he married Sally Alvis after a long courtship. They had three children David, Toni, and Gordon, Jr., who tragically died in a car crash in 1979. His daughter, Toni Parks, carries on the legacy of his work; she started as a musician and composer and has now turned her talents to photography. Sadly his marriage to Sally ended in divorce, as did his subsequent marriage to Elizabeth Campbell, with whom he had a daughter Leslie.

At age 93, he died on March 7, 2006, in his home in New York City. His third wife, whom he divorced years earlier, Genevieve Young, is the executor of his estate. An artist of grand proportions, perhaps the work of Gordon Parks was most important in the awareness of the discrimination and underprivileged position of African Americans.

Bibliography

"Generations: Toni Parks and Gordon Parks." *International Review of African American Art* 20, no. 4 (Inside Back Cover 2006): 63–64.

Grundberg, Andy. "Gordon Parks, A Master of the Camera Dies at 93." *New York Times*, March 8, 2006. Accessed online at http://topics.nytimes.com/top/reference/timestopics/people/p/Gordon_parks/index.html?offset=10&8qa

"The Making of Leadbelly." *Cineaste* 28, no. 4 (Fall 2003): 34–35.

Murph, John. "Gordon Parks." *New Art Examiner* 25 (Fall 1998): 56.

Parks, Gordon. *A Hungry Heart: A Memoir*. New York: Atria Books, 2005.

Starger, Steven. "Half Past Autumn: The Art of Gordon Parks." *Art New England* 25, no. 2 (February/March 2004): 18.

Strosnider, Luke. "Gordon Parks: 1912–2006." *Afterimage* 33, no. 6 (May/June 2006).

Weil, Rex. "Gordon Parks" [Corcoran Gallery of Art, Washington, DC exhibit]. *Artnews* 97, no. 1 (1998): 137–138.

Places to See Parks's Work

Birmingham Museum of Art, Birmingham, Alabama
Gordon Parks Center for Culture and Diversity at Fort Scot Community College, Kansas: www.gordonparkscenter.org
Los Angeles County Museum of Art, Los Angeles, California

ELIOT PORTER

1901–1990

ELIOT PORTER IS ONE OF THE MOST CELEBRATED NATURE PHOTOGRAPHERS of all times. Trained as a biochemist, he cared about the future of the environment, and echoing **Ansel Adams**'s approach to the wilderness, he was active in the Sierra Club. To capture quality pictures of birds, he pioneered strobe techniques and raised the standards of wilderness photography.

Porter was born in Winnetka, Illinois. His father was an architect who functioned like a naturalist. Although his family was financially well off, he began school in a one-room building with no indoor plumbing. As the oldest son, he was soon transferred to a private school for a short while and then sent back to a different public school in Skokie. Surrounding his school were marshlands and cattails, where he and his friends would spend hours searching for turtles, birds, frogs, and snakes. As a young boy, he took a camping trip with his parents and younger brother and sister to the Grand Canyon. They went down a trail on mules and explored the sandstone caves. When he was in high school, his family took a vacation to southern Alaska. In 1922, after his sophomore year in college, he and a few friends traveled across country in a Model-T Ford, enabling him to visit several national parks. Everywhere he traveled, he was drawn to the landscape.

Porter was given his first Brownie camera when he was about eight, and he immediately started photographing the landscape and wildlife around him. He became interested in chemistry, majoring in this subject at Harvard. Wanting very much to involve himself in interesting work, he entered Harvard Medical School in 1924. After graduating, he tried to find pleasure in being a scientist, but he found it lacking.

While in medical school, he attended a party where Ansel Adams was showing his photographs, and Porter brought some of his to share. He remembers that when he saw Adams's work, he was ashamed of the quality of his own work and shocked by the power of

Adams's pictures. "It woke me up to what photography could be. I guess Ansel realized my embarrassment. He suggested that I get a larger camera, which I did" (Esterow 160). Porter realized that photography could be challenging, that it could become art, and that to create high-quality images, he needed better equipment. He purchased a nine-by-twelve-centimeter Linhof.

Soon after meeting Adams, he was introduced to **Alfred Stieglitz,** who agreed to look at his photographs. His response wasn't too encouraging, and he was told to work harder. A year later Porter returned with another group of images and once again asked Stieglitz for his impression. This time the response was pretty much the same. Over the years Porter continued to share his photography with Stieglitz. In 1938, Porter took him a box of pictures he had taken in Austria. Stieglitz went though them twice. Then he simply and pointedly told Porter he had arrived and that he wanted to show these latest works in his highly prestigious gallery. So important was this response that Porter decided to make a career change and leave science behind.

In 1928, he married Marian Brown; together they had a daughter and two sons. The marriage deteriorated after the first four years, and they divorced in 1934. The children went to live with Marian. He met Aline Kilham shortly afterward and married her in 1936; they had three sons.

In 1939, he decided to take up photography full time, and his previous desire to have a medical career fell to the wayside. In 1940, he started using color film to portray the varying colors of foliage. In the 1930s, color photography was associated with advertising and only black-and-white photographic images were thought to be art. Color, in the words of Roland Barthes, was "a coating applied later on to the original truth of the black-and-white photograph" (Hirsch 43). As time progressed, there were changes in the quality of color film and the way the public felt about it. Porter's 1962 book, *In Wilderness Is the Preservation of the World*, published by the Sierra Club, helped change the prevailing attitudes about color pictures and their relationship to art. A dye-transfer process used in film such as Kodachrome, Agfacolor, and Ektachrome provided photographers with an accurate and easy method of making color transparencies. Porter was a leader in using this film to his full advantage, and by the 1980s, color photography was legitimized in the art world.

So intense was his love for nature that he traveled all over the world to take pictures. His trips not only included varying parts of the North America, but also Antarctica and Africa, the Galapagos Islands and Iceland. About Antarctica, which he visited twice, he explained, "It's the most dramatic of all the places I've been to. The atmosphere is so clear that you can see a range of mountains a hundred miles away and you think it's much closer" (Esterow 159). About Maine and Great Spruce Head Island in Penobscot Bay, he said, "My father bought the island, which has about three hundred acres, in 1911. It's a mile long and a half-mile wide, with many indentations. I think it was the closeness to the sea that was pleasurable….I started going there when I was thirteen, and we went every summer for many years" (Esterow 159–160).

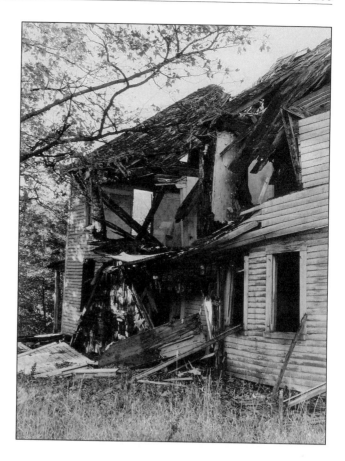

Eliot Porter. *Sandwich Notch House, New Hampshire* (May 1936). Gelatin silver print. © 1990 Amon Carter Museum, Fort Worth, Texas, Bequest of the artist.

Critics have debated his work for decades. While some viewers believe that his pictures are some of the most beautiful and original images ever produced, others wonder why the art world would respond so positively to his work.

In 1979, 55 of Porter's photographs were shown at the Metropolitan Museum of Art in an exhibition called *Intimate Landscapes*. Although his work had been in the Metropolitan since 1949, when Georgia O'Keeffe gave the museum works for Alfred Stieglitz's collection, this was the first time they had embraced a photographer working with color with a one-person show. Many other books have been published on Porter's color photographs. One of the most celebrated is *In Wildness Is the Preservation of the World*, a book made in partnership with Henry David Thoreau that was a catalyst in giving the Sierra Club an international reputation. He also published a popular book with famed author Peter Matthiessen titled *The Tree Where Man Was Born: The African Experience*.

His first book of black-and-white photographs, which centered on the Southwest, was published in 1985. Most of the work in this publication was made between 1939 and 1965. Porter describes the experience of being in the Southwest: "The stimulation of thin air; the intense blueness of the sky; the towering thunderheads of summer that rumble and flash

and produce sheets of rain with a sudden rush of water that soon passes, leaving only a wet arroyo to dry within an hour; the quick change of climate, from burning dry heat that allows no sweat to wet one's clothing to a shivering cold during the rainfall; these are among the attributes of a land that gets into one's blood and bones" (Porter 1985: 25).

Working as an artist who was interested in the modernist way of thinking about art, Porter wrote, "I do not photograph for ulterior purposes. I photograph for the thing *itself*—for the photograph—without consideration of how it may be used. Some critics suggest that I make photographs primarily to promote conversation, but this allegation is far from the truth" (Porter 1985: 11).

In the latter part of his life, Porter settled in Tesuque, New Mexico, with Aline, his wife of more than 50 years. Lou Gehrig's disease plagued him during the last years of his life, and although he stopped photographing, he remained active in the preparations of exhibitions and the publications of his work. Numerous books and catalogs have been published on Porter's work. The major collection of Porter's work is now housed at the Amon Carter Museum in Fort Worth.

Bibliography

Esterow, Milton. "Eliot Porter." *Artnews* 88, no. 4 (1989): 158–161.

Hirsch, Robert. *Exploring Color Photography: From the Darkroom to the Digital Studio*, 4th ed. New York: McGraw-Hill, 2005.

Mathiessen, Peter. Photographs by Eliot Porter. *The Tree Where Man Was Born: The African Experience*. New York: Dutton, 1972.

Porter, Eliot. Foreword by Martha A. Sandweiss. *Eliot Porter*. Boston: New York Graphic Society Books and Little, Brown and Company, in association with the Amon Carter Museum.

———. *Eliot Porter's Southwest*. New York: Holt, Rinehart and Winston, 1985.

———. With an Afterword by Weston J. Naef. *Intimate Landscapes: Photographs by Eliot Porter*. New York: E. P. Dutton and the Metropolitan Museum of Art, 1979.

Thoreau, Henry David. Photography by Eliot Porter. *In Wildness Is the Preservation of the World*. San Francisco: Sierra Club, 1962.

Places to See Porter's Work

Amon Carter Museum, Fort Worth, Texas
Getty Museum of Art, Los Angeles, California
Metropolitan Museum of Art, New York, New York
Mildred Land Kemper Art Museum, Washington University in Saint Louis, St. Louis, Missouri
Museum of Contemporary Photography, Columbia College Chicago, Chicago, Illinois

MARION POST WOLCOTT

1910–1990

MARION POST WOLCOTT WAS A PHOTOGRAPHER WHO USED HER SKILLS AS an image-maker to expose social inequities during the Depression years. Working for the *Farm Security Administration* (FSA), she contrasted the ways in which the rich and poor lived. Refusing to show the poor as victims, she depicted the underprivileged with dignity, diligence, and grace. Reflecting in her later years on her approach, she wrote:

> I had warm feelings for blacks, could communicate effectively with children, had deep sympathy for the underprivileged, resented evidence of conspicuous consumption, [and] felt the need to contribute to a more equitable society.... (Johnson 164)

Born in 1910 in Montclair, New Jersey, to a prominent family, her father was a homeopathic physician. Sickly at birth, she wasn't expected to live past her first year. As a result, in her early years she was surrounded with love. Her older sister Helen was an overachiever, sometimes overshadowing Marion's more slowly developing talents. She had a close relationship with the family's black housekeeper Reasie Hurd and her daughter Edna, friendships that established her ease in being around the African Americans she would later photograph. When Marion was in her teens, her parents ended their marriage in a bitter divorce. After a few difficult high school years, Marion and her sister Helen were educated in a progressive coeducational boarding school where she thrived. She visited her mother in Greenwich Village as often as she could. A social activist and a trained nurse, Nan Hoyt Post worked with Margaret Sanger, the famous advocate for women's health and birth control. In Greenwich Village, mother and daughter were enmeshed in the lives of artists and Marion became interested in modern dance. Consequently, she began studying dance, and at the same time she took classes in early childhood education at the New School for Social Research and New York University.

Marion Post-Wolcott. *Unproductive Land.* Courtesy of Worcester Art Museum, Worcester, Massachusetts.

In 1931, she began teaching in an elementary school in the mill town of Whitinsville, Massachusetts. Living in a boarding house with mill workers, she becomes aware of difficulties in the lives of working class people. Near the end of her teaching time in Whitinsville, her father died leaving considerable debt due to some unsuccessful land deals in Florida. Nonetheless, a small trust for Marion and Helen's education was established.

In 1932, she went to Paris and, later, Berlin to learn about dance. Shortly after, she studied child psychology at the University of Vienna. While in Europe, Post heard Hitler speak and was distressingly struck by the power and energy in the rise of the Nazis. She responded with strong emotion against the political climate as she watched swastikas being burned in the front yards of those who opposed Hitler. Post did what she could to help support her Jewish friends, but Europe was dangerous at this time, and she was forced to return to the United States. However, in her last weeks in Vienna, she took some photos of the local landscape. Her sister Helen, who was also in Europe at the time, had been studying with photographer Trude Fleischmann, who developed Marion's film and encouraged her work.

When she returned to New York State, she took another teaching position and became active in the League Against War and Fascism. She then moved to New York City and began studying photography with Ralph Steiner, who introduced her work to Roy Stryker, Director of the Historical Section of the FSA.

Marion Post took her first photographs in 1933. By 1935, she was freelancing for *Fortune*, *Life*, and the Associated Press. The *Philadelphia Evening Bulletin* hired her in 1937 and

Marion Post Wolcott. *Mountaineer taking home groceries and supplies purchased in town, Eastern Kentucky* (1940). Library of Congress, Prints and Photographs Division, Marion Post Wolcott Collection. Reproduction number: LC–USF34–055972–D.

1938 as a staff photographer. But it is her work with the FSA that she produced from 1938 to 1941 for which she is best known. In this government-sponsored role, she documented the effects of the Depression on farmers.

Traveling alone in rural areas was often difficult. Post described the hardships in letters to Stryker, often commenting on how arduous it was to persuade farm families to let her photograph them. Their lack of enthusiasm to participate was often due to suspicions they had about government photographers. They were also wary of strangers. Post reported that some of her potential subjects wanted to know if she was a gypsy. This comment may have arisen due to the fact that Post had long hair and wore bright clothing with a bandanna scarf on her head. The way she dressed presented a conflict with Stryker who wanted her to dress like a woman, meaning that she shouldn't wear pants. Her feisty response to Stryker was that she would continue to wear slacks because she needed the pockets, and they protected her legs when she was in the fields. While she tried to remedy her colorful look, encountering her subjects was still problematic.

Rooted in political messages, Post Wolcott's FSA photographs were about segregation, poverty, hunger, labor movements, disease, and the results of a poor educational system. To capture the right image, she traveled alone and endured sickness, harsh weather conditions, mud, and mosquitoes. As difficult as it was, she was able to convince her subjects that she cared, and she returned their trust by presenting them with images of hope, dignity, and pride.

FSA photographs depict hard times and are framed in a way that functions to tell a story. For example, soil erosion on farms was an important story that needed to be told during the Depression. Perhaps the most striking image about this problem is presented in Post Wolcott's 1938 photograph of a rundown North Carolina farmhouse. Two children walk toward the viewer, the younger one with very bowed legs caused by rickets.

In 1941, Post married Lee Wolcott, the assistant to Henry Wallace, the Secretary of Agriculture. To concentrate on her family, she resigned from the FSA in February 1942. She then moved to a farm in Virginia to raise four children with her husband. In 1954, the couple relocated to Albuquerque, New Mexico, so that Lee Wolcott could teach at the University of New Mexico. Marion Post Wolcott went back to teaching, working with Navajo children. Her teaching career continued in American schools when Lee joined the Foreign Service, and their travels took them to Iran, Pakistan, Egypt, and India. When Lee Wolcott retired in 1968, they lived in Santa Barbara, California. Photography once again became Post Wolcott's passion in 1975 when she began working with color film. In 1978, they moved to San Francisco, and in 1983, Post Wolcott's work was included in an exhibition at the Light Gallery in New York titled *FSA Color*.

After a year of fighting lung cancer, Post Wolcott died on November 24, 1990. Her work had become widely recognized in the later years of her life. She received the Oakland Museum's Dorothea Lange Award, the Society of Photographic Educator's Lifetime Achievement Award, and the National Press Photographer's Lifetime Achievement Award.

Although Post Wolcott's photographic practice only encompassed a portion of her career, her work, especially the images taken for the FSA, is notable. She is remembered for her perseverance as a female photographer, a social activist, and a photographic pioneer.

Bibliography

Finnegan, Cara A. "Picturing Poverty: Print Culture and FSA Photographs." Washington, DC: Smithsonian, 2003.

Guimond, James. *American Photography and the American Dream*. Chapel Hill: The University of North Carolina Press, 1991.

Hurley, Jack F. Foreword by Robert Coles. *Marion Post Wolcott: A Photographic Journey*. Albuquerque: University of New Mexico Press, 1989.

Johnson, Brooks, ed. *Photography Speaks: 150 Photographers on Their Art*. New York: Aperture, 2004.

Stein, Sally. Introduction. *Marion Post Wolcott: FSA Photographs*. Carmel, CA: The Friends of Photography, 1983.

Wolcott-Moore, Linda. "Marion Post Wolcott." Retrieved September 6, 2006, from http://www.people.virginia.edu/~bhs2u/mpw/mpw-bio.html.

Places to See Post Wolcott's Work:

Center of Creative Photography, Tucson, Arizona
International Center of Photography, New York, New York
J. Paul Getty Museum, Malibu, California
Library of Congress, Washington, DC
Metropolitan Museum of Art, New York, New York
Museum of Modern Art, New York, New York
Smithsonian Institution, Washington, DC

MARTHA ROSLER

b. 1943

MARTHA ROSLER'S GOAL AS AN ARTIST IS TO GIVE VOICE TO THE POWER-less. In doing so she challenges people in power, disrupts the status quo, and works for justice by making visible the injustices of the world. Known as a feminist and a political agitator, her work tackles difficult issues related to motherhood, violence, sexism, poverty, immigration, homelessness, domesticity, the effects of globalization, the penetration of mass media, and the rise of commodity culture. Rosler is also a prolific writer. She has published ten books and written for magazines and journals such as *Artforum, Afterimage,* and *NU Magazine.*

Born and raised in Brooklyn, as a child, Rosler was designated the artist in the family because she was always drawing. Politically active at an early age, she began her activism with antinuclear protests and civil rights work. She studied painting at the Brooklyn Museum of Art and Brooklyn College where she received her BA in 1965. She soon turned to photography as a favored medium and became interested in the way everyday culture was being incorporated into art. Russian painting, design, posters, photography, and theory intrigued her. She moved to San Diego in 1968 to study at the University of California, receiving her MFA in 1974. Here she was exposed to postmodern ideas and the work of the French film-maker Jean-Luc Godard. Alternative ways of making and distributing art also captured her attention.

When Rosler got married after college, she put away her painting and began reading magazines like *Better Homes and Gardens* and *House Beautiful,* which inspired her to decorate her house. Some of her work grows out her experience of working in her home, as well as her lived awareness of the time and energy it takes to be a single parent, which happened after her marriage dissolved. The domestic space provided her with a place to view political issues.

Rosler's series from *Bringing the War Home: House Beautiful* and *Bringing the War Home: In Vietnam,* created from 1967 to 1972, are photomontages that express a strong statement

about the Vietnam War. They were not originally made for the art world context, partly because they are so raw. Instead, they were created for the underground press or the street culture of that time. It wasn't until the late 1980s when an art dealer suggested that Rosler make a portfolio of the images. She agreed so that the work could be seen and talked about in art circles. In the 1990s some of the images were displayed in museum exhibitions, and this series of work became highly visible and discussed. These works place war scenes inside Americans' private home spaces. Riots take place outside a picture window, soldiers invade a sparkling clean kitchen, and the corpses of two Vietcong lie in an attic. Somewhat fittingly, these photomontages were made from illustrations from *House Beautiful,* a magazine she used when she was decorating her own home that presented images of middle- and upper-class domestic comfort. The war scenes came from news magazines like *Life.* In her constructed photographs, the horror of war invades these spaces with terrifying disruption. Weapons and images of destruction along with death enter into the spaces most often associated with a female presence.

Another photomontage series, titled *Beauty Knows No Pain* (1965–1973), uses illustrations from men's magazines as it analyzes the act of men objectifying women. *Make up/Hands up,* one image from this series, depicts a close-up of a woman raising her well-manicured hand to her eye to brush on eye shadow. In place of her eye is a photo of a man with a gun standing behind a woman who also has her hands up, only this woman's eyes are bound by fabric. She is a prisoner who may be killed at any moment. The juxtaposition of images causes the viewer to think about the contexts of the two women, as the meanings of their lives are reflected in the movement of their hands and the attention paid to their eyes.

At a time when feminists were increasingly recognizing the many ways in which women are objectified in art and life, Rosler responded with a performance that later became a video. One scene depicts a nude woman, who is continuously being measured by a clothed man in a white medical coat, while being asked inappropriate questions about her identity. The videotape, titled *Vital Statistics of a Citizen, Simply Obtained* (1977), puts distance between the nude woman, who is Rosler, and the viewer to allow for a space for critical awareness. This conscious choice of camera position was made to signal to the viewer that the video was not entertainment and critical distance is helpful to engage in analysis.

Recognizing that food is central to women's daily lives, in the late 1970s Rosler created a series of works related to meal preparations. She explained, "Food is the art of womanhood....It is an art product, but one that is made for the delectation of others and which disappears....I also saw food in relationship to class differentiation" (Stein and Wooster 145). Three works—*A Budding Gourmet, McTowers Maid,* and *Tijuana Maid*—each constructed as a postcard-novel, address how economic status dictates women's relationship to food.

Rosler's work continuously engages in art theory but avoids the often-difficult language of postmodernism, feminism, and Marxism. Instead she uses a narrative style that is easy

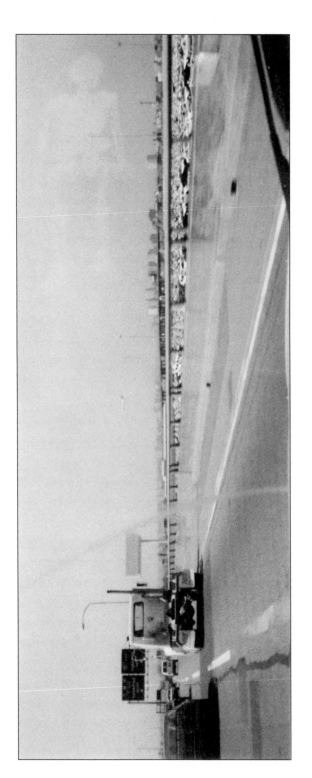

Martha Rosler. *Routes 1 & 9, New Jersey* (1995). C-Print, 26½ × 40 inches. © Martha Rosler, courtesy of Mitchell-Innes & Nash, New York.

to approach. She is aware of the techniques mass media uses to manipulate an audience and chooses instead to approach her viewers with a way of seeing that engages their intellect. For example, in her 1975 video, *Semiotics of the Kitchen*, she mocks heavy theory with humor while exposing women's suppressed rage and underused power. Working at a chopping block in a kitchen, in a deadpan voice she names a series of items in alphabetical order: "Apron, bowl, chopper...." Her gestures become more active and jarring as she continues.

Rights of Passage (1981–1997), a photographic series that Rosler spent many years creating, shows how the growing numbers of highways in the United States have changed the landscape. From a driver's perspective she presents us with featureless highways that have an increasingly ubiquitous quality of looking like no place in particular. In the 1990s she created *In the Place of the Public: Airport Series*, color photographs with text that also addresses a concern for public spaces and how we act, or don't act, in them.

Raising issues related to our need to continuously purchase things, from 1981–1996, Rosler produced a series of color photographs dealing with our commodity culture. A figure is seen gazing into shop windows and museum cases in places all over the world. She focuses in on the gaze that functions to serve our most questionable impulses.

In 2000, the New Museum of Contemporary Art, in collaboration with the International Center for Photography in New York, presented the retrospective, *Martha Rosler: Positions in the Life World*. According to Eleanor Heartney who wrote about this exhibition, "Rosler belongs to a generation of politically oriented artists who view slick presentations with suspicion and expect their audiences to be willing to sort through diverse and often daunting amounts of documentary material" (Heartney 109). Consequently, Rosler's work continues to be homespun and low-tech.

While Martha Rosler often uses photography, as an artist she has also made sculpture, drawn cartoons, produced installations, filmed videos, and created performances. Her work has sparked political debates, addressed art theory, and deconstructed social myths. It uses humor and transgressive approaches. Although it is theoretically accessible to everyday people, it probes deeply into profound questions while leaving the answers, discussions, and debates up to viewers.

Bibliography

Buchloh, Benjamin. "A Conversation with Martha Rosler." In *Martha Rosler: Positions in the World*, ed. Catherine de Zegher. Cambridge, MA: MIT Press, 1998, 23–55.

Heartney, Eleanor. "Documents of Dissent." *Art in America* 3 (2001): 108–113, 159.

Liebs, Holger. "Martha Rosler: 'House Beautiful' in Vietnam." In *Women Artists in the 20th and 21st Century*, ed. Uta Grosenick. New York: Taschen, 2001, 462–467.

Lippard, Lucy R. *The Pink Glass Swan: Selected Feminist Essays on Art*. New York: New Press, 1995.

López, Yolanda M., and Moira Roth. "Social Protest: Racism and Sexism." In *The Power of Feminist Art: The American Movement of the 1970s, History and Impact*, ed. Norma Broude and Mary D. Garrard. New York: Harry N. Abrams, 1994, 140–157.

Rosler, Martha. "Bringing the War Home: House Beautiful." In *New American Feminist Photographies*, ed. Diane Neumaier. Philadelphia: Temple University Press, 1995, 126–129.

———. "New Found Career." In *Martha Rosler: Positions in the World*, ed. Catherine de Zegher. Cambridge, MA: MIT Press, 1998, 62–63. Excerpt reprinted from *Journal of the Los Angeles Institute of Contemporary Art*, 1977.

Stein, Judith E., and Ann-Sargent Wooster. "Making Their Mark." In *Making Their Mark: Women Artists Move into the Mainstream*, ed. Nancy Grubb. New York: Abbeville, 1989, 51–186.

Turner, Grady, T. "Martha Rosler at Jay Gorney." *Art in America* 5 (1997): 126–127.

Places to See Rosler's Work

Contemporary Arts Museum, Houston, Texas
Long Beach Museum of Art, Long Beach, California
Museum of Modern Art, New York, New York

ARTHUR ROTHSTEIN

1914/15–1985

DESPITE CRITICISM THAT ARTHUR ROTHSTEIN'S FARM SECURITY ADMINISTRA-
tion (FSA) photographs were often staged, this work was groundbreaking in the field of
social documentary and bringing attention to rural America in the early twentieth century.
Born in New York City to a Jewish American family, his birth year is uncertain, either 1914
or 1915. From about 1931 to 1935, he studied photography at Columbia University. While
there, he formed the university's first camera club and met Roy Stryker, a professor of eco-
nomics. As a senior, he worked on a project with Stryker, organizing documentary photo-
graphs. Although the project was not completed, this relationship would prove to be pivotal
in Rothstein's career.

In 1935, Stryker hired Rothstein to work for the Resettlement Administration, a U.S.
government agency with the FSA. Rothstein was among the first group of photographers
hired by the FSA. Other FSA photographers in this first group included **Dorothea Lange,
Walker Evans,** and Ben Shahn. Their primary agenda was to document the drastic condi-
tions that rural America was living under due to the effects of the economic depression.

For his first assignment, Rothstein was sent to Virginia to document the farmers who
were being evicted to make room for the Shenandoah National Park. The farmers were
being relocated, or rather they were being displaced, by the Resettlement Administration,
who also funded the documentation of it. Rothstein was aware of the duplicitous nature of
this work, which was an underlying theme in all of his projects for the FSA. Next, he was
sent to Cimarron County, Oklahoma, in the heart of the Dust Bowl—named for the severe
drought and subsequent dust storms that wreaked havoc on the farm land and economy.
These black-and-white photographs of grief-stricken faces and barren land in the Dust Bowl
are some of his most famous images. One particular image, *Dust Storm, Cimarron County,
Oklahoma* (1936), has become a signature photograph of Rothstein's work in the area. The
black-and-white photograph shows a family struggling to walk against the windstorm on

Arthur Rothstein. *Gee's Bend, Alabama (Artelia Bendolph)* (1937). Courtesy of The J. Paul Getty Museum.

their meager property. While on location in the Dust Bowl, Rothstein suffered eye damage due to excessive exposure to the dust.

At the prompting of journalist Beverly Smith, Stryker sent Rothstein to Gee's Bend, a tenant community in Alabama. Gee's Bend was a rural community that suffered greatly not only from the effects of the economic depression, but also from the long-term effects of slavery and the present-day problem of segregation and discrimination from mainstream society. The Resettlement Administration perceived this project as fulfilling multiple goals. On the one hand, Rothstein was documenting a little-known population in a small pocket of rural America—a population that had not evolved much past the days of slavery without formal education and segregation from mainstream society. These people still adhered to traditional cultural ways of their ancestors who were slaves. On the other hand, Rothstein was also documenting the positive effects of the assistance from the Administration for the community, which would be good publicity for the government program.

The images of Gee's Bend stand out from his other work for the FSA. Whereas in previous projects, the people are shown as victims of much destruction and economic hardship,

the people in Gee's Bend are prevailing despite their substandard living conditions. Many of the photographs are taken in the homes while the people are engaged in various domestic activities. This work has been heralded for capturing the traditional African American culture in Alabama.

Rothstein captured the details of their community from the crudely constructed log homes to the handmade clothing. The people are resilient and strong in their community. However, Rothstein also maintained a socially conscious perspective in this work, recognizing that these people had been restricted from social, economic, and educational opportunities. In *Gee's Bend, Alabama (Artelia Bendolph)* (1937), a young African American girl peers out into the distance from inside her log cabin. She stands at an open paneless window. The solid window door has swung open to reveal a collage of newsprint that shows an advertisement with a blonde Caucasian woman. Here, the newspaper represents an America full of consumerism and prosperity, an America that is unattainable for the young girl.

In 1940 Rothstein went to California to photograph the Internment camps that housed more than seventy-five thousand people, primarily Japanese Americans, during World War II. The government was undergoing recurring congressional attacks and questions about the camps. Roy Stryker received orders to produce positive images of the camps for the government to use in defense of continued funding for the camps and detainment of the people. Stryker directed Rothstein to photograph the daily life in a positive light and to primarily focus on women and children. He was told to photograph a nurse helping a child, a woman in postnatal care, or otherwise any image that showed child welfare at work in the camps. Although he was able to photograph more women and children than he could have imagined, his photographs of the Visalia camp were not effective in dissuading the congressional criticisms of the program. Rothstein photographed for the administration for five years, which resulted in a major catalogue of historical documentation and an impressive artistic portfolio.

After a five-year stint with the FSA, Rothstein went to work for *Look* magazine as a staff photographer. He worked with the publication until the end of its run in 1971. In 1972 he was hired by *Parade* magazine as the associate editor and director of photography. Rothstein was an educator as well. He taught photography at Columbia University and at the Newhouse School of Communication. He was the founder of the American Society of Magazine Photographers and served as the editor of the group's publication for one year. Rothstein published several monographs of his work and received numerous distinctive awards and honors.

He died in New Rochelle, New York, on November 11, 1985. Arthur Rothstein was a significant contributing photographer for the FSA, documenting the poor and impoverished conditions that much of rural America suffered during the early to mid-twentieth century.

Bibliography

"Arthur Rothstein: Obituary." *Afterimage*, January 13, 1986: 2.

Fondiller, Harvey V. "Obituary." *Popular Photography*, January 13, 1986: 116.

Porte, Joel. "Looking Back at Vermont." *New England Quarterly 77*, no. 2 (June 2004): 330–332.

Rothstein, Arthur. *Arthur Rothstein's America in Photographs, 1930–1980*. New York: Dover, 1984.

"Telling the News from Desolation Row." *Time* 134 (Fall 1989): 36–37.

Places to See Rothstein's Work

Addison Gallery of American Art, Phillips Academy, Andover, Massachusetts

Amarillo Museum of Art, Amarillo, Texas: *Black Clouds Rising Over the Texas Panhandle* (no date); *Fleeing a Dust Storm* (no date)

Art Gallery of Toronto, Toronto, Canada: *Migrant Family, Oklahoma* (1936)

Block Museum of Art at Northwestern University, Evanston, Illinois

George Eastman House of Photography, Rochester, New York

Harvard University of Art, Cambridge, Massachusetts

International Center of Photography and Film, New York, New York

J. Paul Getty Museum, Los Angeles, California: *Gee's Bend, Alabama (Artelia Bendolph)* (1937)

Library of Congress, Washington, DC

Museum of Modern Art, New York, New York

New York Public Library, New York, New York

Royal Photographic Society, London, England

Smithsonian Institute of American Art, Washington, DC

LUCAS SAMARAS

b. 1936

LUCAS SAMARAS RECENTLY TURNED 70 YEARS OLD AND IS STILL WORKING harder than ever in his art studio; from sculptor to experimental photographer, he continues to evolve as an artist today. Greek-born Samaras is considered to be one of the most important American photographers of the twentieth century.

He was born in the small town of Kastoria in the Macedonian region of Greece. The young Samaras and his family suffered from the effects of the Greek Civil War, which caused the family to flee the country. When they immigrated to the United States in 1948, he was 12 years old. His father was a shoemaker, and his aunt had a dress shop, where the young Samaras routinely played and which would later become a source of inspiration for his art. Just before enrolling in college, he became a U.S. citizen. He attended Rutgers University from 1955 to 1959, where he studied sculpture with artist George Segal, who made an impression on the young Samaras. Samaras emulated the technique and processes that Segal used to create his large plaster sculptures. He also experimented with mixed media sculpture using nails, wood, screws, cloth, and plaster to create eroticized figures, foreshadowing a later series.

In 1959, he enrolled at Columbia University where he studied with Meyer Schapiro, a prominent art historian who promoted *modernism*. As an art student, Samaras primarily studied painting; however, he enjoyed his acting classes as well. He was involved with performance art and Professor Allan Kaprow's art *Happenings*. Kaprow and his art events or "Happenings" could occur anywhere at anytime with one or more actors and typically involved audience participation. These non-narrative performances were usually disjointed and communicated *avant-garde* ideas about art and life. His participation in several Happenings greatly affected Samaras's ideas about the meaning and function of art.

In the mid-1960s, Samaras was using the box as a format for his collage work and attaching objects such as nails, tacks, razorblades, and other sharp and potentially harmful tools. His relationship with photography began when he used it as an element in these collage

box projects. In *Box #61* (1967), the lid is open to reveal a distorted photographic image of the artist. Recalling the sewing pins from his aunt's dress shop, Samaras inserted straight pins into the photograph along the lines of his cheek, moustache, and mouth. This work is visually perplexing and evokes a sense of pain and even torture; yet he explained that the box represents the body and that he sees the process of making these objects as an erotic gesture.

Perhaps his most recognized work is the photographs from the *Transformation Series*. In 1973, he discovered that wet dye in Polaroid prints could be manipulated during processing, which resulted in a wet paint look with flowing lines and distorted images. In his modest apartment, which also functioned as his studio, Samaras took Polaroids of himself in the nude, in strange poses, and several close-ups of various body parts. A self-described peeping tom, here he is peeping at himself. He layered several self-portraits with distorted color and line to create images that are both beautiful and grotesque at the same time. These pictures recall funhouse mirrors that reflect pulled and stretched forms of ourselves, hilarious and terrifying at the same time. The *Transformations Series* brought Samaras a new level of fame and financial success in the art world.

Samaras's fascination with the self-portrait borders on obsession. He has created literally hundreds of self-portraits in varied media, photographs, collage, cut paper, paintings, and pastels. In 2004, curator Martha Prather at the Whitney Museum of American Art in

Lucas Samaras. *Photo-Transformation* (September 9, 1976). Courtesy of The J. Paul Getty Museum. © Lucas Samaras.

New York City held a retrospective of his work, *Unrepentant Ego: The Self-Portraits of Lucas Samaras*. The exhibition featured more than 400 of his vast oeuvre of self-portraits.

Although Samaras commented that he has largely been overlooked by the art world, his work is included in dozens of museum collections throughout the world. An artist is fortunate to have one retrospective exhibition during their lifetime; Samaras has already had seven retrospective exhibitions honoring his work. In 2005, his exhibition *Lucas Samaras: PhotoFlicks (iMovies) and PhotoFictions (A to Z)* opened at Pace/MacGill Gallery in New York City. Inside the gallery Samaras set up six terminals for viewing his vast installation of more than 4,000 still images and 60 short films. The still images and short films reveal the inside of Samaras' life, including such private and mundane activities as filing his nails, working in his studio, or cleaning his ears with a q-tip.

At the age of 70, Samaras is described as trim with long white hair and a long white beard to match. He is still intrigued with his nude image yet is daunted by the aging process and not interested in portraying an old and frail body. Samaras was delighted to find that when he filtered the photograph, his nude form changed into something inhuman and curious. Samaras said of this work, "So, beginning with this ugly picture of myself nude and then putting a filter on, all of a sudden it was OK because it dramatized the event, and made it weird—weird is better than just ugly" (Kunitz 96). In a 2003 interview, Samaras described himself as a recluse. Perhaps this is one reason he works most often in his apartment studio and works with the self-portrait as the main landscape of investigation; as such his subject is always available.

In 2007, Samaras lives and works in New York City. He still works in a studio from his apartment, which has been upgraded to a considerably larger space with sweeping views of the city. In addition to his self-portrait photographic explorations, Samaras makes short films and continues to paint. Through years of exploration with the self-portrait, artist Lucas Samaras has provided a vast oeuvre of mixed media and experimental photography that has contributed to broadening the parameters of art.

Bibliography

Heartney, Eleanor. "Through the Mind's Eye: Samaras' Abstractions [Pace Gallery, New York]." *Art in America* 80, no. 3 (1992): 88–93.

Kunitz, Daniel. "Close Inspection: New York City, New York." *Art Review (London, England)* 3 (2006): 96.

Leffingwell, Edward. "Lucas Samaras at Pace Wildenstein." *Art in America* 90, no. 4 (2002): 146.

"Lucas Samaras: PhotoFlicks (iMovies) and PhotoFictions (A To Z)." *Modern Painters* (July/August 2005): 104.

Pollack, Barbara. "Unrepentant Ego: The Self-Portraits of Lucas Samaras; Whitney Museum of American Art." *Artnews* 103, no. 3 (2004): 127.

Prather, Marla. *Unrepentent Ego: The Self-Portraits of Lucas Samaras.* New York: Whitney Museum of American Art, 2003. (Distributed by Harry N. Abrams, Inc.)

Samaras, Lucas. *Lucas Samaras: Objects and Subjects, 1969–1986.* New York: Abbeville Press, 1988.

Taylor, Sam. "From Tortured Youth to Enchanted Sage [exhibit]." *Art in America* 92, no. 8 (2004): 112–117.

Vrachopoulos, Thalia. "Athens: Lucas Samaras: National Gallery." *Sculpture (Washington, D.C.)* 25, no. 1 (2006): 76–77.

Wakefield, Nellie. "Lucas Samaras: He might make boxes, but as two new shows prove, he won't be put in one, or paintings, or photographs, or sculptures, or jewelry—Art Maverick—Interview." *Interview* (December 2003): Retrieved February 10, 2007, from http://www.findarticles.com/p/articles/mi_m1285/is_11_33/ai_111114535.

Wolfson de Botton, Janet. *Lucas Samaras in the Tate Collection*. Retrieved February 10, 2007, from http://www.tate.org.uk/servlet/ViewWork?cgroupid=999999961&workid=21773.

Places to See Samaras's Work

Albright-Knox Art Gallery, Buffalo, New York
Art Institute of Chicago, Chicago, Illinois
Columbus Museum, Columbus, Georgia
Courtauld Institute of Art, London, England
Dallas Museum of Art, Dallas, Texas
Denver Art Museum, Denver, Colorado
Fogg Art Museum, Harvard University, Cambridge, Massachusetts
Harvard University, Cambridge, Massachusetts
Hirshhorn Sculpture Garden, Washington, DC
J. Paul Getty Museum, Los Angeles, California
Los Angeles County Museum of Art, Los Angeles, California
Lowe Art Museum, Coral Gables, Florida
Modern Art Museum of Fort Worth, Fort Worth, Texas
Museum of Contemporary Art, Chicago, Illinois
Museum of Contemporary Art, Los Angeles, California
National Gallery of Art, Washington, DC
National Gallery of Australia, Canberra
Neuberger Museum of Art, Purchase, New York
Newark Museum, Newark, New Jersey
St. Louis Art Museum, St. Louis, Missouri
San Francisco Museum of Modern Art, San Francisco, California
Smith College Museum of Art, Northampton, Massachusetts
Smithsonian American Art Museum, Washington, DC
Tate Gallery, London, England
University of Michigan Museum of Art, Ann Arbor, Michigan
Walker Art Center, Minneapolis, Minnesota
Whitney Museum of American Art, New York, New York

CAROLEE SCHNEEMANN

b. 1939

KNOWN AS ONE OF THE IMPORTANT ARTISTS OF THE FEMINIST MOVEMENT, Carolee Schneemann has provocatively used her body to explore gender marginalization, the female libido, and women's culturally determined perceptions of her body. While she is best known as a performance artist, most people know her work through photography and film and video. Like **Hannah Wilke,** Schneemann used her body to address issues of perception and social conventions. Consequently, she was often controversial.

Schneemann was born in Fox Chase, Kentucky, in 1939. She went to Bard College where she received a BA and the University of Illinois where she earned an MFA. She has work in museums all over the world and has taught at many universities including New York University, California Institute of the Arts, and the School of The Art Institute of Chicago. She now lives in New Paltz, New York.

She began her career as a painter in New York in the early 1960s and quickly became interested in exploding painting beyond the boundaries of the frame. In her early years as an artist, she involved herself in *Happenings,* art events that involved improvisational theatrical activity. Partly because she had such a beautiful body, she was often referred to as a "dancer" as opposed to an "artist."

In 1963, Schneemann created the edgy work *Eye Body,* an installation made of broken mirrors, glass, and motorized umbrellas that provided the environment for a series of nude photographs of the artist whose body was smeared with paint and surrounded with snakes and ropes. Her facial expressions vary from being happy and sexy to dazed. *Meat Joy* (1963), an even more provocative work, is a taped performance in which partially clothed men and women move together while grasping buckets of paint, plucked chickens, and fish in an effort to explore touch and tactile experiences that could liberate the body.

In 1973, Schneemann performed *Up To and Including Her Limits,* which reflected on Jackson Pollock's approach to *action painting.* Pushing the limits of where the action is seen

and understood, she used her entire body, naked and suspended in space from a rope, to record lines with colored chalk. In this work Pollock's movements were re-energized into kinetic theater. She repeated this work several times, and it is documented in super-8 film; but like much of her work, most art students know the work from text and photographs.

Interior Scroll (1975) is the work that has given Schneemann the most acclaim and vilification. Now referenced most often as a photograph, the performance addressed women's place in filmmaking. After painting her body the naked artist pulled a long, thin coil of paper with text from her vagina. She read the scroll to the audience as she established a meeting with a filmmaker: "he said we are fond of you/you are charming/but don't ask us/to look at your films/…he said we can be friends/equally tho we are not artists/equally…" (Withers 163). Schneemann claimed that she was interested in breaking down the distance that modernist (mostly male) painting had created with the viewer. Instead of addressing a mythology of an abstracted self with distance from an artwork, Schneemann wanted to change women's specific understanding of themselves by giving them the gift of their bodies. The female as a subject of art, from this perspective, is not just a static picture, but is created in relationship to others in a space that is continuously being negotiated and changed. This evolution is done within a space of desire and identification. The photographic image from *Interior Scroll,* according to critic Lucy Lippard, is now an icon of feminist art. It portrays the story that is inside a woman's body.

Schneemann gained inspiration from many role models including Virginia Woolf, Paula Modersohn-Becker, Margaret Fuller, and Simone de Beauvoir. It is no surprise, then that photos and installations of the mid- to late 1980s and 1990s address other artists' work. She made visible underrepresented female artists like Ana Mendieta, a Cuban artist who also used her body in performance and photographic exploration to address politically charged women's issues. In *Hand Heart for Ana Mendieta* (1986), Schneemann created heart-shaped impressions in the snow using paint, blood, and syrup echoing Mendieta's body work.

In the winter of 1996–1997, Schneemann had a retrospective titled *Up To and Including Her Limits* named for her performance at the New Museum of Contemporary Art in New York City. The most critically acclaimed piece in the exhibition was *Mortal Coils* (1994), a memorial to 15 of her friends who had died within a period of two years. Their faces and bodies were projected in a darkened room while ropes hanging from the ceiling twisted on a floor full of flour.

Schneemann successfully uses shock to jar us into exploring our identities and actions. *Infinity Kisses* (1981–1987), for example, questions who or what we show our affection to by presenting us with 140 photographic images of kissing.

In 1996, she investigated the meaning of disease and medical treatment, which can sometimes take on violence that is reflective of the military. In *Known/Unknown* long vertical strips of photographic images that depict cancerous cells are woven together with text

Carolee Schneemann. *Infinity Kisses* (1981–1987). Xerox ink on linen. 84 × 72 inches (213.36 × 182.88 cm). San Francisco Museum of Modern Art. Accessions Committee Fund: gift of Collectors Forum, Christine and Pierre Lamond, Modern Art Council, and Norah and Norman Stone. © 2007 Carolee Schneemann / Artists Rights Society (ARS), New York.

statements from cancer patients. Four video monitors at the center of the installation space are placed amidst cast-latex breasts and straw that mimics arteries and veins. The videos are of surgical footage, intercourse, and a cat eating a mouse.

In 2006, Schneeman once again produced shock waves when she boldly exhibited *Terminal Velocity*, a series of devastating photographs of people falling to their death from the World Trade Center on September 11, 2001. Forty-two computer-scanned photographs from newspaper clippings arranged in a grid quickly communicate the force of gravity and the horror of lives lost. Another recent work that deals with violence depicts color photographs of fenced-in kittens, ready to be eaten by the Chinese. This image is juxtaposed with photographs of the Iraq war. In these works she broadens her earlier feminist critique to draw attention to the fact that our actions depend on how deeply we empathize and respond to the actions of others.

Carolee Schneemann has paved the way for many artists including Janine Antoin, Mathew Barney, Karen Finley, Paul McCarthy, and **Cindy Sherman.** She has also written several books including *Cezanne, She Was a Great Painter* (1976), *Early and Recent Work* (1983), and *More Than Meat Joy: Performance Works and Selected Writings* (1979, 1997). Her work, documented in videos and photographs, continues to resonate as bold and memorable.

Bibliography

Heartney, Eleanor. "Carolee Schneemann at Elga Wimmer." *Art in America* 8 (1996): 113.

Jones, Amelia. "Postfeminism, Feminist Pleasures, and Embodied Theories of Art." In *New Feminist Criticism: Art, Identity, Action*, ed. Joanna Frueh, Cassandra L. Langer, and Arlene Raven. New York: Icon Editions, 1991, 16–41.

Landi, Ann. "Carolee Schneemann." *Artnews* 96, no. 4 (1997): 133–134.

Lippard, Lucy R. *The Pink Glass Swan: Selected Feminist Essays on Art.* New York: New Press, 1995.

Löffler, Petra. "Carolee Schneemann." In *Women Artists in the 20th and 21st Century*, ed. Uta Grosenick. New York: Taschen, 2001, 482–487.

Princenthal, Nancy. "The Arrogance of Pleasure." *Art in America* 10 (1997): 106–109.

Schor, Mira. "Patrilineage." In *New Feminist Criticism: Art, Identity, Action*, ed. Joanna Frueh, Cassandra L. Langer, and Arlene Raven. New York: IconEditions, 1991, 42–59.

Valdez, Sarah. " Carolee Schneemann at P.P.O.W." *Art in America* 6 (2006): 197.

Withers, Josephine. "Feminist Performance Art: Performing, Discovering, Transforming Ourselves." In *The Power of Feminist Art: The American Movement of the 1970s, History and Impact*, ed. Norma Broude and Mary D. Garrard. New York: Harry N. Abrams, 1994, 158–173.

Places to See Schneemann's Work

Detroit Institute of Art, Detroit, Michigan

Franklin Furnace, New York, New York

Getty Center for the History of Art, Santa Monica, California

Los Angeles Institute of Contemporary Art, Los Angeles, California

Museum of Modern Art, New York, New York

Philadelphia Museum of Art, Philadelphia, Pennsylvania

San Francisco Museum of Modern Art, San Francisco, California

University of Massachusetts, Contemporary Archives, Boston, Massachusetts

ANDRES SERRANO

b. 1950

ANDRES SERRANO'S PHOTOGRAPHS ARE WELL KNOWN FOR THEIR SHOCK value, with images of death, sex, the Klan, and religious symbols. His photographs often incite strong emotive reaction, which sometimes results in heated debate and high controversy.

He was born in New York City to a strict Roman Catholic Honduran/Afro-Cuban family. Serrano spent his childhood in the city and then attended the Brooklyn Museum Art School from 1967 to 1969.

He has received extreme criticism for his use of blood and urine. In an early series, *Tableaus*, Serrano began to experiment with bodily fluids in conjunction with the *cibachrome* print. He staged a bloody taxidermied coyote sitting with mouth agape in *The Scream* (c. early 1980s), making reference to Edvard Munch's famous painting of the same name. Following the *Tableaus* series came the *Nomads*, which is a collection of portraits of the homeless population who walk the subway and streets of New York City late at night. In *Nomads (Bertha)* (1990), Serrano portrays this woman with dignity.

He has garnered much attention for manipulating body fluids as art materials, particularly in his series *Fluids*, created from 1985 to 1990. In some works the fluids themselves are not only the materials, but they are the content as well, such as in *Milk, Blood* (1986). One side of the vertically divided canvas is painted with milk, while the other is covered with blood representing white and red, light and dark, cool and warm, life and death. Without the title the work is reduced to minimal color and shape, void of specific meaning.

Serrano's Catholic upbringing informs his work. He feels that religion is closely aligned with the body and with the bodily fluids: milk, blood, and urine. Another photograph from the Fluid Series, *Piss Christ* (1987), has become infamous to a mainstream audience for its shock factor and consequent controversy. Here the title, *Piss Christ*, is powerful enough to incite anger from the audience even before they see the image. Without knowing the title

the artwork is breathtaking. The photograph depicts the traditional Crucifixion bathed in red and gold. The warm, red background is lit by the golden image of Christ sacrificed on the cross. His issues with religion are guided by the structure and "rules" set by the Church. He stresses that *Piss Christ* was an experimentation with color and urine. He was simply interested in what would happen to the photograph if he dipped it in urine.

The uproar over Serrano's *Piss Christ* started when an offended art patron contacted conservative Republican Senator Jesse Helms from North Carolina. The outrage was centered on the fact that taxpayers' money funded the project. In 1997, Serrano received a $15,000 grant from the National Endowment for the Arts (NEA). Subsequent attacks ensued on the NEA. Together with Republican Senator Alfonse M. D'Amato from New York, Helms spoke before the U.S. Senate regarding Andres Serrano and the NEA grant:

> What this Serrano fellow did, he filled a bottle with his own urine and then stuck a crucifix down there—Jesus Christ on a cross. He set it up on a table and took a picture of it. For that, the National Endowment for the Arts gave him $15,000, to honor him as an artist. (D'Amato and Helms 3)

The meeting brought on intense attention from the media. Questions about art, art materials, artists, and who decides how these are defined were raised. Outrage continued, and the painting went under physical attack with baseball bats by two art patrons at Australia's National Gallery, which later dismantled the entire Serrano exhibition.

Art historians have argued that it is the title that is inciting such anger; the very nature of the word "piss" is aggressive. When asked about the public reaction brought on by *Piss Christ* and the controversy surrounding it, Serrano replied:

> To this day, I am the artist but I'm the audience first, I do it for me. But I've realized that I don't simply work in a vacuum; the work does go out there to the real world and people will react to it, but at the time I was just concerned with the ideas and images in my head. (Weintraub 161)

This disputed version of Christ has been compared to Paul Gauguin's *Yellow Christ* (1889). Gauguin's painting attracted attention and criticism for abandoning the prevailing tradition of realism for a stylistic approach to form with a bright palette and most notably for coloring Christ's skin sunshine yellow.

The series *Masks* are portraits of Ku Klux Klan members. Here again, the title is an important component to understanding the work. The title refers to the hoods as masks. Through his work with the Klan members, Serrano was striving to reconcile racist tensions that pervade our society. Serrano talked about his experience working with various members of the Ku Klux Klan, "Being who I am, racially and culturally, it was a challenge for me to work with the Klan, as much for me as for them, that's why I did it" (Weintraub 164). His photograph simply entitled *Klansman (Imperial Wizard)* (1990) is a portrait of a hooded

Klan member from the shoulders up. His eye sears through the opening in the hood, maintaining its hold on the viewer. The photograph is foreboding at 5′ × 4′.

All of the Klan portraits are poignant and representational of a violent power that has long lived in the United States. Some of the photographs are much more confrontational than others. In *Klansman* (*Grand Klaliff* II) (1990), the portrait is a close-up revealing just one eye peeking through the protection of the white hood against a solid black background. Serrano seems to be making a statement here about the complexities of racism; it is more than just whites against blacks.

His next major work, *The Morgue* (1992), is a group of photographs taken of bodies brought to a morgue over a three-month period. Old bodies, young bodies, deaths by natural causes, deaths by various accidents, Serrano captures them all without discrimination or specific mission. *The Morgue* was first exhibited in 1993 as part of the Venice Biennale "Aperto 93" and then again later that year at the Paula Cooper Gallery in New York. Met with controversy, he replied, "[my] work is like a mirror—each spectator responds differently depending on his or her approach" (Oliva and Eccher 135).

Despite such intense attacks from art patrons, galleries, museums, the media, and government officials, his artwork continues to be shown in art venues around the world. In 1985, the Leonard Perlson Gallery in New York hosted his first exhibition, which was followed by another two that year. Serrano's work has been included in several group exhibitions in New York, including *Myth and History* at the Museum of Contemporary Spanish Art and the Whitney Museum of Art's Biennial in New York City.

Andres Serrano portrays those images that represent things in life that can make us feel uneasy and repulsed or wakens in us a new awareness about ourselves. Regardless of the end result, he incites emotion and response.

Bibliography

"A Take on *Piss Christ*. Shoot the Messenger." Retrieved July 28, 2001, from http://www.igloo.itgo. com/1_pisschrist.htm.

Archer, Michael. *Art since 1960*. New York: Thames and Hudson, 1997.

D'Amato, Alfonse M., and Jesse Helms. "Comments on Andres Serrano by Members of the United States Senate." Retrieved on May 18, 1989, from http://www.csulb.edu/~jvancamp/361_r7.html.

Deckman, T.R. "Disputed Artist Explains Works." *The Digital Collegian*. Retrieved on October 2, 1996, from http://www.collegian.psu.edu/archive/1996_jan-dec/1996_oct/1996–10–02_the_daily_collegian/1996–10–020101–001.htm.

Ebony, David. "Andres Serrano at Paula Cooper." *Art in America* 89, no. 12 (2001): 110.

Fusco, Coco. "Shooting the Klan: An Interview with Andres Serrano." *Community Arts Network*. Retrieved on January 3, 2005, from http://www.communityarts.net/readingroom/archive/ca/fusco-serrano.php.

Gleeson, David. "Andres Serrano." *Modern Painters* 14, no. 4 (2001): 97–98.

Karsnick, Alex. "Andres Serrano at the Kansas City Art Institute." *Kansas City Visual Arts Connection*. Retrieved on September 28, 1996, from http://www.kcvac.com/reviews/serrano.htm.

Oliva, Achille Bonito, and Danilo Eccher, eds. *Appearance*. Milano, Italy: Edizioni Charta, 2000.

Piteri, Rita. *The Andres Serrano Controversy*. Retrieved July 28, 2001, from http://www.home.vicnet.au/~twt/serrano.html.

Serrano, Andres. "Andres Serrano [Photo Essay]." *European Photography* 23, no. 72 (2002): 58–64.

Weintraub, Linda. *Art on the Edge and Over*. Litchfield, CT: Art Insights, 1996.

Places to See Serrano's Artwork

Bayly Art Museum at the University of Virginia, Charlottesville, Virginia

Cristinerose Gallery, New York, New York

Fundación Proa, Buenos Aires, Argentina

HyperArt.com, New York: www.hyperart.com

International Center of Photography, New York, New York

Lance Fung Gallery, New York, New York

Modern Art Museum, Fort Worth, Texas

Museum of Contemporary Art, Chicago, Illinois

New Museum of Contemporary Art, New York, New York

Paula Cooper Gallery, New York, New York

Spencer Museum of Art at the University of Kansas, Lawrence, Kansas

Weisman Art Museum at the University of Minnesota, Minneapolis, Minnesota

CINDY SHERMAN

b. 1954

FOR MORE THAN 30 YEARS, CINDY SHERMAN HAS BEEN PLAYING DRESS UP and photographing herself, for which she has gained superstar status in the art world. Inspired by the movies and performance art, Sherman uses herself as the central model or actor playing roles from sex kitten to frustrated housewife to beauty queen. She portrays women in society as they are stereotypically portrayed in film and television. She seems to be questioning the validity of such roles and perceptions, which has garnered much attention from feminist scholars, critics, and fans alike. With the opening of Sherman's first solo exhibition, she received instant notoriety for these caricature self-portraits.

Sherman was born in Glen Ridge, New Jersey, on January 19, 1954, and grew up in Huntington Beach, Long Island. She enjoyed walking the beach outside her family home where neighborhood children played freely. Sherman was inspired by the movies to play dress up as different characters, choosing from a suitcase full of costumes of hand-me-downs and thrift store dresses. Unlike her playmates Sherman says that she preferred playing the monster rather than the bride or princess. Both of her parents supported her artistic interest and flamboyant creativity; her mother was a teacher, and her father was an engineer and an amateur inventor. Art materials were abundant in the household, and Sherman spent hours on end drawing and painting, producing realistic compositions of rooms inside the house. She received support and attention for her artwork at school as well as from the family. Although Sherman was unsure about what it meant to live your life as an artist (she had only been exposed to sidewalk artists, courtroom illustrators, and cartoonists), she decided to pursue art after high school.

Sherman studied art at the University College of Buffalo. There she enrolled as a painting student and regularly visited the Albright-Knox Art Gallery located across the street from the university. It was there that she was influenced by the latest in contemporary art. She was convinced that photography, not painting, would be the best medium for her

conceptual art ideas. With the suggestion from a university photography teacher to take a picture of something that made her feel uncomfortable, Sherman decided to photograph herself in the nude. This experience exposed her to the possibilities of photography and the idea of using her own body as the main tool in her art work. She started to experiment with dressing up and transforming herself into someone else, just as she had as a child, and then photographed herself in various poses. She was delighted with the opportunity to choose from several shots, showing only her best efforts; painting only offered a single copy of the final work. While in Buffalo, Sherman met artist Robert Longo, who influenced her commitment to photography as her medium of choice. Together with Longo and a peer from art school, Charles Clough, Sherman co-founded Hallwalls, an independent artist space. Hallwalls is still a thriving art gallery in Buffalo, New York. After Sherman graduated with her bachelor's degree in 1976, she was awarded a grant from the National Endowment for the Arts, which allowed her to move to New York City.

Her first project post graduation was a series titled *Complete Untitled Film Stills* (1977–1980), a set of 8 × 10 black-and-white prints of herself as a 1950s movie star in various scenes. Although Sherman is the central character in every shot, the images cannot really be considered self-portraits. She is playing a part in the "film." She calls the images Film Stills in reference to a single frame from a motion picture to elicit the anticipation of action in a story; Sherman is the starring actor. The portrait of an unknown woman in each image maintains an air of anonymity with the title *Untitled* and a number, much in the way that the *Abstract Expressionist* painters did, which left the viewer to their own imagination about the meaning of the work. This encourages the viewer to consider the meaning of the art on another level beyond the visual image; what will the character do next and what is the motivation? In *Untitled #21* (1978) Sherman appears as a well-dressed woman about town with a look of fear in her eyes, wide and staring off to the side. Tall buildings loom behind her, and she seems to be running from something or someone. The image evokes a somber air of *film noir* or that of an Alfred Hitchcock thriller. You can almost sense a large mass of black birds headed her way just around the corner.

The series garnered Sherman critical acclaim and much attention during her solo exhibition of this work at Metro Pictures in 1980. She became an overnight sensation in the art world, on which she remarked years later, "I was feeling guilty in the beginning; it was frustrating to be successful when a lot of my friends weren't" (Bright 25). Indeed Sherman experienced success before she was 30 years old, a rare accomplishment.

In 1981, Sherman started photographing in color. In many of these photographs, her make-up becomes a more important element as it transforms her face into a mask, from traditionally feminine and beautiful to garish and disturbing. In the late 1980s she began to design her photographs after famous painted portraits. For instance, in *Untitled #193* (1989), Sherman appears as a Renaissance woman, perhaps a member of the royal court complete with powdered wig and face and dressed in period clothing lounging amidst swaths of fabric

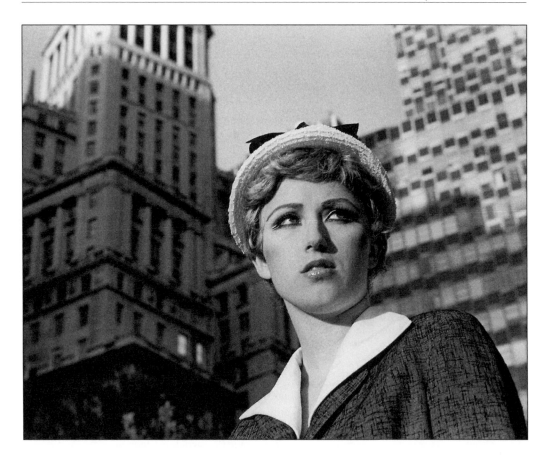

Cindy Sherman. *#21 Untitled* (1978). Courtesy of the artist and Metro Pictures.

as she casually fans herself with a bored expression. Sherman exaggerated the expression in an attempt to show how artists often manipulated the painting to show a more positive and interesting expression on the sitter's face than what existed in reality.

In another series from the 1980s, *Disasters/Fairy Tales Series* (1984–1989), Sherman replaced herself in the image with mannequins, dolls, and medical prostheses in horrific poses reminiscent of slasher B movies from the 1960s. She is drawn to the frightful rush stirred by horror films, which inspired her own film titled *Office Killer* (1997), which ran briefly at an art theater house. Sherman said of working with the darker side of emotions, "I am invigorated by challenge and confrontation and find a curious pleasure in adrenaline-producing cheap thrills common in horror genres" (Kaufman 54).

Scholars and art critics often give her work a feminist critique, stating that Sherman's images exaggerate the stereotypical roles and images of women in the media and society. Sherman offers the possibility of this process, which may lead to the deconstruction of gendered roles functioning within a male-dominated society. At the very least her images push

viewers to ask questions about the nature of the work and about their own perceptions. Sherman has frequently been criticized for refusing most interviews and the unwillingness to theorize about her work. Indeed she does shy away from making theoretical comments about her work, for which she said:

> I was thinking, maybe I am still just dressing up, because I don't theorize when I work. I would read theoretical stuff about my work and think, "What? Where did they get that?" The work was so intuitive for me, I didn't know where it was coming from. So I thought I had better not say anything or I'd blow it. (Bright 25)

Since she first achieved notoriety with the Metro Pictures exhibition in 1980, Sherman's photographs have been exhibited all over the world in numerous solo and group shows. In 1995, Sherman was granted one of the prestigious MacArthur Fellowships, and in 1999, Sherman was named one of the most 25 influential artists of the twentieth century by *Artnews*. Today, she lives and works in New York City and spends time in her home in Sag Harbor when taking a break from the studio. Artist and provocateur Cindy Sherman creates the character and sets the stage and then leaves the rest up to us to fill in the story.

Bibliography

Bailey, Suzanne. *Essential History of American Art*. Bath, UK: Parragon Publishing, 2001.
Bright, Susan. *Art Photography Now*. New York: Aperture Foundation, 2005.
Dykstra, Jean. "Cindy Sherman at Metro Pictures." *Art in America* 93, no. 1 (2005): 120–121.
Kaufman, Jason Edward. "Lens Life: Unmasking Iconic Photographer Cindy Sherman." *Art & Antiques* 28, no. 9 (2005): 50–54.
Krauss, Rosalind E. *Cindy Sherman: 1975–1993*. New York: Rizzoli, 1993.
Sherman, Cindy. *Cindy Sherman: The Complete Untitled Film Stills*. New York: Museum of Modern Art and London: Thames and Hudson, 2003.
———. *Cindy Sherman: Retrospective*. Essays by Amada Cruz, Elizabeth A.T. Smith, and Amelia Jones. New York: Thames and Hudson, 1997.
———. *Cindy Sherman*. New York: Whitney Museum of American Art, 1987.
Sills, Leslie. *In Real Life: Six Women Photographers*. New York: Holiday House, 2000.

Places to See Sherman's Work

Allen Art Museum at Oberlin College, Oberlin, Ohio
Armand Hammer Museum of Art, University of California, Los Angeles, California
Art Gallery of New South Wales, Sydney, Australia
Art Gallery of Ontario, Toronto
Astrup Fearnley Museet for Moderne Kunst, Norway
Birmingham Museum of Art, Birmingham, Alabama
Butler Institute of American Art, Youngstown, Ohio
Cincinnati Art Museum, Cincinnati, Ohio
Grey Art Gallery at New York University, New York, New York
Harvard Art Museums, Cambridge, Massachusetts

Los Angeles County Museum of Art, Los Angeles, California
Massachusetts Institute Visual Arts Center, Cambridge, Massachusetts
Metro Pictures, Inc., New York, New York
Metropolitan Museum of Art, New York, New York
Mildred Lane Kemper Art Museum, St. Louis, Missouri
Milwaukee Art Museum, Milwaukee, Wisconsin
Modern Art Museum of Fort Worth, Fort Worth, Texas
Montclair Art Museum, Montclair, New Jersey
Museum of Contemporary Art, Chicago, Illinois
Museum of Fine Arts, Boston, Massachusetts
Museum of Modern Art, New York, New York
Palmer Museum of Art, Pennsylvania State University, University Park, Pennsylvania
Phoenix Art Museum, Phoenix, Arizona
San Francisco Museum of Modern Art, San Francisco, California
Smith College Museum of Art, Northampton, Massachusetts
Solomon R. Guggenheim Museum, New York, New York
Tate Gallery, London, England
University of Kentucky Art Museum, Lexington, Kentucky
University of Virginia Art Museum, Charlottesville, Virginia
Victoria and Albert Museum, London, England
Wadsworth Atheneum Museum of Art, Hartford, Connecticut
Walker Art Center, Minneapolis, Minnesota
Whitney Museum of American Art, New York, New York
Williams College Museum of Art, Williamstown, Massachusetts

LAURIE SIMMONS

b. 1949

LAURIE SIMMONS IS HAILED AS ONE OF THE LEADING ARTISTS WHO PIONEERED what became labeled as feminist art in the 1970s. She addresses what Betty Friedan called "the woman problem" of the middle-class woman trapped within the confines of domesticity. Often inspired by memories of her childhood growing up in 1950s middle-class suburbia, Simmons confronts the myths that women are faced with, such as the endless quest for feminine beauty or that the love of a man will complete you.

She was born on October 3, 1949, in Long Island, New York, and grew up in the Rockaway suburb of Queens. Her father bought her a *Brownie* camera when she was just six years old, which was her initiation into the world of photography. Yet she did not view photography as art; rather, to her it was a purely documentary process. After high school Simmons enrolled at Temple University's Tyler School of Art in Philadelphia, but she did not study photography. During her junior year Simmons went to Rome, Italy, for an international study program through Temple. She graduated with her BFA in 1971. Simmons moved into a local commune after graduation. Her experience there was life changing. She was greatly affected by discussions she had with other feminists living in her commune and the lesbian commune nearby.

In 1973, she moved to New York City's SoHo district, where she was exposed to the artistic nature of photography for the first time. Once in New York City, Simmons started attending local photography exhibitions, art films, and live art performances. The work of **Jan Groover,** Duane Michals, and John Baldessari greatly affected Simmons' sense of photography and the possibilities of what it could do for her own art. Like many photographers she started by taking pictures of her friends, and before long she met other artists working with photography. Her neighbor and friend, artist Jimmy de Sana, taught Simmons the mechanics of black-and-white photography.

After a freelance photography project for a dollhouse miniature company, Simmons became interested in photographing dolls. She purchased a batch of old dolls and toys at a general store that was going out of business in the Catskills. Simmons was delighted to find dozens of old toys in their original boxes, just like the ones that she had played with as a child in the 1950s. These toys would be the materials for the construction of her tiny interiors and set designs. Remembering the work of Marcel Duchamp and his *readymades*, Simmons set forth experimenting with the dollhouse furniture and tiny dolls. She designed rooms with miniature furniture and decorated the walls with actual size wallpapers with tiny tile floors and other signs of domesticity. Most often her rooms were replicas of a kitchen or bathroom. Simmons purposively distorts the scale, for which she commented, "I never was concerned whether the camera tells the truth. I've always been concerned with how much it can lie and how far can I take this" (Howard 19).

Simmons was reluctant to present these images to the art world; she did not want to be known as an artist photographing dolls. With the encouragement of her husband, painter Carroll Dunham, along with that from the curator at Artists Space in New York City, Simmons exhibited her photographs of dolls and tiny interiors to critical success. This was the first of many series to follow where Simmons used dolls and constructed sets as her photographic models.

In the *Walking Objects Series*, Simmons created anthropomorphic beings with female legs and arms extending from the most unlikely objects, such as small cakes, a revolver, and a purse. These images suggest the whimsical 1950s dancing cigarettes and matchbooks in advertising campaigns. Each image has its own specific commentary: a woman as gun speaks to the fear that women are faced with everyday, a woman as a shiny delicious cake reduces her to an object for consumption and pleasure, and a woman as a purse suggests her role in the economy as a consumer of goods that make her beautiful and feminine.

However, in *Walking Camera (Jimmy the Camera)* (1987), Simmons offers a sentimental message as she pays tribute to her friend photographer Jimmy de Sana. She asked de Sana to pose as a camera just a few years before he died of AIDS. Her choice to use black and white is deliberate as she is saying thank you to de Sana for teaching her the craft. Here she used an antiquated camera as his head and body with his stocking-covered legs coming out of the bottom. Simmons is also commenting on a media-driven environment where personal identity is obsolete.

As a child, Simmons was fascinated with ventriloquism, which led to her series in the early 1990s. She contacted a local ventriloquist and started photographing him with his figure (commonly referred to as the dummy). One particular image was a close-up of the figure without the ventriloquist by his side. The doll's large staring eyes looking straight into the camera, and the perpetual smile, like that of a circus clown, created something eerie and almost lifelike for Simmons. In that moment she decided that photographing the doll

Laurie Simmons. *Walking Camera I (Jimmy the Camera)* (1987). Black and white photograph, 84 × 84 inches (213.4 × 121.9 cm), sheet. Solomon R. Guggenheim Museum, New York. Purchased with funds contributed by the International Director's Council and Executive Committee Members, with additional funds contributed by the Photography Committee, 2003. 2003.80.

without the human was much more powerful. In 1994, Simmons had a doll made in her likeness, which became the starring actor in her next series, *The Music of Regret* (1994). This series of four short films recalls Simmons's teenage years as a girl growing up in the suburbs of 1950s and 1960s America. Each short film tells the story of love, admiration, longing, and regret. The vignettes star the young girl (Simmons) waiting for the right guy to come along and validate her beauty and life's purpose. Regret plays a role as she recognizes the reality of the myth and unfulfilled dreams of her own.

For a recent series completed in 2004, she was inspired by a 1976 decorating book for do-it-yourself projects. Recalling the paper dolls she played with as a child, the book had

outline drawn spaces left bare for the participant to choose wall colors or paper, carpet type and color, and even the placement of furniture. Together with her young daughter, Simmons started to play with the book and fill in the empty spaces. Eventually, Simmons started adding her own materials to the room samples, which morphed into collages with varied fabrics, photographs, wallpaper fragments, and other sundry items to create quirky interiors. She commented on the scale and disproportions of the space:

> At first glance, everything seems right. And then there are all these insidious little reminders that nothing is real. I try to make everything as accurate as possible, given the inherent limits of what I do. But they're still off. ("The Antidecorator," no page numbers)

Once the space was developed, Simmons inserted photographs and funny sex cartoons that became characters in the developing story. Simmons says that she is still dealing with the same subject matter as before but in a new way. In her earlier work she was attempting to evoke a memory or a scene; now she says "it's harder to avoid narrative now. Dolls are by nature expressionless, but it's hard to find a photo or cartoon of a figure that doesn't have emotion. Just by putting them into the picture, I'm creating a story" ("The Antidecorator," no page numbers). Simmons uses the characters to play out naughty scenes that provoke questions about gender roles and stereotypes, such as the raunchy bachelor party or the scene where women stand around baking nothing but decadent cakes with thick, sugary icing.

Her work is part of museum collections all around the world. Additionally, Simmons' work has been exhibited in group and solo shows too many to count in venues such as the University of Miami; the Contemporary Art Museum in St. Louis; the Larissa Goldston Gallery of Modern Art in New York City; the Fotomuseum in Winterthur, Zurich; Metro Pictures in New York City; CEPA Gallery in Buffalo, New York; and the Orlando Museum of Art in Florida. Simmons has also curated exhibitions, such as *The Name of the Place* in 1997 at the Casey Kaplan Gallery, where she exhibited her work as well.

Today, she lives in New York City with her husband, Carroll Dunham, and their two daughters, Lena and Grace, and several family pets. Laurie Simmons wraps a serious feminist message in the guise of toys, dolls, and whimsical spaces.

Bibliography

"The Antidecorator." Home Design, Part 2 (special insert). *New York Times*, April 13, 2003.
Bright, Susan. *Art Photography Now.* New York: Aperture, 2005.
Frankel, David. "The Name of the Place: Casey Kaplan, New York." *Artforum International* 35 (May 1997): 104.
Friedan, Betty. *The Feminine Mystique.* New York: Laurel Publications, 1963.
Howard, Jan. *Laurie Simmons: The Music of Regret.* Baltimore: Baltimore Museum of Art, 1997.
Lahs-Gonzalez, Olivia, and Lucy Lippard. *Defining Eye: Women Photographers of the 20th Century.* St. Louis, MO: St. Louis Art Museum, 1997.

MacAdam, Barbara A. "Laurie Simmons: Sperone Westwater." *Artnews* 103, no. 6 (2004): 112.

Reilly, Maura. "New York: Laurie Simmons at Metro Pictures." *Art in America* 87, no. 2 (February 1999): 108.

Sheets, Hilarie M. "Laurie Simmons: Salon 94." *Artnews* 105, no. 3 (2006): 131.

Timberman, Marcy. "Dolls that Tell Secrets." *Artweek* 21 (November 29, 1990): 11–12.

Vine, Richard. "Metro Pictures, New York; exhibit." *Art in America* 82, no. 11 (December 1994): 95.

Weinstein, Jeff. "Kith and Ken." *Artforum International* 39, no. 5 (January 2001): 29.

Places to See Simmons's Work

Albright-Knox Art Gallery, Buffalo, New York

Allen Memorial Art Museum, Oberlin, Ohio

Baltimore Museum of Art, Baltimore, Maryland

Birmingham Museum of Art, Birmingham, Alabama

Corcoran Gallery of Art, Washington, DC

Dallas Museum of Art, Dallas, Texas

Harvard University Art Museums, Cambridge, Massachusetts

High Museum, Atlanta, Georgia

International Center of Photography, New York, New York

Israel Museum, New York, New York

Los Angeles County Museum of Art, Los Angeles, California

Metropolitan Museum of Art, New York, New York

Museum of Contemporary Art, Los Angeles, California

Museum of Fine Arts, Houston, Texas

Philadelphia Museum of Art, Philadelphia, Pennsylvania

Solomon R. Guggenheim Museum, New York, New York

St. Louis Art Museum, St. Louis, Missouri

Walker Art Center, Minneapolis, Minnesota

Weatherspoon Museum, Greensboro, North Carolina

Whitney Museum of American Art, New York, New York

LORNA SIMPSON

b. 1960

USING PHOTOGRAPHY AS PERSONAL REFLECTION AND A SOCIAL TOOL, Lorna Simpson combines image and coded text to explore issues of race, gender, and history. She examines the many ways that body language can communicate ideas as she cleverly acts to conceal information. By purposely creating ambiguous images, Simpson invites the viewer to complete the story, one that often involves a kind of longing. She questions the roles that we play, but she does not want to script our response, which she believes is up to the viewer. Focusing on African American women in much of her work, she exposes the mechanisms of racism as she analyzes the past and asks us to participate in decoding the present. In her later work she has moved from ideas related to the politics of identity with an aim at more carefully exploring the body's relationship to experience. Her work is both political and poetic. Her photographs transcend the limitations of human imposition. As critic bell hooks claims, Simpson's figures bear witness to knowledge as they remake history by inviting viewers to question what they see.

Born in Brooklyn, New York, Simpson's parents were politically active in the 1960s, which influenced her early life. Her father was a social worker, and her mother was a hospital secretary. She grew up in Hollis and Queens, took dance lessons, and saw plays on Broadway. She went to the High School of Art and Design and Manhattan's School of Visual Arts, where she learned about documentary photography. At first she did documentary work of people on the street, but this made her uncomfortable because she felt as if she were invading their privacy. She went to the University of California, San Diego, to do graduate studies with an emphasis on conceptual art. Here she was exposed to underground films and performance, giving her new ways to think about narrative in her photographs.

One of her best-known works is titled *Guarded Conditions* (1989). In 18 Polaroid images the same anonymous black woman in a white garment that may be a shift, a hospital gown, or something else, stands with her back to viewers. Although at first these photographs

look identical, closer scrutiny reveals differences in the model's body stance. These backside images function like blank screens onto which viewers can project disquieting understandings. Underneath the images Simpson has repeatedly written the words, "SEX ATTACKS SKIN ATTACKS." Much has been written about this work of art as it evokes ideas about slave auctions, hospital settings, and criminal line-ups, as well as acts of defiance.

Focusing on other body parts, *Necklines* (1989) depicts three close-up views of a woman's neck. Two text panels play with the word "neck" as they list words and phrases such as: "necktie," "neck & neck," "neck-ed," and "neckless." As it is with her other work, the particular (this specific neck) becomes more universal (a woman's neck), and more generalized histories can then be told.

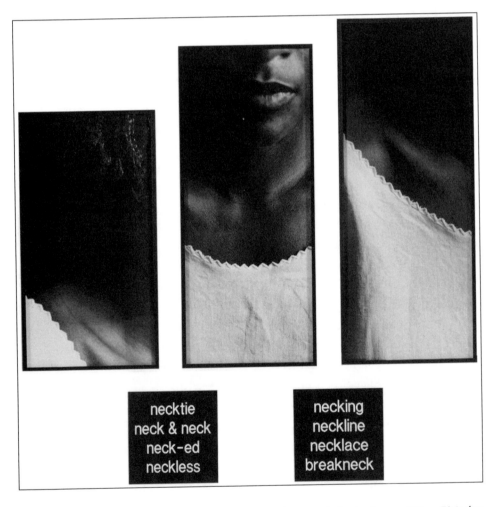

Lorna Simpson. *Necklines* (1989). Gelatin silver prints and engraved plastic plaques, 68½ × 70 inches (173.99 × 177.8 cm). San Francisco Museum of Modern Art. Accessions Committee Fund purchase. © Lorna Simpson.

Simpson's explorations are politically charged as they focus on uncomfortable issues. In *Wigs* (1995), for example, she exposes the high rate of cancer in the black community. Thirty-nine panels, 21 with photos and 18 with text, ask viewers how wigs are used. They cover up the effects of cancer, but they also signify difference, self-esteem, and self-deception as when a light-skinned slave would try to pass for white by covering her hair.

Inspired by the photographs of **James VanDerZee,** Simpson noticed how he repeatedly used the same props in his Harlem studio. Learning from VanDerZee, Simpson has become an expert in using objects in her staged scenes. Her series titled *9 Props* (1995) presents an empty room with a lone object like a cup, vase, or goblet. The text accompanying the prop draws attention to what is missing—figures that VanDerZee would have posed with them—the now all-too-absent black middle class.

In her series titled *Details* (1996), Simpson presents us with 21 photogravures that once again ask us to read body language. Each image is a fragment of a studio portrait that has been cropped so that we focus on hands, which are placed with or nearby various props. Text just below each image creates complexity and emotion with words such as "stopped speaking to each other," "carried a gun," or "soulful." These text-and-image juxtapositions call out to viewers to make some sense of the relationship. Like her other work these images are ambiguous and can be read in a variety of ways, just as they can be arranged in different sequences.

Simpson also explores issues related to sexuality and homophobia, female and male relationships, violence, battery, and AIDS. In the mid-1990s she begins to stage scenes without the human figure. Like a crime scene investigator, she photographed spaces that produce disquieting emotions. Occasionally, these images are mural size, pieced together from a grid of smaller prints. Under a *diptych* of vacant, somewhat seedy hotel beds, she writes. "It is late, decided to have a quick nightcap at the hotel having checked in earlier that morning. Hotel security is curious and knocks on the door to inquire as to what's going on, given our surrounding we suspect that maybe we have broken 'the too many dark people in the room code.' More privacy is attained depending on what floor you are on, if you are in the penthouse suite you could be pretty much assured of your privacy, if you were on the 6th or 10th floor there would be a knock on the door." This text, coupled with the images, makes social and personal space visible, as viewers negotiate and explore issues of race and economic position.

Simpson's move away from a focus on the figure in later work does not signal a move from an interest in the body. Instead, viewers are primed for placing the body in the photographic spaces when none is there. In many photographs, ghosts seem to linger. In *Cloud* (2005), for example, smoke hovering in an otherwise empty room projects an idea of a remaining presence.

Lorna Simpson's work is complex, allowing for multiple interpretations. In the mid-1990s she began to print her images on felt, which absorbs light instead of glossy photographic

Lorna Simpson. *Cloud.* (2005).
© Lorna Simpson. Courtesy
of Worcester Art Museum,
Worcester, Massachusetts.

paper that reflects it. Her artwork continues to invite analysis and command narrative. Simpson increasingly seems to be calling on us to define "self" through encounters with the world, as opposed to exploring a definition bound by skin. She also makes visible how slippery our grasp of the world really is.

More recently Simpson has been working with film and video. Her work *Easy to Remember* (2001), shown at the Whitney Biennial, and *Thirty-One* (2001), a work commissioned for Documenta XI, a major art exhibition in Kassel, Germany, are notable.

Simpson was the first black woman to be selected for the Venice Biennale, and she now is widely collected by museums around the world. In 2006, she had a major traveling exhibition organized by the American Federation of the Arts. She continues to live and work in Brooklyn, the city where she was born, with her husband, photographer **James Casebere,** and her daughter Zora.

Bibliography

Annenberg Media, Learner.org. "A World of Art, Biographical Sketch: Lorna Simpson." Retrieved December 22, 2006, from http://www.learner.org/catalog/extras/wabios/simpson.html.

Copeland, Huey. "'Bye, Bye Black Girl': Lorna Simpson's Figurative Retreat." *Art Journal* 64, no. 2 (2005): 62–77.

Enwezor, Okwui. Curator's Foreword by Helaine Posner, Essay by Hilton Als, Conversation with the Artist: Issa Julien and Thelma Golden. Preface by Shamim M. Momin. *Lorna Simpson.* New York: Abrams, 2006.

Heartney, Eleanor. "Figuring Absence." *Art in America* 12 (1995): 87–88.

hooks, bell. *Art on My Mind: Visual Politics.* New York: The New Press, 1995.

Lahs-Gonzales, Olivia, and Lucy Lippard, with an Introduction by Martha A. Sandweiss. *Defining Eye: Women Photographers of the 20th Century: Selections from the Helen Kornblum Collection.* St. Louis, MO: St. Louis Museum of Art, 1997.

Lippard, Lucy, R. *Mixed Blessings: New Art in a Multicultural America,* New York: Pantheon, 1990.

Pollock, Barbara. "Turning Down the Stereotypes." *Artnews* 101, no. 8 (2002): 136–139.

Robinson, Jontyle Theresa. "Passages: A Curatorial Viewpoint." In *Bearing Witness: Contemporary Works by African American Women Artists.* New York: Rizzoli and Spellman College, 15–37.

Places to See Simpson's Work

Albright Knox Art Gallery, Buffalo, New York
Art Institute of Chicago, Chicago, Illinois
Baltimore Museum of Art, Baltimore, Maryland
Bronx Museum of the Arts, New York
Brooklyn Museum of Art, Brooklyn, New York
Chase Manhattan Bank, New York, New York
Cleveland Museum of Art, Cleveland, Ohio
Contemporary Arts Center, Honolulu, Hawaii
Corcoran Gallery of Art, Washington, DC
Davis Museum and Cultural Center, Wellesley College, Wellesley, Massachusetts
Denver Art Museum, Denver, Colorado
Des Moines Art Museum, Des Moines, Iowa
Detroit Institute of Arts, Detriot, Michigan
Fogg Art Museum, Harvard University, Cambridge, Massachusetts
High Museum of Art, Atlanta, Georgia
Kalamazoo Institute of Arts, Kalamazoo, Missouri
Krannert Art Museum, University of Illinois at Champaign, Champaign, Illinois
Metropolitan Museum of Art, New York, New York
Miami Art Museum, Miami, Florida
Milwaukee Art Museum, Milwaukee, Wisconsin
Museum of Contemporary Art, Chicago, Illinois
Museum of Contemporary Art, San Diego, California
Museum of Modern Art, New York, New York
New School for Social Research, New York, New York
New York Public Library, New York, New York
St. Louis Art Museum, St. Louis, Missouri
San Francisco Museum of Modern Art, San Francisco, California
University of New Mexico, Albuquerque, New Mexico
Wadsworth Athenaeum, Hartford, Connecticut
Whitney Museum of Art, New York, New York
Yale Art Gallery, New Haven, Connecticut

AARON SISKIND

1903–1991

HERALDED AS ONE OF THE MOST SIGNIFICANT CONTRIBUTORS TO TWENTIETH-century photography, Aaron Siskind made a name for himself as a documentary photographer during the Depression and then became known for his photographic exploration of the abstract.

He was born to Russian Jewish immigrants on December 4, 1903, in New York City, as the fifth of six children, Siskind attended public schools in New York City and graduated from De Witt Clinton High School. He studied poetry and literature at City College and graduated with his Bachelor of Social Science degree in English Literature in 1926. With aspirations of becoming a writer, Siskind found employment as an English teacher for the New York public school system right after graduation. In 1929, he married Sidonie Glaller. His interest in photography was sparked when he received a camera as a wedding gift from a close friend. Siskind immediately began taking pictures during their honeymoon in Bermuda. Although their union inadvertently introduced Siskind to photography, it did not last, and the marriage was annulled in 1945.

By 1932, Siskind was committed to photography and joined the New York Photo League, a group of *socio-photographers* working to record the social conditions of the underprivileged citizen. He was impressed with the documentary fieldwork projects that the group had completed. At this time Siskind was ready to upgrade his camera, and he purchased a Voigtlander Avus that he used for the fieldwork that he was about to embark on. He became a strong proponent of the organization and leader. With several artists from the Photo League School, he established the Feature Group, dedicated to documentary projects. Over the next several years, Siskind was involved in group and independent documentary projects, such as *The Catholic Worker Movement; Dead End: The Bowery; The End of City Repertory Theatre; The Harlem Document; Lost Generation: Plight of Youth Today; The Most Crowded Block in the World; Park Avenue: North and South; Sixteenth Street: A Cross-section of New York;* and *Tabernacle City.*

The photographs from New York City's Harlem, which resulted in the project the *Harlem Document*, are often cited as his most well-recognized images. Critics have suggested that as a Jewish American man, Siskind's empathy for the African American community was important in the success of these images. Siskind portrayed the people in a genuine and spontaneous way. He showed the interiors of clubs alive with dance and celebration, crowds walking down the street, and images of people living in substandard living conditions and surviving despite extreme discrimination.

An untitled photograph from around 1940 is an example from the series *The Most Crowded Block in the World*. Siskind takes us inside a comfortable family space shielded from the chaos of the outside world that the title of the series suggests. Here a motherly woman carries a young child through the house that is sparse but warmly decorated. There is a filled bookcase against one wall, a small painting on another, and crocheted doilies lined up along the top couch pillows where two small dolls lie—signs of domesticity and harmony. Despite living on the most crowded block in the world, they have made a home.

In the early 1940s Siskind made a sharp departure in his work from social commentary and documentation to abstract images that focused on line, shape, and form. He started mingling with the prevailing Abstract Expressionist painters of the day, such as painters Franz Kline, Barnett Newman, and Adolf Gottlieb. He remained close friends with Kline for the remainder of Kline's life and even paid homage to his friend posthumously in a series of photographs. Siskind commented about his shift from social documentary work to *Abstract Expressionism*, "For the first time in my life, subject matter, as such, had ceased to be of primary importance....instead, I found myself interested in the relationship of these objects, so much so that these pictures turned out to be deeply moving and personal experiences" (Scheinbaum and Russek, Ltd., par. 5). He bought a large-format view camera that allowed Siskind to take his pictures extremely close-up with clarity in precision, focusing on the minutest of detail and obscuring the true nature of the object. For instance, he photographed close-ups of house siding with peeling or dripping paint, leaves, rocks, lines in the road, and even trash. In the spirit of *Dada* and Marcel Duchamp, Siskind also worked with found materials for abstract subject matter.

Siskind met and socialized with other leading photographers experimenting with Abstract Expression, such as the renowned **Edward Weston.** Siskind met Weston in Carmel during a trip to California in 1947. He was also well acquainted with photographer Max Yavno and traveled to California on various occasions to visit his colleague and friend.

Aaron Siskind was a respected educator. He started his career as an adjunct instructor at Trenton Junior College in New Jersey and later the California School of Fine Arts. In 1951, he taught a summer session at Black Mountain College in Asheville, North Carolina, where he met **Harry Callahan.** That same year Callahan invited Siskind to teach with him at the Institute of Design at the Illinois Institute of Technology in Chicago. In 1951, he went to work there as a member of the photography faculty department. In 1952, Siskind married his second wife Cathy Spencer, but the relationship ended in divorce just five years later.

Although he was struggling with personal relationships, Siskind excelled as an educator, and in 1959, he was named the Director of the Photographic Department.

He traveled around the world for artistic inspiration throughout his life to places such as Greece, Italy, France, Peru, and Spain. In 1955, Siskind took the first of many trips to Mexico. Siskind was enthralled with photographing architecture throughout most of the 1950s. Inspired by the diverse buildings and structures that he encountered during his many travels, he produced a large body of work focusing on architecture during this period.

Over the next decade Siskind oversaw graduate projects and continued to make his own work. He married for the third time in 1960 to Caroline Brandt. In 1971, they moved to Providence when he accepted a position to teach at the Rhode Island School of Design. Siskind was reunited with Harry Callahan who had left the Institute in Chicago years before and had been teaching at the Rhode Island School of Design since 1960.

In the early 1970s Siskind returned to photographing the figure after focusing on the abstract object since the early 1940s. In his series *Terrors and Pleasures of Levitation*, Siskind photographed divers mid-air in black-and-white format against a plain sky. He used a hand-held twin-lens reflex camera to shoot the divers at Lake Michigan in Chicago. Each diver is twisted and contorted as if in fear, just as the title suggests; but another glance reveals that the elegant bodies are seemingly floating through the air in a pleasant and easy going way. In *Terrors and Pleasures of Levitation, No. 99* (1972), the diver appears to be frozen in mid-air, taking the time to look around at his surroundings and enjoy the view.

Aaron Siskind. *Terrors and Pleasures of Levitation, #471* (1954). © Aaron Siskind Foundation/Courtesy George Eastman House, Rochester, NY.

Siskind retired from Rhode Island School of Design in 1976 after his wife Caroline died. Later that year he received a National Endowment for the Arts, which funded travel and his next series of work. His accomplishments are indeed impressive spanning more than 60 years. September 30, 1983, was declared Aaron Siskind Day in Providence, Rhode Island. In addition to his art work and teaching, Siskind was a writer and editor. He published several monographs and was the co-editor of *Choice* magazine. The Aaron Siskind Foundation was formed by Siskind himself to serve as a photography resource and to support contemporary photographers after his death. He died on February 8, 1991, at the age of 87. Once an English teacher, Aaron Siskind unexpectedly came into possession of a camera that would change his life forever. He used the camera as a tool for social change and then for artistic expression.

Bibliography

Falkenstein, Michelle. "Portraits of Aaron Siskind [Exhibitions and book celebrate 100th anniversary of his birth]." *Artnews* 102, no. 9 (2003): 46.

Farnell, Cynthia C. "Newport Art Museum/Newport, Rhode Island: Aaron Siskind and His Rhode Island Circle [Exhibit]." *Art New England* 25, no. 3 (April/May 2004): 30.

Kuspit, Donald. "Aaron Siskind: Robert Mann Gallery/Andrea Rosen Gallery/Whitney Museum of American Art/Studio Museum in Harlem [exhibit]." *Artforum International* 42, no. 5 (January 2004): 154.

"Obituary." *Aperture* 123 (Spring 1991): 91.

Scheinbaum and Russek, Ltd. *Aaron Siskind Biography.* Retrieved February 9, 2007, from http://www.photographydealers.com/siteindex.html.

Shulman, Ken. "Aaron Siskind and Carl Chiarenza: Robert Klein [exhibit]." *Artnews* 103, no. 2 (2004): 118, 120.

Siskind, Aaron. *Aaron Siskind: Road Trip, Photographs, 1980–1988.* San Francisco: Friends of Photography, 1989.

———. *Aaron Siskind Photographer.* Rochester, NY: George Eastman House, 1965. Distributed by Horizon Press, New York.

———. *Places: Aaron Siskind Photographs.* New York: Light Gallery and Farrar, Straus, and Giroux, 1976.

Woodward, Richard B. "Aaron Siskind: Robert Mann; The Studio Museum in Harlem; Andrea Rosen; The Whitney Museum [exhibit]." *Artnews* 102, no. 11 (2003): 116.

Places to See Siskind's Work

Aaron Siskind Foundation: www.aaronsiskind.org
Addison Gallery of American Art, Andover, Massachusetts
Akron Art Museum, Akron, Ohio
Carlos Museum, Emory University, Atlanta, Georgia
Cleveland Museum of Art, Cleveland, Ohio
Currier Gallery of Art, Manchester, New Hampshire
Dallas Museum of Art, Dallas, Texas
Denver Art Museum, Denver, Colorado
DePaul University Museum, Chicago, Illinois

Fred Jones Jr. Museum of Art, University of Oklahoma, Norman, Oklahoma

George Eastman House of Photography, Rochester, New York: Harlem Documentary; Pleasures and Terrors Portfolio

Harvard University, Cambridge, Massachusetts

J. Paul Getty Museum, Los Angeles, Calfornia

James A. Michener Art Museum, Doylestown, Pennsylvania

John & Mable Ringling Museum of Art, Sarasota, Florida

Kemper Museum of Contemporary Art, Kansas City, Missouri

Los Angeles County Museum of Art, Los Angeles, California

Massillon Museum, Massillon, Ohio

Michael C. Carlos Museum, Atlanta, Georgia

Montana Historical Society, Helena, Montana

Museum of Contemporary Art, Los Angeles, California

Museum of Fine Arts, St. Petersburg, Florida

Museum of Fine Arts, Santa Fe, New Mexico

National Gallery of Art, Washington, DC

Nelson-Atkins Museum of Art, Kansas City, Missouri

Neuberger Museum of Art, Purchase, New York

Orlando Museum of Art, Orlando, Florida

Pomona College Museum of Art, Pomona, California

San Francisco Museum of Art, San Francisco, California

Smart Museum of Art, University of Chicago, Chicago, Illinois

Smithsonian American Art Museum, Washington, DC

Spencer Museum of Art, University of Kansas, Kansas, Missouri

University of Michigan Museum of Art, Ann Arbor, Michigan

SANDY SKOGLUND

b. 1946

SCULPTOR, DESIGNER, AND PHOTOGRAPHER SANDY SKOGLUND SUCCESSFULLY merges her diverse skills to create what she calls "film in a frame," photographs of magical and curious environments that leave the viewer delighted and baffled at the same time.

She was born on September 11, 1946, in Quincy, Massachusetts, the oldest of four children. Skoglund had an early affinity for art and started to draw regularly at the age of five or six. After living in North Weymouth for about six years, the family moved to Cape Elizabeth, Maine, and then to Windsor, Connecticut, for two to three years and finally to Anaheim, California. Skoglund commented that moving to different regions as a child helped shape her perspective and appreciation for diversity. After high school she went to Smith College in Northampton, Massachusetts, on scholarship. There she studied with Eliot Offner who was supportive of Skoglund's creative development and aspirations of becoming an artist. In 1967, she had the opportunity to study at the Sorbonne University and Ecole Du Louvre in Paris, France. She graduated from Smith with her BA in 1968. Without money or a job, she moved home after college.

Once back with her parents, she got a job teaching art at a local junior high school. Skoglund was not thrilled to be living back at home and worked hard to save her money so that she could return to school and making art. Eventually, she had the finances to go to school, and she enrolled in the graduate art program at the University of Iowa. There she majored in painting and worked with instructors Byron Burford and Forrest Bailey. In addition to her painting courses, she studied filmmaking, intaglio printing, and multimedia sculpture. She felt that her years there were productive and that the open and creative environment was conducive to learning and achieving success. Skoglund completed her MA in 1971 and MFA in painting in 1972.

After graduation she packed up her things and moved to New York City. At first life in the big city was a struggle, and she was living the life of the proverbial starving artist.

Skoglund worked as a go-go dancer in New Jersey, at a music store, and as an occasional studio assistant stretching and prepping canvases for artists. This life was difficult and left little to no time for Skoglund to make her own art. In 1973, she applied for a teaching job and was hired at the Hartford Art School in West Hartford, Connecticut, where she taught for three years. While at Hartford, Skoglund made a series of dot drawings, foreshadowing the repetitive nature of objects in her installation works.

In 1976, she was hired by Rutgers University where she still works today, teaching photography, figure drawing, and painting. Her shift from Hartford to Rutgers was pivotal in her career as an art educator. She explained that she went "from the conceptual to the more political and representational, more social. I really wanted to get out of the isolation of the studio" (Tarlow 26). She takes her role as an art educator seriously. Skoglund embraces the opportunity to make connections between art, multiculturalism, and society in the classroom that is not always possible through art objects alone.

In the summer of 1978, Skoglund lived in a trailer on a farm in upstate New York. She was there with her husband while he was on assignment at a small television station. Her experience in upstate New York was vastly different from living in Manhattan. She loved the wide open space of the country, and she found the people to be refreshingly friendly. Skoglund began to take pictures for the sheer joy of creating something visually pleasing. Influenced by the flat images and contrived domestic scenes of television advertising that she grew up with in the 1950s, she photographed herself in various positions throughout the trailer. She was fascinated with the trailer's décor of faux surfaces that emulated expensive materials. For instance, the cheap Formica was colored and swirled to resemble marble; and the dark paneled walls, to give the impression of wood. This summer was a pivotal point in Skoglund's development as a photographer and toward what would become her mature work.

In 1978, she produced her first major body of photographic work. She photographed a series of food sculptures that she created, showing how the food we eat *aesthetically* reflects the environment we live in. She arranged the food in patterns and shapes reflecting the colors and rhythm of the design in the plates or counters that they were placed on. For instance, in *Luncheon Meat on a Counter*, the swirls and circles of the pimento loaf sandwich meat mimic that of the marble counter, disguising its true identity at first glance. In another work she has meticulously organized peas and small bits of carrots into a checkered pattern on a plate of contrasting colors and design.

From there Skoglund leapt from creating table top-size sculptures to room-size installations for subject matter to photograph. The rooms are small sets that recall a Disney movie, except here the scene is injected with a twisted reality, partial animation and fantasy mixed in with human figures. Using color to create tension and curiosity, Skoglund portrays various animals in bold bright colors invading the human constructed environment yet the humans never seem to be aware of the intrusion. For instance, in *Revenge of the Goldfish* (1981), neon

Sandy Skoglund. *The Wedding* (1994). Dye destruction print. 37½ × 47⅜ inches (95.25 × 120.33 cm). San Francisco Museum of Modern Art. Anonymous gift. Copyright © 1994 Sandy Skoglund.

orange fish swim through a solid bright blue room; literally everything has been painted blue from the sheets, furniture, walls, and ceiling to the clothes that the figures are wearing. The fish are huge and much scarier than the benign goldfish that live inside small glass bowls atop children's dressers and desks. They are swimming through the air, along the ground, under the bed, in the dresser, and in the sheets while a young boy sits calmly on the edge of the bed, and his mother is asleep completely oblivious to their presence.

She remarked about her use of animals, "I'm interested in using animals to express a variety of human emotions, and I'm interested in movement. The way fish move: sinuous, swishy, sensual, movey. I wanted to activate the whole space using that brushstroke, if you will" (Rosen 84). In *Fox Games* (1989), solid red foxes run rampant through an all-gray restaurant, while unsuspecting patrons enjoy their meal and a waiter pours wine. The red foxes have completely overtaken the space, standing on table tops, playing in the aisles, and leaping over chairs. One gray fox blends into the background as it slithers across the floor with dead prey in its mouth.

In *Atomic Love (No. 36)* (1992), Skoglund is commenting on the alienation and lack of connectedness between people in a media-centered society. The domestic set is complete with kitchen table, teapot, child's high chair, and toy bunny on the floor. The entire space is painted yellow and covered in raisins, like dots, recalling her early drawings. There is a man and woman, perhaps a married couple, who are dressed in the yellow raisin motif, but their faces and limbs are exposed. Yet all of the other family members, including baby, are completely masked in yellow with raisin dots, reduced to mannequins that have completely blended into their surroundings. The family has become disconnected in a fast-paced, individualistic society that is driven by technology and the mass media. The couple are human and present to each other but seem to be in some distress and most disturbingly oblivious to the faceless people in the room.

Skoglund has received critical acclaim for her work. Her prints and installations have been widely exhibited in venues such as the Whitney Museum of American Art in New York City; the American Center in Napa, California; Savannah College of Art and Design; Janet Borden Gallery in New York City; Memorial Art Gallery in Rochester, New York; Johnson Museum of Art at Cornell University in Ithaca, New York; Dayton Art Institute in Dayton, Ohio; Center for Visual Art in Denver, Colorado; and the New Jersey Center for the Visual Arts in Summit, New Jersey. She was awarded with a National Endowment for the Arts grant, New York State Foundation for the Arts grant, Award for Excellence from the Trustees at Rutger's University, and a College Medal from Smith. In 1992, she was named a Distinguished Chair at the School for Visual Arts at Hartford Art School.

She lives in Jersey City, New Jersey. Although she is best known for photographing her fantastical environments constructed with food, bold color, animals, and clueless human characters, Sandy Skoglund is an art educator dedicated to bringing social awareness, such as multiculturalism and an appreciation for diversity, to students through art.

Bibliography

Hoy, Anne H. *Fabrications: Staged, Altered and Appropriated Photographs*. New York: Abbeville Press, 1987.

Muehlig, Linda. *Sandy Skoglund*. New York: Harry N. Abrams, 1998.

Richardson, Nan. "Sandy Skoglund: Wild at Heart." *Artnews* 90, no. 4 (1991): 114–119.

Rosen, Randy, and Catherine C. Brawer. *Making Their Mark: Women Artists Move into the Mainstream, 1970–1985*. New York: Abbeville Press, 1989.

Tarlow, Lois. "Sandy Skoglund." *Art New England* 19, no. 6 (October/November 1998): 25–27.

Wolf, Sylvia. *Focus: Five Women Photographers*. Morton Grove, IL: A. Whitman, 1994.

Places to See Skoglund's Work

Addison Gallery of American Art, Andover, Massachusetts
Akron Art Museum, Akron, Ohio
Baltimore Museum of Art, Baltimore, Maryland

Boise Gallery of Art, Boise, Idaho
Brooklyn Museum, Brooklyn, New York
Center for Creative Photography, University of Arizona, Tucson, Arizona
Centre Georges Pompidou, Paris, France
Chase Manhattan Bank, New York, New York
The Art Institute of Chicago, Illinois
Cincinnati Museum of Art, Cincinnati, Ohio
Columbia Museum of Art, Columbia, South Carolina
Columbus Museum of Art, Columbus, Ohio
Corcoran Gallery of Art, Washington, DC
Cornell Museum, Rollins College, Winter Park, Florida
Dallas Museum of Art, Dallas, Texas
Dayton Art Institute, Dayton, Ohio
Denver Museum of Art, Denver, Colorado
Fred Jones Jr. Museum of Art, University of Oklahoma, Norman, Oklahoma
George Eastman House of Photography, Rochester, New York
Groninger Museum, Groningen, The Netherlands
Hallmark Photographic Collection, Kansas City, Missouri
High Museum of Fine Arts, Atlanta, Georgia
J. Paul Getty Museum, Los Angeles, California
Joslyn Art Museum, Omaha, Nebraska
Los Angeles County Museum of Art, Los Angeles, California
Lowe Museum of Art, University of Miami, Coral Gables, Florida
Mead Art Museum, Amherst College, Amherst, Massachusetts
Metropolitan Museum of Art, New York, New York
Museum of Contemporary Art, Montreal, Canada
Museum of Fine Arts, Houston, Texas
Nelson-Atkins Museum of Art, Kansas City, Missouri
New Orleans Museum of Art, New Orleans, Louisiana
Princeton University Museum of Art, Princeton, New Jersey
Sandy Skoglund Art Site: www.sandyskoglund.com
Smith College Museum of Art, Northampton, Massachusetts
Sonje Museum of Contemporary Art, Seoul, Korea
St. Louis Art Museum, St. Louis, Missouri
Tampa Museum of Art, Tampa, Florida
University of Kentucky, Lexington, Kentucky
University of Massachusetts Museum of Art, Amherst, Massachusetts
University of Texas, Austin, Texas
Wadsworth Atheneum, Hartford, Connecticut
Wake Forest University Fine Arts Gallery, Winston-Salem, North Carolina
Walker Art Center, Minneapolis, Minnesota
Whitney Museum of American Art, New York, New York

MIKE AND DOUG STARN

b. 1961

IDENTICAL TWINS DOUG AND MIKE STARN WORK AS A TEAM. TOGETHER THEY visibly manipulate their photographs to undermine the realism of the photographic medium. It is the precision and cleanness of the photograph they aim to undo. They strive to make their images look handmade as they tear, crumple, and otherwise distort and violate the exactness of the photograph. In this way they consistently reject the idea that a moment in time can be captured or that time should be thought of as precise and consistently linear. While they are often categorized as photographers, they also create sculpture, painting, video, and installation work.

The Starns were born in Abscon, New Jersey. Always close, their photographic collaborations started at the age of 13, when they participated in a junior high science fair project that dealt with photographic processes. They graduated from the School of the Museum of Fine Arts in Boston in 1985 and quickly received critical acclaim with their first exhibition of sepia-toned manipulated and mutilated photographs. In their work *Large Horses #4* (1985–1988), a toned silver print with tape that depicts two close-ups of horses' heads, the handmade quality of the work is evident. Viewers can easily note the artists' personal touch by the handmade quality of the artwork. This up-front aspect of their images places their photographs in the realm of painting, as the surface of the work is cared for and considered.

The two photographers first attracted critical attention in 1985 when they manipulated photographs by tearing, taping, and stressing them and allowing the mechanical photographical processes to be visible. In 1987, their work was displayed at the Whitney Museum in its Biennial exhibition. The selected images challenged ideas of "pure art" as they gave movement and energy to the usual static photograph.

Because the Starns work so closely together, early in their career, their artistic way of producing art called into question the notion of the modernist artist who creates an individual expression. Mike and Doug Starn's artwork is so seamless that it is difficult to identify how

Doug and Mike Starn. *Stretched Christ* (1985–1986). Toned silver print, tape, wood, plexiglass, 28 × 142 × 45 inches. Edition: unique. © 2007 Doug and Mike Starn/Artists Rights Society (ARS), New York.

they differ in their vision or ideas, if indeed they do. In 1989, Mike Starn explained, "We're not really two separate people coming together. We find it very easy to picture what the other is talking about. Sometimes I think of something and Doug has already thought of it also" (Heartney 144). Doug chimes in that he can't imagine working alone.

In their body of work titled *Spectroheliographs* (1990–1994), shown at the Leo Castelli gallery in 1994, viewers found glowing gold-brown light boxes arranged in a grid. Inside each box was a manipulated photographic image of a *Young Woman* (ca. 1468). She represents the life-cycle and centuries of social change; an aura envelops her and represents her as the sun. Surrounding her are photographs from Skylab that reflect on the desire for science to participate and answer age-old questions about the cosmos. In this work these often opposing ways of approaching the world co-exist with each other.

Artistic works created by the Starn twins raise many questions. Because they combine cellophane tape with their photographs, in the 1980s critics asked if the work could still be considered photography. Additionally, the artists call into question the *Cartesian* way of thinking, which sets up dualisms. In response the Starns make metaphor and material fluid. They poetically create in a space that fuses presence and absence and darkness and enlightenment.

The instability and uncertainty of time is portrayed in the Starns' mixed media piece *Behind My Eye* (1998). Using a book-like format covered in tape, it supports the notion that time is fluid. Basing their work on Einstein's idea that there is no universal time that rules the universe, and that time is not neutral, the Starns question whether our vision could see the way the camera does.

Continuing their exploration of questioning the prevailing way of seeing, for more than 10 years, the Starns took photographs of nocturnal moths. Interested in the way they approach porch lights at night, they continue their inquiry into time and representation. They used a medium format camera with an enhanced macro lens to magnify the images. Edward

Lefingwell explains how the photographers created and displayed the works at the Neuberger Museum at the State University of New York in Purchase in 2004:

> In some cases, the resulting images have been exposed onto mulberry paper treated with silver emulsion, then developed. The prints are tea-stained and sulfurtoned. As bits of printed image flake and wear away, the works begin to resemble the powdery surface of moth wings. Pinned in the manner of entomological displays inside simple wood display boxes, the photos have the look and feel of things historic—characteristic of the Starn's production. (Lefingwell 50)

To somewhat reference the objects as scientific specimens, which they are not, they were haphazardly placed on long study tables under fluorescent tube lights, where participants could put on white gloves to study them. This exhibition, titled *Behind Your Eye*, also included handmade books, video projections, and other photographic images. A 10 foot high by 30 foot wide digital print of a moth in flight was also displayed. Because its surface is so glossy, it reflects anything or anyone who comes near it, changing the image as the environment changes.

A monograph, which shows all the series of nocturnal moth studies, accompanies this traveling exhibition. As an introductory statement, the Starns wrote:

> Light is power, knowledge, it is what we want, it is what we need, it is satisfaction, fulfillment, truth, and purity. It is history, the future, and spirituality. Light is what we fear and hate. Light is what controls every decision and action we take. Light is thought. Light has gravity, light is what attracts us. Light implies, necessitates, darkness—the shadows created by anything physical. But black is not only the lack of light, black is also the complete absorption of light. A black hole is nothing and everything. Black is the void and reservoir of what we want and need, what controls us. We are what controls us, because what controls us defines us. The light is us.

In this provocative statement, and in the stunning images of moths going toward the light, the Starns meld oppositions thereby collapsing Cartesian ways of thinking.

Their series titled *Black Pulse* (2004) are images of decaying leaves, which are scanned and digitally stripped to reveal the structure of their veins. Again, the Starns printed these photographs in an oversized format, and in keeping with a long-time practice, they pin them directly onto the museum walls.

Doug and Mike Starn live and work in New York City. They have won the Medal Award from the School of the Museum of Fine Arts in Boston, a Massachusetts Council on the Arts Fellowship, a grant from the National Endowment for the Arts, and the International Center for Photography's Infinity Award for Fine Art Photography. The Starn twins have had exhibitions all over the world.

Bibliography

Barrett, Terry. *Criticizing Photographs: An Introduction to Understanding Images*, 3rd ed. Mountain View, CA: Mayfield Publishing, 2000.

"Doug and Mike Starn: Career Narrative." Retrieved in February 2007 from http://www.starn studio.com.

Heartney, Eleanor. "Combined Operations." *Art in America* 6 (1989): 140–147.

Hirsch, Robert. *Exploring Color Photography: From the Darkroom to the Digital Studio*, 4th ed. New York: McGraw Hill, 2005.

Lefingwell, Edward. "Fields of Light." *Art in America* 11 (2004): 50–51, 53.

Starn, Mike, and Doug Starn. *Mike & Doug Starn Attracted to Light*. New York: Powerhouse Books, 2003.

Vine, Richard. "Doug and Mike Starn at Leo Castelli." *Art in America* 9 (1994): 133–114.

Places to See the Starn Twins' Work

Akron Art Museum, Akron, Ohio
Baltimore Museum of Art, Baltimore, Maryland
Brooklyn Museum of Art, Brooklyn, New York
The Art Institute of Chicago, Illinois
Chrysler Museum of Art, Norfolk, Virginia
Corcoran Gallery of Art, Washington, DC
Everson Museum of Art, Syracuse, New York
Guggenheim Museum, New York, New York
Hammer Museum, University of California Los Angeles, Los Angeles, California
High Museum of Art, Atlanta, Georgia
Jewish Museum, New York, New York
Los Angeles County Museum of Art, Los Angeles, California
Metropolitan Museum of Art, New York, New York
Minneapolis Institute of Art, Minneapolis, Minnesota
Museum of Contemporary Art, Los Angeles, California
Museum of Contemporary Photography, Columbia College, Chicago, Illinois
Museum of Fine Arts, Boston, Massachusetts
Museum of Fine Arts, Houston, Texas
Museum of Modern Art, New York, New York
New York Historical Society, New York, New York
Philadelphia Museum of Art, Philadelphia, Pennsylvania
Portland Museum of Art, Portland, Oregon
Ringling Museum, Sarasota, Florida
Rose Art Museum, Brandeis University, Waltham, Massachusetts
Santa Barbara Museum of Art, Santa Barbara, California
San Diego Museum of Contemporary Art, San Diego, California
San Francisco Museum of Modern Art, San Francisco, California
Wadsworth Athenaeum, Hartford, Connecticut
Whitney Museum of American Art, New York, New York

EDWARD STEICHEN

1879–1973

EDWARD STEICHEN IS HERALDED AS ONE OF THE MOST IMPORTANT PHOTOGRAPHERS of the twentieth century and perhaps one of the most criticized for abandoning fine art for financial security in the commercial sector. He was born in Bivange, Luxembourg, in 1879 to Marie Kemp and Jean-Pierre Steichen. His parents were peasant workers and wanted to give their children financial opportunities, which prompted their immigration to the United States when the young Edward was just three years old. He became a naturalized citizen in 1900. The family settled in Hancock, Michigan, where his father worked in the copper mines until his health became too fragile. At that time his mother opened a millinery shop, where she made and repaired hats. Steichen had great respect and love for his mother, whom he said always found time to converse with her children despite a grueling work load and endless domestic chores.

Steichen became curious about photography in 1895 when he was 16 years old. He started hanging out a local camera shop where the owner took an interest in him. After several visits the store owner taught Steichen the mechanics of all the cameras. His mother gave him the money to buy a secondhand Kodak box camera. He took pictures of the family cat, his mother's millinery shop, and around the family home. Out of 50 exposures, Steichen was disappointed to learn that only one image was clear enough for printing, which was an image of his sister playing the piano.

Initially trained as a painter, Steichen was hired into a four-year apprenticeship program at the American Fine Art Company in Milwaukee. The primary advertising contracts for the company were for flour mills, pork packing companies, and brewers. Steichen observed that the illustrations were not realistic and suggested that photographs be used in lieu of drawings. His boss gave him the time to go out into the field and shoot some images but told him that he had to use his own equipment. Steichen went back to the camera store where he got his first camera and purchased a Primo Folding View Camera for the assignment. This

camera used plates allowing him to shoot and process one image at a time, which was much faster and cheaper than an entire roll of film. He set up a darkroom in the house and processed his first images guided only by the written instructions included with the purchase of the camera. He took many photographs of hop vines, ears of wheat, fields, and pigs. He impressed the pork packing company, who requested that all future placards, posters, and advertising material be rendered in the likeness of the pigs in his photographs. Even though Steichen's photographs were not yet accepted as the finished product themselves, they were useful in the process, and he took note of the purely functional role that photography could play.

Steichen found few opportunities to learn about photography while living in Milwaukee. He found a few photographic magazines at the library, but the reproductions were boring to him. However, he was interested in many of the books on art, which he read and studied diligently by learning the painting techniques himself. He spent a great amount of time painting landscapes, particularly scenes by moonlight.

Around 1896 Steichen organized a small group of friends who all had interest in learning how to paint. They rented a room and hired a model for life drawing classes and were tutored by the German painter Richard Lorence, who volunteered his services. After one year the group's size had increased, as well as their reputation, and the Ethical Culture Society donated their basement to the group. They established themselves as the Milwaukee Art Student's League. Steichen was elected the first president. He learned much about painting during his time there but little about photography, which was still largely considered by painters to be a technical recording process rather than an artistic one. Steichen determined that a photograph must somehow become more like a painting to be accepted as art. He began taking pictures in the woods during nature hikes and worked to make an image fuzzy and played with light qualities to evoke an emotional response. He created these special effects by gently shaking the camera during exposure or wetting the lens. At first he cropped the prints to create the desired composition, and eventually he shifted to framing out the composition before he took the photograph. Steichen remarked years later that his early photographs were like the paintings of the *Impressionists*, although at the time he was unaware. In contrast Steichen worked to create a clear and precise image when photographing portraits and social gatherings, which he did as frequently.

In an issue of *Harper's Weekly*, Steichen learned about the first major art exhibition of photography in the United States held in Philadelphia in 1898. Delighted that photography had begun to gain recognition as an art form, he submitted an application to the salon for the following year's exhibition. Two of his photographs were included in the second Philadelphia Photographic Salon in 1899. One of the jurors, Clarence White, took notice of Steichen's photography and said that it was interesting. However, his work did not receive much attention beyond that. Yet, this did not deter Steichen's ambition to live his life as an artist.

After the completion of his four-year apprenticeship with the American Fine Art Company, Steichen was hired by a commercial advertising firm making $50 per week, a handsome pay in 1899. Yet he longed for creative freedom; and in 1900, he decided to go to Europe with an artist friend from the Student's League, Carl Björncrantz. His father strongly objected, but his mother was unfailingly supportive and told her son to follow his dreams.

On a stopover in New York City, Steichen became overwhelmingly impressed with the city and was completely taken when he saw an enlarged image of a painting that he had completed for an advertising campaign for Cascarets during his apprenticeship. He decided then that New York City was indeed the art center of the world. When Steichen told Clarence White that he was going to New York City, White suggested that he make a special trip to the New York Camera Club. The Club was run by the well-known **Alfred Stieglitz,** who was known for his pioneering efforts in the acceptance of photography as fine art. He was a leader in the *pictorialist* movement, which involved working with photography as art rather than pure documentation. Steichen had been experimenting with a pictorialist approach for years, and Stieglitz took notice of his portfolio. Stieglitz purchased three of Steichen's prints for $5 a piece on the spot. Stieglitz was impressed that Steichen was both a painter and a photographer and urged him to pursue photography.

After one year in Europe, he returned to New York City and promptly contacted Stieglitz, who invited him back to the Camera Club and introduced him to the artists there. Stieglitz had named a group of photographers the *Photo-Secession* artists, who were many of the original pictorialist photographers. By 1903, the group formally organized and set forth their agenda, including Steichen, as the *Photo-Secessionist Movement* in the periodical *Camera Work*, published by Stieglitz and the Camera Club.

Steichen decided to rent a small space and put his shingle out as an independent portrait photographer. Before long he was able to support himself financially with this work and had regular clients including the Stieglitz family. Steichen became a regular dinner guest at the Stieglitz home, and soon he was a friend to the entire family. In 1905, Steichen felt that he had outgrown his space and moved across the hall to a larger studio. The space he left behind was room 291, which Steichen determined would be a good gallery space for the Photo-Secession artists. He approached Stieglitz with the idea, and after some convincing Stieglitz approved the expense and the Photo-Secession organization had its own official gallery space. The Little Galleries, as they were first called, became known as the 291 gallery.

Steichen's portrait studio continued to grow as did his boredom, and he decided to return to Europe for awhile. He met with Auguste Rodin to photograph him and organize an exhibition of Rodin's drawings to be held at 291. He also met with Pablo Picasso, who agreed to show his work for the first time in the United States at 291. Steichen returned to New York City to curate the Rodin and Picasso shows along with many others with Stieglitz at 291.

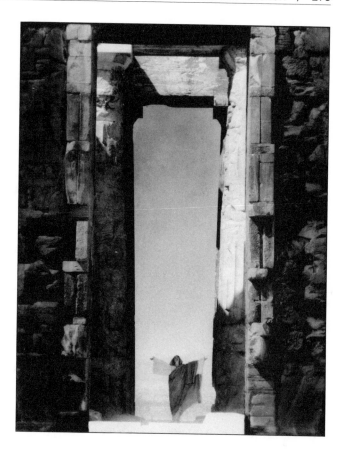

Edward Steichen. *Isadora Duncan, Parthenon, Athens* (1920). 9¹⁵/₁₆ × 7¹⁵/₁₆ inches. Amon Carter Museum, Fort Worth. Reprinted with permission of Joanna T. Steichen.

He also exhibited his own work at the gallery during these years. The relationship between Stieglitz and Steichen became strained over the next several years as they developed opposing artistic ideologies. Stieglitz was loyal to the pictorialist movement and creating art for art's sake, as Steichen increasingly felt that art should have some function in society as well.

After the United States became involved in World War I, the two artists argued even more as they disagreed politically. Steichen had emotional ties to France, which caused him to side with the Americans while Stieglitz remained loyal to Germany. Eventually, 291 closed due to several of the artists joining the military and the public's general lack of support for the arts. Steichen decided to join the U.S. Army in 1917. He became a lieutenant for the Signal Corps and worked as a documentary and aerial photographer. Steichen was greatly affected by his war experiences and photographing enemy territory and actions, gunfire, dead bodies, and destroyed countries.

After the war Steichen went through a depression for several days before returning home to Voulangis, France. For the next three years, he became rejuvenated through rest and painting. He primarily painted the flowers in his garden. One day he found a painting made by his gardener and discovered that the amateur artist was producing something

more vibrant and creative than he was able to achieve. He pulled out all of his paintings and burned them in a large bonfire right there on the lawn. Steichen was done painting and recommitted his energy to photography. Yet this time would be different from his early days with pictorialism and the *Photo-Secessionist Movement*. This time Steichen wanted his work to touch a larger audience.

During the war Steichen's work was about capturing a clear and accurate photograph. Steichen wanted to perfect this technique and decided on another apprenticeship. This time he designed a series of lessons to study and work through until he achieved a certain level of competency. After less than a year of working through these technical studies, Steichen happened to meet the famous dancer Isadora Duncan. On the occasion of their meeting, Duncan invited Steichen to travel to Greece with her and the dancing company as the photographer. While there, he urged her to let him take motion pictures of her dancing, but she refused. However, she did agree to let Steichen photograph her. After much persuasion she agreed to be photographed at the Parthenon in Athens, although she hesitated and said that she felt like an intruder. In *Isadora Duncan at the Portal of the Parthenon* (1921), her arms are outstretched in one of her most beautiful and recognizable movements as she stands just inside the grand scale of the Parthenon's entrance, which looms over the diminutive dancer.

Steichen lived in France for the next several years making frequent trips to New York City. In 1923, he decided that his self-imposed apprenticeship had come to an end, and he was going to stay in New York City. Shortly after the move he was hired as a commercial photographer at *Vanity Fair* and *Vogue*. Steichen developed a lucrative career for himself in commercial and fashion photography, for which he was widely criticized by Stieglitz and others for abandoning photography as purely art. Today art critics often mention that Steichen's greatest artistic achievements came from his days with gallery 291.

Despite such criticisms his career with commercial photography was a success. Steichen's work with *Vanity Fair* led to high-profile portraits for the magazine, including Charlie Chaplain, Cary Grant, John Barrymore, Lillian Gish, and Greta Garbo. Steichen continued to work in the world of commercial and fashion photography until the outbreak of World War II in 1941. Having experience with military photography, he was invited by a captain in the U.S. Navy to organize a small unit of photographers for the U.S. Naval aviation division. He accepted his post and was honorably discharged as captain in 1946.

In 1947, Steichen was hired by the prestigious Museum of Modern Art in New York City as the director of the Department of Photography. Perhaps most notably Steichen was heralded for his curatorial efforts in the exhibition *The Family of Man* (1955). This ground breaking exhibition featured the work of 500 photographers chronicling family life, love, and death in 68 countries. He curated many highly acclaimed exhibitions during his tenure at the museum until his resignation in 1962, which came after suffering from two strokes.

There is little written about Steichen's personal life. He was married to one woman and survived her death in 1957. The couple had children, and he collaborated with his daughter,

Mary Steichen Martin, on *The First Picture Book: Everyday Things for Babies*, published by Harcourt Brace. He died in his home in Redding, Connecticut, on March 25, 1973. Steichen had a keen sense of the role of the artist and that of the camera and the technical proficiencies associated with making a work of art:

> The camera is a witness of objects, places, and events. A photograph of an object is, in a sense, a portrait. But the camera with its glass eye, the lens, and its memory, the film, can in itself produce little more than mirrored verisimilitudes. A good photograph requires more than that. When an artist of any kind looks at his subject, he looks with everything that he is. Everything that he has lived, learned, observed, and experienced combines to enable him to identify himself with the subject and look with insight, perception, imagination, and understanding. (Steichen 10)

One of the most revered and profound contributors to the development of photography as art, Edward Steichen dedicated his life to the art and craft of photography, constantly challenging his role as artist and curator.

Bibliography

Gedrim, Ronald J., ed. *Edward Steichen: Selected Texts and Bibliography.* New York: G.K. Hall & Co., 1996.

Hobson, Katherine. "A New Cultural Revolution: The Art of the Sale." *U.S. News and World Report* 131, no. 2 (July 9–16, 2001): 62–4.

Johnston, Patricia. *Real Fantasies: Edward Steichen's Advertising Photography.* Berkeley, CA: University of California Press, 1997.

Pollack, Barbara. "Edward Steichen: Whitney Museum of American Art." *Artnews* 99, no. 11 (2000): 155.

Prose, Francine. "The Portrait J.P. Morgan Hated." *Artnews* 99, no. 9 (2000): 130–132.

Smith, Joel. *Edward Steichen: The Early Years.* Princeton, NJ and Chichester, England: Princeton University Press, in association with the Metropolitan Museum of Art, 1999.

Steichen, Edward. *A Life in Photography.* Garden City, NY: Doubleday, 1963.

Places to See Steichen's Work

Art Institute of Chicago, Chicago, Illinois

Cincinnati Art Museum, Cincinnati, Ohio: *Time-Space Continuum* (no date)

Cleveland Museum of Art, Cleveland, OhioDenver Art Museum, Denver, Colorado

Fine Arts Museum of San Francisco, San Francisco, California: *The George Washington Bridge, New York, New York* (1930)

Fred Jones Jr. Museum of Art at the University of Oklahoma, Norman, Oklahoma: *Cheruit Gown (Marion Morehouse – Mrs. e.e. cummings)* (1927); *Rodin: Balzac Towards the Light Midnight* (ca. 1905)

Frederick R. Weisman Art Museum, Minneapolis, Minnesota

Hood Museum of Art, Dartmouth College, Hanover, New Hampshire

J. Paul Getty Museum, Los Angeles, California: *Self-Portrait* (1901)

John & Mable Ringling Museum of Art, Sarasota, Florida

Lowe Art Museum, Coral Gables, Florida

Metropolitan Museum of Art, New York, New York

Milwaukee Art Museum, Wisconsin

Minneapolis Institute of Arts, Minnesota

Museum of Fine Arts, Boston, Massachusetts

Museum of Fine Arts, Houston, Texas: *Trees, Long Island* (1905)

National Gallery of Art, Washington, DC

National Portrait Gallery, Washington, DC

Neuberger Museum of Art, Purchase, New York

Norton Museum of Art, West Palm Beach, Florida: *Gladiola with Black Flower* (1920s)

Oklahoma City Museum of Art, Oklahoma City, Oklahoma

San Diego Museum of Art, San Diego, California

Sheldon Art Gallery, Lincoln, Nebraska: *Shrouded Figure in Moonlight* (no date)

Smithsonian American Art Museum, Washington, DC: *Jean Walker Simpson* (no date)

Snite Museum of Art, Notre Dame, Indiana

St. Louis Art Museum, St. Louis, Missouri

Toledo Museum of Art, Toledo, Ohio

University of Michigan Museum of Art, Ann Arbor, Michigan

Washington County Museum of Fine Arts, Hagerstown, MD

Whitney Museum of American Art, New York City, New York

ALFRED STIEGLITZ

1864–1946

WIDELY KNOWN AS THE "FATHER OF MODERN PHOTOGRAPHY," ALFRED Stieglitz was instrumental in broadening the scope of photography from pure documentation to fine art alongside traditional media, such as painting and sculpting. The oldest son of six children, he was born in Hoboken, New Jersey, in 1864 to German immigrant parents. His father was a profitable business owner and an amateur painter. Both parents were great supporters of the arts and frequently invited artists to take respite in the family's summer home in Lake George, New York. This early exposure to artists nurtured Stieglitz's respect for their passion and work. In 1881, his father moved the family to Berlin, where Stieglitz began his studies in mechanical engineering. However, he soon abandoned these studies to pursue his interest in photography, for which he had the support of his family. He started to formally study photography while living in Germany in 1883. Even after the family returned to the United States, Stieglitz remained in Europe with generous funding from his father. He traveled throughout Europe, including Austria and Italy, photographing the countryside.

After his sister's death Stieglitz returned to the United States in 1890. His family felt that the 26-year-old artist should be working in a suitable business and be married. He complied, and three years later he held a respectable job in business and was married to a family friend and wealthy heiress, Emmeline Obermeyer. Their marriage was troubled from the start as they held differing ideals about life and society. Despite their unhappiness, they had a daughter, Kitty, in 1898, who became one of Stieglitz's favorite photographic subjects.

Since both Stieglitz and Obermeyer received stipends from their families, he did not have to seek employment and was able to work tirelessly for the arts in a variety of capacities. From his early days as a photography student in Berlin, he saw himself as a rebel, and this distinction remained with the artist for the remainder of his career. From 1893 to 1896, he worked as an editor at *American Amateur Photographer*. Stieglitz was asked to resign because

of his elitist attitudes that offended many subscribers. After he left the magazine, Stieglitz turned his attention to the New York Camera Club. There his work included reconstructing the club's newsletter into a serious scholarly art publication, which later became the widely read *Camera Work*.

Stieglitz was determined to establish photography as a fine art. However, there was much debate on the topic at the time. Opposing arguments suggested that photography was a lazy form of painting and that photographers were artists who did not want to take the time to develop traditional art skills and techniques. These oppositions fueled Stieglitz's drive for the quest, and he spent the next several decades proving his claim that indeed photography is art.

In the early twentieth century he became increasingly frustrated with most members at the New York Camera Club and their unwillingness to accept photography as a serious art. He decided to take matters into his own hands, and in 1902, Stieglitz organized artists who were interested in seeking a new approach to photography, abandoning academic photography. Artists who embraced a new aesthetic and purpose for photography as a form of artistic expression banded together into what became known as the *Photo-Secessionist Movement*. This movement sprung out of the *Pictorialist Movement*, where artists worked to create images that resembled painting. Stieglitz dedicated his energy to this mission by establishing, writing, and editing journals that supported this effort, *Camera Notes* and *Camera Work*. From 1902 to 1905 he rarely took photographs; rather, he dedicated himself to the promotion of other artists.

He decided to establish an elite art club with like-minded *avant-garde* thinkers and artists. Particularly, he was in search of an artist who was both a painter and a photographer, which he thought would help the case for photography as art. Stieglitz decided that person was the well-established artist **Edward Steichen,** with whom he had developed a close friendship. Together they founded the Little Galleries of the Photo-Secession in 1905. The gallery was located at 291 Fifth Avenue in New York City, and later it became known as 291. Studio 291 became the center of the avant-garde art movement in New York City during that time. Artists, dancers, writers, and philosophers came in and out of the studio, creating an open space for dialogue among the group, as well as developing a strong social circle. It was a space to exhibit art that existed outside of academic tradition. Stieglitz organized numerous exhibitions, which effectively changed the way that photography was distinguished. Previously, photography was solely a technical, documentary technique; now it was also viewed as a form of artistic expression. Painters and sculptors were exhibited as well, including Rodin's drawings and the premier of Pablo Picasso's work in the United States; both exhibitions were thought to be radical at the time.

In 1907, Stieglitz, along with his wife and daughter, went to Europe on a large ocean liner. After a few days of living in opulence among the nouveau riche on board, he felt stifled and went in search of fresh air. While walking the decks, he discovered another population of passengers on board the steerage: men, women, and children crowded below the main

decks. He was inspired to photograph what he saw on that trip. By showing people from varied economic backgrounds and the conditions under which they live, Stieglitz felt that his work showed a deeper understanding of the human condition. This trip resulted in his *Steerage* series.

In 1917, the United States joined European allies in World War I against Germany and Austria. Many of the Studio 291 artists, including Edward Steichen, joined the U.S. military, and soon the central group of people at the gallery had dispersed. Stieglitz's pacifist attitude and alliance with Germany prevented him from joining in the efforts. Soon the gallery and Stieglitz himself were considered a threat to the war effort, which resulted in economic hardships for him and his family and prompted the closing of the gallery and the end of the publication *Camera Works*.

Notwithstanding his popularity and presence in the art community, Stieglitz was widely criticized for his superior attitudes toward art and himself. A generous and staunch supporter of many emerging artists, Stieglitz felt betrayed and abandoned when artists matured and became independent. Perhaps most notably Edward Steichen and Stieglitz went through a falling out and did not speak to one another for years during and after World War II. After the war Steichen began to make photography that would sell, as he needed to earn money to support his family, for which Stieglitz was critical. Yet Stieglitz failed to remember that he knew nothing of financial need, as he was supported by his family's trust throughout his life.

In his promotion of emerging artists, Stieglitz adopted artists who became known as the Stieglitz Circle, including painters John Marin, John Dove, and perhaps most profoundly was the artist who would later become his wife, Georgia O'Keeffe. The only photographer that he mentored as part of the 291 group was **Paul Strand**. Stieglitz was influential on Strand's development as a photographer and artist. Their relationship was close until Strand's work became political during the 1930s Depression. Ultimately, they went their separate ways, as Strand felt that Stieglitz held elitist attitudes about art.

Already associated with Georgia O'Keeffe through a Studio 291 exhibition, Stieglitz was swept away by the much younger artist. His wife, Emmeline, divorced him in 1918 after finding Stieglitz photographing O'Keeffe in their home. He was obsessed with photographing every part of O'Keeffe over a long period of time, which he did for the remainder of his photographic career until 1937. Stieglitz photographed O'Keeffe hundreds of times, creating one of his largest bodies of work. An exhibition of more than 300 of these photographs received critical acclaim for the then-famous and established Stieglitz and instant popularity for the emerging painter O'Keeffe.

Stieglitz and O'Keeffe married in 1924. Although O'Keeffe had an appreciation of New York City, she longed for the open frontier of the Southwest and began spending time there. After his heart attack in 1937, Stieglitz said that his heart condition precluded him from being able to withstand the high altitudes of New Mexico and that he could no longer travel to Santa Fe. The two made a pact and spent winters together in New York City at the

Alfred Stieglitz. *Georgia O'Keeffe* (1929). Courtesy of the George Eastman House, Rochester, NY.

Manhattan Shelton, one of the first skyscraper hotels. Feeling most comfortable at his family's home in Lake George, situated in the Adirondacks of New York, he spent every summer there for the rest of his life, while O'Keeffe returned to Santa Fe for six months each year.

Although Stieglitz was no longer able to take photographs after his heart attack, he continued to curate exhibitions, promote artists, and publish art criticism until his death in 1946 in New York City. Despite the fact that he restricted access to most of his own work, Alfred Stieglitz was considered by many to be the father of photography. Previously withheld photographs were exhibited posthumously in venues such as the Museum of Modern Art in New York City and the National Gallery of Art in Washington, DC. Alfred Stieglitz dedicated his life to the pursuit of the medium as fine art, which resulted in a vast photographic oeuvre, critical writings and publications, and the support of leading artists that influenced the acceptance of photography as a fine art.

Bibliography

Abrahams, Edward. "Let them all be damned—I'll do as I please." *American Heritage* 38 (September/October 1987): 44–57.

"Alfred Stieglitz." *American Masters.* Public Broadcasting Series. Retrieved October 26, 2006, from http://www.pbs.org/wnet/americanmasters/database/stieglitz_a.html.

Boxer, Sarah. "Georgia O'Keeffe: A Portrait by Alfred Stieglitz at the Metropolitan Museum of Art." *New York Times (Late New York Edition)*, August 1, 1997: C26.

Connor, Celeste. "Glossed Over: The Artist's Book, Part I." *Artweek* 36, no. 2 (March 2005): 12–13.

Doyle, J. Ray. "Technical page." *American Artist* 51 (September 1987): 32.

Loke, Margarett. "Alfred Stieglitz: Museum of Modern Art." *Artnews* 94, no. 12 (1995): 139.

Stevens, Mark. "Obituary." *Newsweek* 107 (March 17, 1986): 77.

Places to See Stieglitz's Work

Allen Art Museum at Oberlin College, Oberlin, Ohio
Art Institute of Chicago, Chicago, Illinois
Cantor Center for Visual Arts at Stanford University, Stanford, California
Cincinnati Art Museum, Cincinnati, Ohio
Clark Art Institute, Williamstown, Massachusetts
Cleveland Museum of Art, Cleveland, Ohio
Currier Gallery of Art, Manchester, New Hampshire
Detroit Institute of Arts, Detroit, Michigan
Fred Jones Jr. Museum of Art at the University of Oklahoma, Norman, Oklahoma
George Eastman House, Rochester, New York
Gibbes Museum of Art, Charleston, South Carolina
Heckscher Museum of Art, Huntington, New York
High Museum of Art, Atlanta, Georgia
J. Paul Getty Museum, Los Angeles, California
James A. Michener Art Museum, Doylestown, Pennsylvania
Jewish Museum of New York, New York, New York
Kemper Museum of Contemporary Art, Kansas City, Missouri
Los Angeles County Museum of Art, Los Angeles, California
Metropolitan Museum of Art, New York, New York
Milwaukee Art Museum, Milwaukee, Wisconsin
Museum of Fine Arts, Houston, Texas
Museum of Fine Arts, Santa Fe, New Mexico
National Galleries of Scotland, Edinburgh, Scotland
New York Public Library Digital Gallery, New York, New York: http://digitalgallery.nypl.org
Phillips Collection, Washington, DC
Princeton University Art Museum, Princeton, New Jersey
San Francisco Museum of Modern Art, San Francisco, California
Sheldon Art Gallery, Lincoln, Nebraska: *Steerage* (date unknown)
Smithsonian Archives of American Art, Washington, DC
Worcester Art Museum, Worcester, Massachusetts

PAUL STRAND

1890–1976

GREATLY INFLUENCED BY ALFRED STIEGLITZ, PAUL STRAND IS KNOWN FOR his detailed formalist photographs that utilize straight photographic methods, where the camera records exact images. Along with Stieglitz, **Edward Weston,** and **Ansel Adams,** Strand stressed the honesty of the medium and the infinite tonal qualities that could be captured on film. He felt a profound obligation to photograph truths by portraying the emotional significance of his subjects. He was politically conscious of what was happening around him and wanted to use his photographs to artistically document the world.

Born in New York, Strand received his first camera from his father in 1902. Two years later he joined the Ethical Culture School, a school founded by secular German Jews, where he took photography lessons from **Lewis Hine,** who at the time was involved in a project photographing Ellis Island immigrants. Strand's early teachings were based on the promotion of moral and social responsibility.

After high school Strand joined the Camera Club of New York and set up a portrait business. Showing his work to Stieglitz, he was encouraged to change his approach from using a soft-focus lens to one that would allow him to sharpen his images. It was the clear images of New York's beauty and grit that first distinguished him as a photographer. So drawn to the idea of photography's ability to objectively portray a subject that in 1971 he wrote, "Unlike the other arts which are really anti-photographic, this objectivity is of the very essence of photography, its contribution and at the same time its limitation" (Johnson 128). Recognizing that the photographer deals with both limitations and potentials, Strand claimed that the photographer should have

> a real respect for the thing in front of him, expressed in terms of chiaroscuro (color and photography have nothing in common) through a range of almost infinite tonal values which lie beyond the skill of human hand. The fullest realization of

this is accomplished without tricks of process or manipulation, through the use of straight photographic methods. (Johnson 128)

Stieglitz, who gave Strand the foundation for these ideas, remained a strong mentor and friend in the 1910s and 1920s. He devoted the last two issues of his magazine *Camera Work* to Strand's early images.

Strand's development as an artist mirrors the development of modern art. Influenced by the 1913 Armory Show in New York, he was challenged to find a photographic way to respond to new developments in painting. His first exhibition was in 1916 at Stieglitz's "291" gallery where he presented his modernist ideas.

One of Strand's most widely recognized photographs from these early years is *Blind Woman* (1916). The image portrays a frontal view of an older woman who leans against a wall with a sign hung around her neck labeling her blind. Two other photographs from this time that are still considered among his best are *The White Fence* (1916) taken in Port Kent, New York, and *Wall Street*, New York. Crisp contrasts of light and dark mark both images.

While Strand was concerned about the social meanings of his images and the impact they had on the viewer, he approached his work with the eye of a modernist. He looked for tones, textures, repetitions of shapes, and the way the light fell on his subject. Framing a good composition was of extreme importance to him as can be seen in his still life of bowls, titled *Abstraction* (1916). This close-up of bowls with sharp shadows heightens our awareness of the objects as shapes that can be beautiful. They become abstracted from their ordinariness, giving us a new way to perceive them. Embracing other aspects of modernism, he focused on the industrial, commercial, and technical aspects of our changing society.

Strand's work really came alive when he was first exposed to the landscape of the Southwest. It was in New Mexico where he fully embraced the lessons of abstraction. Drawn to weathered wood, adobe buildings, expansive sky, and rich landscape, he was able to spend time in isolation, exploring his ideas without interruption. He spent time there with Georgia O'Keeffe, another young artist mentored by Stieglitz. Moving to other places in the Southwest, he often returned to the same subject or themes, working on a series of studies, an approach used by many other artists including O'Keeffe.

Over the years Strand's encounters with famous artists and arts patrons were many. Mabel Dodge Luhan invited him to stay at her Taos ranch, and painter John Marin was his Taos neighbor one summer. He would meet Arthur Dove and numerous other writers, photographers, and artists.

Commercial filmmaking helped Strand pay the bills in the 1920s and 1930s. In 1921, he worked with painter Charles Sheeler on a short documentary film titled *Manhattan*, where quotes from Walt Whitman's poetry are paired with a celebrated cityscape of modern New York. In 1932, he went to Mexico to make a government-sponsored film called *Redes* (The Wave), a documentary on the difficult lives of fishermen. His socialist tendencies were

Paul Strand. *Wall Street* (1915), from *Camerawork*, October 1916. Photogravure. 5 × 6½ inches (12.7 × 16.51 cm). San Francisco Museum of Modern Art. Collection of the Prentice and Paul Sack Photographic Trust. © Aperture Foundation, Inc., Paul Strand Archive.

further developed during this time by the effects of Mexico's revolution and civil war and the sympathy he felt for artists such as Diego Rivera and David Alfaro Siquieros. Other New Mexican writers and thinkers fed into his growing interest in Marxist politics, which solidified in 1933. He admired the Soviet filmmakers of the time and met the pioneering documentary filmmaker Robert Flaherty. However, in the 1940s, he made the decision to concentrate on still photography; and in 1944, Nancy Newhall curated his first major retrospect, held at the Museum of Modern Art in New York.

His first wife, Rebecca, was one of the most important people in Strand's life. "Beck" Salsbury loved the western United States and had been a student with him at the Ethical Culture School. Her father, Nate Salsbury, was the creator and co-owner of Buffalo Bill's Wild West show. Paul Strand and Rebecca married in 1922. Rebecca looked like O'Keeffe with her tall body, remarkable bone structure, graceful fingers, large nose, and heavy-lidded eyes. Both women dressed in a masculine manner, caring little for fashion, and styled their

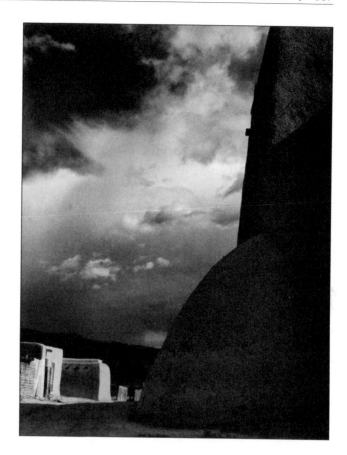

Paul Strand. *Buttress, Ranchos de Taos Church, New Mexico* (1932). Platinum print, 6 × 4⅝ inches (15.24 × 11.75 cm). San Francisco Museum of Modern Art. Collection of the Prentice and Paul Sack Photographic Trust. © Aperture Foundation, Inc., Paul Strand Archive.

hair simply. Both Strand and Stieglitz photographed her and O'Keeffe in the 1920s and early 1930s, but Strand kept the photos of Rebecca a hidden part of his work, possibly due to the fact that they would be compared to the portraits Stieglitz made of O'Keeffe during the same period. Rebecca respected her husband's work and supported his career, often working secretarial jobs; but by 1930 Strand's relationship with both Rebecca and Stieglitz was deteriorating. The Strands divorced in 1933. Paul Strand would marry two more times. His second marriage to actress Virginia Stevens in 1936 lasted about a decade.

Strand produced several photography books during his lifetime. Using his photographs and Nancy Newhall's text, the 1950 publication *Time in New England* is critically thought of as one of the great American photography books.

His travels would take him all over the world, including to France, Italy, the Hebrides, Egypt, Morocco, Ghana, Romania, and in various places in the United States. Strand moved to France in 1950 to escape McCarthyism and the Cold War. In 1951, he married his third wife, Hazel Kingsbury, who was many years younger than him. Hazel Strand was also a photographer, and her images helped document Strand's later years. They lived in Paris

temporarily and then settled in Orgeval, a town not far from Paris. In 1952, with Strand's photographs and text by Claude Roy, *La France de Profil* was published, a book of images that was to be seen as both art and documentary work. Made with the help of his wife, it includes telling portraits and glorious textured photos of windows, doors, walls, flowerpots, foliage, and waterways. It is the only one of Strand's books where the photographs are listed as illustrations.

In 1956, Strand exhibited work at the Museum of Modern Art with Walker Evans, Manuel Alvarez-Bravo, and August Sander in an exhibition titled *Diogenes with a Camera III*. In 1959, he took pictures of Egypt and published the book *Living Egypt* with text by James Aldridge. Increasingly his photographs have been published and exhibited all over the world.

Strand was working on a book of garden pictures before he died, a book that was never completed. He died peacefully in his home in Orgeval, leaving the world a body of work that embraced and transformed our way of seeing the world.

Bibliography

Barrett, Terry. *Criticizing Photographs: An Introduction to Understanding Images.* Mountain View, CA: Mayfield, 1990.

Brown, Milton W. "The Three Roads." *Paul Strand: Essays on His Life and Work*, ed. Maren Stange. New York: Aperture, 1990, 18–30.

Busselle, Rebecca, and Trudy Wilner Stack. *Paul Strand Southwest.* New York: Aperture, 2004.

Duncan, Catherine. "An Intimate Portrait." *Paul Strand: The World on My Doorstep.* New York: Aperture, 1994, 8–23.

Johnson, Brooks, ed. *Photography Speaks: 150 Photographers on Their Art.* New York: Aperture, 2004.

Paul Strand: A Retrospective Monograph, The Years 1915–1946. New York: Aperture, 1972.

Paul Strand: A Retrospective Monograph, The Years 1915–1968. New York: Aperture, 1971.

Rathbone, Belinda. "Portrait of a Marriage: Paul Strand's Photographs of Rebecca." *Paul Strand: Essays on His Life and Work*, ed. Maren Stange. New York: Aperture, 1990, 72–86.

Yates, Steve. "The Transition Years: New Mexico." *Paul Strand: Essays on His Life and Work*, ed. Maren Stange. New York: Aperture, 1990, 85–99.

Places to See Strand's Work

Art Institute of Chicago, Chicago, Illinois
Brooklyn Museum of Art, Brooklyn, New York
Cleveland Museum of Art, Cleveland, Ohio
Grand Rapids Museum of Art, Michigan
J. Paul Getty Museum, Los Angeles, California
Kemper Museum of Contemporary Art, Kansas City, Missouri
Metropolitan Museum of Art, New York, New York
Museum of Fine Arts, Houston, Texas
Museum of Fine Arts, Santa Fe, New Mexico

Museum of Modern Art, New York, New York
Philadelphia Museum of Art, Philadelphia, Pennsylvania
St. Louis Art Museum, St. Louis, Missouri
San Francisco Museum of Modern Art, San Francisco, California
Williams College Museum of Art, Williamstown, Massachusetts
Yale University Art Gallery, New Haven, Connecticut

HULLEAH J. TSINHNAHJINNIE

b. 1954

HULLEAH J. TSINHNAHJINNIE CREATES ART THAT CHALLENGES STEREOTYPI-
cal images of Native Americans in mass media and culture. Working from a feminist lens
that is informed by her Native American heritage, Tsinhnahjinnie presents alternative views
of Native American women for consideration and acceptance.

She was born in 1954 into the Bear and Raccoon clans of the Seminole and Muskogee
Nations in Phoenix, Arizona. She was named Hulleah after her great-grandmother, who
was a woman with an independent spirit. She always felt a sense of pride that her mother
gave her and her siblings family names, rather than American names. In 1966, the family
relocated to Rough Rock, Arizona, to live on the Navajo reservation. From 1975 to 1978,
she attended the Institute of American Indian Art in Santa Fe, New Mexico. As a senior,
she transferred to the California College of Arts and Crafts in Oakland, where she received
her BFA in painting with a minor in photography in 1981. After graduation, she was hon-
ored as a Chancellor's Fellow from the University of California at Irvine to pursue her MFA
Following her graduate work, Tsinhnahjinnie entered the commercial art world with ease as
a freelance artist and graphic designer, which she did for many years.

In the early 1990s, she completed her series, *Native Programming*, addressing Euro-
centric stereotypes of Native Americans. By framing the images inside of a television set,
she is representing the missing presence of Native American people in the media. In her
work *Vanna Brown*, a character created as the direct opposite of the popular Vanna White,
Tsinhnahjinnie positions her character as an assertive Native American female voice in
mass media.

In 1994, she completed her series *Photographic Memoirs of an Aboriginal Savant*. In this
mixed media work, she combined poetry, storytelling, and recounting family oral history
with photographs that tell the story of a Native American girl. In this emotional account
of her life, Tsinhnahjinnie talks about what it feels like to be born on occupied land and to
live on the Navajo reservation. She lives in two worlds, on the reservation and outside the

reservation, where she goes to school. A row of high school photographs fills one page, typical teenagers, except here she has blackened out their eyes as if with a scarf to mask their identities. Below are the words:

> Non-native teachers preparing
> native students
> for the
> outside world.
> Outside the reservation,
> outside an aboriginal existence,
> They meant well. (Tsinhnahjinnie)

She is addressing the absence of Native Americans in the public educational system and the assimilation process that the students inevitably undergo.

In 2000, she wrote an essay, *Native to Native*, about her journey to Lima, Peru, where she traveled to the rainforest to visit another indigenous culture. The village welcomed Tsinhnahjinnie and her friend and traveling companion, Ana. The villagers shared with them their way of life, from daily chores in the house and in the fields where they grow vegetables to private meeting halls and ceremonial dances. Tsinhnahjinnie was greatly affected by this trip, which led her to make the connection between this South American indigenous culture's survival and that of her own North American Native culture.

In 2003, the Andrew Smith Gallery held a solo exhibition of her work, *Portraits Against Amnesia*, a series of ten photographs. Each art work originated with an appropriated image from turn-of-the-century postcards. The postcards are old portrait studio photographs of Native peoples who have been dressed and posed to fit the dominant EuroAmerican style of the day. For instance, in *Grandma*, a young woman—Tsinhnahjinnie's grandmother—wears a suitable fashion and a solemn expression. She willingly stands for the camera but is unable to hide her unhappy disposition, surely due to being forced to conform into a costume that does not represent who she really is. After enlarging the image, Tsinhnahjinni manipulates the composition by adding abstract shapes and symbols. She digitally inserted circles throughout the image, as if they are dancing around the figure, which represent the spirits that follow and help us from before birth to after death. In another work from the series, *Grandchildren*, she addressed the issue of secrecy surrounding multiculturalism within Native cultures. The grandchildren represent the blending of the families throughout the generations.

In *Hoke-tee*, a sepia-toned photograph of a small child standing in the seat of a chair has been overlaid on top of a black-and-white image of an astronaut on the moon. Here, she juxtaposed the picture of Native American child—restricted from the benefits of mainstream technology as she lives in the oppressed margins of society—with the American iconic image of advancement in science, a man walking on the moon.

Hulleah Tsinhnahjinnie (Seminole/Muscogee/Diné). *Oklahoma, the unedited version,* from the series *Native Programming* (1990). Digital print. Courtesy of the artist.

Tsinhnahjinnie has been an educator since she gave a visiting lecture at the San Francisco Art Institute on Native American Art History in 1992. The following year, she was a visiting professor in photography at the Institute of American Indian Arts in Santa Fe, New Mexico. Subsequent teaching assignments include short-term residencies at a variety of institutions such as San Francisco State College, Bug-Ga-Na-Ge-Shig School at the Leech Lake Reservation, Minnesota Youth Media Project at the Minnesota Indian Center, and Stanford University in Palo Alto. Today, she is a professor in the Native American Studies department at the University of California at Davis.

She was the Artist-in-Residence at Light Works located on the campus of Syracuse University in New York in 1995 and again in 1999. Light Works offers grants to artists who are emerging in the field of photography or to established artists who are working outside the mainstream. Now she is experimenting with video as well as photography. In addition to her studio art and teaching responsibilities at UC Davis, she is a well-published art critic and scholar.

Artist, writer, and scholar, Hulleah J. Tsinhnahjinnie creates socially conscious work that speaks to the Native American experience about surviving as oppressed members living in the outskirts of society.

Bibliography

Abbott, Larry, Rosemary Diaz, and Michael Hice. "Artists of Change: Breaking through the Millennium." *Native Peoples* 13, no. 4 (June/July 2000): 50–57.

Fitzsimmons, Casey. "Cultural Confrontation: Art and society, face to face: Wiegand Gallery, College of Notre Dame, Belmont, California; exhibit." *Artweek* 22 (November 21, 1991): 12.

Jenkins, Steven. "A Conversation with Hulleah J. Tsinhnahjinnie." *Artweek* 24 (May 6, 1993): 4–5.

La Marr, Jean, Mario Martinez, and Hulleah Tsinhnahjinnie. *Talking Drum: Connected Vision: Native American Artists Addressing Affinities with the Indigenous People of South Africa.* Oakland, CA: Salad Bar, 1990.

Lippard, Lucy R. *Mixed Blessings: New Art in a Multicultural America.* New York: Pantheon, 1990.

Neumaier, Diane, ed. *Reframings: New American Feminist Photographies.* Philadelphia: Temple University Press, 1995.

Rapko, John. "Sovereignties." *Artweek* 24 (May 6, 1993): 4.

Roscoe, Will, ed. *Living the Spirit: A Gay American Indian Anthology Compiled by Gay American Indians.* New York: St. Martin's Press, 1988.

Tsinhnahjinnie, Hulleah. "Women of Hope." *Native Peoples* 10 (Spring 1997): 50–56.

———. "Native to Native." *Native Peoples* 13, no. 2 (February/March 2000): 28–32.

———. *Hulleah Tsinhnahjinnie's Web site.* Retrieved January 15, 2007, from www.hulleah.com.

Places to See Tsinhnahjinnie's Work

Andrew Smith Gallery, Santa Fe, New Mexico

The Art Museum, Princeton University, Princeton, New Jersey

Eltejorg Museum of American Indians and Western Art, Indianapolis, Indiana

Hulleah Tsinhnahjinnie's Web site: www.hulleah.com

Institute of American Indian Arts Museum, Santa Fe, New Mexico

Light Work, Syracuse University, New York

National Museum of the American Indian, Suitland, Maryland

Native American Women Photographers as Storytellers, Women Artists of the American West: http://www.cla.purdue.edu/WAAW/Jensen/NAW.html

JERRY UELSMANN

b. 1934

JERRY UELSMANN'S PHOTOGRAPHS ARE KNOWN FOR THEIR SURREAL CONtent as well as for their technical form. He seamlessly superimposes multiple negatives to make a singular image. Because he combines unusual or odd subjects, the result is a work that provokes thought as it creates a disturbing, humorous, or distorted sense of reality.

Uelsmann was born and raised in the inner city of Detroit and became involved in photography in high school. He received his BFA from the Rochester Institute of Technology in 1957 and his MS and MFA from Indiana University in 1960. At first he thought he would be a portrait photographer, but he liked the idea of playing with the medium so much that he wanted to go in a different direction. It was in his last year of graduate work when he found his voice. He moved to Gainesville straight from graduate school and began teaching at the University of Florida. He retired in 1997. Drawn to the natural environment, he enjoys traveling, often returning to the same places. His wife, Maggie Taylor, also a photographer, often travels with him.

Like many of the surrealists from the early part of the twentieth century, Uelsmann is interested in all kinds of objects, including kitsch and folk art. Centered in France, early forms of surrealism were characterized by the irrational and the incongruous. The movement relied heavily on the unconscious dream world, and its goal was to bring the reality of dreams closer to the reality of the waking world. While the power of Uelsmann's work comes from the juxtaposition of odd combinations of scenes and objects instead of dreams, he clearly works from a belief in the power of the unconscious. He explains that he likes what happens in dreams; he just doesn't work from his own personal dreamspace. He was influenced by **Minor White,** who taught him that you could look at an image for a meaning other than the obvious one. This teaching translated to his working process. Often the messages of his work come after he's made his shot. Possibly this is because he focuses so intensely on detail when he's working that he doesn't recognize the symbolic implications until later. He recognizes that sometimes the meaning of one of his

photographs seems so obvious that he wonders how it could be possible that he didn't see it earlier. Nonetheless, this is the way his creative process flows. It comes from his unconscious and later becomes visible. His desire is to amaze himself and the anticipation of this desire is what motivates him.

Uelsmann became interested in the ideas that an image could evoke from a viewer. Like Minor White, he enjoys the landscape, but wants to communicate not a literal way of seeing it, but a way of having an experience with it. Along with White and other artists who have similar goals, Uelsmann works within the context of a modernist aesthetic. He claims to have no conscious intent when he photographs, and he doesn't like to be too analytical about things. He works spontaneously and wants to create something that has a life of its own, in a visually cohesive manner. Uelsmann says he feels like he has a guardian angel because he's had so many synchronistic things happen to him in his life.

No one questions Uelsmann's technical expertise. He is able to make his images meld together with ease and precision. His work is accessible to everyone as each part is easy to recognize. Uelsmann admits that sometimes working at his art is difficult. But he finds it more frustrating not to work than to experience the frustration he sometimes has when he is working on a difficult process.

Humor is evident in much of his work, in his teaching, and lecturing. He likes to play with words by giving viewers a visual translation. For example, instead of "high chair," he would give us "eye chair." He often toys with our memories of home and small-town life in America by using the eagle, an apple, or a strawberry. Sometimes he plays with the scale of his objects, or he disturbs our spatial understanding by positioning an object in such a way that we have no understanding of how it is supported.

Like Ansel Adams, Uelsmann is drawn to Yosemite. He goes there every year claiming that if you return to the same place over and over again, you can establish a rapport with it. As a way of poking fun at Adams and his many images of Half Dome, using his technical skills in the darkroom, Uelsmann put two images together and made Full Dome. He says jokingly, that this is what Adams wanted him to do. His other images from Yosemite include a dark image of a young man in a lotus position floating above the ground but under a huge broken tree branch; a lone tree on a mountainside with the shadow of a person running; and images of rocks and tree trunks with human faces in them.

Uelsmann often mixes time periods by placing something from the mythic past, like broken statues or ruins, with a contemporary item. While the message many have a disturbing element to it, it is rarely desperate or dooming. By using the photographic medium to play with our sense of reality, he makes commentary on our acceptance of the photograph as a document of reality. In this way he enters into the philosophical debate about what photography is or should be. He feels he has succeeded when he has created something with multiple meanings or a layered kind of reality. In this way, he keeps us questioning.

Jerry Uelsmann. *Untitled (Tree with leaf root)* (1964). Gelatin silver print, 13½ × 9¹⁵⁄₁₆ inches (34.3 × 25.2 cm). Jerome Wheelock Fund. Courtesy of Worcester Art Museum, Worcester, Massachusetts.

Uelsmann recognizes that the digital revolution in photography makes it easier to do what he has painstakingly accomplished in his darkroom. But he is not interested in learning to work digitally. He continues his desire to make photographs that invite the viewer to participate, claming that the more difficult the images are, the more meaningful they are.

In his later years, he says he has become more spiritual, possibly due to the death of both his parents. He has been exploring images with a boat, which is a metaphor for taking a spiritual journey, reflecting on the fact that the Egyptians buried their dead in boats so that they had a vessel to take them on their travels.

Jerry Uelsmann has had exhibitions all over the world including two international retrospectives in 2007, one at the International Center of Photography, Scavi Scaligeri in Verona, Italy, and the other at the Beijing World Art Museum in China. He is a Fellow of the Royal Photographic Society of Great Britain and one of the founders of the American Society for Photographic Education.

Jerry Uelsmann. *Untitled* (1976). Gelatin silver print, 19½ × 14¹⁄₁₆ inches (49.5 × 35.7 cm). Thomas Hovey Gage Fund. Courtesy of Worcester Art Museum, Worcester, Massachusetts.

Bibliography

Barrett, Terry. *Criticizing Photographs: An Introduction to Understanding Images*, 3rd ed. Mountain View, CA: Mayfield, 2000.

Bunnell, Peter C. "Introduction." In *Jerry Uelsmann: Silver Meditations*. Dobbs Ferry, NY: Morgan and Morgan, 1977.

Four Directions in Modern Photography: Paul Caponigro, John T. Hill, Jerry N. Uelsmann, Bruce Davidson. Catalog for the exhibition at the Yale University Art Gallery, December 14, 1972 through February 25, 1973. New Haven, CT: Yale University Art Gallery, 1972.

Johnson, Brooks. *Photography Speaks: 150 Photographers on Their Art*. New York: Aperture, 2004.

Uelsmann, Jerry. "Meet the Artist: Jerry Uelsmann." Process and Perception: A Thomas P. Johnson Distinguished Visiting Lecture Series. Rollins College, Winter Park, Florida, October 12, 2006.

———. *Uelsmann Yosemite*. Gainesville: University Press of Florida, 1996.

Places to See Uelsmann's Work

Center for Contemporary Photography, University of Arizona, Tucson, Arizona

The Art Institute of Chicago, Chicago, Illinois

Fred Jones Jr. Mueum of Art, University of Oklahoma, Norman, Oklahoma
George Eastman House, Rochester, New York
Metropolitan Museum of Art, New York, New York
MIT List Visual Arts Center, Cambridge, Massachusetts
Museum of Contemporary Photography, Columbia College, Chicago, Illinois
Museum of Fine Arts, Boston, Massachusetts
Museum of Modern Art, New York, New York
National Museum of American Art, Washington, D.C.
Sioux City Art Center, Sioux City, Iowa
Whitney Museum of Art, New York, New York

DORIS ULMANN

1882–1934

DORIS ULMANN IS PERHAPS BEST KNOWN FOR HER WORK PHOTOGRAPH-ING the people of the Appalachian Mountains, a self-funded expedition that she undertook during the years of the Great Depression. Her soft-focus prints are heralded for creating a romantic or sympathetic quality to her subject matter. Stylistically, her images have been compared to that of *Impressionist* paintings.

She was born on May 29, 1882, in New York City, the second child of Gertrude Mass and Bernhard Ulmann. Bernhard was from a prominent Jewish European family who immigrated to the United States. Upon his arrival he was met with a warm welcome as many Americans themselves had recently immigrated; however, he also was faced with intolerance and discrimination for being a Jew in a predominantly Christian culture. Despite the obstacles, Bernhard built a prosperous textile business with his brother and married a woman from a wealthy German Jewish family.

The young Ulmann and her older sister grew up with many economic and social opportunities. The house was filled with servants, and the girls were expected to dress and behave with certain decorum. They were educated in literature and the domestic arts, such as needlepoint and quilting. Ulmann loved reading and was inspired by her uncle's book collection to one day have her own collection of autographed books written by authors whom she would also photograph.

After graduating from public high school in 1900, Ulmann enrolled at the Ethical Culture School, part of the Ethical Culture Society in Manhattan. The school was founded by Felix Adler. Adler felt that the lives of the underprivileged should be valued as all others and that society must undergo a reconstruction to provide equity for all people. This perspective greatly affected Ulmann's own ideals and work throughout her life.

As a young adult, Ulmann became passionate about photography. Her socialite status in New York City gave her access to prominent members of the community, whom she

photographed, including Albert Einstein; Edna Woolman Chase, the editor of *Vogue*; and Clarence White, a photography professor. She was uninspired by this work, and by the 1920s Ulmann turned her camera away from the wealthy and influential members of society to those less fortunate than herself.

Infused with the social consciousness that she developed while a student at Adler's Ethical Culture School, Ulmann wanted to give these downtrodden and often forgotten cultures dignity and recognition through her lens. She did extensive photographic studies with Native American tribes, African American communities, and Appalachian schools and neighborhoods. She covered nearly all of the financial expense for most of these expeditions. The success of her father's business left Ulmann, her mother, and her sister very wealthy upon his death. Indeed, Ulmann would not have been able to pursue her photographic fieldwork without the financial independence that she received from her trust and later her inheritance.

In the early 1930s, Ulmann traveled to the Appalachian Mountains to take pictures for Allen Eaton's book on local crafts. However, the fruits of her labor far exceeded the requirements of the project, resulting in the body of work for which she is best known. Over a period

Doris Ulmann. *Old Man Using Draw Knife* (1930). Library of Congress, Prints and Photographs Division, Doris Ulmann Collection. Reproduction number: LC–USZ62–49613.

of several years, she photographed the Southern Highlands area of the Appalachian Mountains, which resulted in literally thousands of images—the largest known record of the region. Ulmann was captivated with the people, and they were with her, evidenced by the candid and sincere portraits. In *Woman on a Porch* (ca. 1930), the subject is dressed in a long-sleeved, striped shirt and a simple hat while sitting hunched over in a rocking chair on the porch, just as she might on any ordinary day. Her expression is without emotion, reservation, or suspicion of Ulmann's presence or work. In another image from this series, *Man in White Shirt in Field* (ca. 1930), a man stands patiently as she takes his portrait in a large field. His white shirt is clean, buttoned up, and tucked in neatly, as he stands straight with an air of pride despite the daily duties of his dirty and laborious farm work. Ulmann's titles are simple and descriptive. For example, in *Old Man Holds a Potato* (1930), a white-bearded farmer sits next to a wooden fence with a sack of potatoes next to him as he inspects one close-up. In *Old Man Using Draw Knife* (1930), Ulmann photographed the man just as he paused and looked up from his daily chores. These images illustrate the mundane and ordinary aspects of her subjects' daily lives, yet they are eloquent compositions that exude humanity and compassion.

Doris Ulmann. *Old Man Holds a Potato* (1930). Library of Congress, Prints and Photographs Division, Doris Ulmann Collection. Reproduction number: LC–USZ62–49616.

Ulmann went to South Carolina when she was commissioned to provide photographs for Julia Peterkin's novel *Roll, Jordan, Roll* (1933). She documented the Gullah, a traditional African American culture located in South Carolina's islands and coastal shores. The Gullah communities were slowly dying out, which added another layer of significance to her documentation. She returned to the Gullah many times over a period of six years. These portraits are equally as compassionate and sympathetic as those taken in the Appalachian Mountains. Likewise, these photographs are now an important document of the Gullah during the 1930s.

Although Ulmann reportedly had lovers in her lifetime, she did not marry. She was romantically involved on and off with her longtime assistant and traveling companion, John Jacob Niles. Niles was an actor, musician, and folk music collector who has been inaccurately given credit for propelling Ulmann's career. Throughout her life, she endured much loneliness and suffered from chronic health problems, which may have been attributable in part to her chain smoking. She died tragically in 1934. She was 50 years old. Although Doris Ulmann's career was cut short, she will be forever credited and remembered with fondness for her body of work photographing the Appalachian, African American, and Native American communities with a lens for social change.

Bibliography

Hobbs, June Hadden. "Country Churchyards." *Southern Quarterly* 39, no. 4 (Summer 2001): 189–191.

Jacobs, Philip Walker. *The Life and Photography of Doris Ulmann*. Lexington, KY: The University Press of Kentucky, 2001.

Sloane, Joseph C. "The Appalachian Photographs of Doris Ulmann by Doris Ulmann." *Art Journal* 31, no. 3 (Spring 1972): 352.

Places to See Ulmann's Work

Amon Carter Museum, Fort Worth, Texas

Art Institute of Chicago, Chicago, Illinois

Berea College, Berea, Kentucky

Cammie G. Henry Research Center, Eugene P. Watson Memorial Library, Northwestern State University of Louisiana, Natchitoches, Louisiana

Center for Creative Photography, The University of Arizona, Tucson, Arizona

Cincinnati Art Museum, Cincinnati, Ohio

Cleveland Public Library, Cleveland, Ohio

Cornell University, Ithaca, New York

Duke University, Durham, North Carolina

Fred Jones Jr. Museum of Art, University of Oklahoma, Norman, Oklahoma

Gibbes Museum, Charleston, South Carolina

Givens Collection, Special Collections and Rare Books Department, University of Minnesota, Minneapolis, Minnesota

Haverford College, Haverford, Pennsylvania

High Museum of Art, Atlanta, Georgia

Historic New Orleans Collection, New Orleans, Louisiana

Howard University, Washington, DC
Indiana University, Bloomington, Indiana
International Center of Photography, New York, New York
J. Paul Getty Museum, Los Angeles, California
King Library, University of Kentucky, Lexington, Kentucky
Library of Congress, Washington, DC
Los Angeles County Museum of Art, Los Angeles, California
Metropolitan Museum of Art, New York, New York
Montclair Art Museum, Montclair, New Jersey
Museum of Fine Arts, Boston, Massachusetts
Museum of Modern Art, New York, New York
National Gallery of Australia, Canberra, Australia
National Gallery of Canada, Ottawa, Canada
National Portrait Gallery, Washington, DC
New York Historical Society, New York, New York
New York Public Library for the Performing Arts, New York, New York
North Carolina Division of Archives and History, Raleigh, North Carolina
Ohio State University, Columbus, Ohio
Philadelphia Museum of Art, Philadelphia, Pennsylvania
Rare Book Library, Columbia University, New York, New York
Rosenbach Museum and Library, Philadelphia, Pennsylvania
San Francisco Museum of Art, San Francisco, California
Smithsonian American Art Museum, Washington, DC
South Carolina Historical Society, Charleston, South Carolina
Stanford University, Stanford, California
Swarthmore College, Swarthmore, Pennsylvania
University of Cincinnati, Cincinnati, Ohio
University of Connecticut, Storrs, Connecticut
University of Georgia, Athens, Georgia
University of Kansas, Medical Center Library, Kansas City, Kansas
University of Kentucky Art Museum, Lexington, Kentucky
University of Michigan, Ann Arbor, Michigan
University of North Carolina, Chapel Hill, North Carolina
University of Oregon, Eugene, Oregon
University of Pennsylvania, Philadelphia, Pennsylvania
University of South Carolina, Columbia, South Carolina
University of Washington, Seattle, Washington
Yale University, New Haven, Connecticut

JAMES VANDERZEE

1886–1983

AS A PHOTOGRAPHER WHOSE WORK SPANNED OVER 70 YEARS, JAMES VanDerZee is most widely recognized for his documentary photographs of the Harlem Renaissance (1919–1920), but as **Deborah Willis** points out, it would be more accurate to view him as one of the creators of the Harlem Renaissance. His talents also included playing the violin and piano, which he viewed as an extension of his visual artwork. In most every portrait he made, VanDerZee worked to dispel the negative stereotyping of African Americans that was common during his time. It is because of VanDerZee's work, and the care he took in preserving his images, that we have such a rich documentary history of Harlem today.

Born and raised in Lenox, Massachusetts, VanDerZee grew up in an upper-middle-class African American home with an older sister and four younger siblings, although a brother died of pneumonia at a young age. His father, a man VanDerZee described as gentle, was clearly regarded as the respected head of the family. His mother and father had once been a maid and a butler, respectively, to Ulysses S. Grant. It is probable that they left their positions in the Grant household when the Grant's firm collapsed, and they lost their fortune. The VanDerZees moved to Lenox, where the extended family lived, and everyone black worked for white people. When James was born, his father was as a baker, but he soon became an Episcopal church sexton. James went to school with children who were Irish, Canadian, and Scottish, and often the VanDerZee children were the only blacks in the school. Although he liked his teachers, James didn't care for studying, but he excelled in areas where he could use his imagination. His entire family was musically inclined, and they encouraged their children to excel both intellectually and artistically.

James was always fascinated by images, and his interest in photography grew from looking at pictures of all kinds. His first camera was a prize for selling a number of packets of ladies' sachet powder. None of the images he took from this camera turned out, but the experience challenged him to learn more. Shortly before he turned 14, he purchased a second camera from doing odd jobs and started to teach himself what he needed to know.

In 1905, VanDerZee moved to New York, which he found exhilarating. Soon after, VanDerZee met Kate L. Brown, who became his wife after she got pregnant. Shortly afterward, his daughter Rachel was born. Kate was not always supportive of VanDerZee's interest in photography; consequently, he worked as an elevator operator to bring in a steady paycheck. The marriage did not last, and in 1916, Kate took Rachel and left VanDerZee. It wasn't long before Gaynella Greenlee came into his life. They married after VanDerZee secured a divorce and Gaynella's first husband passed away. Although Gaynella was of European descent (a German father and a Spanish mother), when asked, she claimed to be a light-skinned black woman.

VanDerZee had left high school without earning a diploma. He was a photographer who was largely separated from the aesthetic discussions of the art world. And yet, as a photographer who basically taught himself what he needed to know, he had a highly developed, sophisticated aesthetic.

In Harlem, he was called a "professor," a term of respect often given to musicians. VanDerZee performed in the orchestras at the Lincoln Theatre, playing for silent films and the Apollo Theatre in Harlem. He also played violin in the Harlem Orchestra though it is said that he was equally as good on the piano. He felt that this was ironic since he was not able to get a formal education. Although he didn't regard himself as an expert musician, he recognized that he was better than most. His performance was well received by his community, he once said, because he played songs that had the kind of melody that was easy to follow and enjoy.

VanDerZee lived in his first wife's hometown of Phoebus, Virginia, for a short period of time, from 1907 to 1908. Here, he documented town activities along with the educational experiences of students and teachers at Hampton Institute (now Hampton University), a well-known school that was founded in the 1860s to educate Native Americans and African Americans. In these images, VanDerZee depicted teachers as powerful people who have the ability to change their students' lives. They look directly at the camera indicating that they are on an equal level with viewers.

In the early days, before flash bulbs, he used flash powder like everyone else. VanDerZee knew that if you used too much at one time, you could burn yourself. Reflecting on the smoke the powder made, he explained, "You'd open the lens of the camera, let the powder go off—bang!—and close the camera up. Course there was a great deal of smoke to it afterwards. If there was a high ceiling it was all right, because it took a little time for the powder to go up and come down. I'd try to make a second shot quick, because when all that smoke came down everyone would start coughing and choking" (Johnson 104).

In 1916, he and Gaynella opened the Guarantee Photo Studio in New York where he photographed notable figures from the Harlem Renaissance along with many middle-class African Americans. Unlike many of the notable photographers of his generation, he did not work for any of the popular magazines; instead his clients were the everyday

James VanDerZee. *Black Cross Nurses Watching a UNIA Parade on Seventh Avenue* (1924). Gelatin silver print. 4½ × 6½ inches (11.43 × 16.51 cm). San Francisco Museum of Modern Art. Collection of the Prentice and Paul Sack Photographic Trust.

people in Harlem, and they allowed him to pay his bills. While he is known for the celebrity portraits he took, what they provided him with was a reputation that attracted the ordinary Harlem resident. Among the famous figures are his portraits of performers Florence Mills, Mamie Smith, and Bill "Bojangles" Robinson, athletes from the New York Black Yankees, and heavyweight boxing champions such as Jack Johnson, Hally Wills, Sam Langford, and Joe Louis. He photographed the poet Countee Cullen, and religious leaders such as Daddy Grace and Adam Clayton Powell, Sr. He also photographed Marcus Garvey, the leader of the black nationalist movement. By the 1920s, his photographic style had been established. He wanted every picture to look better than the person who posed.

Because his income depended on the middle class, he knew that he had to make each individual and group feel unique. He was good at finding multiple ways to pose his subjects and make them feel special. He used his imagination and often retouched or hand-colored a print, sometimes making a nose sharper or another facial feature look better. He would correct poor dental work or spruce up worn-out clothing. He repeatedly used a few favorite props, which included a cutout of a cocker spaniel, a simulated fireplace, elaborately painted

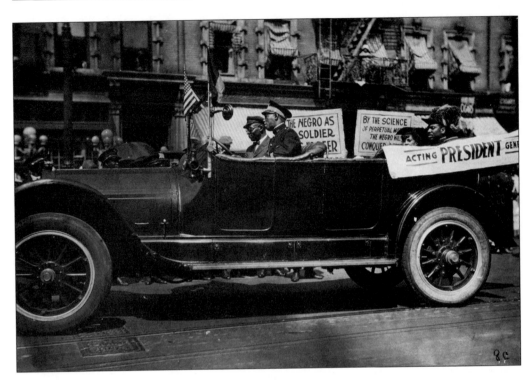

James VanDerZee. *Marcus Garvey, United Negro Improvement Association Parade, NYC* (1924). Gelatin silver print, 4⅝ × 6⅞ inches (11.75 × 17.46 cm). San Francisco Museum of Modern Art. Collection of the Prentice and Paul Sack Photographic Trust.

backdrops, and a doll that could substitute for a child. When making mortuary portraits, he would sometimes place a previous portrait of the deceased with the open casket image to depict a kind of life-after-death idea or to help viewers remember the subject in life. VanDerZee enjoyed hand-coloring directly on a print. Working with either oil or watercolors, he could change the color of a dress or brighten up a bouquet of flowers.

VanDerZee made greeting cards and calendars to help increase his income. He would creatively write "Merry Christmas" in a subject's cigarette smoke or find some other way to capture the interest of a paying customer. He also restored old photographs when he could.

In 1969, the Metropolitan Museum of Art curated an exhibition with VanDerZee's photographs titled, "Harlem on My Mind." One of the largest exhibitions the Metropolitan had ever mounted at the time, it occupied 13 galleries. Besides photographs, it included music and audio of people talking. Thomas Hoving, then director of the museum, claimed that in his mind VanDerZee was "the single most important contributor to the show" (Hoving 165). In his book, *Making the Mummies Dance*, Hoving describes his curatorial staff's early meeting with the photographer, "They found a harried man in his

seventies surrounded by dozens of cardboard boxes filled with thousands of photographs and negatives. Each was labeled by the year and identified every person in the shot. These photos—from the twenties up to 1968—chronicled almost every aspect of Harlem" (Hoving 165). The curators immediately understood that they had "stumbled across not only the backbone of the show but one of the country's most important photographic archives as well" (Hoving 165–166).

The exhibition quickly brought international attention to VanDerZee's work. However, at that time the artist and his wife had just been evicted from the Harlem home they had lived in since 1945. A bag filled with his negatives and prints was placed on the sidewalk. So stressful was this event for his wife Gaynella that she fell ill with senile dementia, a condition that she would have until her death seven years later.

The exhibition at the Metropolitan jump-started a career that had been waning over the past years making it impossible to pay bills. VanDerZee was grateful for the attention. But his show created a great deal of controversy. Some people felt it wasn't politically driven enough as it didn't deal directly with discrimination and segregation. Others felt it focused too much on the past. His images of well-dressed, good-looking middle-class black people enjoying their well-furnished homes were something new to the museum visitor. He depicted an African American world where people worked hard, loved their families, and enjoyed life in spite of racial prejudice and hostility.

VanDerZee taught himself to be a great photographer. He recognized where his talent came from: "Being an artist, I had an artist's instincts. Why, you have an advantage over the average photographer. You can see the picture before it's taken; then it's up to you to get the camera to see it" (Johnson 104). He died in Washington, D.C., shortly before his 97th birthday. He was a man with a good memory, a strong sense of humor, and a keen eye for composition. Throughout his life, he exhibited a remarkable confidence. VanDerZee's archival materials can be found in the Studio Museum in Harlem.

Bibliography

Guilmond, James. *American Photography and the American Dream*. Chapel Hill: University of North Carolina Press, 1991.

Haskins, Jim. *James VanDerZee: The Picture-Takin' Man*. Trenton, NJ: Africa World Press, 1991.

Hoving, Tomas. *Making the Mummies Dance: Inside the Metropolitan Museum of Art*. New York: Simon and Schuster, 1993.

Johnson, Brooks. *Photography Speaks: 150 Photographers on Their Art*. New York: Aperture, 2004.

Westerbeck, Colin. With an essay by Dawoud Bey. *The James VanDerZee Studio*. Chicago: The Art Institute of Chicago, 2004.

Willis, Deborah. *Reflections in Black: A History of Black Photographers, 1840 to the Present*. New York: W. W. Norton, 2000.

Willis-Braithwaite, Deborah. *VanDerZee: Photographer, 1886–1983*. Biographical essay by Rodger C. Birt. New York: Harry N. Abrams in association with the National Portrait Gallery, Smithsonian Institution, 1993.

Places to See VanDerZee's Work

Corcoran Gallery of Art, Washington, DC
Fred Jones Jr. Museum of Art, University of Oklahoma, Norman, Oklahoma
Los Angeles County Museum, Los Angeles, California
Museum of Fine Arts, Houston, Texas
Smithsonian Institution, Washington, DC
Studio Museum, Harlem, New York

TODD WALKER

1917–1998

TODD WALKER CROSSED AESTHETIC AND STYLISTIC BOUNDARIES WITHIN photography from military documentation to commercial advertising to creative experimentation and finally to the classroom as an educator. Harold Todd was born on September 25, 1917, in Salt Lake City, Utah. He moved to Los Angeles, California, with his family as a child. His father worked as a civil engineer and architect at Hollywood motion picture studios and introduced photography to his young son. Walker recalled spending time in a makeshift darkroom in their bathroom, watching his father develop images for work. Greatly influenced by his father, Walker started taking photographs with a box camera and shot images of airplanes at a field near Glendale as a young boy. Unfortunately, Walker's father died when he was just 14 years old during the Great Depression, leaving him to provide for his mother and sister.

With his father's reputation at the studios, Walker got a job working as a painter and set designer for the motion picture studios and then at the scenic department at RKO Radio Pictures in Hollywood. While he was working at RKO, Walker saw the first issue of *Life* magazine, which heightened his interest in photography. In 1938, the first issue of *U.S. Camera* was published and featured the abstract photographs by **Edward Weston**, which profoundly impacted Walker's notion of modern photography.

He started experimenting with enlarging photographic images from his father's old plate back camera and eventually built his own enlarger. By this time Walker had joined a photography club at the studio, where he learned more techniques and processes. He would arrive early to the meetings and get advice from Ernie Bachrach, who helped him experiment with various processing formulas. Walker learned about the chemistry of photographic processing through these experimentations.

In 1939, he attended Glendale Junior College, where he took classes in art history, drawing, chemistry, and photography. Walker was interested in attending the Art Center School in Los Angeles but was unable to afford full-time tuition and support his mother and sister

at the same time. However, he could pay for a six-week summer course on creative photography. In this course taught by Eddie Kaminski, Walker photographed nature scenes at the beach and learned how to manipulate the film by cutting and pasting his photos into collages. He also learned how to use *solarization*, where the image is exposed to ultraviolet lights or x-rays to produce distorted color effects.

In 1941, he ran out of money for classes and decided to apply for a scholarship to continue his education. However, his application was denied, and Walker was forced to leave school. He decided to try and find a job using his photographic skills. Walker put together a portfolio, and before long he was hired as a contract photographer for Tradefilms in Hollywood. His first assignment was to make instructional photographs for learning how to use flush rivets on the wing of an airplane. Walker's work was well received, and he was hired to do a second project. He continued on with Tradefilms and became involved with experimentation in aerial photography. During an excursion with a test pilot, Walker took photographs and played with attaching the camera to the plane's wing. He was exhilarated by this experience, which influenced Walker's interest in becoming a pilot himself.

Up to that point Walker had been receiving annual draft deferments from the military because he was the sole supporter of his mother and sister. Yet in 1943, Walker failed to file his deferment papers in time, and he was drafted into the U.S. Army. He completed pilot training at Williams Field in Arizona and became a Second Lieutenant Pilot. For the first couple of years in the Army, Walker was restricted from taking photographs since he was unable to have a camera. However, toward the end of the war, he had the opportunity to work in the darkroom in the portrait studio on the Luke Field base in Phoenix, Arizona.

After World War II Walker embarked on a career in commercial photography. He opened a studio in Beverly Hills, California, where he worked as an independent contractor in advertising, industrial, and editorial work until 1970. Through the 1950s Walker made a name for himself as a commercial photographer, and his work was published in popular magazines such as *Life*, the *Saturday Evening Post*, and *Ladies' Home Journal*. He won several awards from the American Institute of Graphic Arts through the 1950s and 1960s. Despite such grand achievements in commercial photography, he longed for creative freedom.

In his own time Walker began to experiment with various styles including *modernism*, the *California Landscape School*, editorial photojournalism, and documentary. Likewise, he explored various photographic techniques, such as working with blueprints, *collotype*, *photolithography*, *gum printing*, and *silk-screening* processes. In an early untitled work, Walker used several effects to create a collage with various colorings of the same image of a nude figure lying in the grass. In another untitled image from 1970, a woman is encased in fabric stretched tight over her body as if she were in a cocoon. The black-and-white image has been distorted and multiplied to create a surreal effect. These images are a stark contrast to his work photographing Chevrolets and commercial advertisements. Although this work was often misunderstood, his pursuit of the creative image was endless.

In the mid-1960s Walker began creating handmade books when his wife Betty gave him a small offset printing press. He wrote, designed, and produced many limited editions of books with photolithographs of his work. Walker said of his work and process:

> I see things in relationship: how one thing falls against another, whether it's the way a line appears or the way a value is altered by what's next to it. For me the camera opened up the possibility of perceiving what was actually in front of me. It's still exciting for me to look at something and realize something about it that I hadn't realized before. (Johnson 3)

In 1966, he accepted a teaching position in the photography department at the Art Center College of Design in Los Angeles. He held short teaching assignments at the University of California in Los Angeles and at California State College in Northridge and gave dozens of lectures at schools around the country including Penland School of Crafts in North Carolina, Oakland Museum of Art in California, Philadelphia College of Art, and Atlanta

Todd Walker. *Untitled* (n.d.) Photographs, mixed printing techniques, 19¾ × 16 inches (50.2 × 40.6 cm). Walker Image Trust. High Museum of Art, Atlanta; Gift of Hogtown Original Graphics Society, 19978.5 K.

College of Art. In 1970, he was approached by photographer **Jerry Uelsmann** to swap houses so that Uelsmann could teach at UCLA, and Walker could teach at the University of Florida in Gainesville. Walker closed his commercial studio permanently and moved to Gainesville, where he taught for the next seven years. In 1977, he was offered a position at the University of Arizona in Tucson, where he worked until 1985, at which time he retired and was given Professor Emeritus status. After retiring from teaching Walker experimented with computer-based photography.

His exhibition record is extensive. Walker's photographs have been in solo and group shows all over the world in venues such as the Center for Creative Photography in Tucson, Arizona; Santa Fe Center for the Arts in New Mexico; San Francisco Museum of Modern Art; Philadelphia College of Art; Light Gallery in New York City; Texas Center for Photographic Studies in Dallas; University of Alabama in Birmingham; the International Center of Photography in New York City; the Venice Bienniale in Italy; and the Festival of Royan in France.

Walker was married for 44 years before his wife, Betty, died. They had two daughters, Melanie and Kathleen. He had a reputation for being a strong family man and reportedly talked about his family incessantly at work. He died on September 13, 1998. He was passionate about his work and dedicated his life to the pursuit of creativity in photography, although he shyed away from the term "artist," Walker remarked:

> I wonder what art is about and I'm not sure that what I do is art because I'm a photographer, not an artist. But whatever you do, the secret is to do what you think you ought to do, and do the hell out of it! (Morrissey)

Pilot, educator, and photographer, Todd Walker dedicated his life to the quest of pushing the limits of photography as an artistic medium.

Bibliography

Coleman, A.D. "Latent Image: Lights on & Chin Up." *The Village Voice*, November 18, 1971: 32–33.

Johnson, William S. "Todd Walker." *Afterimage* 26, no. 3 (November/December 1998): 3.

Kelly, Charles. "Todd Walker: An Interview." *Afterimage* 21, no. 1 (March 1974): 2–5.

Morrissey, Thomas F. "An Interview with Todd Walker, ca. 1978." Retrieved January 20, 2007, from http://personal.riverusers.com/~jdf/todd_walker/intvw.html.

Rice, Leland. "Photography: Expanding the Art of Photography." *Artweek* 1, no. 31 (September 19, 1970): 7.

Wise, Kelly, ed. *The Photographer's Choice: A Book of Portfolios and Critical Opinion.* Danbury, NH: Addison House, 1975.

Places to See Walker's Work

Brooklyn Museum of Art, Brooklyn, New York
California State University at San Diego, San Diego, California

Center for Creative Photography, University of Arizona, Tucson, Arizona
The Art Institute Chicago, Chicago, Illinois
Columbia College Gallery, Chicago, Illinois
Crocker Art Museum, Sacramento, California
Fogg Art Museum, Cambridge, Massachusetts
George Eastman House, Rochester, New York
High Museum of Art, Atlanta, Georgia
Minneapolis Institute of Art, Minneapolis, Minnesota
Mint Museum of Art, Charlotte, North Carolina
Museum of Fine Art, St. Petersburg, Florida
Museum of Modern Art, New York, New York
National Gallery of Canada, Ottawa, Ontario
New Orleans Museum of Art, New Orleans, Louisiana
New York Public Library, New York, New York
Oakland Art Museum, Oakland, California
Pasadena Art Museum, Pasadena, California
Philadelphia Museum of Art, Philadelphia, Pennsylvania
Phoenix College, Phoenix, Arizona
Phoenix Public Library, Phoenix, Arizona
Portland Museum of Art, Portland, Oregon
Rutgers University Library, Special Collections, Camden, New Jersey
San Diego State College, San Diego, California
San Francisco Museum of Modern Art, San Francisco, California
Sheldon Art Gallery, Lincoln, Nebraska
Southern Illinois University, Carbondale, Illinois
University of Alabama, Tuscaloosa, Alabama
University of Arizona Library, Special Collections, Tucson, Arizona
University of California at Los Angeles, Los Angeles, California
University of Colorado Library, Special Collections, Boulder, Colorado
University of Florida Library, Special Collections, Gainesville, Florida
University of Kansas, Lawrence, Kansas
University of Northern Iowa, DeKalb, Iowa
University of Oklahoma, Norman, Oklahoma
University of Virginia, Charlottesville, Virginia
Utah Museum of Fine Arts, The University of Utah, Salt Lake City, Utah
Utah State University, Logan, Utah
Virginia Museum of Fine Arts, Richmond, Virginia

CARRIE MAE WEEMS

b. 1953

AN INTERNATIONALLY ACCLAIMED ARTIST, CARRIE MAE WEEMS WORKS AT the juncture of possibility that is riddled with complexity and tension. It is as if her work is both a captured moment in time and a narrative, fluid through time and space. Grounded in African American folklore, her work demands a viewer's participation, shaping our identity as a dialogue begins on the topics of race, gender, oppression, and place. In this dialogue the photographer transports us in a space of hope, grace, and transcendence. Because of the way that she works and the purpose of her activity, Weems is identified as a photographer, installation artist, folklorist, storyteller, cultural historian, anthropologist, educator, critic, activist, and mythmaker. She often calls herself "an image maker."

Weems was born in Portland, Oregon, in 1953, and her parents were working-class people from Mississippi. Before starting her college education, she had had a number of working-class jobs and had engaged in activist work, identifying herself as a feminist. In 1979, at the age of 27, she enrolled in the BFA program at the California Institute of the Arts, earning her degree in 1981. Here she began her work photographing African Americans. Her inspiration at this time came not from her art professors, but from her literature and folklore teachers. She continued her education at the University of California, San Diego, where she earned her MFA in 1984. Here she met Fred Lonidier, the first photography professor who gave her serious critical feedback on her images. Searching for black photographer role models, she found the work of **Roy DeCarava,** who she admired for his commitment to his own community. Later she discovered the famous folklorist, anthropologist, and writer Zora Neale Hurston, who became a role model as well.

Weems's early work used the informality of the snapshot and perspective of the first person to construct a history of the African American people that is largely invisible. Her series *Family Pictures and Stories* (1978–1984) depicts everyday experiences and relationships.

Narratives help create a story. For example, *Welcome Home*, a picture of the artist and a rela-
tive, gives us this text:

> I went back home this summer. Hadn't seen my folks for awhile, but I'd been think-
> ing about them, felt a need to say something about them, about us, about me and
> to record something about our family, our history. I was scared. Of What? I don't
> know, but on my first night back, I was welcomed with so much love from Van and
> Vera, that I thought to myself, "Girl, this is your family. Go on and get down."

As she worked to understand her own family through the lens of a 35mm camera,
Weems became increasingly interested in folklore and storytelling. Wanting to learn more,
she entered her second master's program, this time at the University of California, Berkeley.
Here she worked with Alan Dundes, who was expanding folklore theory to incorporate
material culture. He helped her see that she could look at photography as folklore. She also
began to see how jokes could be used in her work to address topics that were otherwise off
limits.

Her series of works titled *Ain't Jokin* (1987–1988) uses jokes to explore extremely diffi-
cult issues. She makes visible deep-seeded thoughts, inviting the viewer to react. Sometimes
she poses a question, used as a title, such as *"how do you get a nigger out of a tree?"* or *"what's
a cross between an ape and a nigger?"* Pictures illustrate the racist statements in ways that
horrify while they draw you in. Others, more simply, give a descriptive title such as *Black
Woman with Chicken*, which captions a young attractive black woman with a fried chicken
leg, thereby building on a stereotype. One of her most reproduced works comes from this
series. Titled *Mirror, Mirror*, it questions the idea of beauty. An attractive black woman
looks into a mirror she is holding as a rather frightening white woman, dressed in a white
hat and veil and holding a star, looks back at her. The caption reads: *"Looking into the mirror,
the black woman asked, 'Mirror, Mirror on the wall, who's the finest of them all?' The mirror says,
Snow White you black bitch, and don't you forget it!!!"*

American Icons (1988–1989), another one of her series, looks at how stereotypical black
images are used in everyday items. Photographed are ashtrays, salt and pepper shakers,
and various other popular culture items that demean African Americans. In 1989–1990,
Weems pushed her exploration of racist ideas further in her series *Colored People*. Facial
portraits of men, women, and children where tinted with various colors. Sometimes the
images were repeated. Below each photograph, which is mounted and framed in black, are
the words such as *"Magenta, Colored, Girl,"* each word titling an identical image that changes
with the meaning of the word.

In *Untitled (Kitchen Table Series)* (1990), Weems begins an investigation of gender.
This series of 20 images and 13 text panels portrays Weems herself, sometimes alone, and
sometimes with children, other female friends, and a male visitor. They are all staged around
a table, beneath one single hanging light. The viewer is situated at one end of the table.

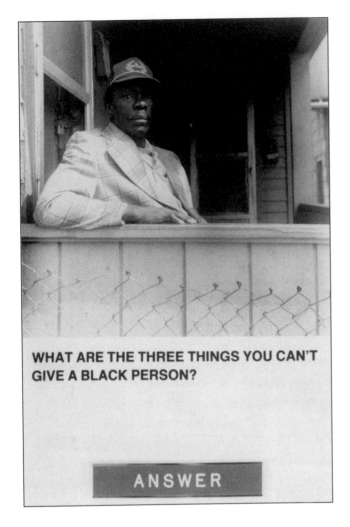

WHAT ARE THE THREE THINGS YOU CAN'T GIVE A BLACK PERSON?

ANSWER

Carrie Mae Weems. *Ain't Jokin', What are Three Things You Can't Give A Black Person?* (1987–1988). Gelatin silver prints with text panels, 16⅝ × 14⅜ inches, ed. 5. Collection of the Modern Art Museum of Fort Worth, Museum purchase made possible by a grant from the Burnett Foundation.

While these images, at first glance, seem to be about a black female subject, they transcend both race and gender, making a statement about the black subject as being more universal and less restricted to an isolated identity. These images are about how we construct our lives in the presence of others.

Weems followed this work with *Sea Island Series* (1991–1992), *Africa Series* (1993), and a group of photographs and captions called *From Here I Saw What Happened and I Cried* (1995–1996). In these powerful and highly significant photographs, Weems responds to an exhibition of rare photographs of African Americans from 1840 to the 1860s exhibited at the Getty Center. Using captions and her narrative technique, she created an alternative history, one that places the viewer in much the same position as the narrator. An African woman begins the sequence with the title words of the series, and she ends with the words, "*And I cried.*" In between these two images that face each

Carrie Mae Weems. *Untitled* (Kitchen Table Series) (1990). 27¼ × 27 inches. Gelatin silver print with text panels. Collection of the Modern Art Museum of Fort Worth, Museum purchase made possible by a grant from the Burnett Foundation.

other are portraits of other re-photographed and colored images of African Americans who worked in various demeaning positions. Some are tortured; others are stereotyped. These works raise important questions about identity, context, and historical understanding.

More recently Weems displayed her work in the exhibition *Cuba on the Verge: An Island in Transition*. Her works came from her *Dreaming in Cuba* (Afro-Cuban Identity) series. One large gelatin silver print, 31 inches square, called *In the Halls of Justice* shows a striking woman balancing on a marble balustrade. The strong and massive architectural space surrounds her as she looks at a light in the distance. Edward Leffingswell, a writer for *Art in America*, claims "Weems finds the general in the specific, her figures at once resolutely individual and representative of some quality of character, patient observation, consolation, healing and endurance" (Leffingwell 67).

Weems is now working with film, continuing her efforts to establish a strong presence of the African American middle class is mainstream history. She continues to explore the distance we have in relationships, between races and genders, between nationalities and the hierarchical structures, such as the ones found between those who own land and businesses and those who work for them. Her work continues to develop as she blends more ingredients into her installations. In addition to the words and captions for which she is known, she has added various kinds of sound, audio narrative and music, and she has incorporated sculpture with her work.

Weems means to change the world with her work. She says, "My responsibility as an artist is to work, to sing for my supper, to make art, beautiful and powerful, that adds and reveals, to beautify the mess of a messy world, to heal the sick and feed the helpless; to shout bravely from the roof-tops and storm barricaded doors and voice the specifics of our historic moment" (Patterson 22).

Bibliography

Heartney, Eleanor. "Carrie Mae Weems." *ARTnews* 90, no. 1 (1991): 154–155.

Kirsh, Andrea, and Susan Fisher Sterling. *Carrie Mae Weems.* Washington, DC: The National Museum of Women in the Arts, 1993.

Larsen, Ernest. "Between Worlds." *Art in America* 76, no. 5 (1999): 122–129.

Leffingwell, Edward. "Photography: Focus on Cuba." *Art in America* 81, no. 11 (2003): 66–69.

McInnes, Mary Drach. 1999. *Telling Histories: Installations by Ellen Rothenberg and Carrie Mae Weems.* Seattle: University of Washington Press and Boston University Art Gallery.

Patterson, Vivian. 2000. *Carrie Mae Weems: The Hampton Project.* Williamstown, MA: Aperture, in association with Williams College Museum of Art, Williamstown, MA.

Piché, Thomas, Jr., and Thelma Golden. *Carrie Mae Weems: Recent Work, 1992–1998.* New York: George Braziller Publisher, in association with Everson Museum of Art, Syracuse, NY.

Princenthal, Nancy. "Carrie Mae Weems at P.P.O.W." *Art in America* 81, no. 6 (2003): 123.

Places to See Weems's Artwork

Everson Museum of Art, Syracuse, New York

Fabric Workshop and Museum, Philadelphia, Pennsylvania

The Jewish Museum, New York, New York

Maier Museum of Art at Randolph-Macon College, Ashland, Virginia

Modern Art Museum of Fort Worth, Fort Worth, Texas

Norton Museum of Art, West Palm Beach, Florida

Santa Barbara Museum of Art, Santa Barbara, California

Whitney Museum, New York, New York

WILLIAM WEGMAN

b. 1943

BORN IN HOLYOKE, MASSACHUSETTS, ON DECEMBER 2, 1943, WEGMAN developed an early interest in art. He received his first Polaroid camera as a young boy and instantly fell in love with photography. Although he worked with photography experimentally, Wegman was focused on developing his skills and talents in painting. He studied painting in college and graduated with his BFA in 1965 from the Massachusetts College of Art in Boston. Directly after college he enrolled in graduate classes, and in 1967, he graduated from the University of Illinois in Champaign-Urbana with his MFA in painting.

Wegman accepted a faculty position at the University of Wisconsin and taught at the Wausau, Waukesha, and Madison locations. He worked in Wisconsin for two years before moving to Long Beach, California, for a one-year teaching position at California State College. During his years as an educator, he began to depart from painting and started experimenting with photography and videography. In one of his early series of photographs, titled *Family Combinations* (1972), Wegman superimposed images of himself, his mother, and his father on top of each other, in combinations such as mother/son, mother/father, and father/son.

Just after he moved to Long Beach, California, in 1970, Wegman adopted a Weimaraner, and he named the dog Man Ray. His name was in honor of the photographer **Man Ray,** whose work greatly influenced Wegman. Wegman left teaching in 1972 and moved to New York City with Man Ray. He began to photograph and videotape Man Ray in humorous poses with a sundry of unlikely props for the next 12 years. Man Ray was photographed in bed with another dog lying in front of a television as if they were watching together, learning to drink milk out of a glass, transformed into another animal, or simply in various natural dog stances that accentuated his natural beauty. Wegman's photographs of Man Ray reveal an admiration and love for his dog. His working and personal relationship with Man Ray

would prove to be one of the most important in the elevation of his career from artist to the level of popular culture interest. Wegman and Man Ray were invited to appear on the Johnny Carson show. Years later Wegman was invited on the David Letterman Show with two other of his dogs.

After Man Ray died on March 27, 1982, Wegman decided that no other dog would ever replace his beloved friend, and he would not adopt another dog. In January 1983, Man Ray was named The Man of the Year by New York's *The Village Voice*. The image of Man Ray on the front cover compounded Wegman's depression and feelings of loss. For the next couple of years, Wegman photographed anything but dogs. In 1984, he was unexpectedly reunited with the canine species during a trip to Memphis, Tennessee. He was giving a guest lecture at Memphis State University about his work with Man Ray when a professor approached him about her Weimaraners that she bred and invited him out to her farm. After much hesitation and commitment to not adopting a dog, Wegman agreed to visit the dog farm.

There he met Fay, and it was love at first sight. In 1986, Fay moved to New York City to live with Wegman. Fay was indeed a different dog from Man Ray, and she needed wide

William Wegman. *Dusted* (1982). Color Polaroid, 24 × 20 inches. Courtesy of the artist.

open spaces to run and play. The hustle and bustle of the big city was overwhelming and even frightening for this country dog. Wegman decided to buy some land in Maine. He built a studio on the farmland so that he could spend extended periods of time painting while Fay ran and played freely. At first he kept his vow not to photograph dogs again and did not take Fay's photograph. After several months of training and bonding with Fay, Wegman finally broke down quite unexpectedly and spontaneously. During a shoot in the woods, with Fay at his side, he was struggling with setting up a costume on a branch, but the costume remained lifeless and kept falling down. Fay was sitting dutifully by, and Wegman called her over, and within seconds she was donning the Halloween mask and ready for action. *Wonder Woman* (1986) was the first of many photographs of Fay.

Wegman resumed photographing dogs with a vengeance, and Fay was his new starlet. He dressed her in fanciful hats and long curly wigs and other guises and posed with human bodies as if she was half dog/half human. He scoured thrift stores for dresses and other clothing that she could wear for his pictures. Fay had a litter of puppies in 1989, and one of those puppies had a litter in 1995 expanding their family and cast of characters.

Undoubtedly, he is most well known for photographing his now-famous Weimaraners; however, he has completed other notable projects as well. Wegman has produced several books using Fay and her children to play out various traditional fairytales and children's stories that he wrote himself, such as *Little Red Riding Hood*, *Mother Goose*, *Farm Days*, *Surprise Party*, and *Chip Wants a Dog*. He has also produced numerous videos with his canine cast for *Saturday Night Live*, *Sesame Street*, and *Nickelodeon*. Wegman was commissioned by the First Lady Barbara Bush with her dog Millie and Millie's two-week-old puppies for the cover of *Life* magazine in 1988. In 2004, Wegman was commissioned by Crypton Super Fabrics, a textile manufacturer, to create a line of fabrics inspired by his infamous dog portraits. He designed several fabrics with canine images, including a pen and ink of a dog's profile. The commercial fabric is used in schools, hotels, hospitals, and sold in high-end pet stores and home decorating stores.

The special relationship Wegman has with his dogs is undeniable and unique with each dog. The stoic poses of Man Ray differ from the playful and often unsure glances seen in the face of Fay. Indeed he took note of the dog's role when comparing Man Ray and Fay in the studio. Wegman commented, "I was struck by the difference between her and Man Ray's balancing ability. With him you don't see the intensity, the struggle for equilibrium. Just the pose. I began to focus on Fay Ray's unique nature" (Wegman 1999: 36). Wegman's work has been exhibited around the world in venues such as Centre Pompidou in Paris, the Whitney Museum of American Art in New York City, Pace/MacGill Gallery in New York City, Marc Selwyn in Los Angeles, Sperone Westwater Gallery in New York City, and the Texas Gallery in Houston. Today, William Wegman lives and works in Maine and New York City, where he continues to receive artistic inspiration from his family of dogs.

Bibliography

Cohen, Joyce. "Massachusetts College of Art in Boston: William Wegman: Strange But True." *Art New England* 20, no. 2 (Februrary/March 1999): 43–44.

Simon, Joan. *William Wegman: Funny/Strange.* New Haven, CT: Yale University Press, in association with Addison Gallery of American Art, Andover, MA, 2006.

Want, Christopher. "Le Chien Man Ray." *Art Monthly* 208 (July/August 1997): 48.

Wasley, Paula. "Beyond Houndstooth." *Artnews* 103, no. 11 (2004): 35.

Wegman, William. *Fay.* New York: Hyperion, 1999.

———. *William Wegman Polaroids.* New York: Harry N. Abrams, 2002.

Places to See Wegman's Work

Albright-Knox Art Gallery, Buffalo, New York

Armand Hammer Museum of Art, University of California, Los Angeles, California

Brooklyn Museum of Art, New York, New York

Butler Institute of American Art, Youngstown, Ohio

Carnegie Museums of Pittsburgh, Carnegie Institute, Pittsburgh, Pennsylvania

Chrysler Museum of Art, Norfolk, Virginia

Contemporary Museum of Honolulu, Honolulu, Hawaii

Corcoran Gallery of Art, Washington, DC

Denver Art Museum, Denver, Colorado

Frederick R. Weisman Art Museum, Minneapolis, Minnesota

Freedman Gallery, Albright College, Reading, Pennsylvania

Honolulu Academy of Arts, Honolulu, Hawaii

John and Mable Ringling Museum of Art, Sarasota, Florida

Kemper Museum of Contemporary Art, Kansas City, Missouri

Los Angeles County Museum of Art, Los Angeles, California

Lowe Art Museum, University of Miami, Coral Gables, Florida

Massachusetts Institute of Technology, Cambridge, Massachusetts

Miami Art Museum, Miami, Florida

Minneapolis Institute of Arts, Minneapolis, Minnesota

Modern Art Museum of Fort Worth, Fort Worth, Texas

Museum of Contemporary Art, Los Angeles, California

Museum of Fine Arts, Boston, Massachusetts

Museum of Fine Arts, Houston, Texas

Museum of Modern Art, New York, New York

Neuberger Museum of Art, Purchase, New York

Philadelphia Museum of Art, Philadelphia, Pennsylvania

Scottsdale Museum of Contemporary Art, Scottsdale, Arizona

Smithsonian American Art Museum, Washington, DC

Southern Alleghenies Museum of Art, Loretto, Pennsylvania

Stuart Collection, University of California, San Diego, California

University of South Florida Contemporary Art Museum, Tampa, Florida

Walker Art Center, Minneapolis, Minnesota

Wegman World Web site: www.wegmanworld.com

Whitney Museum of American Art, New York, New York

EDWARD WESTON

1886–1958

EDWARD WESTON IS HERALDED AS ONE OF THE MOST SIGNIFICANT CON-tributors to modern abstract photography in the early twentieth century. Edward Henry was born in Highland Park, Illinois, on March 24, 1886, and lived primarily in Chicago throughout his childhood. He attended Oakland Grammar School and developed an interest in photography at an early age. Weston started photographing as a teen and received his first camera, a Kodak Bulls-eye #2, for his sixteenth birthday in 1902. He photographed the parks in Chicago and his aunt's farm, which garnered him much attention. In 1903, his work was included in an exhibition at The Art Institute of Chicago. The publication, *Camera and Darkroom*, printed his work in 1906. Shortly thereafter Weston moved to California to pursue a life as a photographer.

At first Weston worked as a surveyor for San Pedro, Los Angeles, and Salt Lake Railroad. He then went door to door to sell his services including photography of family pets, children, and funerals. Soon he realized that further training and education was necessary. Weston attended the Illinois College of Photography in Effington in 1908 for a one-year study program that he finished in six months. After completion he returned to Los Angeles where he went to work for George Steckel Portrait Studio as a *retoucher*. In 1909, he was hired by the Louis A. Mojoiner Portrait Studio as a staff photographer and quickly became proficient with lighting and posing the models. That same year he married Flora May Chandler, and they had four sons, Chandler, Brett, Neil, and Cole.

In 1911, Weston set up his first photographic studio in Tropico, California, (today known as Glendale). He worked out of this studio for the next 20 years. Weston's early work reflects the prevailing style of *pictorialism*, as in *Costume Study* (1916–1917), where the image is hazy and evokes a dreamlike quality. Here the model Yvonne Verlaine is draped in a flowing gown that pools on the ground in front of her, while another swath of fabric

hangs from the ceiling completely enveloping her in a shimmering encasement. He became known for photographing modern dance studies and high-profile portraits.

Weston met photographer Margrethe Mather in his Tropico studio when he hired her as his studio assistant. Mather was also his most frequent model during those years. He would later say that she was the first important woman in his life. During these years Weston began his shift from pictorialism to straight photography, which **Imogen Cunningham** credited to Mather's influence. A visit to the ARMCO Steel Plant in Middletown, Ohio, was also influential in Weston's stylistic shift. He was taken with the sharply focused images and later wrote: "The camera should be used for a recording of life, for rendering the very substance and quintessence of the thing itself, whether it be polished steel or palpitating flesh" (Cole Weston, par. 2).

By 1922, Weston was romantically involved with artist Tina Modotti. Together they began to travel regularly to Mexico. On certain occasions they took Weston's sons, Brett and Cole, who Weston mentored along the way and who both later became professional photographers themselves. In 1923, Weston and Modotti stayed on in Mexico and opened a photographic studio there. Although their relationship was brief, it was highly publicized and a topic of great controversy. Weston took many photographs of Modotti, such as *Tina Modotti, Half-Nude in Kimono* (1924). This provocative image shows Modotti's body but not her face, with a decorative kimono softly framing her body. A letter written on December 26, 1924, by Modotti to Weston reveals her deep affection for him:

> I will be a good girl while you are gone Edward—I will work hard—and that for two reasons: that you may be proud of me—and that the time of our separation may move more swiftly—Edward—beloved—thank you whatever comes! Tina. (Morgan, 2000, par. 14)

While in Mexico, Weston intermingled with artists Diego Rivera, Frida Kahlo, and David Siqueiros, who all highly respected his work in modern photography. He returned to California in 1926.

In 1929, he moved to Carmel, California. Weston continued photographing in the straight photography style. Along with artists **Ansel Adams**, Imogen Cunningham, Willard Van Dyke, and several others, he co-founded the photographer's group f64 in 1932. Their debut exhibition was at the M. H. de Young Memorial Museum in San Francisco on November 15, 1932. The group's name, f64, referred to the smallest aperture in a large format, 8 × 10 view camera (at that time) to create the sharpest image possible. The group's mission was to advocate photography as a medium that clearly and accurately represented the subject and to achieve the highest level of technical proficiency in the craft. Although Weston intended for the group to be as prominent as that of Stieglitz's 291 gallery in New York City, Group f64 only exhibited together a few times before disbanding. However, Weston and many others in the group maintained a straight photography philosophy throughout their careers.

Edward Weston. *Rubbish* (1939). Gelatin silver print, 7⅝ × 9⅝ inches (19.37 × 24.45 cm). San Francisco Museum of Modern Art. Albert M. Bender Collection, Albert M. Bender Bequest Fund Purchase. © 1981 Center for Creative Photography, Arizona Board of Regents.

In 1936, he received the first Guggenheim Fellowship awarded to photographers for his work. After completing the Fellowship he traveled throughout the West and Southwest photographing the landscape with his assistant and second wife, Charis Wilson. Weston became widely known for his abstract photography with sharp focus and clarity. He photographed close-ups of peppers, nudes, landscapes, shells, and even garbage. In *Rubbish* (1939) broken furniture pieces and the head from a decorative duck lay on the ground as if randomly discarded, but the composition is perfectly framed with the most delicate details in sharp focus. Here he transformed the objects from mere trash to artistic subject matter with his camera.

A prolific writer as well as visual artist, Weston kept a daily journal from about 1915 to 1934, which he called his *Daybooks*. He wrote at 5 A.M. each morning while consuming a strong pot of coffee. These books chronicled much of his life and would later be published in 1961 and then again in 1966. Weston wrote many articles about his work and philosophy in publications such as *American Photography*, *Photo Era*, and *Photo Miniature*.

In 1946, Weston was diagnosed with Parkinson's disease. That same year the Museum of Modern Art in New York City held a retrospective exhibition of his work. Over the next 10 years, as his health declined, he supervised the printing of his photographs by his sons Brett and Cole. Weston trained not only his sons in photography but also his grandson, Kim, as well. Today his great granddaughter, Cara Weston, is the co-trustee, Web site director, and photographer in her own right.

Weston died in his home in Carmel, California in 1958, and his ashes were scattered into the Pacific Ocean at Pebbly Beach at Point Lobos. Edward Weston was instrumental in the development of what became known as modern abstract photography and will be remembered for his vast oeuvre and the legacy of the Weston family of photographers.

Bibliography

Lowe, Sarah M. *Tina Modotti & Edward Weston: The Mexico Years.* London and New York: Merrell, 2004.

Marsching, Jane D. "Museum of Fine Arts/Boston: Edward Weston: Photography and Modernism." *Art New England* 21, no. 4 (August/September 2000): 37.

Metropolitan Museum of Art online. *Group f64.* Retrieved January 17, 2007, from http://www.metmuseum.org/toah/hd/f64/hd_f64.htm.

Morgan, Susan. "Romancing Edward: Love letter to Edward Weston." *Aperture* 159 (Spring 2000). Retrieved November 21, 2006, from http://vnweb.hwwilson.com.proxy.lib.fsu.edu/hww/results_single_ftPES.jhtml.

Stebins, Theodore E, Jr., Karen Quinn, and Leslie Furth. *Edward Weston: Photography and Modernism.* Boston: Museum of Fine Arts, in association with Bulfinch Press, Little, Brown, 1999.

Warren, Beth Gates. *Margrethe Mather & Edward Weston: A Passionate Collaboration.* New York and London: Santa Barbara Museum of Art, (Santa Barbara, CA) in association with W. W. Norton, 2001.

Weston, Cole. "Edward Weston Biography." *Edward-Weston.com: The Edward Weston/Cole Weston family website.* 2005. Retrieved January 17, 2007, from http://www.edward-weston.com/edward_weston_biography.htm.

Weston, Edward. *Edward Weston: The Form of the Nude.* London and New York: Phaidon Press, 2005.

———. *Edward Weston: The Last Years in Carmel.* Chicago: The Art Institute of Chicago, 2001.

Places to See Weston's Work

Art Institute of Chicago, Chicago, Illinois
Ball State Museum of Art, Muncie, Indiana
Brooklyn Museum of Art, Brooklyn, New York
Center for Creative Photography, University of Arizona, Tucson, Arizona
Dayton Art Institute, Dayton, Ohio
Edward Weston Web site: www.edward-weston.com
Fine Arts Museums of San Francisco, San Francisco, California
Fred Jones Jr. Museum of Art, University of Oklahoma, Norman, Oklahoma
Harvard University Art Museums, Cambridge, Massachusette
High Museum of Art, Atlanta, Georgia

J. Paul Getty Museum, Los Angeles, California
Metropolitan Museum of Art, New York, New York
Milwaukee Art Museum, Milwaukee, Wisconsin
Museum of Contemporary Art, Los Angeles, California
Museum of Fine Arts, Houston, Texas
Museum of Fine Arts, Santa Fe, New Mexico
Museum of Modern Art, New York, New York
New Orleans Museum of Art, New Orleans, Louisiana
New York Public Library, New York, New York
Phillips Collection, Washington, DC
Portland Art Museum, Portland, Oregon
Ruth Chandler Williamson Gallery at Scripps College, Claremont, California
San Francisco Museum of Modern Art, San Francisco, California
Worcester Art Museum, Worcester, Massachusetts

MINOR WHITE

1908–1976

MINOR WHITE WAS A FOUNDER OF *APERTURE* MAGAZINE, A TEACHER, A critic, and a leading twentieth-century photographer. Interested in Gestalt psychology, Zen, and meditation, he thought of his work as spiritual. He taught at the California School of Fine Arts and Massachusetts Institute of Technology (MIT) and was known for his unusual teaching methodologies. Like **Alfred Stieglitz, Paul Strand,** and **Imogen Cunningham,** White was a very influential modernist photographer. He wanted his photographs to visually suggest associations to the viewer. He once said, "Let associations rise like a flock of birds from a field" (White 1984: 15). White's photographs are often thought of as abstractions, since viewers are not always sure of what they are seeing. Images of paint peeling, water splashing against the rocks or sand, and clouds in darkened skies take on heightened and suggestive qualities in White's compelling photographs.

White was born in Minneapolis, Minnesota, as an only child. When he talked about his childhood, he spoke of his grandparents, who lived close by, and not his parents. His grandmother tended a garden, which he loved, and was a terrific cook. His grandfather was an amateur photographer, and Minor became interested in photography at an early age. He went to the University of Minnesota, where he studied botany and English. Until the mid-1930s, he concentrated on being a poet while he continued photographing. He was especially interested in William Wordsworth and William Blake. In 1937, he started documenting the architecture in Portland, Oregon. He became a member of the Portland Camera Club and learned as much as he could about photography by going to the library and reading. Soon he was hired as a "creative photographer" for the Works Progress Administration. In 1942, he was drafted into the army, where he stayed until 1945. While in the military, he joined the Roman Catholic Church to see if "praying used the same energies that creativeness did" (Baker 21). He soon found Catholic worship basically unsatisfying and stopped attending church. After the war, White moved to New York to learn about

museum work from famed photography historians Beaumont and Nancy Newhall. After a year he left New York with the Newhalls to teach at the California School of Fine Arts, where he stayed for seven years. Here he met Ansel Adams and **Dorothea Lange.**

In the 1950s White became increasingly interested in Zen ideas, which helped him formulate his theory of "Equivalence," a term he borrowed from Alfred Stieglitz. The central idea is that a photograph can produce an emotion that is different and unrelated to the subject matter portrayed in the image. White used the word to explain how a photographer or viewer can use the material world to elicit a way of corresponding or communicating that produces a deep kind of understanding about one's self and the world. Consequently, the content of White's photographs is not intended to be read literally. Instead, he believed the images should be read symbolically. He explains, "While rocks were photographed, the subject of the sequence is not rocks; while symbols seem to appear, they are pointers to the

Minor White. *Zion National Park, Utah* (1960). Gelatin silver print, 7½ × 9⅜ inches (19.05 × 23.81 cm). San Francisco Museum of Modern Art. Anonymous gift. Reproduced with permission of the Minor White Archive, Princeton University Art Museum. © The Trustees of Princeton University.

significance" (Johnson 194). He goes on to say, "the meaning appears in the space between the images, in the mood they raise in the beholder" (Johnson 194), an idea reflective of Abstract Expressionist painters such as Barnett Newman.

In 1952, White founded *Aperture* magazine with **Ansel Adams,** Dorothea Lange, and the Newhalls. He edited the first issue and stayed in this role until 1975, a year before his death. In the early years the magazine's format was modernist. Photographs were shown on clean white pages without distracting text. Information about the image was placed at the back of the magazine. From this perspective the photograph, and only the photograph, is to be critically seen and enjoyed. Any information that interfered with the pristine image was seen as hampering the formalistic way of seeing.

White was a striking man who was much photographed in his later years. He had long white hair and strong features. He had the ability to evoke responses from his students that tapped into their emotional response to a photograph. In this way he helped create a new kind of language for speaking about photographs. His contribution to teaching is as important as his photographic work. In 1969, he published his personal ideas in the book *Mirrors, Messages, Manifestations.*

As a professor at MIT, his teaching methods were unconventional. He wanted students to learn to meditate before they shoot, and he believed that the power of inducing a trance-like state would help his students learn to experience a print in a deep and meaningful way. Students were often reluctant to give as much as he asked. While communicating to others was extremely important to him, he was not always articulate. He was narrowly focused and not well informed about most areas of knowledge. But he had numerous disciples. It was not unusual for his apprentices to become live-in students in his home. They were his closest associates. In 1973, White had a stroke, and a student saved his life by giving him mouth-to-mouth resuscitation. Nonetheless, even students who lived in his home would say that they didn't really know him well. Minor White's life was spent joyfully experiencing the world with his camera. When he fell into depression, he dealt with it without human intervention. It was nature that came to his rescue. There is speculation that White was a closeted bisexual, and because he lived at a time when an open bisexual lifestyle was thought to be unacceptable, this may account for the distance and turmoil he often communicated to others.

White was also a founding member of the Society for Photographic Education. His dedication to photography and educating the public about it is evident in the creative community he helped create and sustain. In 1984, several years after his death, some of the students and friends wrote about the influence he had on their lives. *Minor White: A Living Remembrance* includes photographs by Ansel Adams, Alfred Stieglitz, **Judy Dater,** and **Aaron Siskind** among others and many quotes by White and his photographic community.

Stieglitz once asked White if he'd ever been in love, with the purpose of communicating that if someone could experience love, they could photograph. White replied affirmatively.

Minor White. *Vicinity of Dansville, New York* (ca. 1955); printed ca. 1976. Gelatin silver print, 9¼ × 12 inches (23.5 × 30.48 cm). San Francisco Museum of Modern Art. Gift of anonymous donor. Reproduced with permission of the Minor White Archive, Princeton University Art Museum. © The Trustees of Princeton University.

His personal life and feelings were seamlessly tied to his photography. This way of living and working is what made him such a powerful presence to others who came seeking his advice.

Ansel Adams remembers a lecture White gave in Tucson, Arizona, shortly before he died. He showed a series of color slides, all detailed images of sand and beaches. They were varied and detailed. As he moved from one slide to another, he said nothing. After the last slide was shown, he turned up the lights and said, "Thank you very much." It was his way of giving his audience a powerful experience.

Bibliography

Adams, Ansel. "My Last Memory of Minor." In *Minor White: A Living Remembrance*. Millerton, NY: Aperture, 1984, 30.

Barrett, Terry. *Criticizing Photographs: An Introduction to Understanding Images*, 3rd ed. Mountain View, CA: Mayfield Publishing, 2000.

Comer, Stephanie, and Deborah Klochko. Essay by Jeff Gunderson. *The Moment of Seeing: Minor White at the California School of Fine Arts*. San Francisco: Chronicle Books, 2006.

Danziger, James, and Barnaby Conrad III. *Interviews with Master Photographers*. New York: Paddington Press, 1977.

Hall, James Baker. "Biographical Essay." In *Minor White: Rites & Passages*. New York: Aperture, 1978, 16–21.

Johnson, Brooks. *Photography Speaks: 150 Photographers on Their Art*. New York: Aperture, 2004.

Minor White: A Living Remembrance. Millerton, NY: Aperture, 1984.

White, Minor. *Mirrors, Messages, Manifestations*. New York: Aperture, 1969.

Places to See White's Work

Art Institute of Chicago, Chicago, Illinois
Fogg Art Museum, Harvard University, Cambridge, Massachusetts
George Eastman House, Rochester, New York
Massachusetts Institute of Technology Museum, Cambridge, Massachusetts
Museum of Contemporary Photography, Columbia College, Chicago, Illinois
Museum of Modern Art, New York, New York
New York Public Library, New York
Princeton University Art Museum, Princeton, New Jersey
San Francisco Museum of Modern Art, San Francisco, California
Smithsonian Institution, Washington, DC

HANNAH WILKE

1940–1993

PHOTOGRAPHER, SCULPTOR, PAINTER, AND PERFORMANCE ARTIST, HAN-
nah Wilke broke ground in conceptual feminist art using her body as the central subject
matter. She was born Arlene Hannah Butter on March 7, 1940, in New York City. She
became fascinated with photography and with the nude female form in art at an early age.
Wilke began making self-portraits wearing only her mother's fur stole at the age of 14. Di-
rectly after finishing high school, she enrolled in art classes at the Tyler School of Art in
Philadelphia. There she earned her BFA and then her MFA in 1961.

After graduate school Wilke started experimenting with creating female genitalia out
of terra cotta, latex, plaster, dryer lint, and gum. Although much of her work was initially
focused on creating sculptural form, she eventually turned to her own body as the ulti-
mate subject matter. Wilke expressed feminist ideals in her artwork and used her own
nudity as a mechanism to do so. She said, "with the creation of a formal imagery that is
specifically female...Its content has always related to my own body and feelings, reflect-
ing pleasure as well as pain, the ambiguity and complexity of emotions" (Rosen 134).
Wilke was considered by many to be traditionally beautiful, and critics felt that she ran
the risk of exploiting herself in much of her performance and photographic work where
she appears partially or completely nude. She qualified her version of feminism and re-
sponded to these critics by stating that she was in control of her body and the representa-
tion of it.

In one of her most famous performances, Wilke performed a strip tease that she did as
part of a Marcel Duchamp installation at the Philadelphia Museum of Art in 1976, *Through
the Large Glass.* Dressed in a white fedora and suit, she posed dramatically and then began
to strip behind Duchamp's sculpture, *The Bride Stripped Bare by Her Bachelors, Even.* Here
Wilke used her sexuality to address the role of women in history as sex objects. While some

critics felt that she was perpetuating the female stereotype as sex symbol, others recognized that Wilke was asserting her control and shattering the image of victim.

In *S.O.S. Starification Object Series* (1974–1982), Wilke initiated the series with a performance and then organized the results into a grid of several black-and-white photographs. In the performance she gave audience members pieces of gum to chew which she shaped into tiny vulvas. She then put the gum all over her body in patterns similar to ritualistic scarring. She used the word *starification* as a pun on star/scar, which symbolized how the making of a Hollywood star is negative and can inflict psychological scars. S.O.S. signifies a cry for help. The tiny vulvas symbolize the mental and physical wounds that women suffer to achieve beauty through dieting, make-up, surgery, and by wearing restrictive clothing and shoes. She then photographed herself nude from the waist up and posed like a fashion model while adorned with these scars or tiny vulvas.

Wilke used the female body to confront issues other than sexuality and objectification. She also addressed illness and aging. In the 1970s she did a series of photographs

Hannah Wilke. *S.O.S. Starification Object Series* (1974–1982). Performalist self-portraits with Les Wollam, 10 black and white photographs, 15 gum sculptures, 41³/₁₆ × 58⅜ × 2¹⁵/₁₆ inches (F). Private Collection. Courtesy of the Ronald Feldman Fine Arts, New York. © Marsie, Emanuelle, Damon, and Andrew Scharlatt/Licensed by VAGA, New York, NY.

dealing with her mother's battle with cancer, *So Help Me Hannah*. This work resulted in 48 black-and-white self-portraits, which were accompanied by framed quotations by artists, philosophers, and critics. In one image with her mother, *Portrait of the Artist with Her Mother, Selma Butter* (1978–81), they are both nude from the waist up. Wilke stands strong and beautiful next to her mother's frail body marked with the scars from her mastectomy, conjuring thoughts about mothers and daughters, aging and illness. Although her husband Donald Goddard took these photographs, Wilke is the creative force behind these images. This is similar to the later work of Andy Warhol, where the staff at the factory actually completed the silkscreen prints that he designed and directed.

At the height of her career, Wilke was diagnosed with cancer. In the work that followed, Wilke gave us a gift of seeing her in the most vulnerable state of illness as she was physically ravaged with the disease and the effects of treatment. The *Intra-Venus* series is a group of 13 gigantic color self-portraits that deal with her sickness, which would become her last project. In these images Wilke is surrounded by the hospital setting while she appears to be calm. She shows us her balding head from the effects of chemotherapy, the tubes, hospital bed, and stark surroundings that remind us of dying and death. In *February 19, 1992 #6*, Wilke glares at us through her thinning hair and bloodshot eyes with a somber face. These stark images give us another side of Wilke, one that cannot be mistaken for glamour, sexual exploitation, or self-indulgence.

She died on January 28, 1993, after a seven-year battle with lymphoma. Posthumously, her work continues to be controversial. In 1999, the Copenhagen Contemporary Art Center and the Helsinki City Art Museum, in association with the Ronald Feldman Gallery in New York City and the Estate of Hannah Wilke hosted a retrospective of her work. However, with great disappointment the exhibition did not travel to the United States. Wacks (1999) suggested that perhaps curators are still baffled about how to classify her work, and even though decades have passed, they are still concerned that art audiences will not respond to her in-your-face approach to female nudity. Provocateur Hannah Wilke is an artist who put herself in the center of her art to address issues of female stereotypes, sexuality, objectification, aging, illness, and finally death.

Bibliography

Daigle, Claire. "Hannah Wilke." *Art Papers* 21 (January/February 1997): 60.

Lucie-Smith, Edward. *Art Today*. London and New York City: Phaidon Press, 1995.

Rosen, Randy. *Making Their Mark: Women Artists Move into the Mainstream, 1970–85*. New York: Abbeville Press, 1989.

Wacks, Debra. "Naked Truths: Hannah Wilke in Copenhagen." *Art Journal* 58, no. 2 (Summer 1999): 104–106.

Wilke, Hannah. *Hannah Wilke: A Retrospective*, ed. Thomas H. Kochheiser and essay by Joanna Frueh. Columbia, MO: University of Missouri Press, 1989.

Places to See Wilke's Work

California State University, Long Beach, California
David Winton Bell Gallery at Brown University, Providence, Rhode Island
Electronic Arts Intermix, New York, New York: www.eai.org
Ronald Feldman Gallery, New York, New York
Solway Jones Gallery, Los Angeles, California

DEBORAH WILLIS

b. 1948

WINNER OF THE PRESTIGIOUS MACARTHUR AWARD IN 2000, DEBORAH WILlis is a photographer, an art historian, a museum curator, an educator, and a prolific writer. Without a doubt she has had success with her efforts to make the contributions of black photographers visible and valued. Her books are in libraries and in the hands of students and scholars everywhere, and her many curated exhibitions have been praised and widely reviewed. As a photographer, she is a visual storyteller who gives voice to the black experience, with a focus on black women's lives.

Willis is currently a professor of photography and imaging at New York University's Tisch School of the Arts. She was born and raised in North Philadelphia. Her father was a policeman and a tailor as well as being the family photographer. A cousin, who lived close by her home, had a photography studio, so becoming a photographer seemed natural. Although she had little time to watch television, she understood early on that the programs she watched and the books and magazines she read that had black characters or images in them did not reflect the lives of the people she knew. The only difference was what she found in **Roy DeCarava's** photographs in the book *The Sweet Flypaper of Life* (1955), which he published with Langston Hughes. She remembers that before she went out to play, she had to finish chores she had in her home. Her mother had a beauty shop, where she listened to the women talk, gossip, and enjoy each other's company. Her aunts and cousins washed clothes for a living, and they were often the topic of the conversation.

She began teaching photography to others in her late teens. Willis studied liberal arts at Temple University in Philadelphia from 1967 to 1972. In 1975, she received her BFA from Philadelphia College of Art and in 1980 her MFA from Pratt Institute in Brooklyn. But her education didn't stop there. In 1986, she received another masters (an MA) in art history and museum studies at the City College of New York. In 2003, she was awarded a PhD

in cultural studies from George Mason University in Fairfax, Virginia. She has one son, Hank Willis Thomas, who is a photographer.

As an artist, Willis questions, "What did it mean for a black woman to be an artist in our grandmothers' time? In our great-grandmothers' day?" (Willis 2007). Like the celebrated author Alice Walker, she asks readers of her photographs and publications to think about the experience of black women in times when it was a crime to read and write, and an art education, or any formal education for that matter, was not an option. She asks that we think about ways in which the children and grandchildren of these women, who also lived in limiting circumstances, found ways to invent and experience themselves and their identities through creative means. By exploring these questions, she often looks to her own family history, using photographs from family albums, the family photographs she transfers onto her *photo-quilts* and installations about their lives. She explores her own family history "as well as her own photographs to make constructed and fabricated histories about black women and [other] women" (Willis 2007).

Continuing her interest in exploring the identity of black women, she has looked at what the physical body communicates in her series on bodybuilding. Her photograph *Nancy Lewis: Red Nails* (1999) is a rich color image of three figures with bright, glossy, red-polished fingernails situated between the muscular thighs of a female bodybuilder. Its color, detail, and texture are striking. In this series Willis draws connections between the past physical labor experienced by black women and the present body structure of a black female bodybuilder. This work also raises questions about gender, since men have traditionally been thought of as doing hard physical work. Willis explains that this series explores the ways in which the black female body can literally reconfigure itself. In 2002, she co-authored a book with Carla Williams on the topic titled *The Black Female Body: A Photographic History*.

Willis's mother is still a hairdresser. This personal history certainly influenced her desire to take photographs of activities within beauty shops. *Beauty Series 1; Mrs. Brown's Shampoo* (2000), for example, portrays the way in which black women care for each other in this space. Pictures on the walls depict images of black women and their hair, and combs, dryers, and other hair-care tools fill the room. Because hair has been a much debated and discussed characteristic of black women that reflects on identity, Willis's photographs of beauty shops become a catalyst for discussions about women's community space, the function of gossip and storytelling, and the place that hair plays in women's identity. For the photographer the beauty shop was the place that gave her the inspiration to learn about black women's lives and histories. Because the women who came into the shop were mostly day-workers and live-ins, they generally came on Saturdays and Sundays, a time when the artist was not in school and could spend time listening. She remembers, "They often spoke freely about the women they worked for and shared stories that were both humorous and humiliating encounters with their employers" (Willis 2007).

Deborah Willis. *Beauty Series* (n.d.). Courtesy of Deborah Willis and Bernice Steinbaum Gallery, Miami, FL.

Connecting the past experiences of black women with today's experiences is one of the artist's goals. By thinking of herself and her contemporaries in relationship to her ancestors and other black women from the past, she questions ideas that have been impressed in our minds about the ways that they have been represented and generally understood. In this manner she acknowledges that we are able to "become aware of the visual by decoding past and present images of black women" (Willis 2007). The story becomes important to Willis and, through her work, she wants to encourage other black women who have worked in cottage industries to speak about their lives and experiences.

Recognizing that the church is one of the most important places where black identity is formed, Willis took a picture of one of historic Eatonville, Florida's most important churches. In taking the photograph *The Pulpit, from Eatonville* (2003), she participated in the documentation of folklorist and writer Zora Neale Hurston's hometown as it adheres to tradition and adapts to the present.

Author of many books and essays, perhaps her most celebrated is *Reflections in Black: A History of Black Photographers, 1840 to the Present* (2000). This publication accompanied the landmark exhibition at the Smithsonian, the largest and most extensive ever shown on the topic. It included more than 300 images taken by photographers of African descent.

The book is much celebrated for its excellent scholarship in an area where too little research had previously been done.

Besides winning a John D. and Catherine T. MacArthur Award (2000), Deborah Willis has a long list of awards and recognitions, including becoming a John Simon Guggenheim Memorial Foundation Fellow (2005), earning an Alfonse Fletcher, Jr. Fellowship (2005), a National Endowment for the Humanities planning grant for documentary film for *Reflections in Black* (2003), and Exposure Group's John H. Johnson Award for Lifetime Achievement in Photography, Washington, DC (2002). At the time the last award was granted, Willis was in her mid-fifties, and she has demonstrated no desire to slow down. Her accomplishments are extraordinary.

Bibliography

Willis, Deborah. "Artist's Statement." Personal correspondence with author, February 3, 2007.
————. *Black: A Celebration of a Culture.* New York: Hylas, 2004.
————. Foreword by Robin D. G. Kelley. *Reflections in Black: A History of Black Photographers 1840 to the Present.* New York: W. W. Norton, 2000.
Willis, Deborah, and Carla Williams. *The Black Female Body: A Photographic History.* Philadelphia: Temple University Press, 2002.

Places to See Willis's Work

Avon Collection, New York, New York
Benton Museum of Art, University of Connecticut, Storrs, Connecticut
Center for Creative Photography, Duke University, Durham, North Carolina
Center for Creative Photography, University of Arizona, Tucson, Arizona
Light Works, Syracuse, New York
Los Angeles County Museum of Art, Los Angeles, California
Museum of Fine Arts, Houston, Texas
New York Public Library, Schomburg Center for Research in Black Culture, New York
University of Alabama, Birmingham, Alabama

JOEL-PETER WITKIN

b. 1939

TECHNICALLY PERFECT, JOEL-PETER WITKIN'S PHOTOGRAPHS DEPICT REPUL-
sive images that raise questions about what constitutes art, how we relate to outcasts and
disease, and our relationship to death. Witkin is an artist whose artistic purpose extends
far beyond shock, as he is genuinely interested in the lives of the unusual people he photo-
graphs. He is also known for the visual references he makes to masterworks of art as he calls
up voices of artists from the past. Witkin refers to himself as a portraitist, "not of people but
of living conditions" (Köhler 158). His intention is to give extravagant violence and pain the
respect he feels it deserves.

Witkin was born in Brooklyn to a Jewish father and a Roman Catholic mother. Largely
because his parents had such a conflict over their religious beliefs, they divorced when
Witkin was young. He claims to have started his artwork when he witnessed a traumatic
event:

> It happened on a Sunday. I was six years old. My mother was walking with my
> brother and me down the stairs of the apartment house we lived in. We were on
> our way to church. As we walked though the hallway to the building exit we heard
> an incredible crash then screams and cries for help. Three cars were involved in
> the accident, and there were families in all three of them. In the general confusion
> I somehow let go of my mother's hand. Then I saw something roll out of one of the
> overturned cars. It kept rolling until it reached the place on the curb where I was
> standing. It was a little girl's head. (Köhler 158)

From 1961 to 1964 Witkin was a combat photographer for the U.S. Army, taking
pictures in Europe and Vietnam. This experience no doubt further contributed to his pas-
sionate need to resolve the suffering and death to which he was continuously exposed. He
earned his BA in 1974 from Cooper Union in New York. In 1986, he received his MFA

Joel-Peter Witkin. *Abundance, Prague* (1997). © Joel-Peter Witkin, Courtesy Silverstein Photography, NYC, Catherine Edelman Gallery, Chicago, Galerie Bandoin Lebon, Paris.

from the University of New Mexico in Albuquerque, where he explored various ways of manipulating the photograph.

When he was 16, Witkin went to Coney Island to photograph a three-legged man, a *hermaphrodite*, and a little person called "the Chicken Lady." The images were for his twin brother Jerome who was creating a painting on "freaks," a term often used in the 1940s and 1950s but not widely used today. Jerome Witkin continues to paint realistic images today, often of hallucinatory musings. His work can be full of humor and charm; it can also deal with tortured figures and the garish kind of colors that are reflective of Joel-Peter Witkin's images.

When Witkin was 16, **Edward Steichen** chose one of his photographs for the New York Museum of Modern Art's permanent collection. This was an extraordinary accomplishment, and it resulted in his lifelong devotion to photography.

His obsessive fascination with unusual people, from those who have been called "freaks" to little people, hermaphrodites, amputees, and Siamese twins, often seems to cross the line to being vulgar. They are spectacles that confront our sense of what is normal and decent. Witkin finds his subjects, who become his collaborators (if that can be said of a

Joel-Peter Witkin. *The Kiss,
New Mexico* (1982). © Joel-Peter
Witkin, Courtesy Silverstein
Photography, NYC, Catherine
Edelman Gallery, Chicago, Galerie
Bandoin Lebon, Paris.

corpse), in medical schools, asylums, and morgues around the world. Each of his subjects reflects back on the many personas of the photographer himself. Many times a viewer's first reaction is disgust at his portrayals, which can be frightening and repulsive. His corpses are not just people who have died, but people who have suffered horrendous deaths. Dismemberment is common. But Witkin's goal is to find beauty in people who society has dismissed as monsters. It is not just to dismiss them for the mutilation and abnormalities they experience.

His constructed works that are taken from and reference famous paintings and sculptures are rooted in surrealism. By using artists such as Blake, Bosch, Goya, and Miro, he honors their work while he recontextualizes it in an attempt to make a new kind of history and, therefore, a new way of seeing. He often uses Baroque staging and lighting in his images, which gives the photograph an eerie quality. He works with negatives by scratching the negative and toning or bleaching the print. By elaborately reconstructing famous paintings in photographic form, he questions the way we experience a photograph. Sometimes the title provides the association, as in the case of two decapitated heads that either kiss or devour each other; the title is *Le Braiere (The Kiss)*, conjuring up Brancusi's famous work by the same name, only here the meaning is twisted around.

Often Witkin places masks on his subjects, probably in an effort to provoke questions about what is revealed and what is concealed. Severed heads can also take on the look of masks, raising questions about our ability to become someone else or take on their suffering.

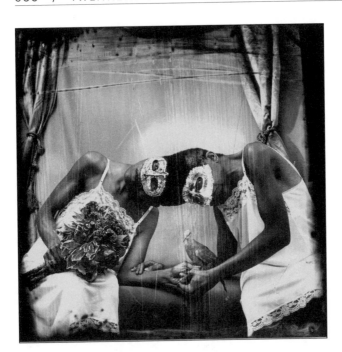

Joel-Peter Witkin. *Siamese Twins, Los Angeles* (1988). © Joel-Peter Witkin, Courtesy Silverstein Photography, NYC, Catherine Edelman Gallery, Chicago, Galerie Bandoin Lebon, Paris.

Witkin's work evokes narratives from the viewer. For instance, his 1997 photograph titled *Abundance* depicts a woman from Prague who has no arms or legs. Abandoned by her mother when she was born, she lives with a huge dog in an apartment. She is positioned on an urn; her head is adorned with flowers, fruit, and pearls. In portraying his subjects this way, Witkin does not hide difference. Instead, he seeks ways of making difference more meaningful.

Because the content of Witkin's work is often so terrifying and repelling and yet so formally beautiful and exquisitely made, he raises questions about art and beauty. And because he portrays such horrifying deaths, he causes critics to ask whether death has replaced sex as the new pornography.

Joel-Peter Witkin positions himself in the role of someone who loves the unloved, regardless of deformity or disease. While some viewers may think Witkin an artist who works only to shock, critic Keith Seward writes, "Witkin is not a rubberneck, an exploiter, or a pessimist, but one who says Yes to everything questionable, even to the terrible" (Witkin 108).

Joel-Peter Witkin has exhibited work all over the world and has received grants from the Ford Foundation and the National Endowment for the Arts. In 1988, he won an International Center of Photography Award. The artist lives and works in Albuquerque, New Mexico.

Bibliography

Buck, Chris, and Christine Alevizakis. "Joel-Peter Witkin," February 2, 1989. Retrieved February 3, 2007, from http://photographerinterviews.ifihadahifi.com/2001/witkin/.
Ebony, David. "Jerome Witkin at Jack Rutberg." *Art in America* 2 (2005): 137–138.

Köhler, Michael, ed. With Texts by Zdenek Felis, Michael Köhler, and Andreas Vowinckel. *Constructed Realities: The Art of Staged Photography*. Zurich, Switzerland: Edition Stemmle, 1989/1995.

Palmer, Christa. "Metroactive: A History of Truth." Retrieved on February 3, 2007, from http://www.metroactive.com/papers/sfmetro/10.97/art1–97–10.html.

Seward, Keith. "Joel-Peter Witkin—exhibit at the Pace/MaGill Gallery, New York, New York—Reviews." *Artforum International* 31 (Summer 1993): 107–108.

Witkin, Joel-Peter. *Witkin*. Zurich: Thames and Hudson, 1995.

———. *Gods of Earth and Heaven*. Altadena, CA: Twelvetrees Press, 1989.

Places to see Witkin's Work

Center for Creative Photography, University of Arizona, Tucson
Minneapolis Institute of Art, Minneapolis, Minnesota
Museum of Fine Arts, Museum of New Mexico, Santa Fe, New Mexico
Museum of Modern Art, New York, New York
San Francisco Museum of Modern Art, San Francisco, California
University of South Florida Contemporary Art Museum, Tampa, Florida
Whitney Museum of Art, New York, New York
Williams College Museum of Art, Williamstown, Massachusetts

GLOSSARY

Abstract Expressionism: An art movement that began in the 1950s in New York City. First applied to Wassily Kandinsky's early abstract paintings, the term was later used to refer to other artists such as Arshile Gorky and Jackson Pollock. It described an outlook that was associated with a revolt against traditional styles or predetermined techniques. It embraced freedom of expression and spontaneity.

Action Painting: A way of painting associated with Jackson Pollock, where he splashed and dripped paint onto a canvas often placed on the floor. The term was coined by critic Harold Rosenberg in 1952. Action Painting documented the process of painting and was not seen only as a finished work of art. Action Painting is one form of Abstract Expressionism.

Appropriationist: Someone who appropriates or takes over pre-existing images and places them in new and different context thereby creating a new purpose or meaning. A good example is the work of **Sherrie Levine.**

Ashcan School: American realist painters in the early twentieth century, namely Robert Henri, Arthur B. Davies, Ernest Lawson, William Glackens, Everett Shinn, John French Sloan, and George Luks. A short-lived art style, these Ashcan School artists exhibited together only one time.

Autopole: An instrument used to attach lights to alter the photographic image, originally known as a telescopic lighting pole, which was invented by **Berenice Abbott.**

Avant-garde: Something that appears to be ahead of its time.

Brownie camera: Originating in 1900, this Kodak camera was made to be affordable and easy to use by anyone of any age. The Brownie camera evolved dozens of times throughout the decades but was always promoted as the camera for anyone.

Cartesian thinking: A way of thinking originally proposed by the influential French philosopher René Descartes (1596–1650) who claimed that the humans were made up of two kinds of substances, mind and body. The mind is a thinking being that has consciousness, and the body works like a machine that has material properties, which follow the laws of physics. Cartesian dualisms came from these foundational ideas.

C-Print: Short for Cibachrome, it is a brand of paper and processing technology used for making color prints from slides.

Cibachrome: Photographs printed from slides, allowing the photographer to manipulate the brightness of the color.

Collodian wet-plate process: A photographic technique invented by Frederick Scott Archer in 1851 that quickly produces great subtlety of tones. It involves using a glass plate coated with collodian in a solution of silver iodide and iodide or iron, which is exposed to light and developed when it is still wet. This process contributed to an increase in photographic expansion in the nineteenth century.

Collotype: A photographic printing process introduced in Britain in the 1860s that uses gelatin plates.

Conceptual art: A term that describes various kinds of art where the idea is more important than the final product, although a final product is not necessary. This kind of art originated with Marcel Duchamp; however, not until the 1960s did it take off as a major way of working. The overriding notion of Conceptual art is that the artistic part of the work does not reside in the material piece, but in the idea it represents. An artist working from a Conceptual art point of reference generally wants to divert attention away from the object and onto the idea that is being communicated.

Cubism (Cubist): Most formative from 1907 to 1914, this Western art movement is recognized as one of the most important turning points in Modern art. It is generally attributed to Pablo Picasso and Georges Braque although many other artists played with their ideas and broadened the category. Influenced by African sculpture and painting by Paul Cezanne, Cubism was a radical departure from the prevalent idea that art should imitate nature. Instead, an approach was taken that played with perspective with an aim toward creating the illusion of three-dimensional space on a two-dimensional picture plane. The result was the portrayal of many different views of an object at the same time. Also represented in sculpture, Cubists aimed to depict objects as they are understood as opposed to capturing them in a single moment in time and space.

Cyborg: Most commonly, a human being who has artificial organs or machine parts. Often thought of as a superhuman, cyborgs have varying degrees of mechanical enhancements.

Dada (Dadaist): A movement in Europe and the United States that rebelled against the establishment by creating anti-art. Growing out of disillusionment created by the World War I, it focused on anarchy, cynicism, irony, irrationality, and the absurd. Founded in Zurich by a group of artists and writers, its goal was to disrupt the complacency of the general public. Marcel Duchamp and **Man Ray** were leading figures.

Diaspora: A relocation of people from one geographical region to another, most often due to oppression, war, slavery, or other traumatic experience.

Diptych: Two panels of artwork or leaves hinged or otherwise placed together.

Distortion Easel: Photography equipment that was invented by **Berenice Abbott** to alter the effects of the photographic image in the darkroom.

Duchamp, Marcel (1887–1968): An influential French artist and theorist who, with Francis Picabia, became the leader of the New York Dada movement. He invented the Readymade with a bicycle wheel that he mounted on a kitchen stool. Perhaps his best known piece is the urinal he titled *Fountain*, which he signed R. Mutt in 1917. He was a legend in his own lifetime, and he revolutionized the way people thought about art by trying to discourage ideas related to traditional aesthetics.

Ektachrome: Kodak's version of the Agfacolor process that was introduced in the early 1940s, allowing photographers to print their own color film. This simplified process only required a single developer to make the positive image from the negative.

Ektacolor: A term used to describe a Kodak product line, from special paper to chemical agents for processing color prints.

Equivalence: A term used by **Alfred Stieglitz** and developed by **Minor White** as an approach for looking at photographs. It is an emotional response by a viewer that is unrelated to the subject matter of an image.

f64: California-based group of photographers who worked to represent their subjects in a straightforward way. Inspired by the German movement called The New Objectivity, the American artists differentiated their work by focusing on technical proficiencies as well. Started in 1932 by artists Ansel Adams, **Imogen Cunningham, Edward Weston,** Willard Van Dyke, and others.

Farm Security Administration (FSA): A government organization, founded by Roosevelt in 1937, for the purpose of documenting the effects of the Depression on farm workers across the United States. Directed by Roy Stryker, it was inspired by both urgency and idealism. Photographers who worked in the FSA included Charlotte Brooks, **Walker Evans, Dorothea Lange,** Russell Lee, **Arthur Rothstein,** and **Marion Post Wolcott.**

Fauvism: One of Europe's first avant-garde art movements, it focused on a style of painting that used vivid, nonnaturalistic colors. Henri Matisse was the dominant figure who began painting with intense, contrasting colors as early as 1899.

Feminism: A movement that focuses on equity for women, the most recent wave began in the 1960s. The Feminist Art Movement focuses on why and how women's achievements were not visible in the art world, and the different ways that women and men perceive the world. It stresses parity in creative expression, as well as in political and economic arenas.

Ferrer School: Commonly referred to as the Ferrer School for its anarchist and socialist ideals, The Modern School in New York City taught artists, writers, and freethinkers. The school opened in 1911 and moved to Piscataway Township, New Jersey, after events leading to the government investigation of such institutions. The directors felt that the school and its students were no longer safe in the city.

Film noir: A term used to describe Hollywood crime dramas that were made in the 1940s and 1950s. Made in black and white, they focused on moral ambiguity and actions that were sexually motivated. The term is French for "black film." Cindy Sherman's untitled black-and-white photographs from her *Film Still Series* evoke a dark and somber mood, recalling 1950s film noir.

First Wave Feminist Movement: An activist movement in the United States and the United Kingdom that focused on gender inequities during the nineteenth century and early twentieth century. Their main cause was gaining women the right to vote. The term "first wave" was coined after the "second wave" of feminism began in the 1960s.

Formalism: A way of looking at art that emphasizes an analysis of the formal elements as opposed to content of a work of art. In a formalist analysis a critic might talk about such things as light, shadow, balance, and movement, instead of the narrative of the image.

Gallery 291 (also known as Studio 291, the 291 gallery, or 291): A New York, avant-garde art space established by **Alfred Stieglitz** in 1905. At the prompting of **Edward Steichen,** Stieglitz agreed to move "The Little Galleries" to a space across from Steichen's art studio. Located at 291 Fifth Avenue, the gallery soon became simply known as "291." The gallery presented the first American exhibitions of such notable artists as Henri Matisse, Henri de Toulouse-Lautrec, and Constantin Brancusi. Many photographers were shown in this gallery, which helped to elevate the medium to a high art. The gallery was closed in 1917 when the building was destroyed. From 1925 to 1929 Stieglitz's work was continued in the Intimate Gallery and from 1929 to 1946 in An American Place.

Great Migration (Negro): A movement of blacks from the rural South to the North from 1914 to 1950. They left Jim Crow laws hoping to find "the Promised Land" when industrial jobs opened up in cities like New York, Philadelphia, Detroit, Baltimore, Chicago, and Milwaukee. Smaller industrial towns were also affected.

Happening: An art form that is both planned and spontaneous, it usually combines both theatrical performance and visual art. Happenings are not restricted to a gallery space, and they rely on some aspect of chance. Allen Kaprow coined the term in 1959.

Hermaphrodite: An animal or person with the sexual organs of both the male and female.

Impressionism (Impressionists): A loosely formed art movement that originated in France in the 1860s, Impressionism generally refers to artworks that focus on the physics of color. Most Impressionists applied paint using small strokes or touches of the brush filled with pure color as opposed to making broader brush strokes with blended color. Consequently, most Impressionist paintings were brighter than the work of their contemporaries. Impressionists often worked outdoors, which helped them focus on capturing a fleeting impression of light as opposed to a more stagnant synthesis of light that defined studio practice.

MacArthur Award: Often called the "genius" award, the John D. and Catherine T. MacArthur Foundation gives out fellowships to several individuals each year who have "shown extraordinary originality and dedication in their creative pursuits and a marked capacity for self-direction." The program's goal is to enable recipients to use their creativity for the good of humanity. **Lee Friedlander, Cindy Sherman,** and **Deborah Willis** have won MacArthur Awards.

Minimalism (Minimalists): A term coined in the 1950s and 1960s to refer to an artwork that was generally three-dimensional and either formed by chance or made of simple geometric forms. Minimal art, in any media, is seen as a reaction against emotiveness as the artist aims to make the work impersonal.

Modernism: General term that refers to the art and architecture that dominated twentieth century Western culture's procession of avant-garde movements. Generally speaking, modernism favors an art for art's sake approach. Regarding dance, modernism occurred in the early twentieth century as a direct rebellion against the constraints of Classical ballet. Modern dance, also called free dance or interpretive dance, rejected traditional toe shoes and costumes, broadening the scope of dance performance beyond the ballet. Dancers such as Isadora Duncan and Martha Graham pioneered the Modern dance movement.

Modernity: The term refers to the condition of being modern. Although it can describe a wide range of periods, and should be understood in context, in the contemporary context, it refers to a period between 1870 to 1910 through the present.

New York School of Artists: A name given to innovative painters in general, and Abstract Expressionists in particular, living and working in New York during the 1940s and 1950s.

Office of War Information: A government organization that took over the Farm Security Administration in 1943.

Photogram: A photographic image made without a camera, by placing an object directly on the photographic paper and exposing it to light. **Man Ray** experimented with the photogram process, calling his works rayographs.

Photogravures: Engravings that are commercially made from photographs.

Photolithography: A way of making a print from a plate that combines photography and lithography processes.

Photomontage: A visual composition made by overlapping photographs or fragments of photographs on paper.

Photo-Secessionist Movement: A photographic initiative aimed at succeeding from academic photography to a more artful approach to the medium, which arose toward the end of the nineteenth century in England, Germany, and Austria as the Link Ring Movement, and spread to the United States in the early 1900s. In 1902, Alfred Stieglitz organized photographers in the initiative, which became known as the Photo Secessionist Movement. It formally lasted from 1905 to 1917. Perspectives on the movement were expressed in Stieglitz's scholarly journal, *Camera Work*.

Photo-quilts: Quilts made with photographic images transferred onto the fabric of the quilt top. **Deborah Willis** makes photo-quilts.

Pictorialism: Late nineteenth century, early twentieth century avant-garde movement in photography that aimed to create photographic images that felt and looked like paintings.

Polaroid: The term refers to a type of synthetic plastic sheet that is used to polarize light. It is also a trade name for products sold by the Polaroid Corporation. These include instant print photographic film and cameras.

Pop Art: Art that uses imagery from mass media like comic strips, advertisements, images from television and film, and commercial packaging. There is both irony and a celebratory appeal to this work. It began in the late 1950s and took off as a major art movement in the 1960s in both Britain and the United States. English critic Lawrence Alloway coined the term. In the United States, Pop art was initially positioned as a reaction against Abstract Expressionism in an effort to bring back figural imagery and quasi-photographic techniques.

Popular culture: Seen as the culture of the people, it is vernacular, everyday, and mainstream. It can include various objects and practices related to clothing, music, sports, film, television, magazines, and food. Popular culture is often contrasted with high or elite art.

Postmodernism: A difficult term to define, it refers to a way of thinking that implies that the modern historical period is waning or past. Generally thought of as a movement comprised of ideas that are contrary to Modernism, Postmodernism focuses on a decentralized, participatory, media-driven society in which copies of things proliferate, and the original can be hard to find.

Readymades: A term coined by Marcel Duchamp that refers to everyday objects that are removed from their context, placed in a gallery context, and treated as works of art.

Retoucher: The process of repairing damaged photographs, originally done by dark room assistants, which is now most frequently accomplished with the right software program.

Retrospective exhibition: An exhibition that covers an artist's entire career. The focal artist is generally a living artist.

Roll film camera: A camera that uses photographic film wound on a spool with a paper backing.

Self-taught: A term most often used to define someone who did not learn his or her art in a formal school setting. However, the term is controversial since it calls into question how people learn as it recognizes that the learning process is complex and systemic.

Silk-screening: A printing process that utilizes stencils and ink that is brushed through a fine screen made of silk.

Socio-photographer: A term used by the New York Photo League in the 1930s, socio-photographers worked to document the conditions and struggles of society's subcultures.

Solarization: Process of exposing photographic image to ultraviolet light or x-rays to change the coloring.

Straight Photography: A style of photography that attempts to depict the image as realistically as possible.

Sublime: A term first used in the eighteenth century, it is often associated with ideas from the philosopher Immanuel Kant and characteristics of limitlessness, grandeur, and extraordinariness, as well as terror. The sublime is more than picturesque in that it inspires awe.

Surreal: Related to Surrealism, it is characterized by that which is dreamlike, irrational, and related to the unconscious. It can be bizarre and fantastic.

UNICEF: Created in 1946, the United Nations Children's Fund is a non-profit organization that provides long-term humanitarian aid to children in developing countries who are living in poverty.

Venice Biennial: A prestigious international art show that takes place in Venice, Italy, every two years.

Works Progress Administration: A program started by President Franklin D. Roosevelt in 1935 that placed forty thousand unemployed artists in jobs in four Federal Arts Projects. This was the largest government-sponsored intervention in cultural production in U.S. history.

SUGGESTED READINGS

Adams, Ansel. *Making a Photograph: An Introduction to Photography*. London: The Studio Ltd. and New York: The Studio Publications, Inc., 1935.

Bright, Susan. *Art Photography Now*. New York: Aperture, 2005.

Campany, David. *Art and Photography*. New York: Phaidon, 2003.

Cartier-Bresson, Henri. *The Decisive Moment*. New York: Simon and Schuster, 1952.

Cotton, Charlotte. *The Photograph as Contemporary Art*. New York: Thames and Hudson, 2004.

DeCarava, Roy, and Langston Hughes. *The Sweet Flypaper of Life*. New York: Hill and Wang, 1955.

Evans, Walker. Introduction by James Agee. *Many Are Called*. Boston: Houghton Mifflin, 1966.

Greer, Fergus. *Portraits: The World's Top Photographers*. East Sussex, UK: Rotovision, 2004.

Jeffrey, Ian. *The Photo Book*. London: Phaidon Press Ltd., 2000.

Lahs-Gonzalez, Olivia, and Lucy Lippard. Introduction by Martha A. Sandweiss. *Defining Eye: Women Photographers of the Twentieth Century*. St. Louis, MO: The St. Louis Museum of Art, 1997.

London, Barbara, John Upton, and Jim Stone. *Photography*, 9th ed. Upper Saddle River, NJ: Prentice Hall, 2007.

Newhall, Beaumont. *History of Photography: From 1839 to the Present*. New York: Bulfinch Press, 1982.

Parr, Martin, and Gerry Badger. *The Photobook: A History*, Vol. 1. New York: Phaidon, 2004.

———. *The Photobook: A History*, Vol. 2. New York: Phaidon, 2006.

Sontag, Susan. *On Photography*. New York: Farrar, Straus and Giroux, 1977 (first published in 1973).

Steichen, Edward. *A Life in Photography*. Garden City, NY: Doubleday, 1963. Published in collaboration with The Museum of Modern Art.

Szarkowski, John, Lee Friedlander, Walker Evans, and William Klein. *The Photographer's Eye*. New York: The Museum of Modern Art, 2007 (first published in 1964).

Things as They Are: Photojournalism in Context since 1955. Introductory Essay by Mary Panzer, preface by Michiel Munneke, afterword by Christian Caujolle. New York: Aperture, 2006.

Willis, Deborah. *Black: A Celebration of a Culture*. New York: Hylas, 2004.

———. Foreword by Robin D. G. Kelley. *Reflections in Black: A History of Black Photographers 1840 to the Present*. New York: W. W. Norton, 2000.

INDEX

About the Authors

KRISTIN G. CONGDON is a Professor of Film and Philosophy at the University of Central Florida. She has published extensively on the study of folk arts, community arts, and contemporary art issues. She is co-editor of several books. She is the 1998 and 1999 recipient of the Manual Barken Memorial Award for scholarship from the National Art Education and the 1998 Ziegfeld Award from the United States Society for Education Through Art for international work in the arts.

KARA KELLEY HALLMARK is an art teacher at Union Hill Elementary in Round Rock, Texas. She has a BFA in art history, MA in art education, graduate certificate in gender studies, and a PhD in art education with a minor in women's studies. Past publications include *Encyclopedia of Asian American Artists* (Greenwood, 2007), and *Artists from Latin American Cultures* (Greenwood, 2002), also co-authored with Kristin G. Congdon. Other publications include papers for art education conferences and a desktop publication for the House of Blues folk art collection in Orlando, Florida.